ALISON JACKSON

ALISON JACKSON

CONFIDENTIAL

TASCHEN

HONG KONG KÖLN LONDON LOS ANGELES MADRID PARIS TOKYO

Self-portrait of the artist, 2007 Alison Jackson,
courtesy of Kasim Kutay and ICA, London

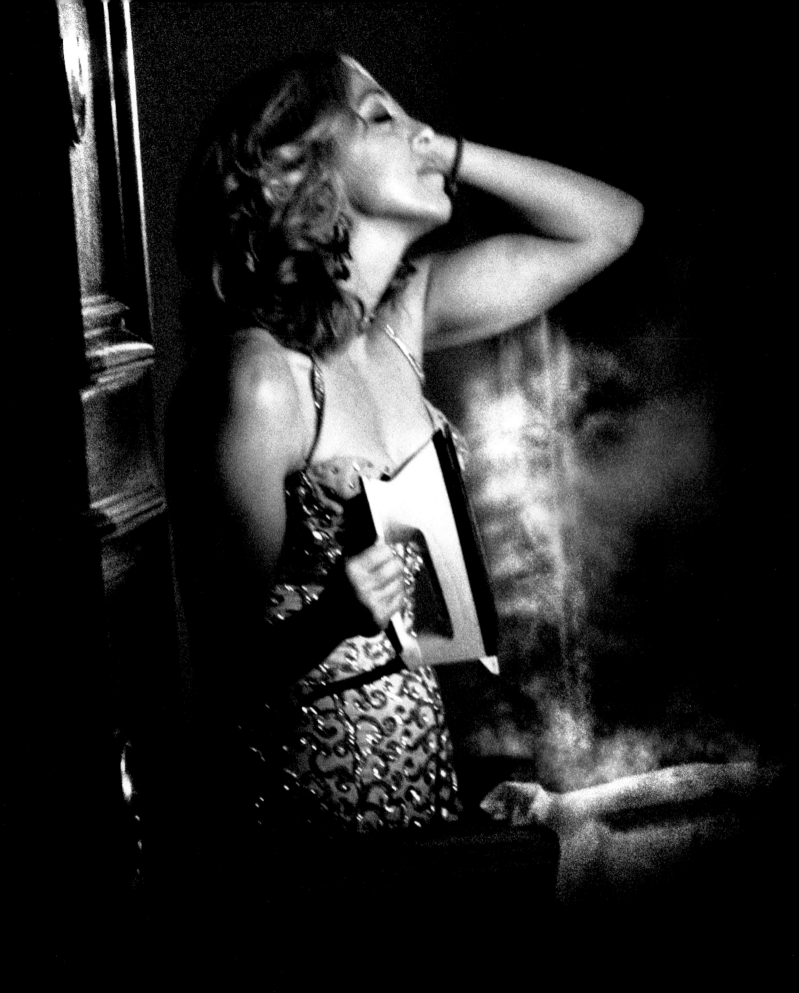

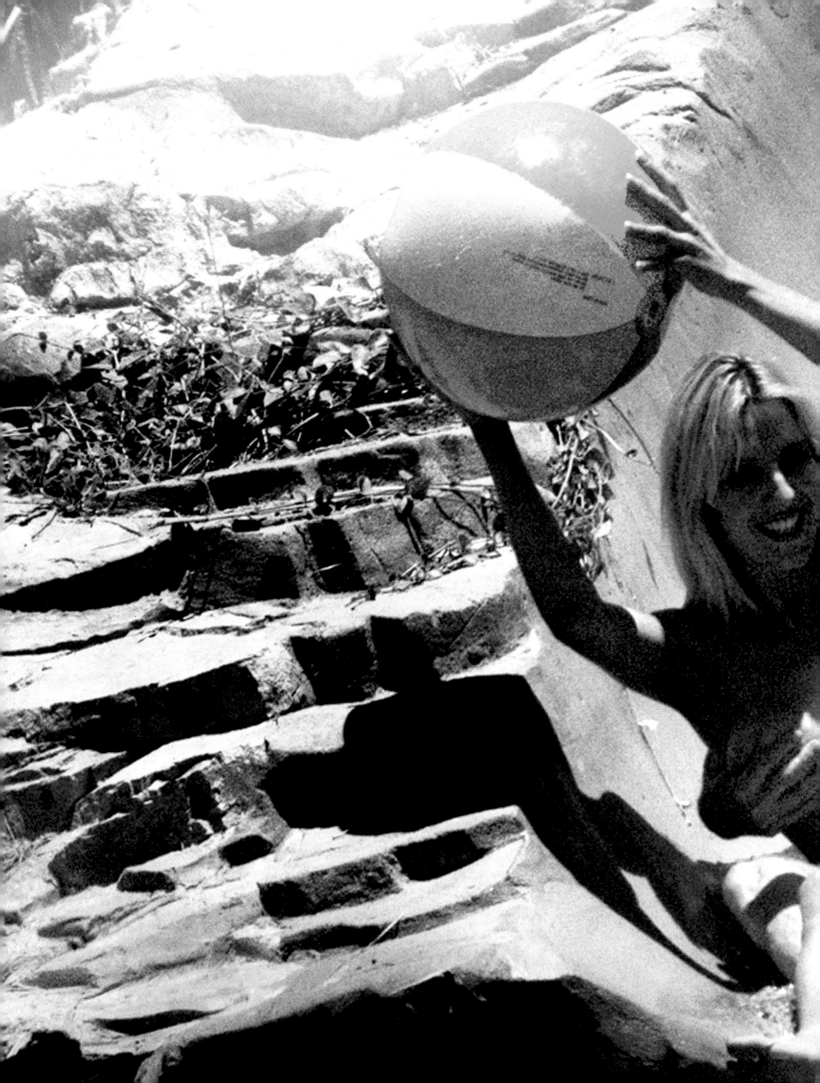

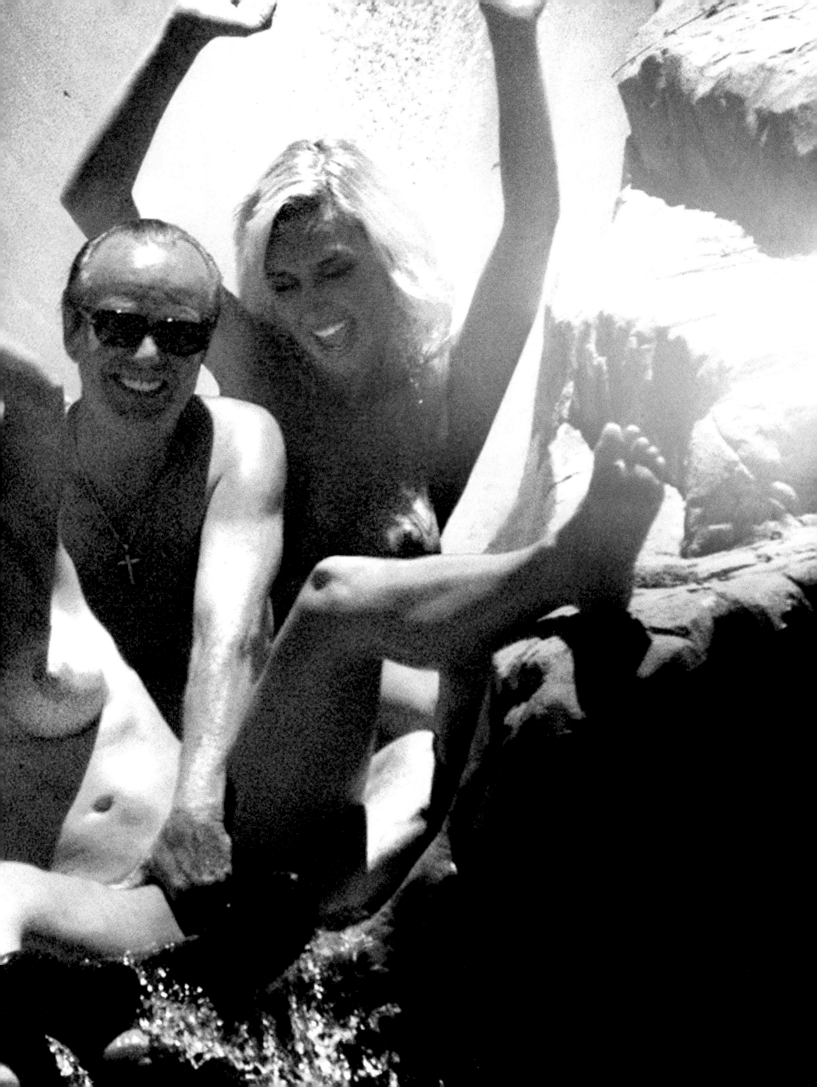

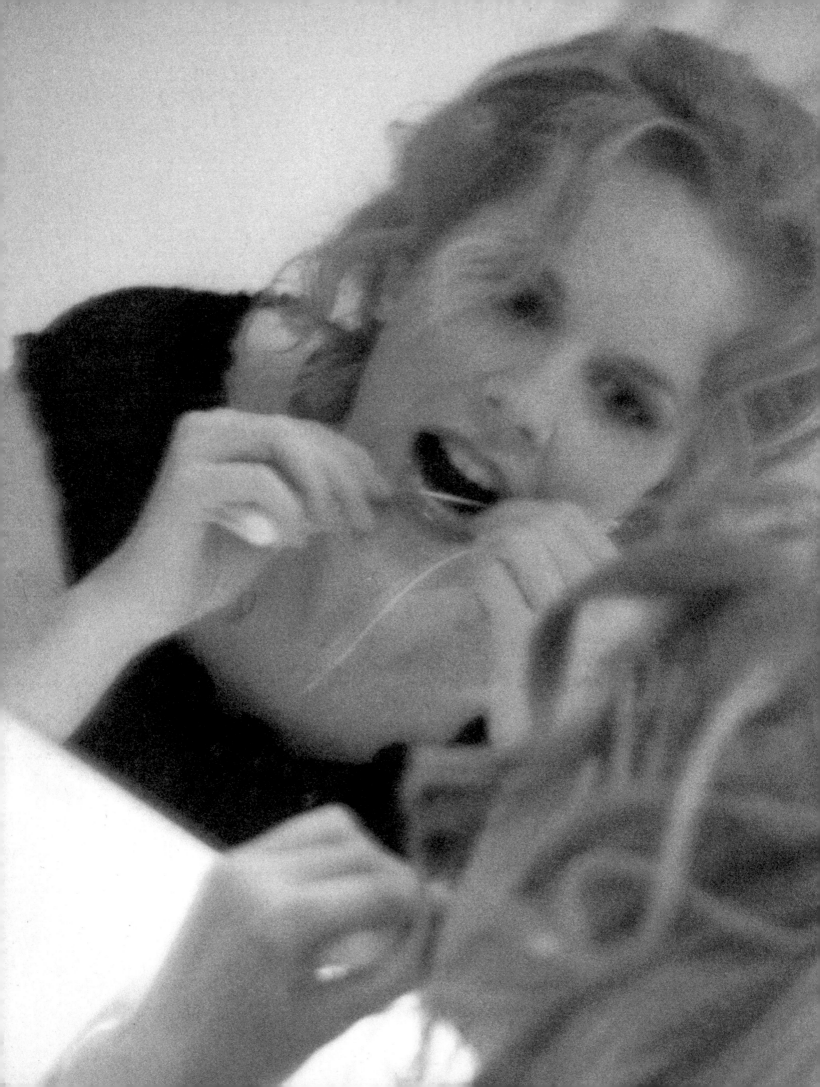

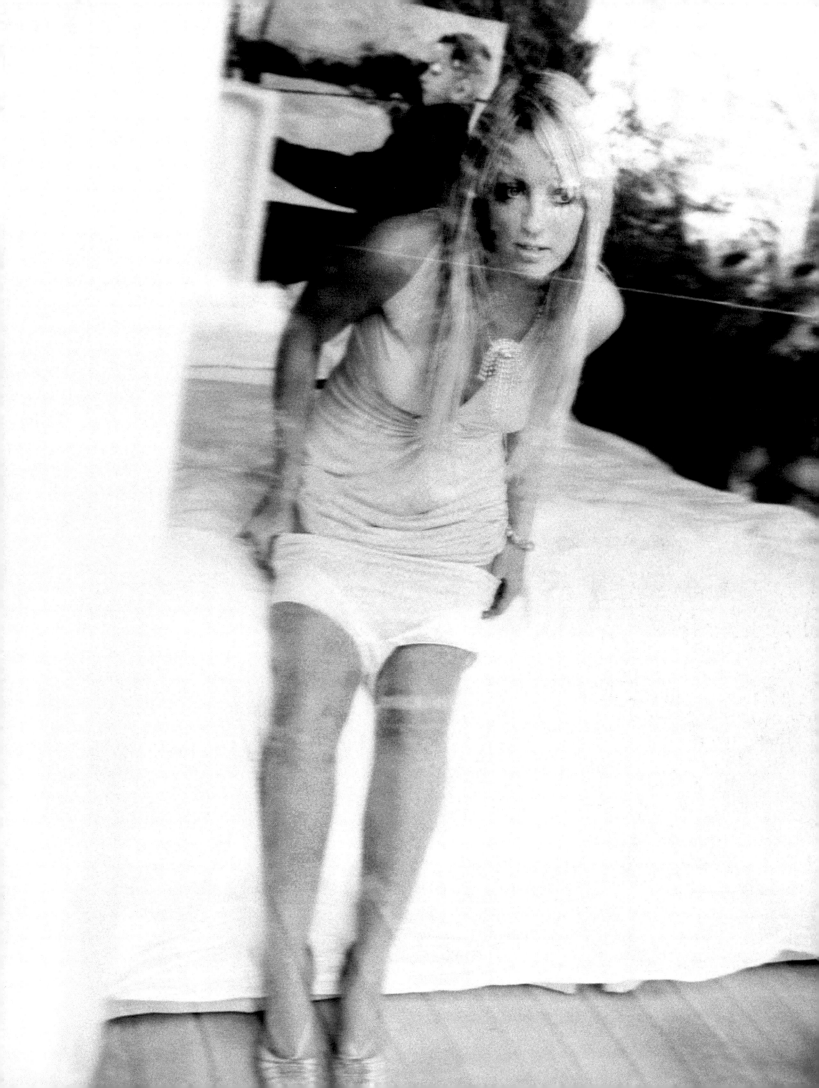

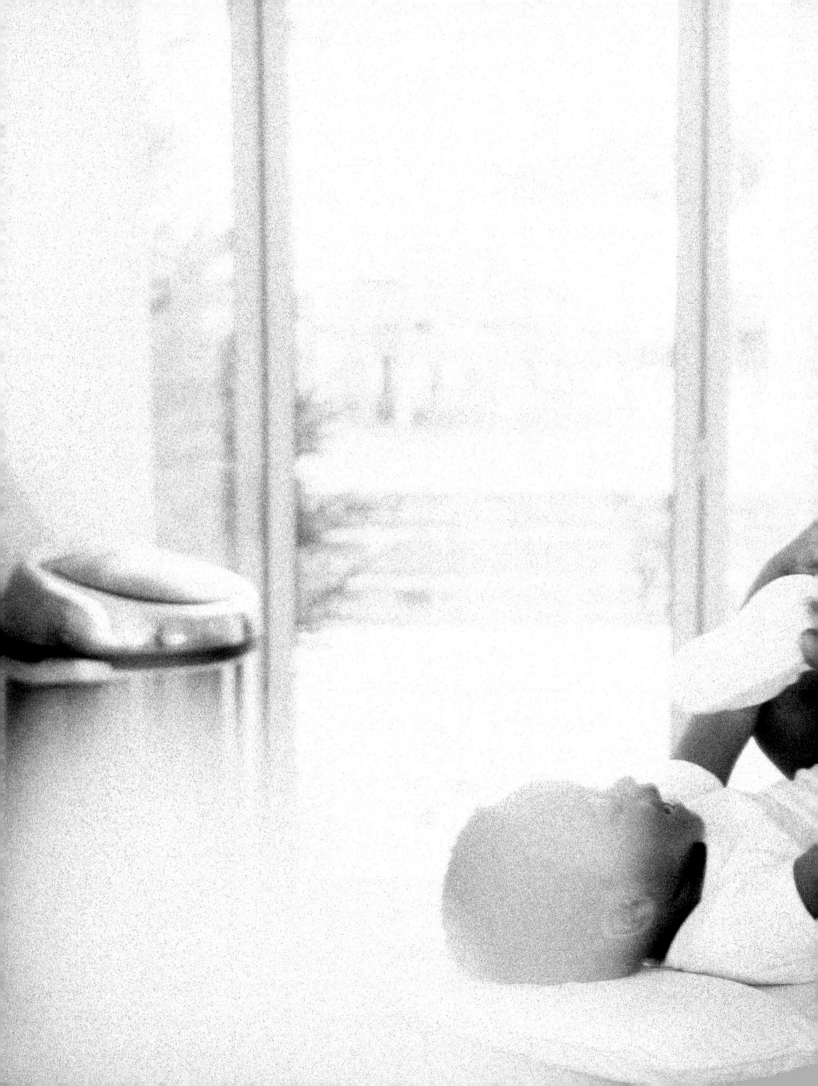

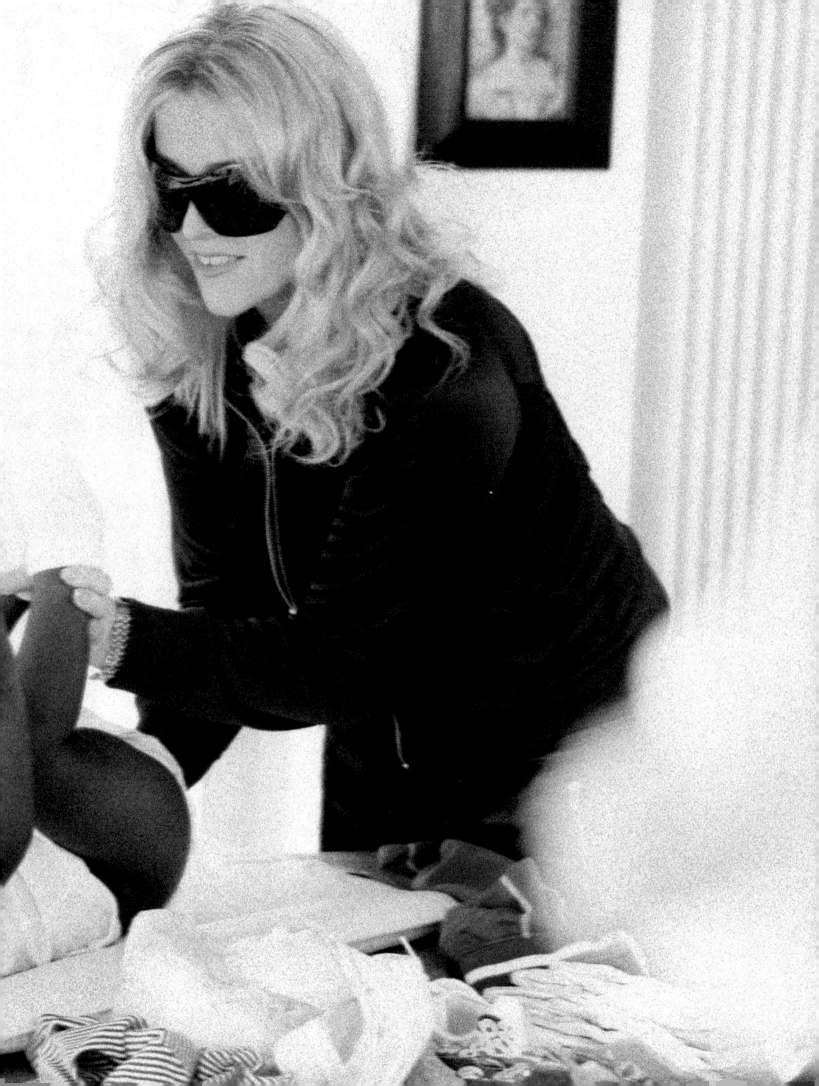

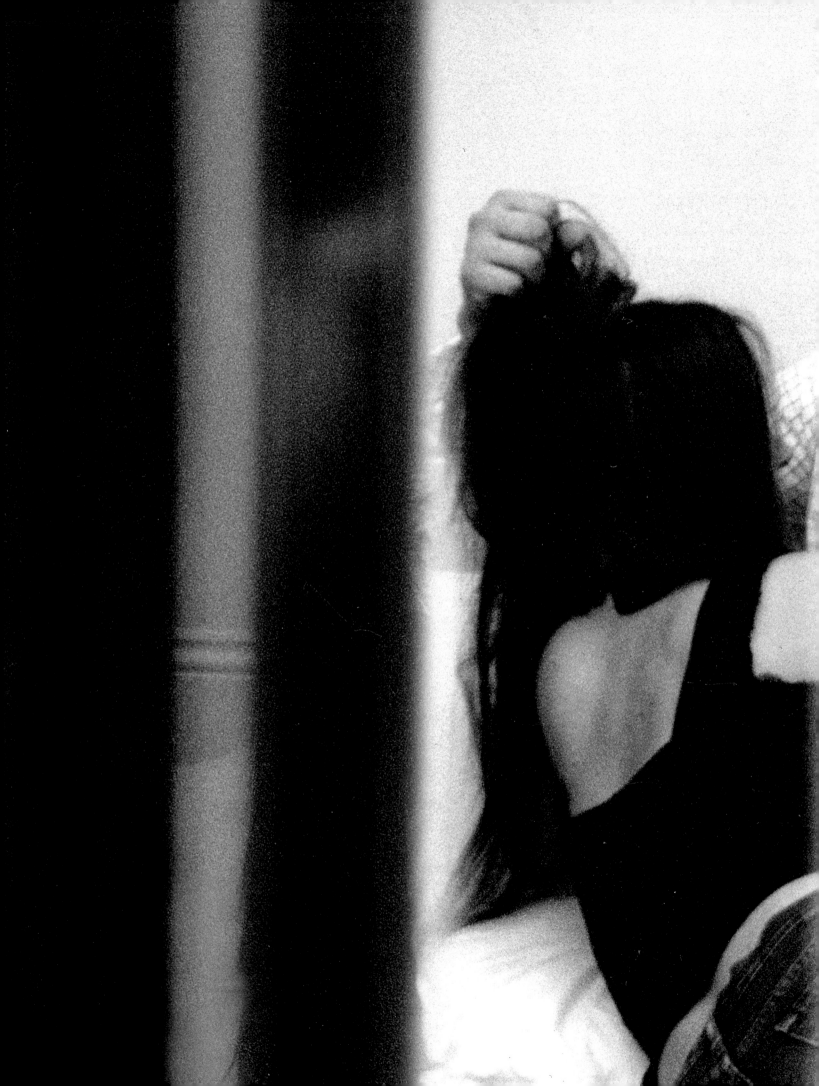

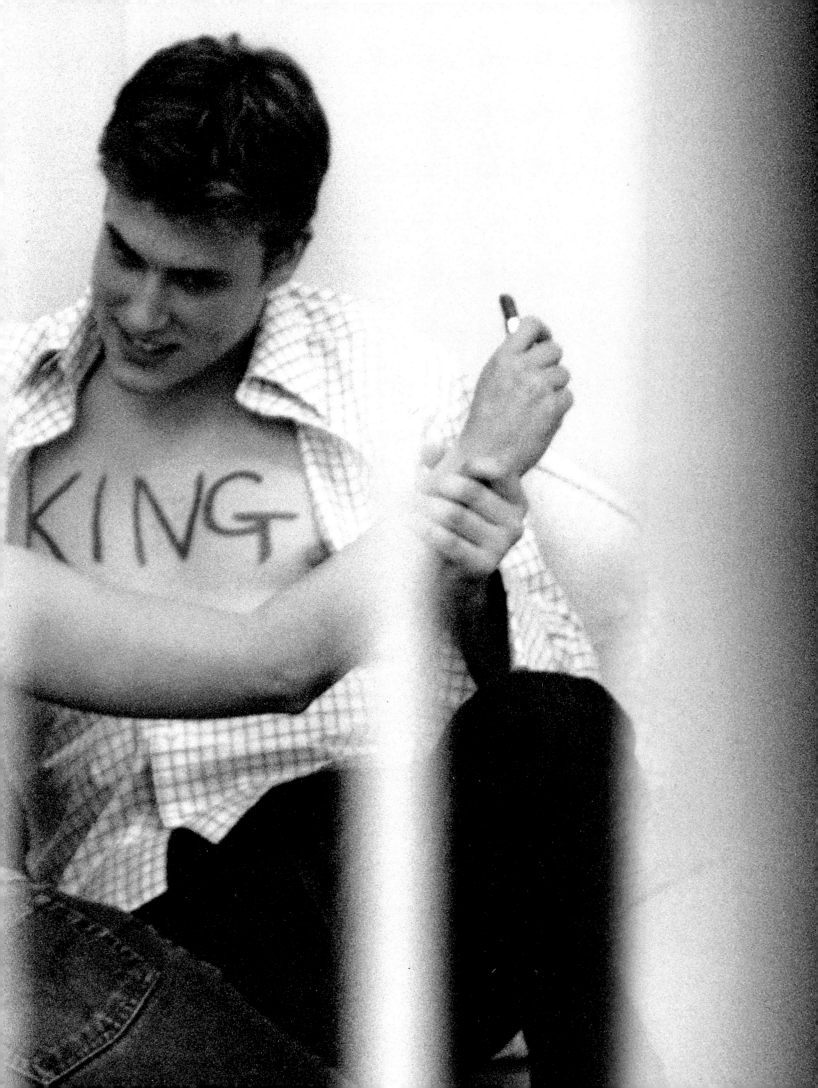

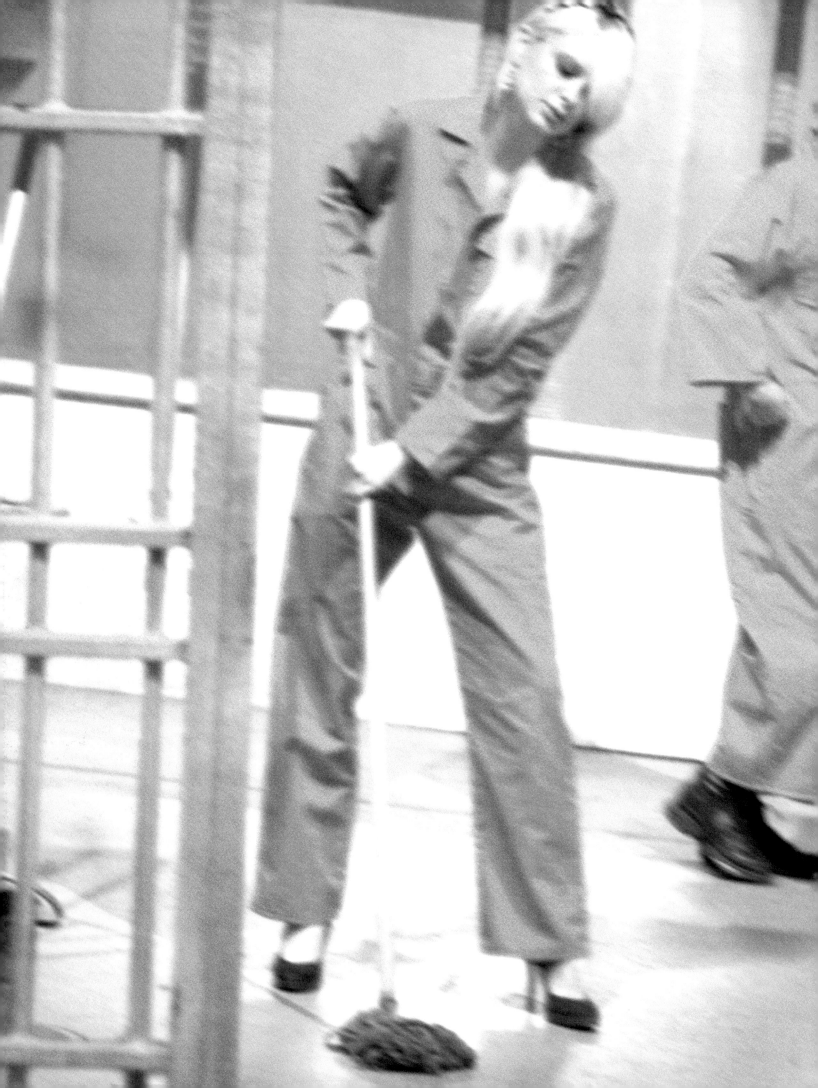

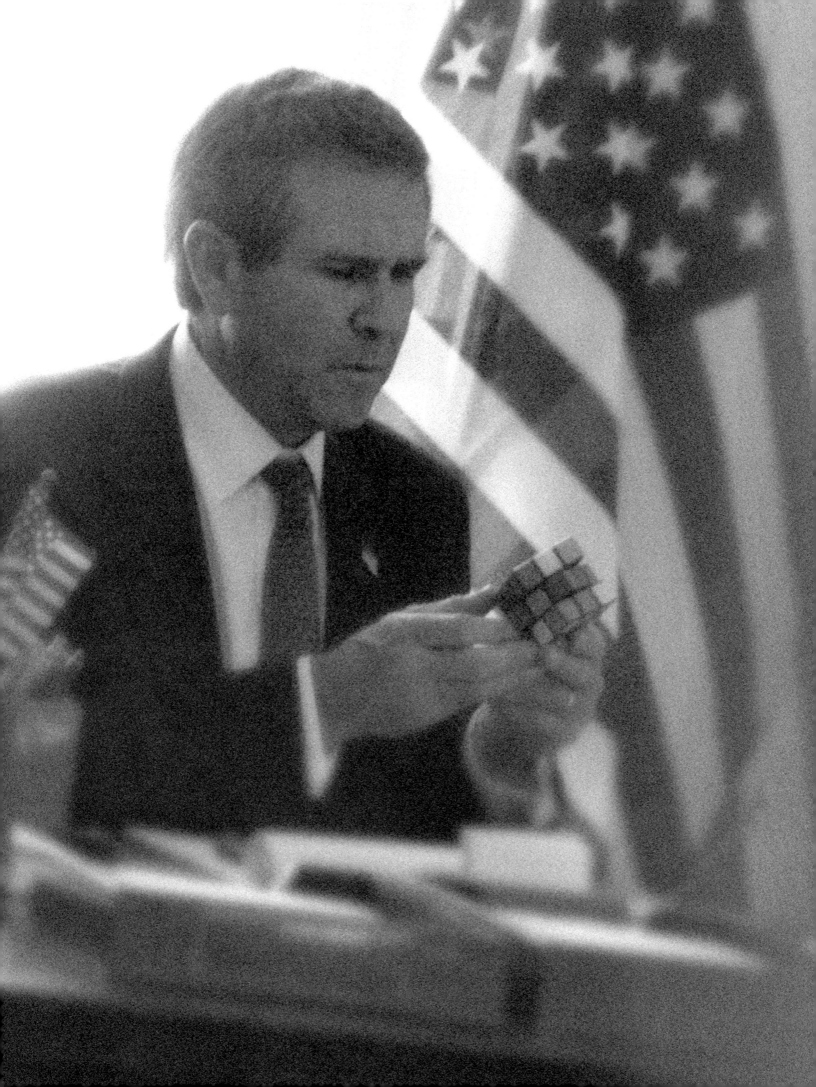

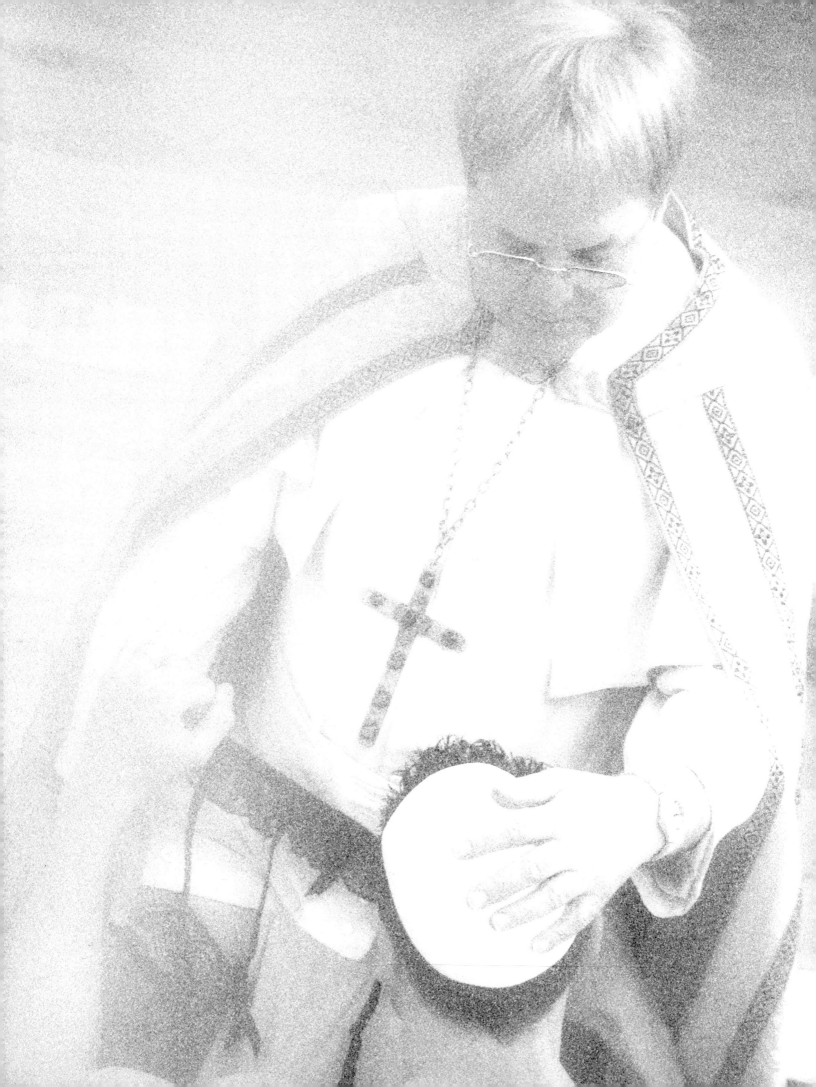

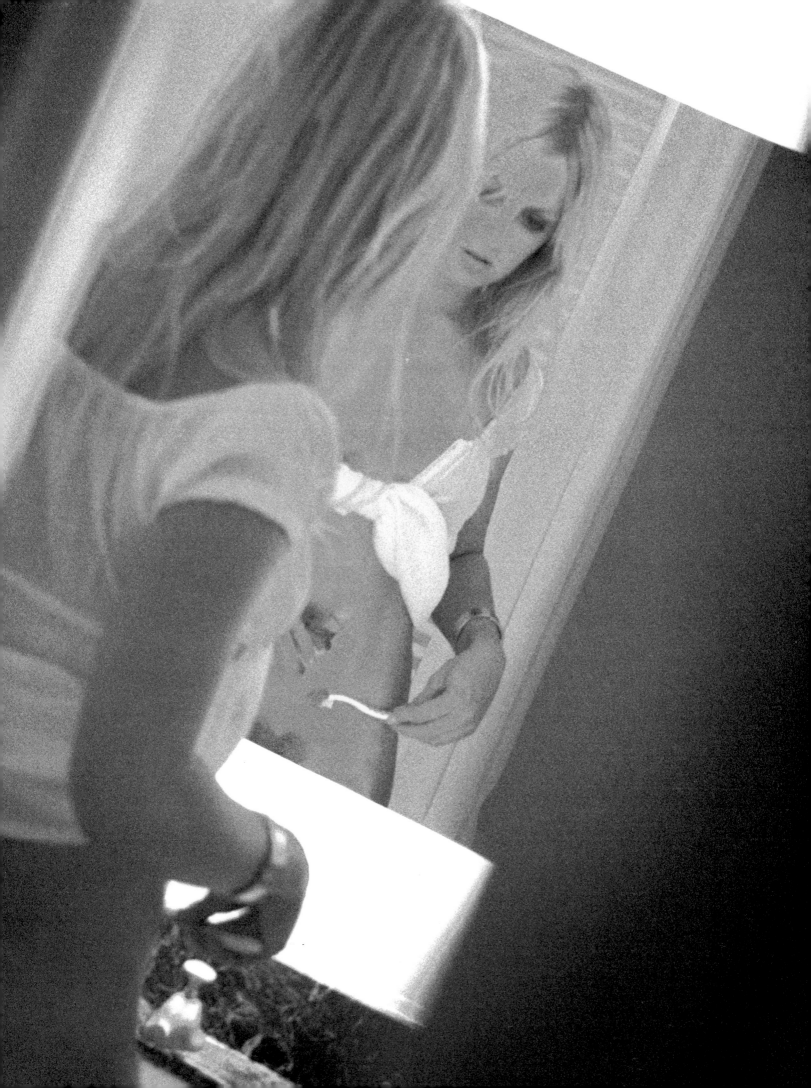

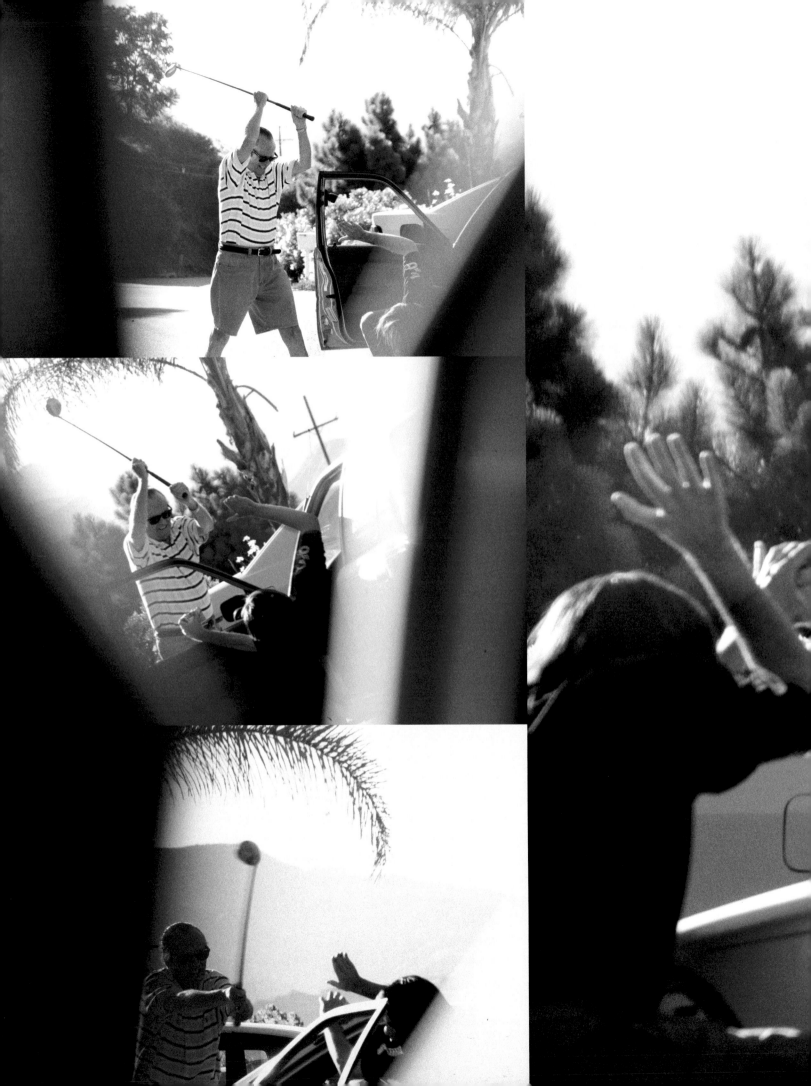

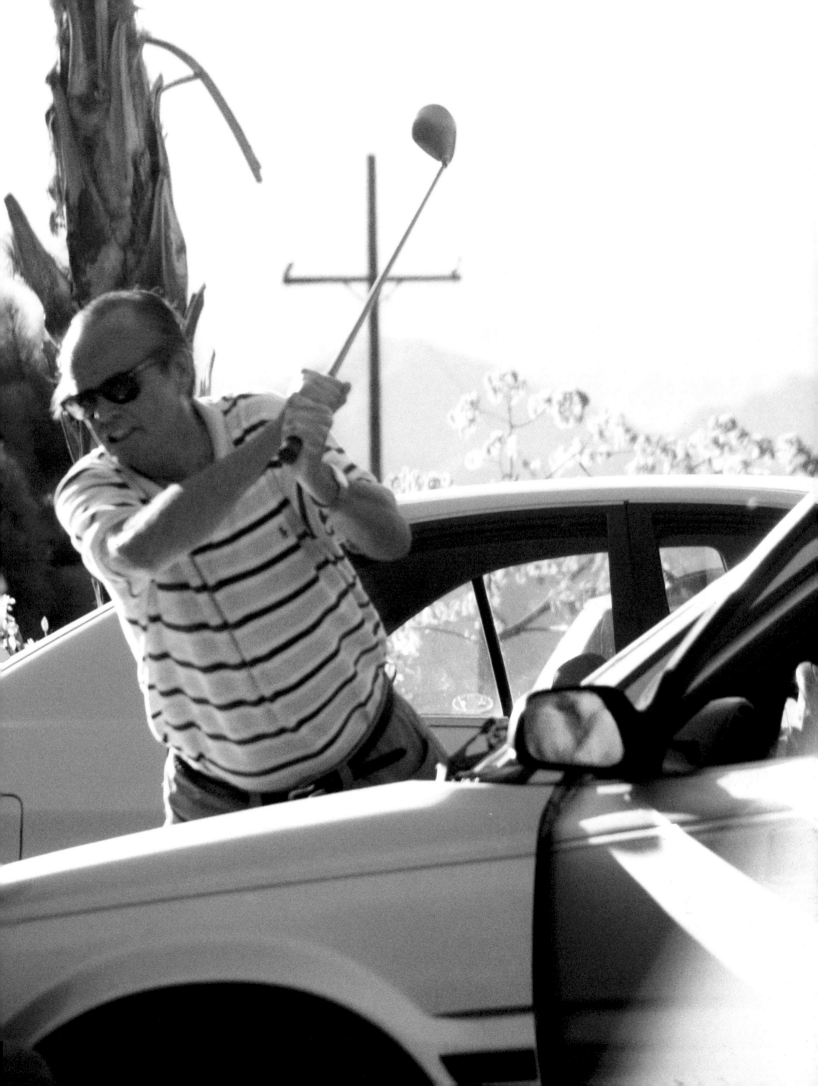

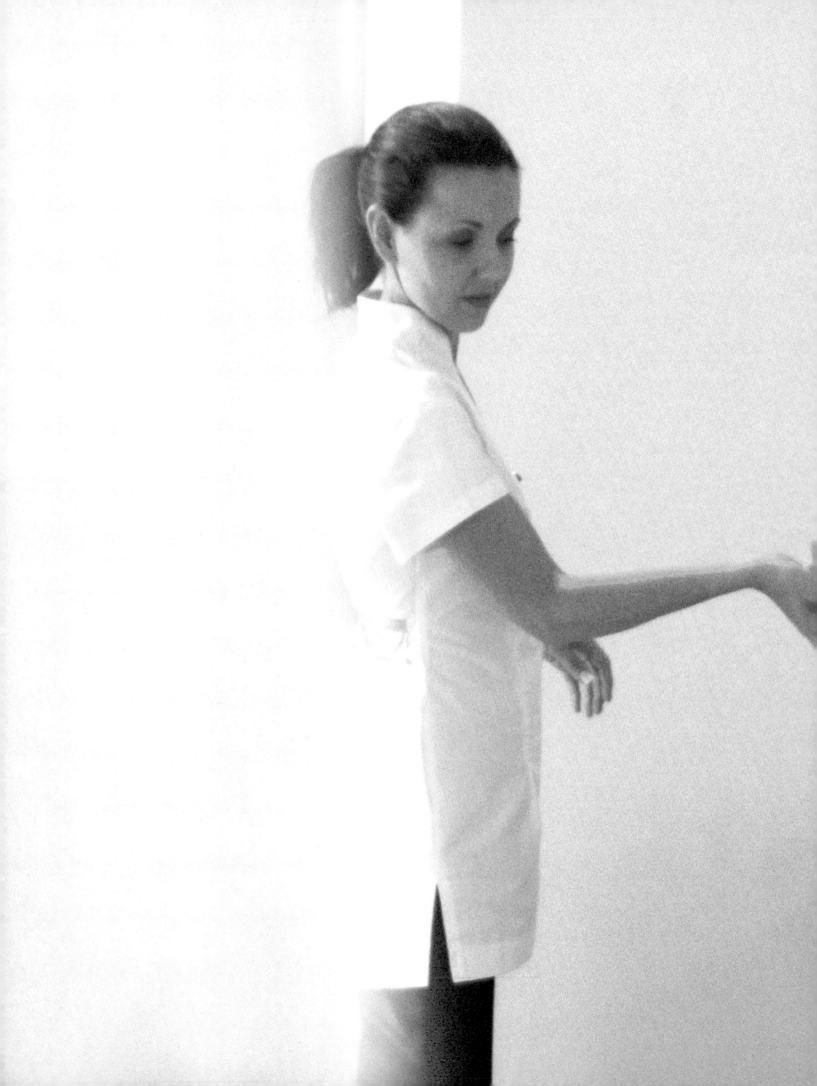

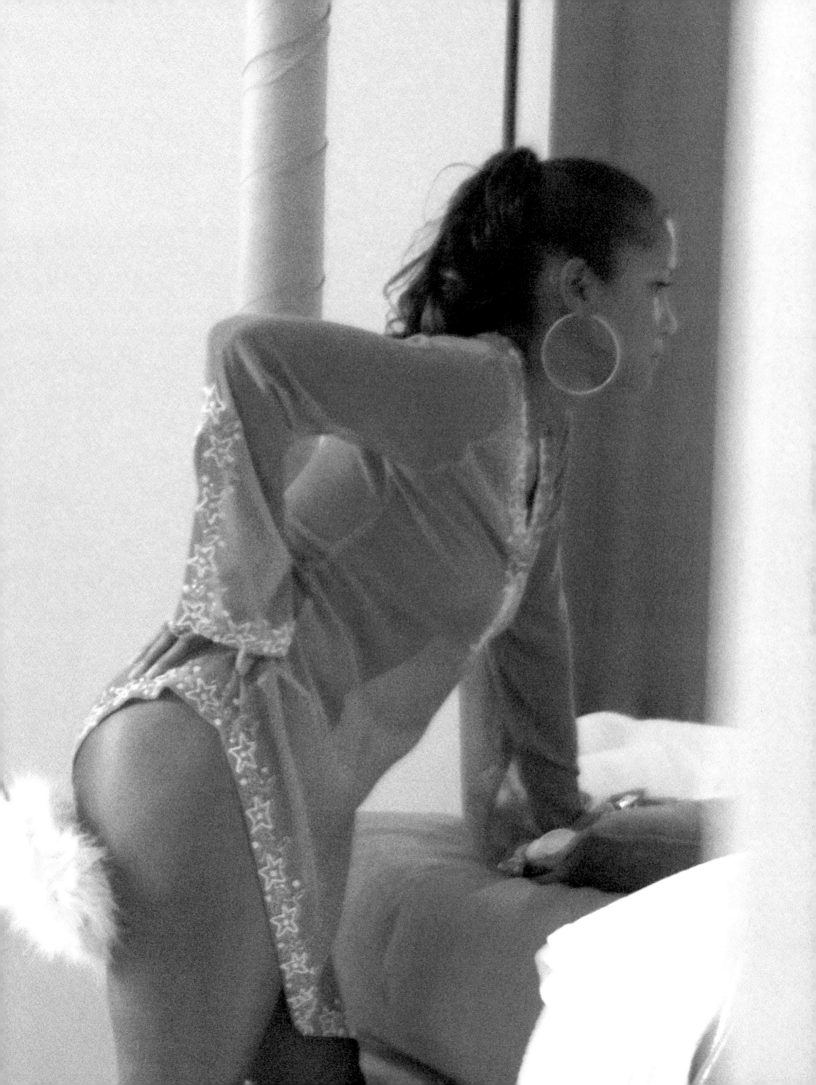

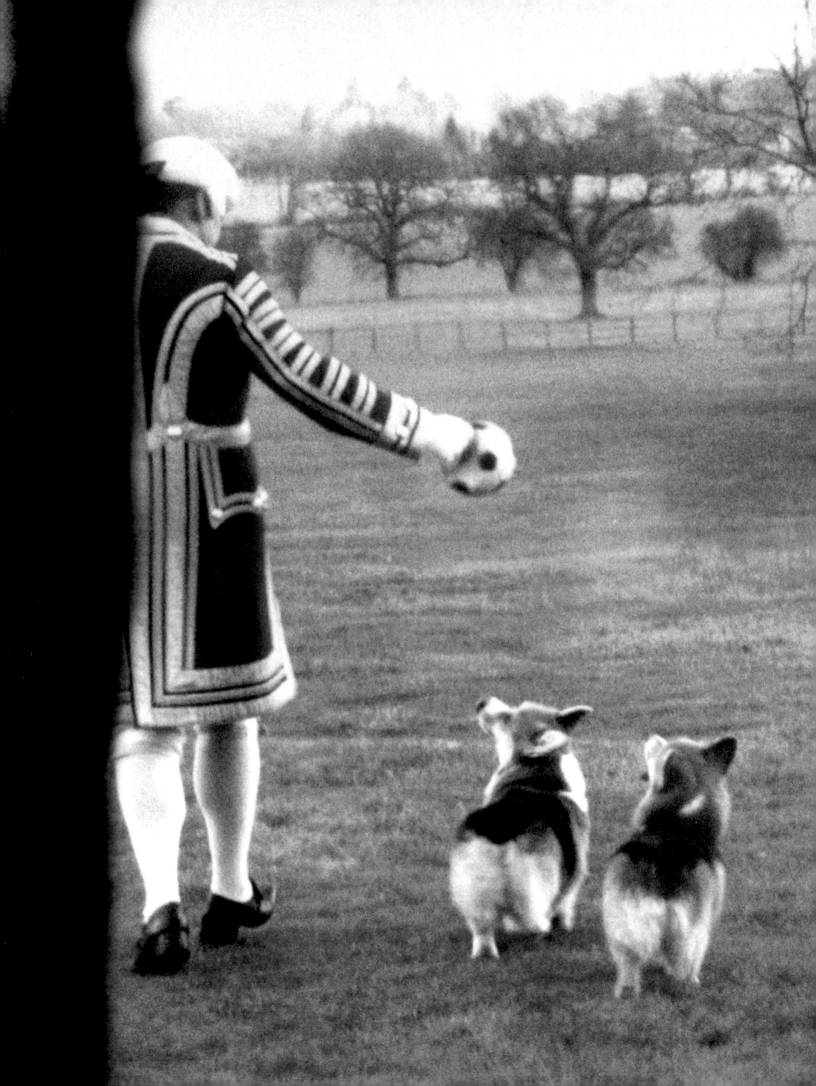

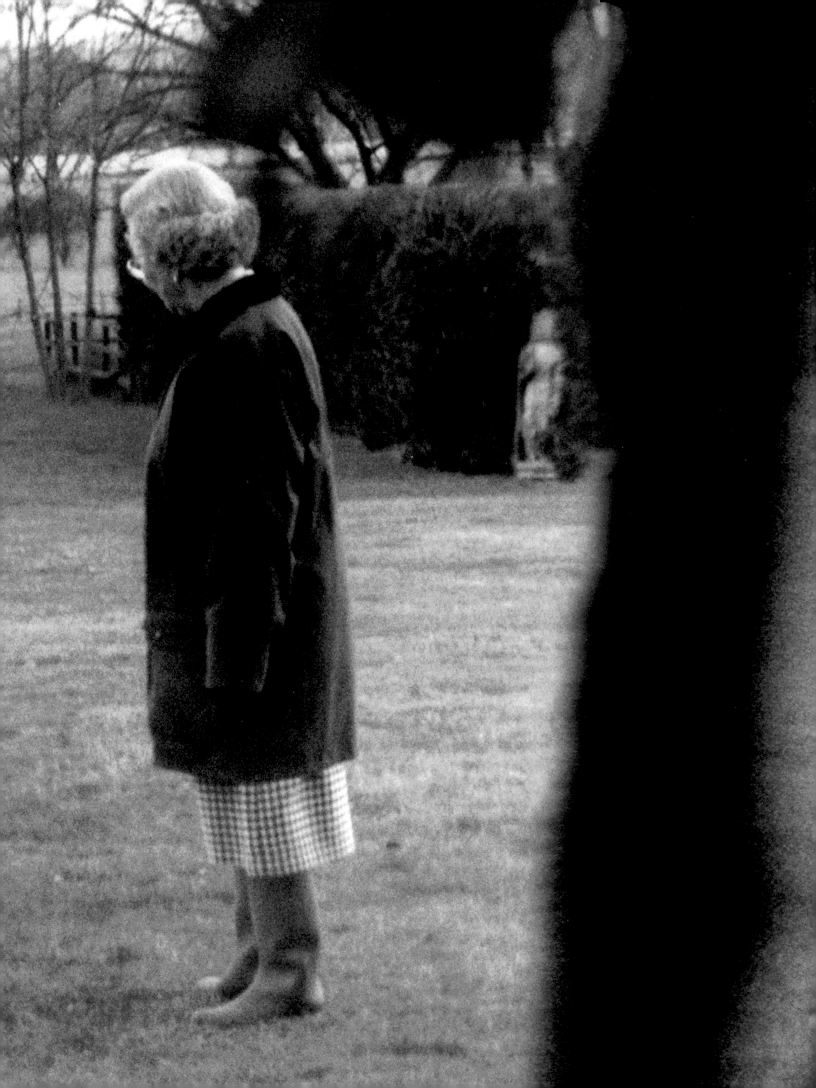

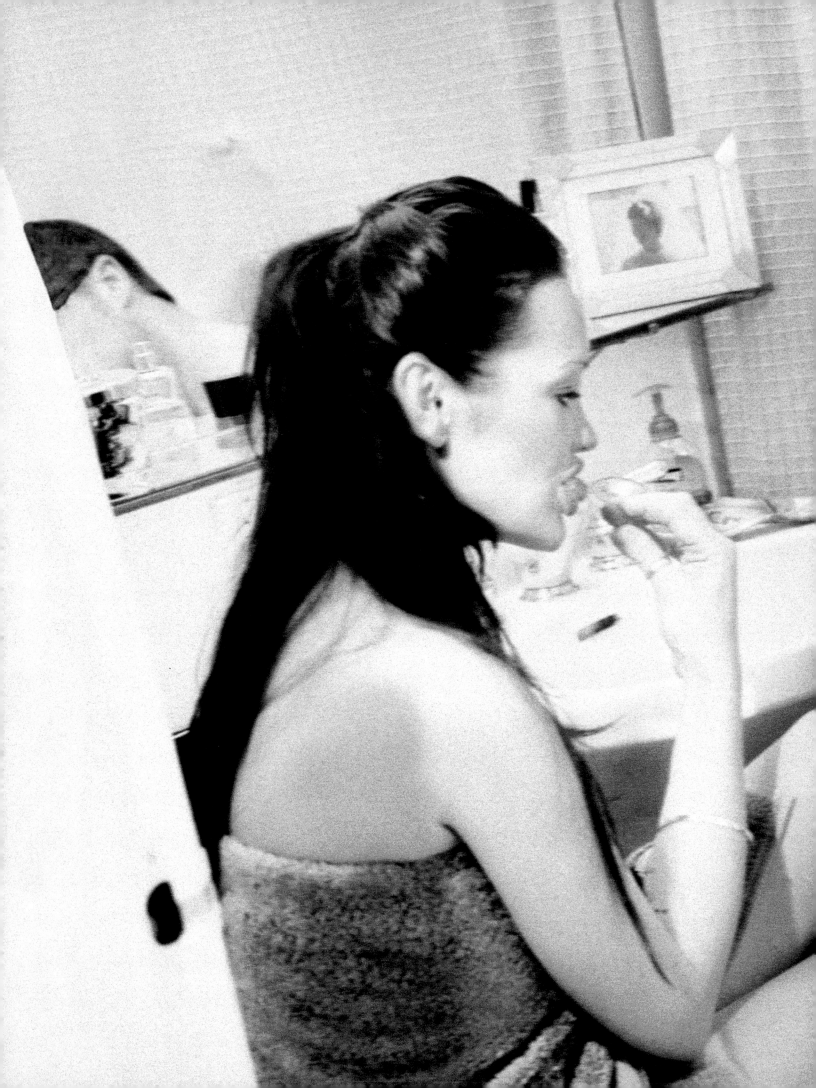

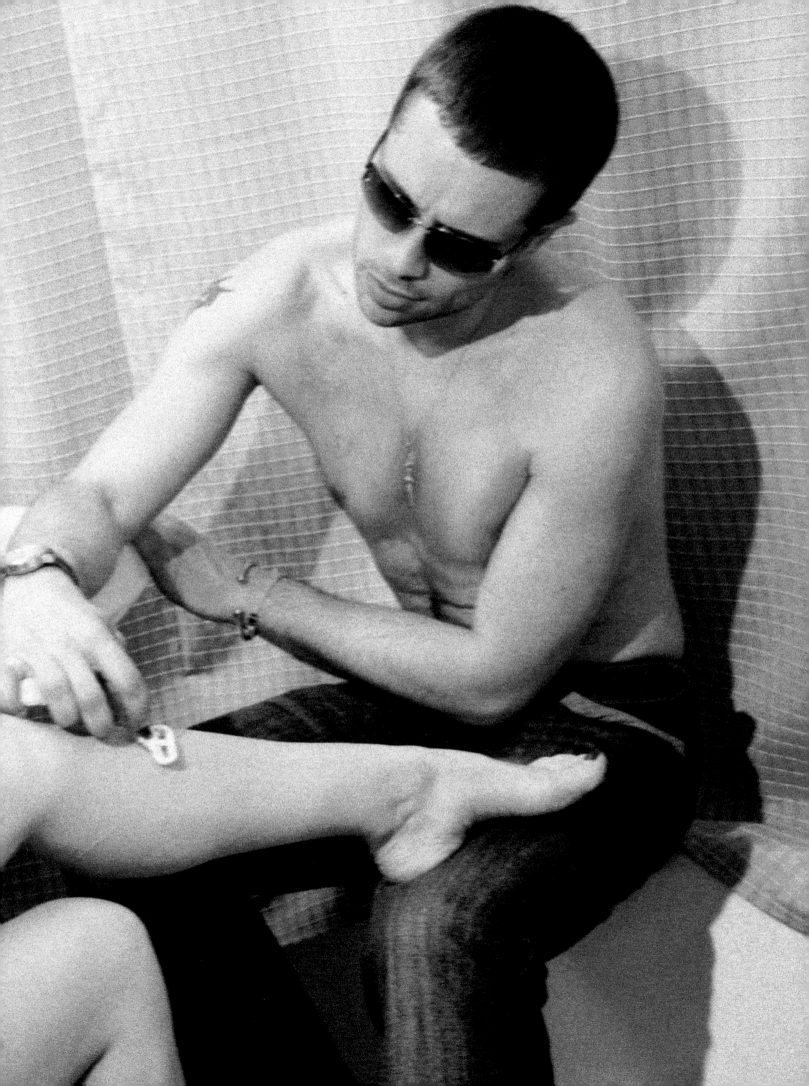

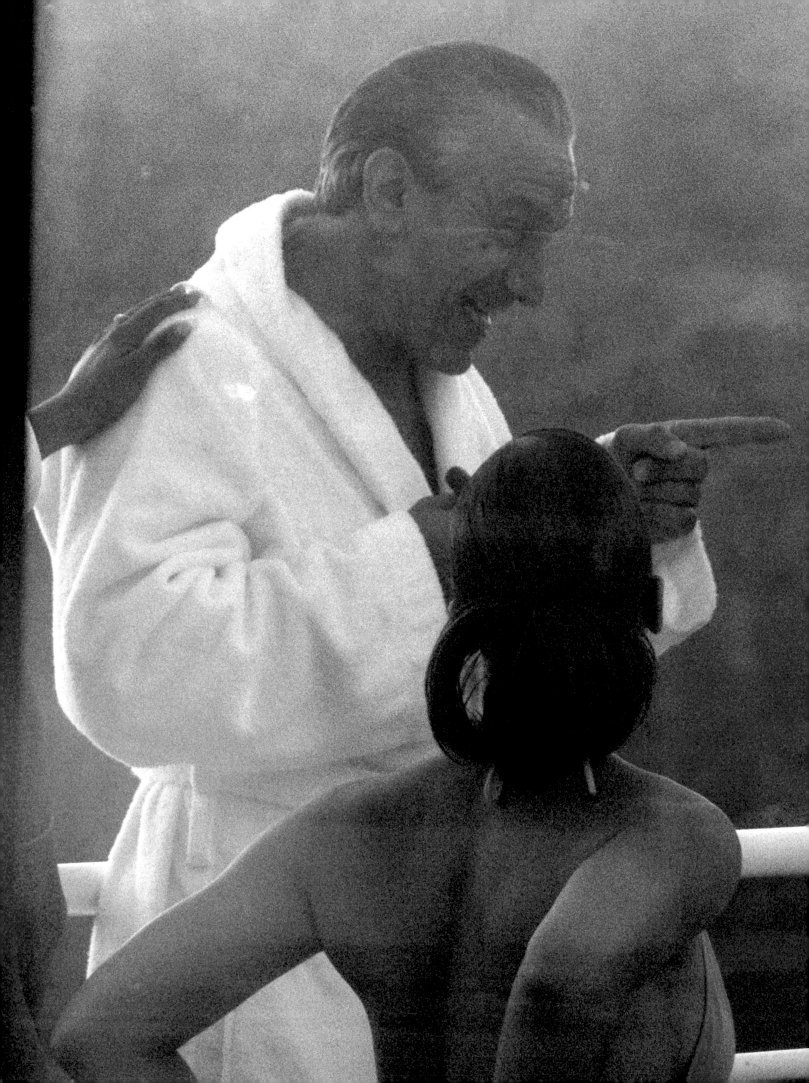

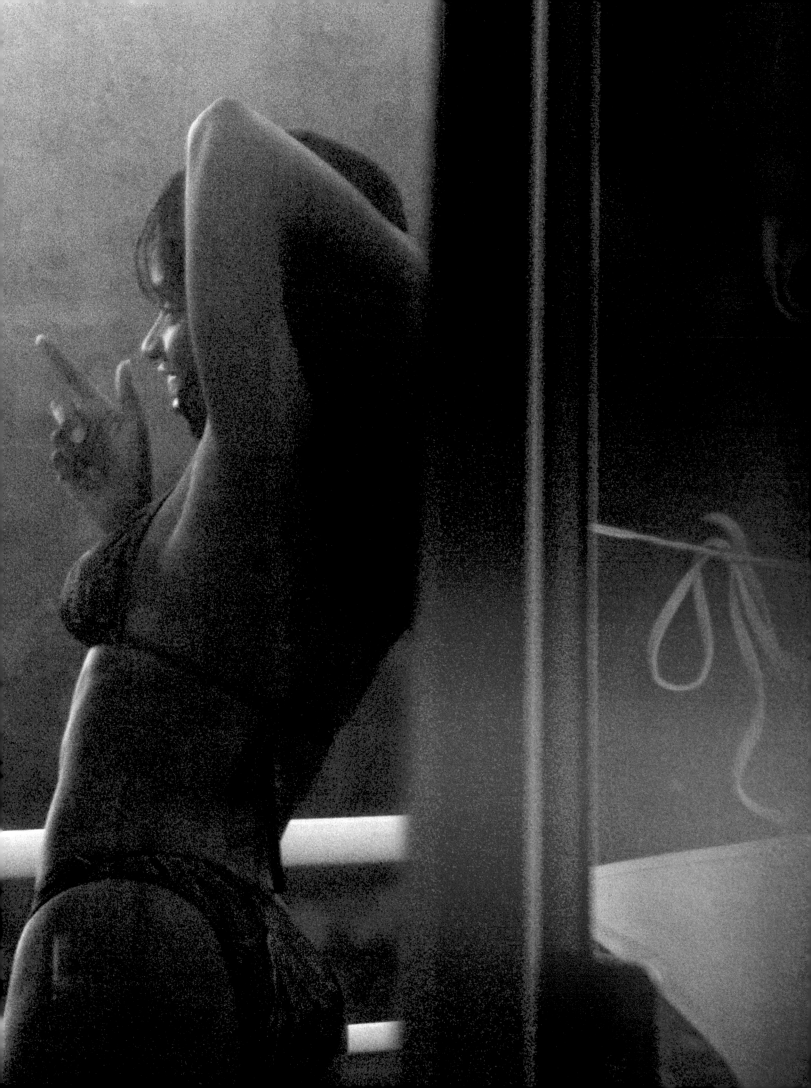

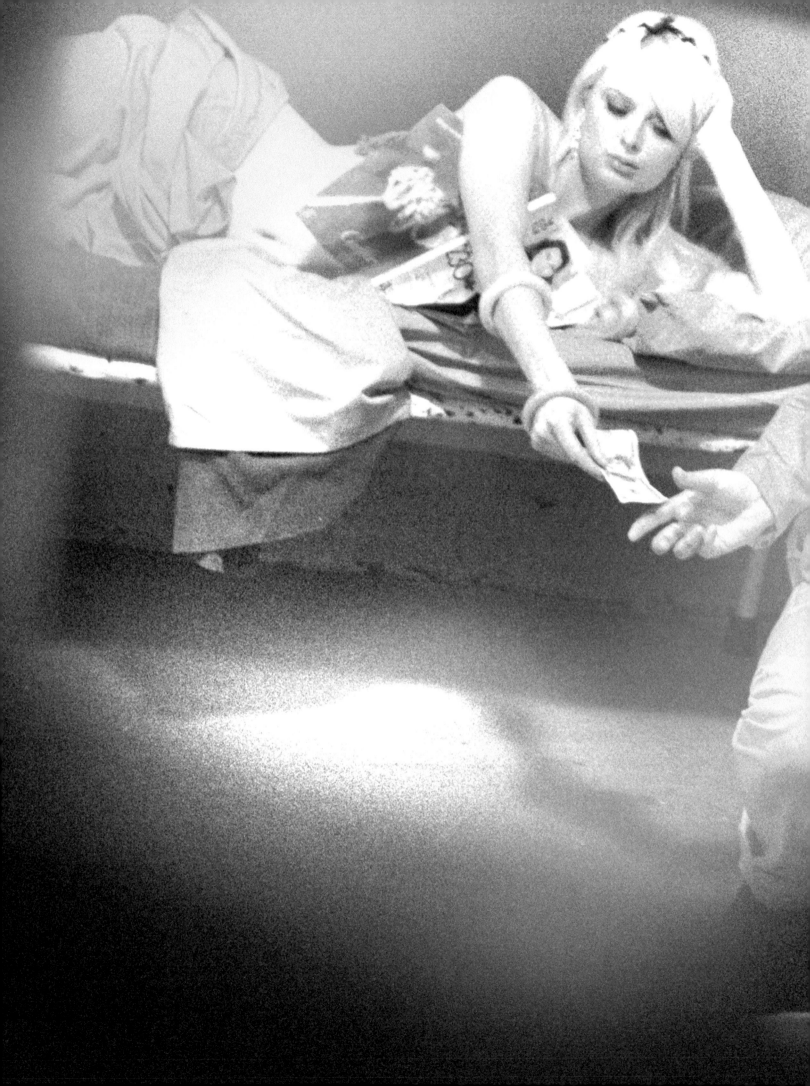

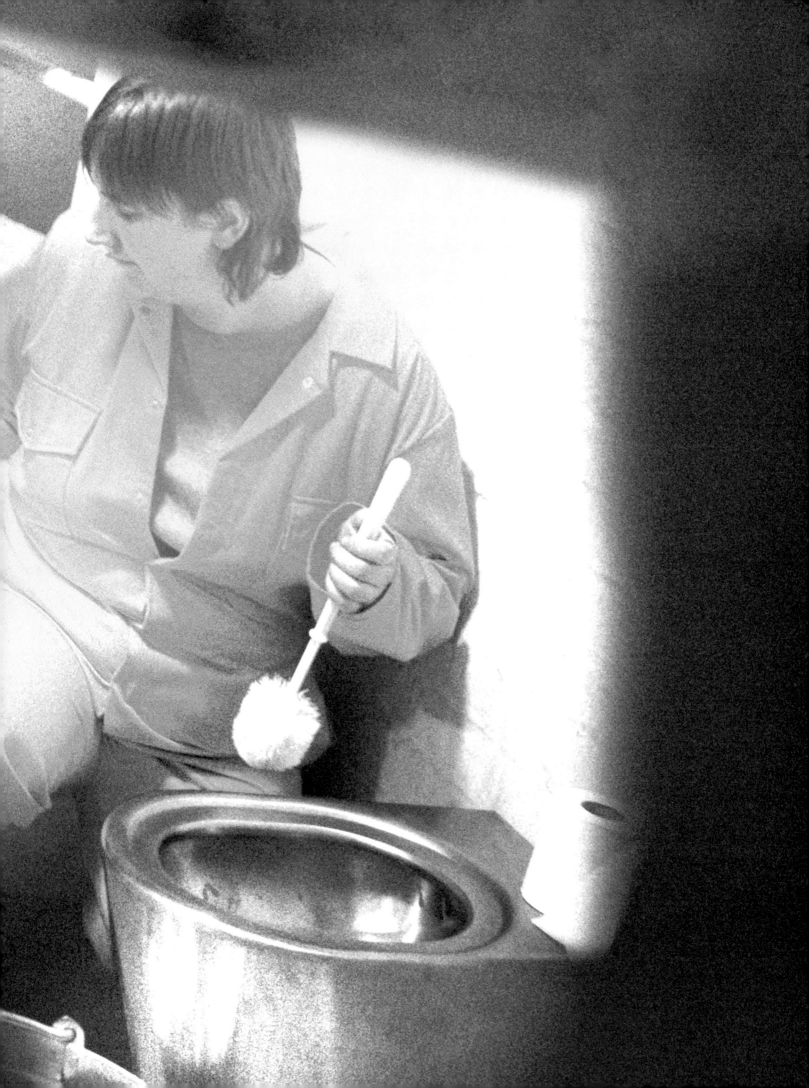

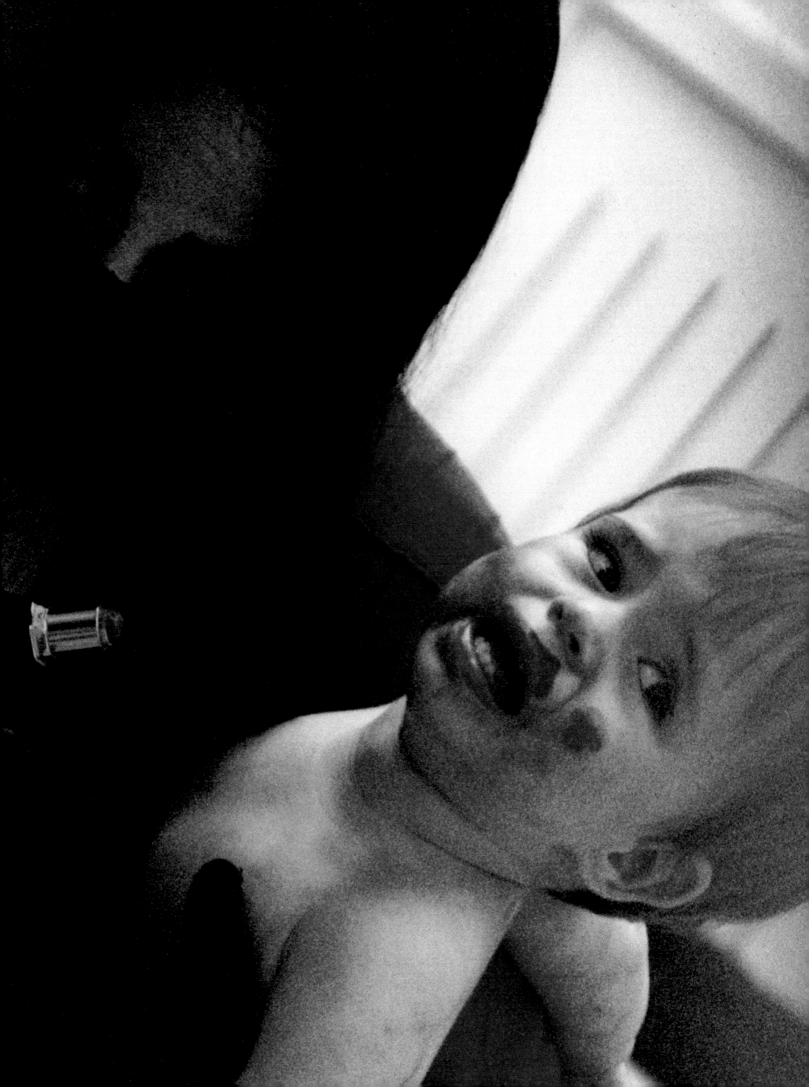

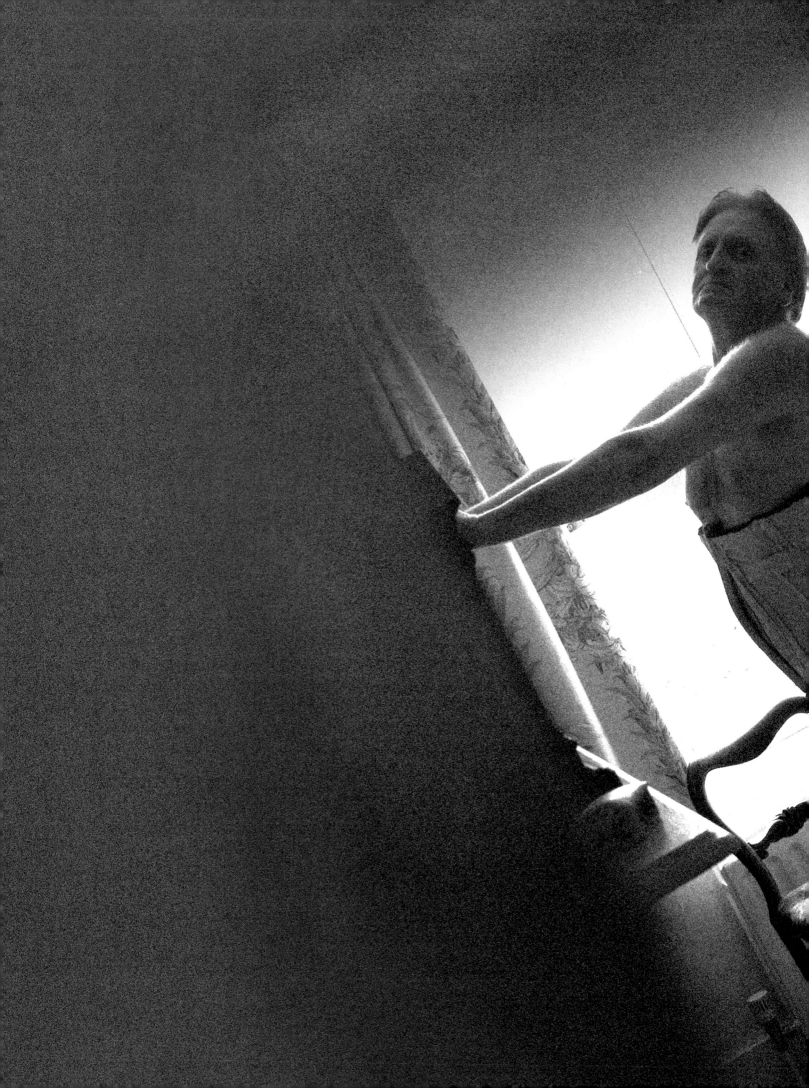

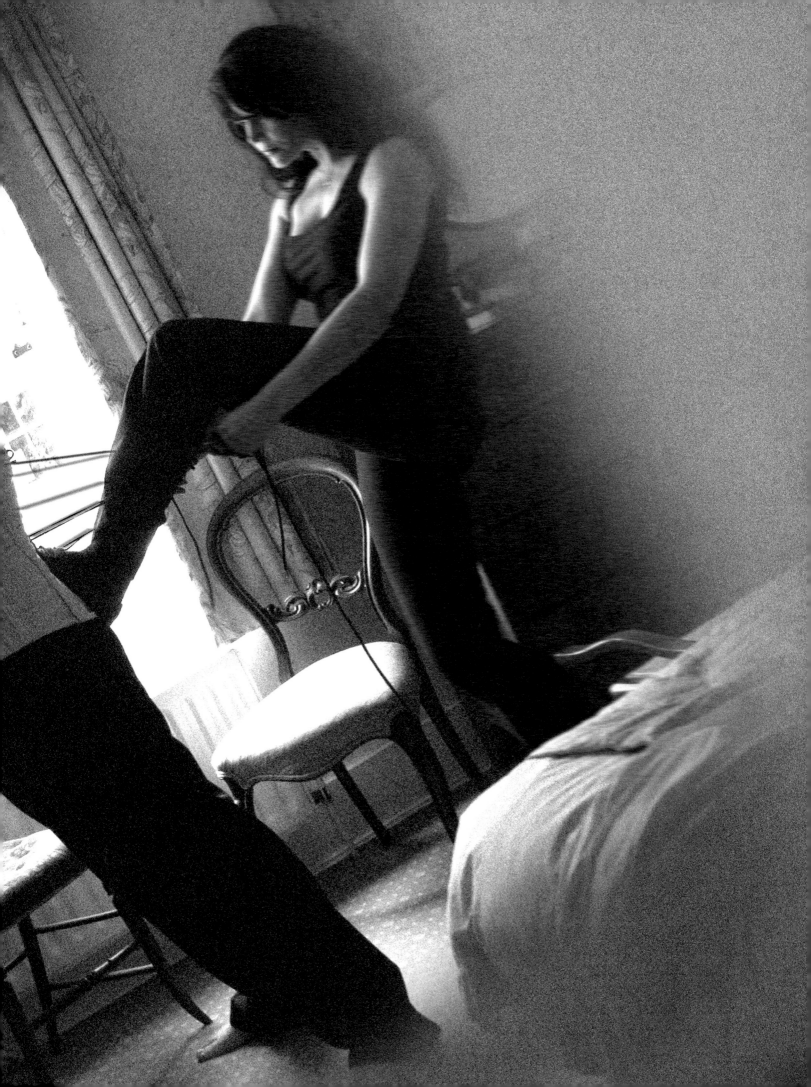

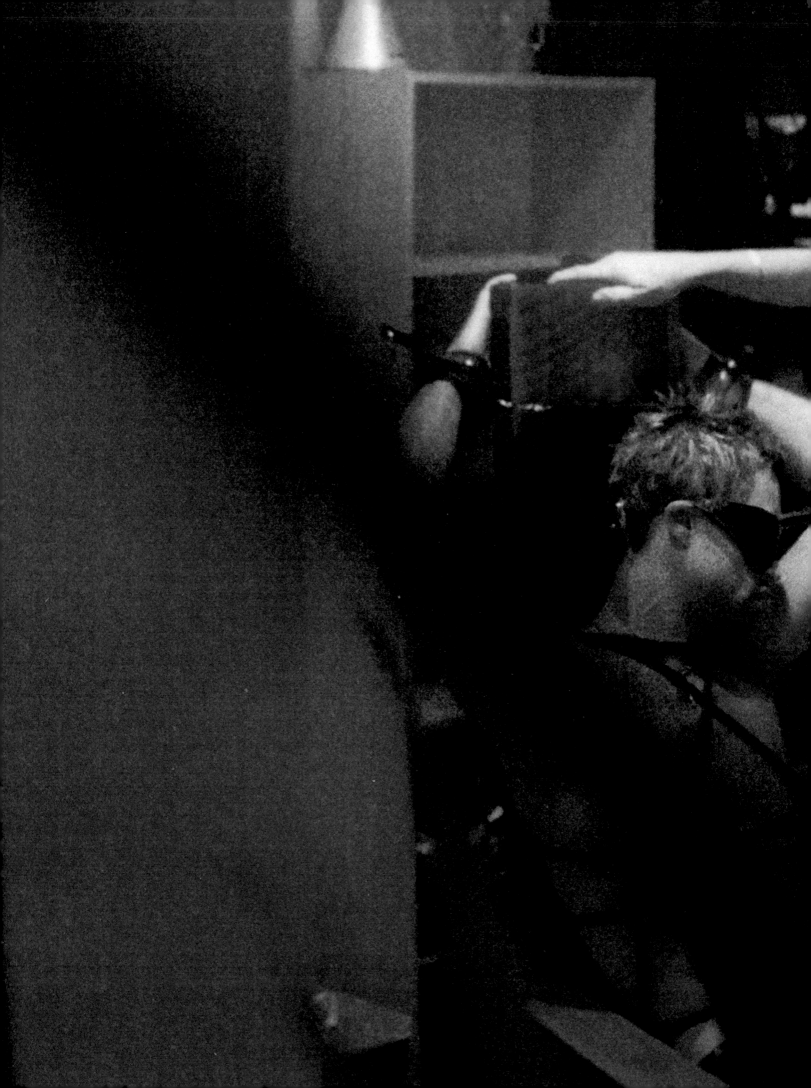

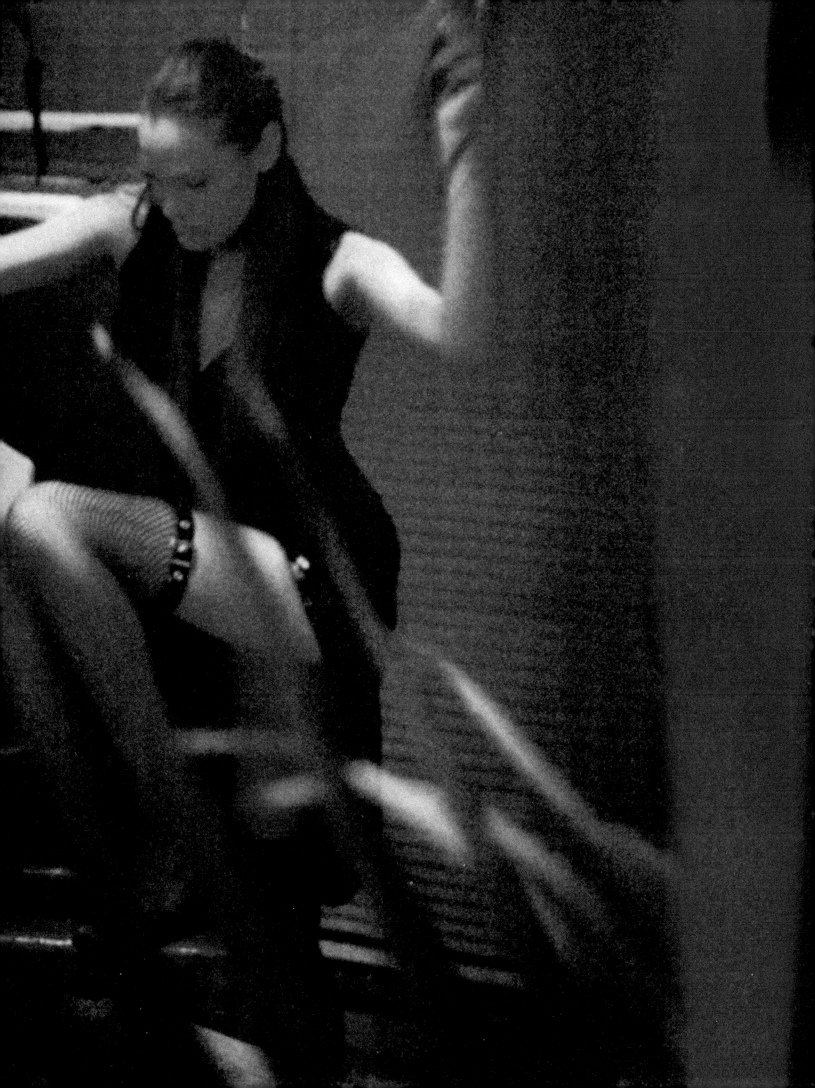

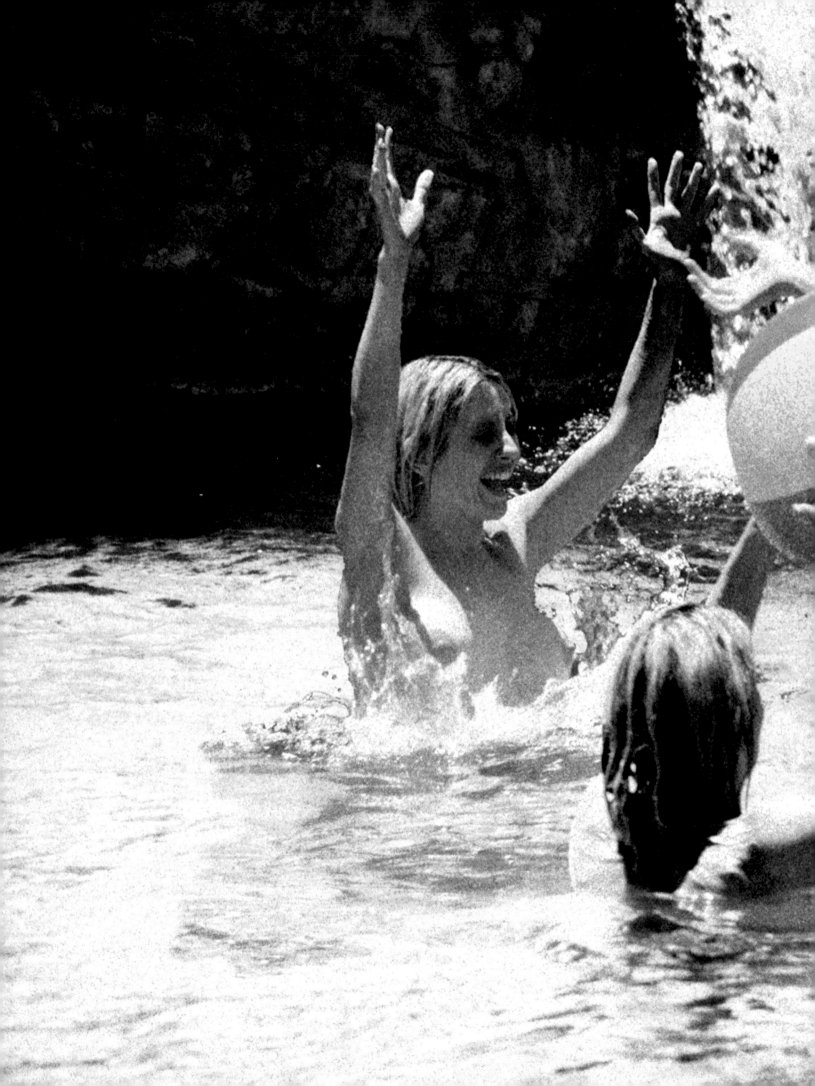

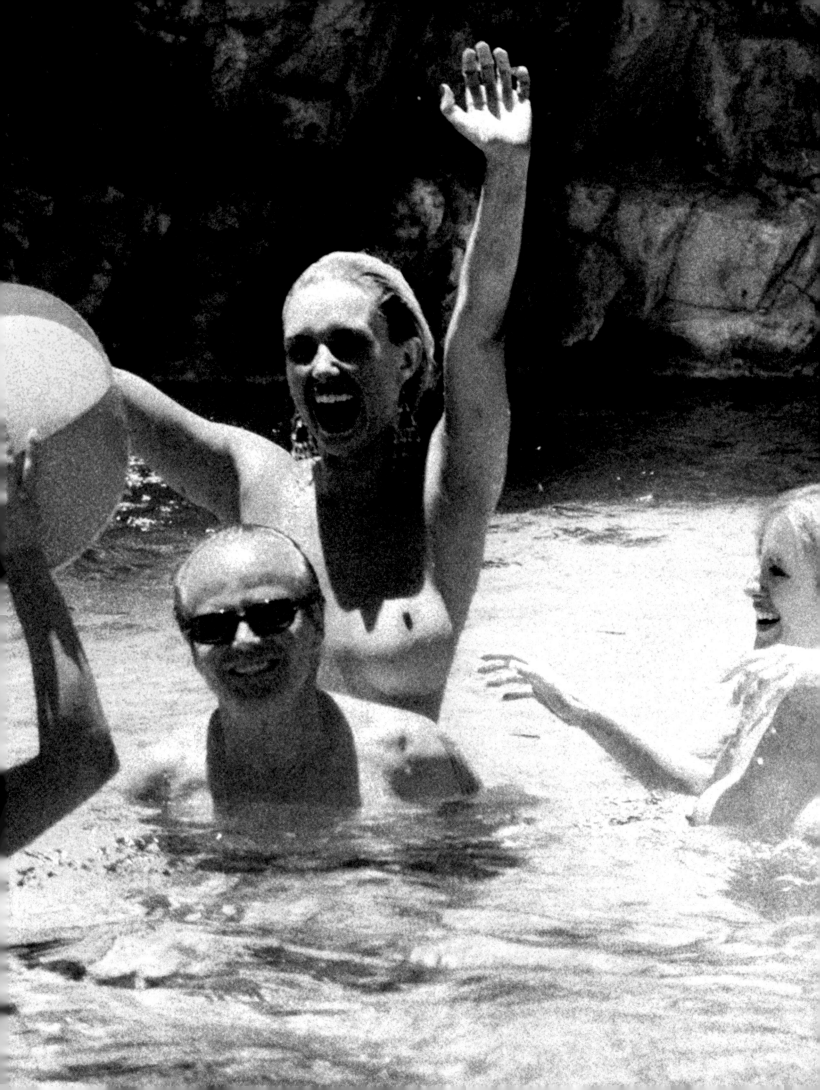

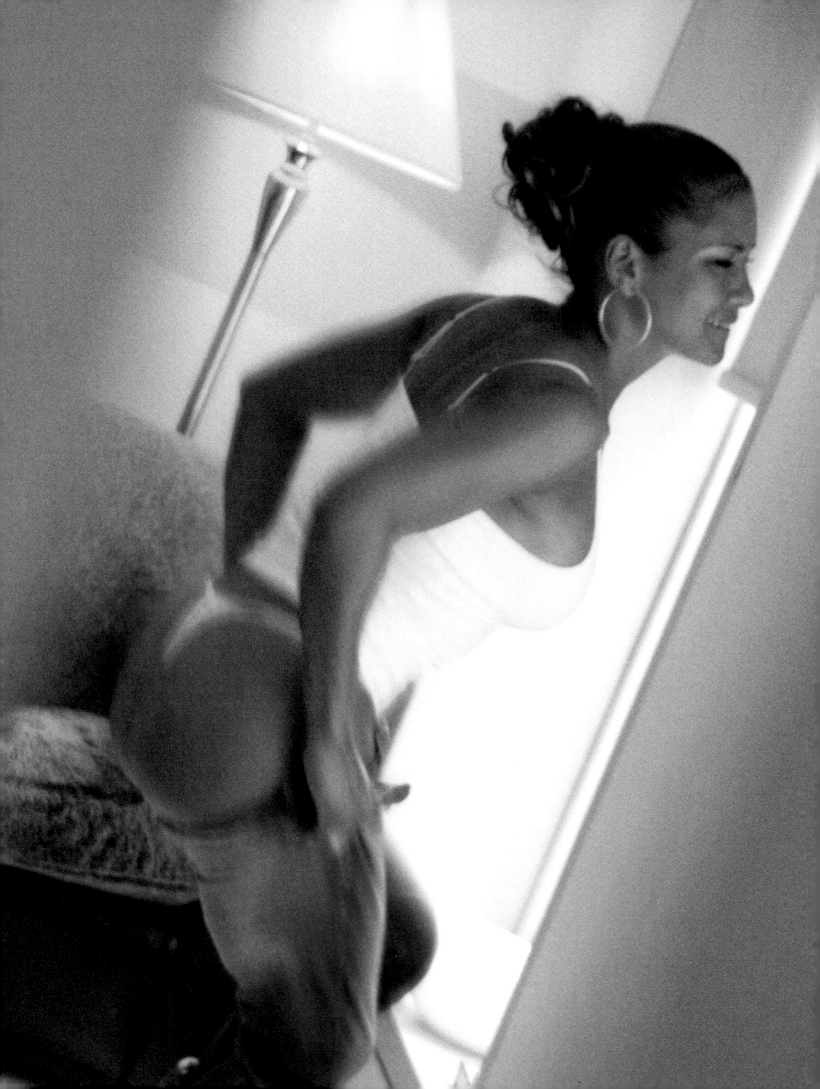

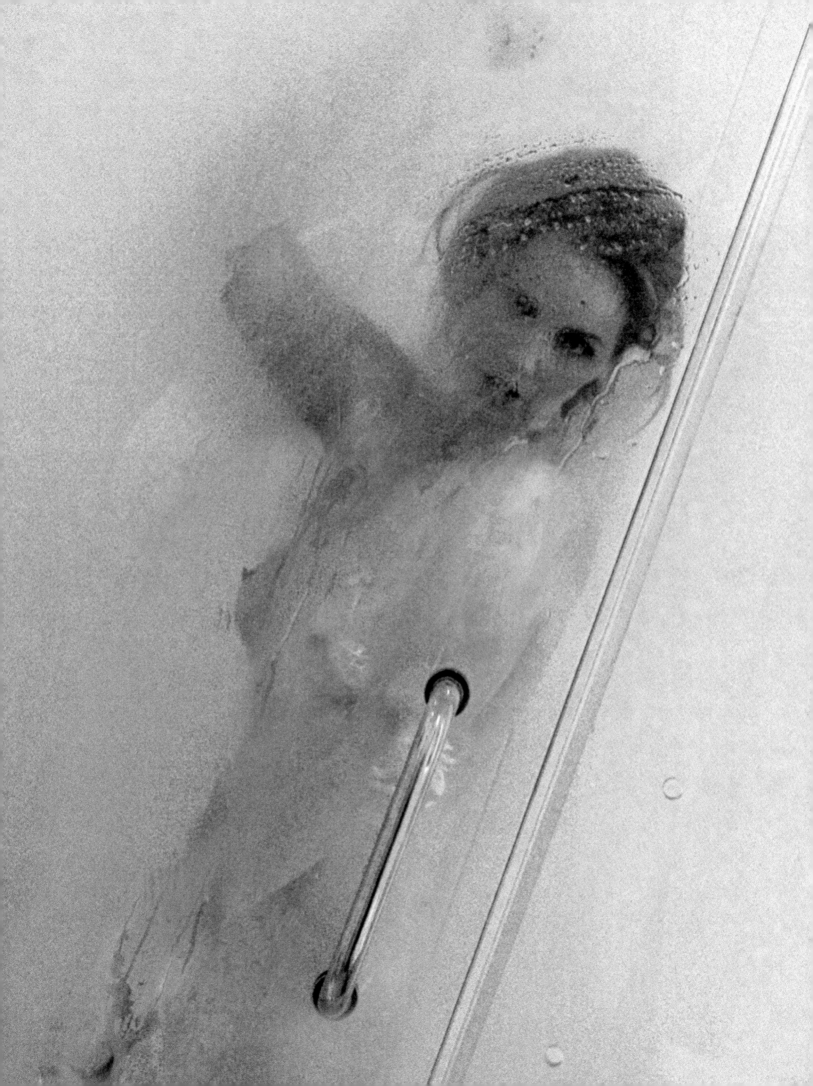

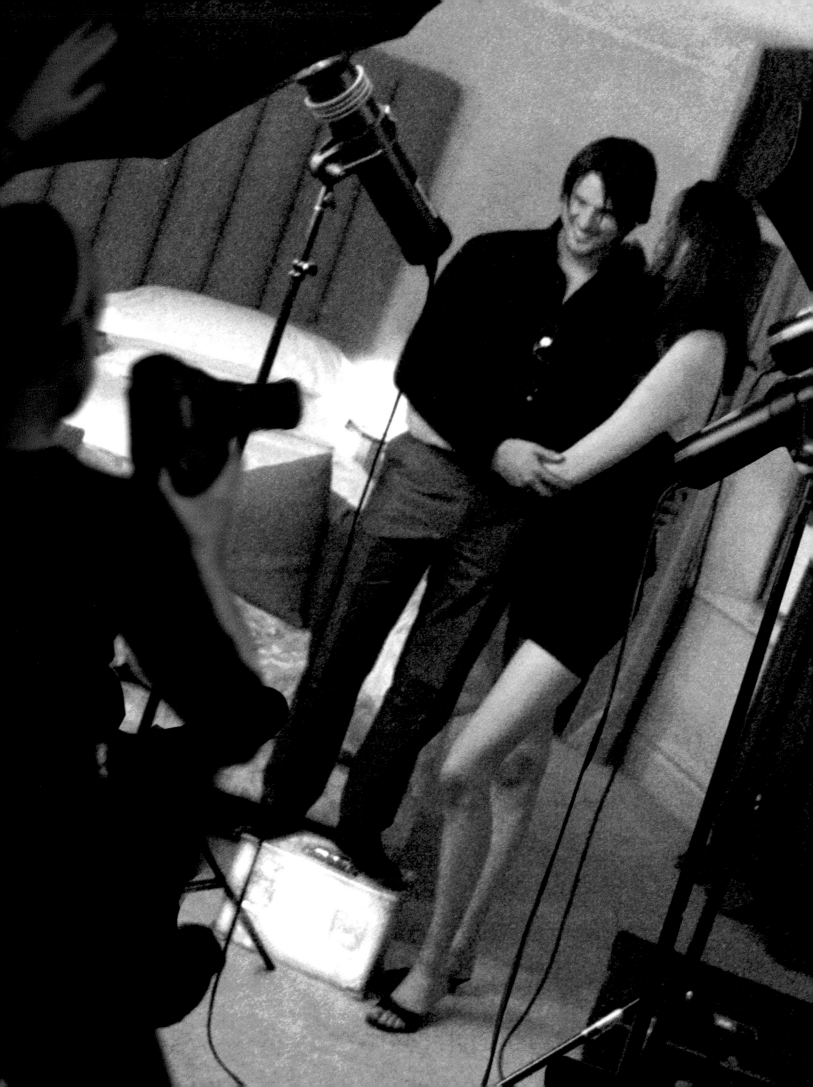

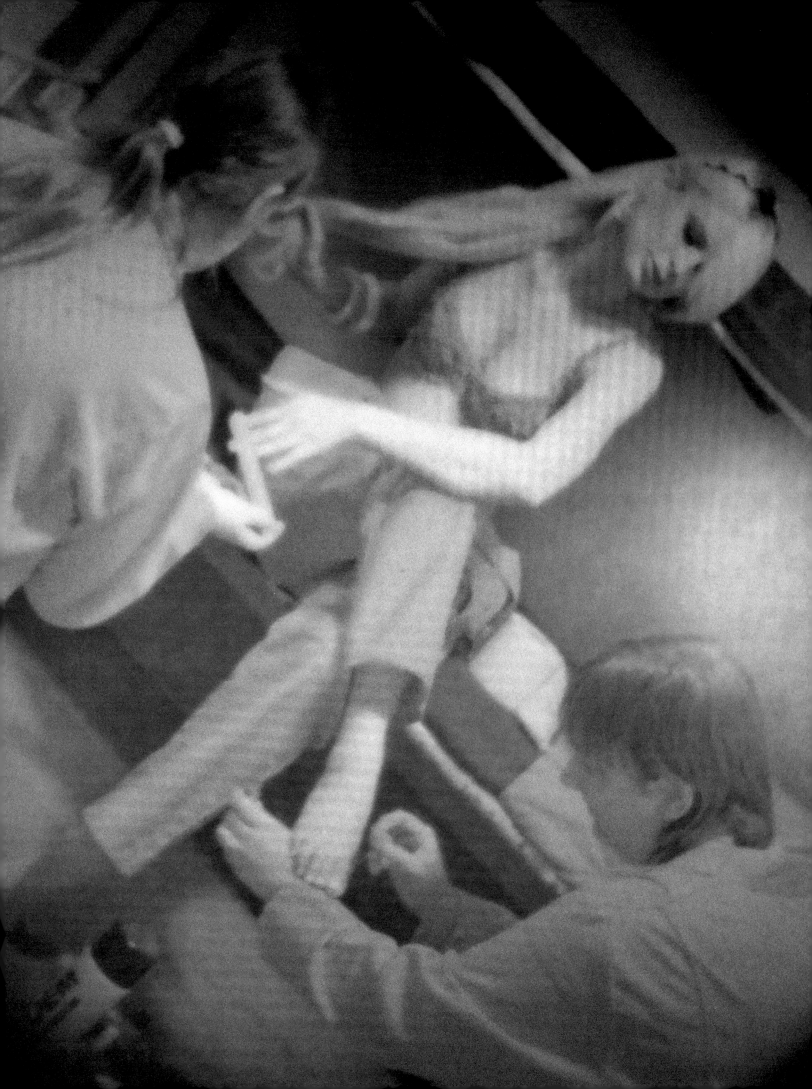

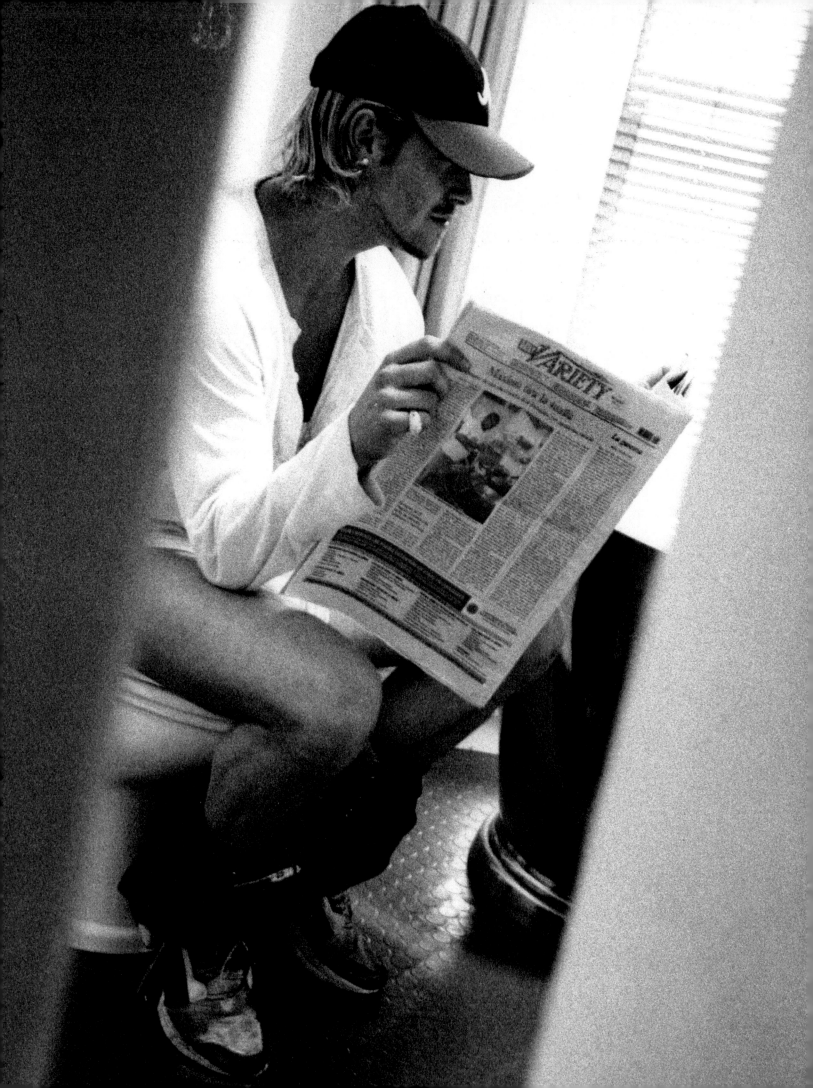

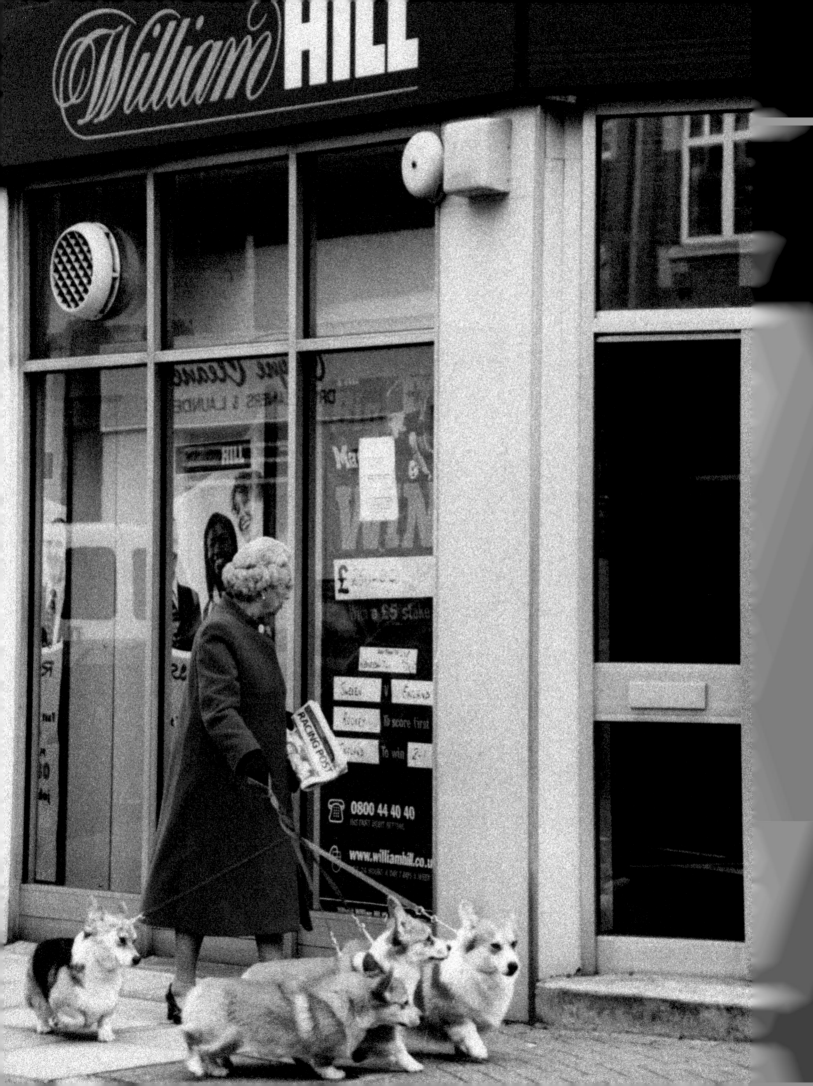

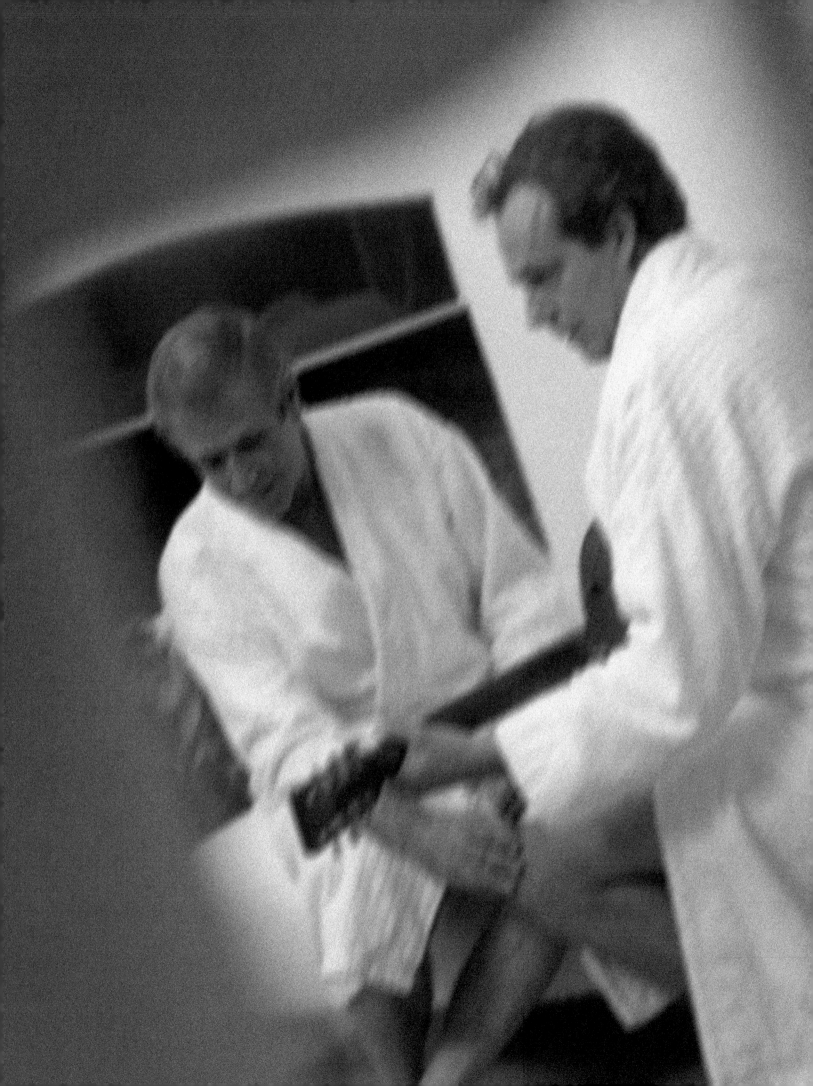

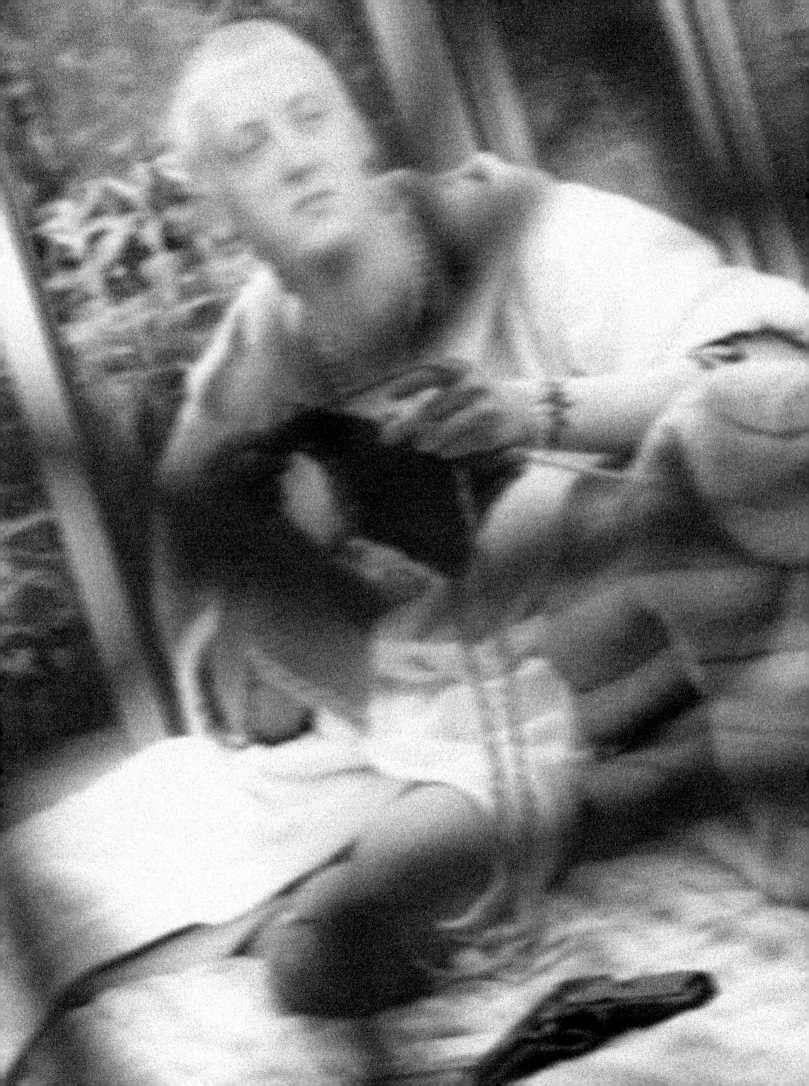

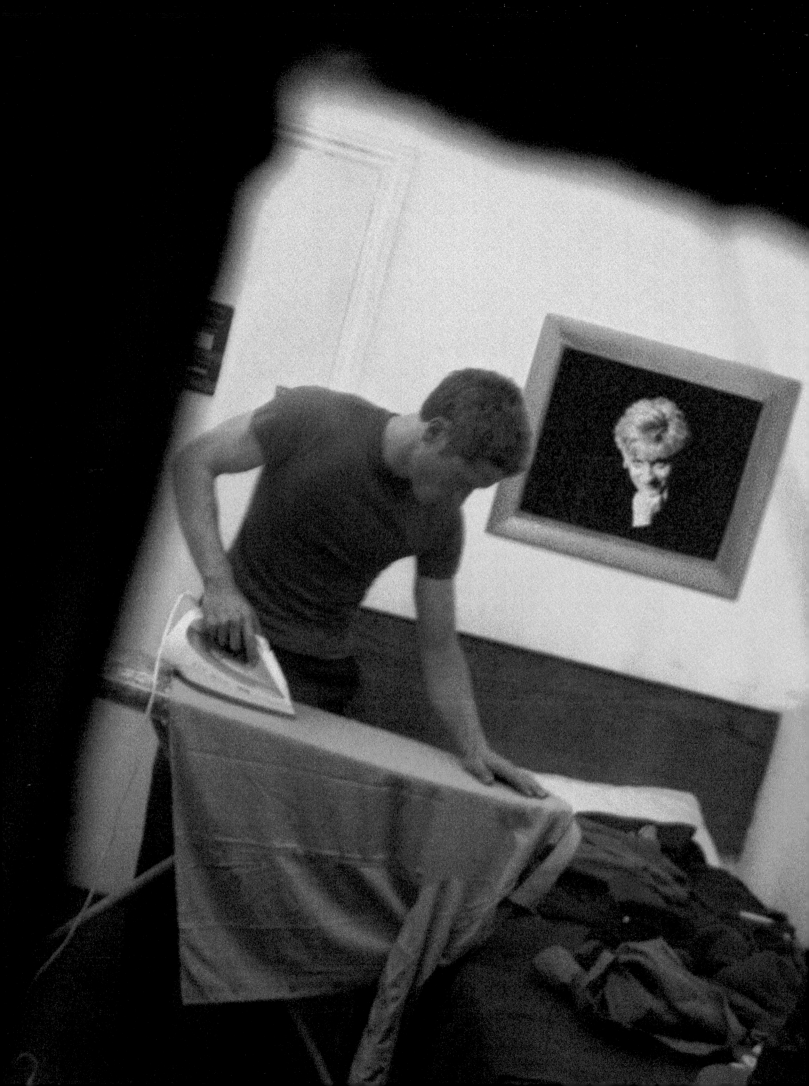

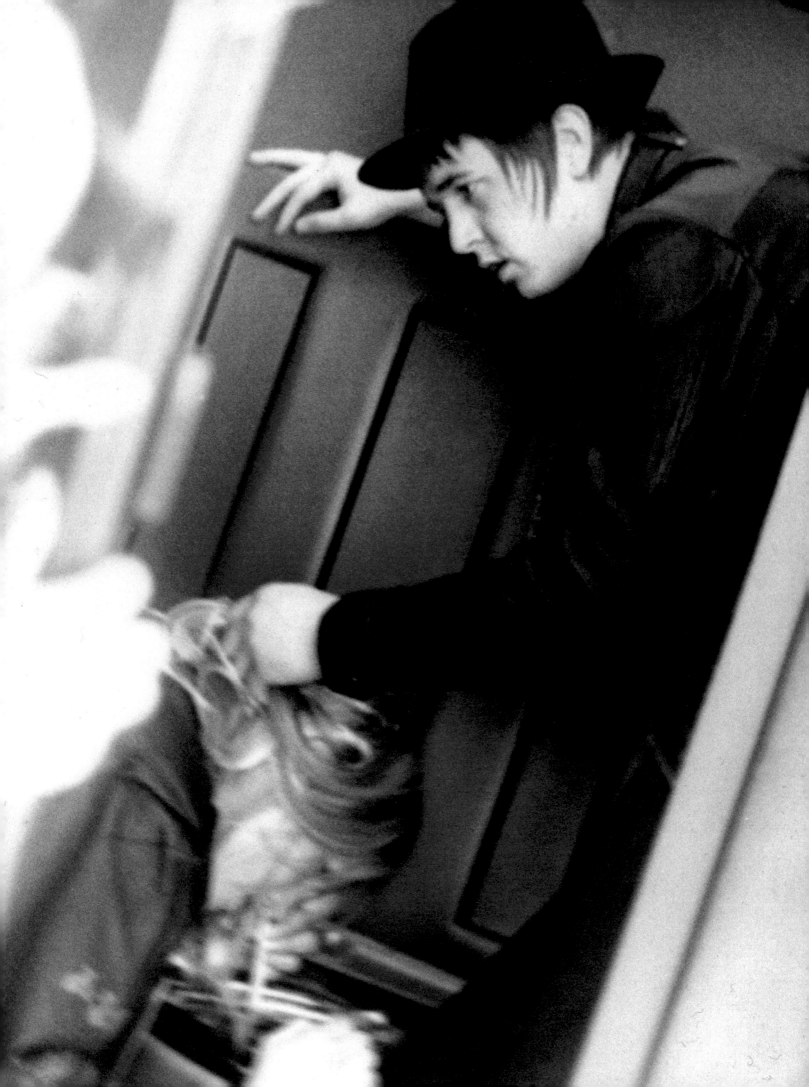

MATERNITY

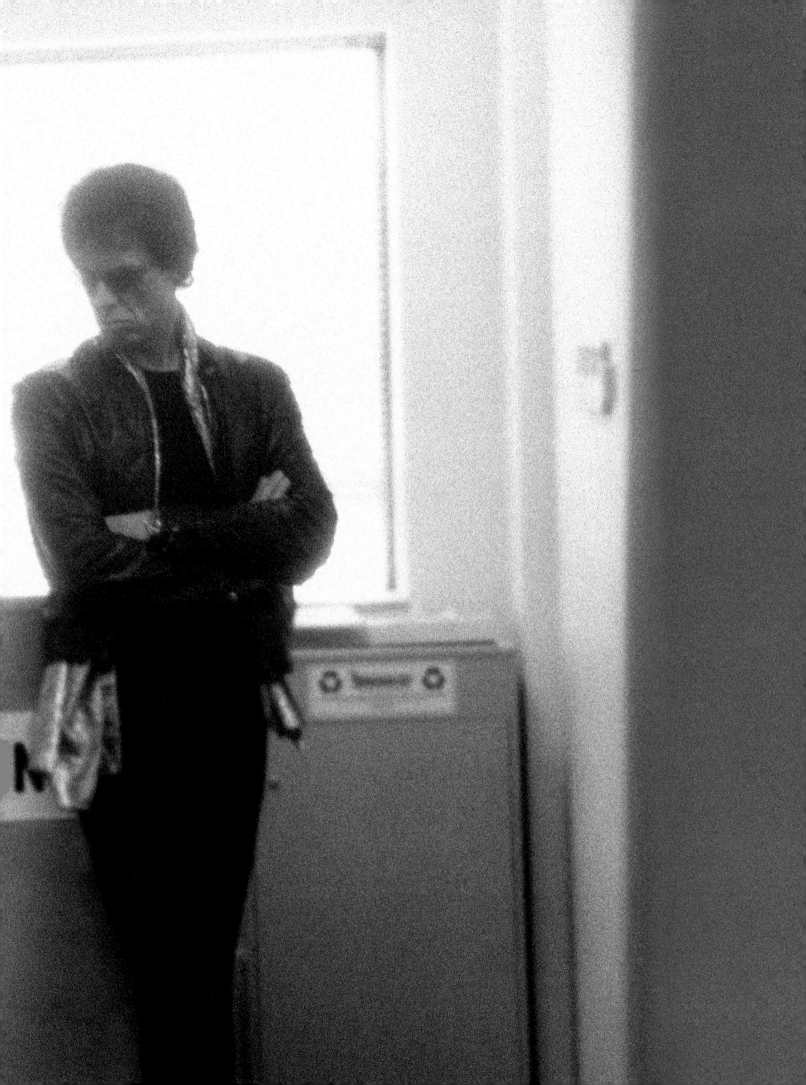

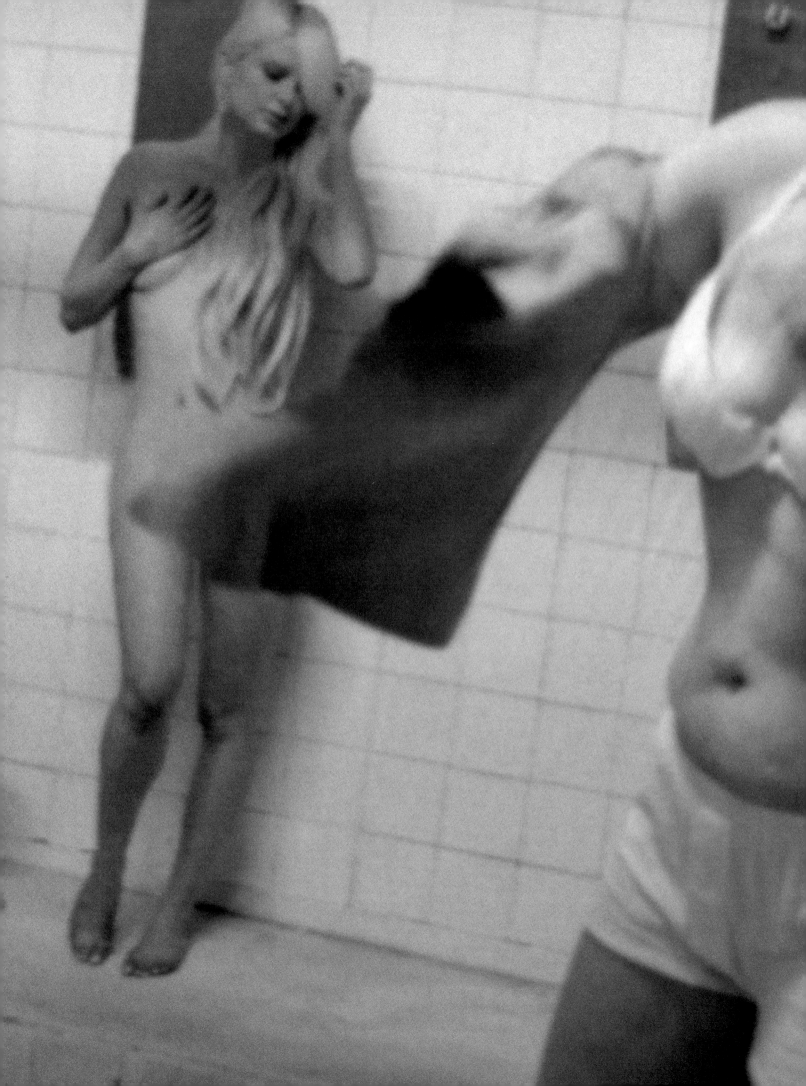

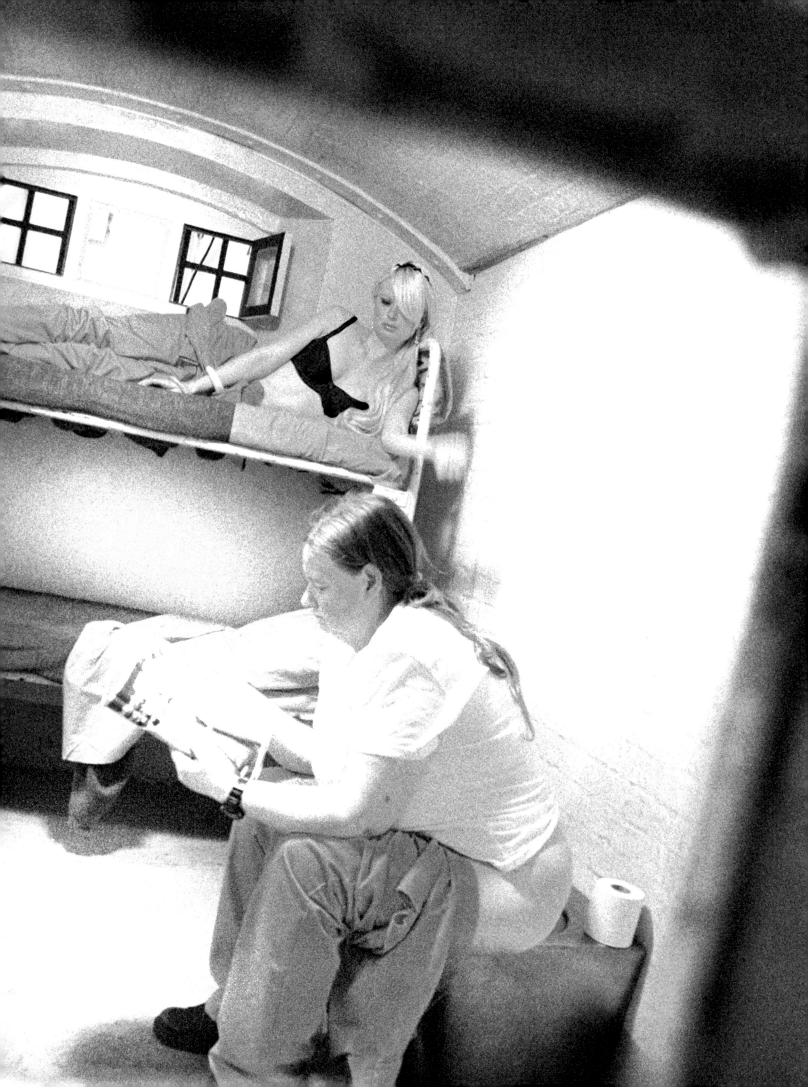

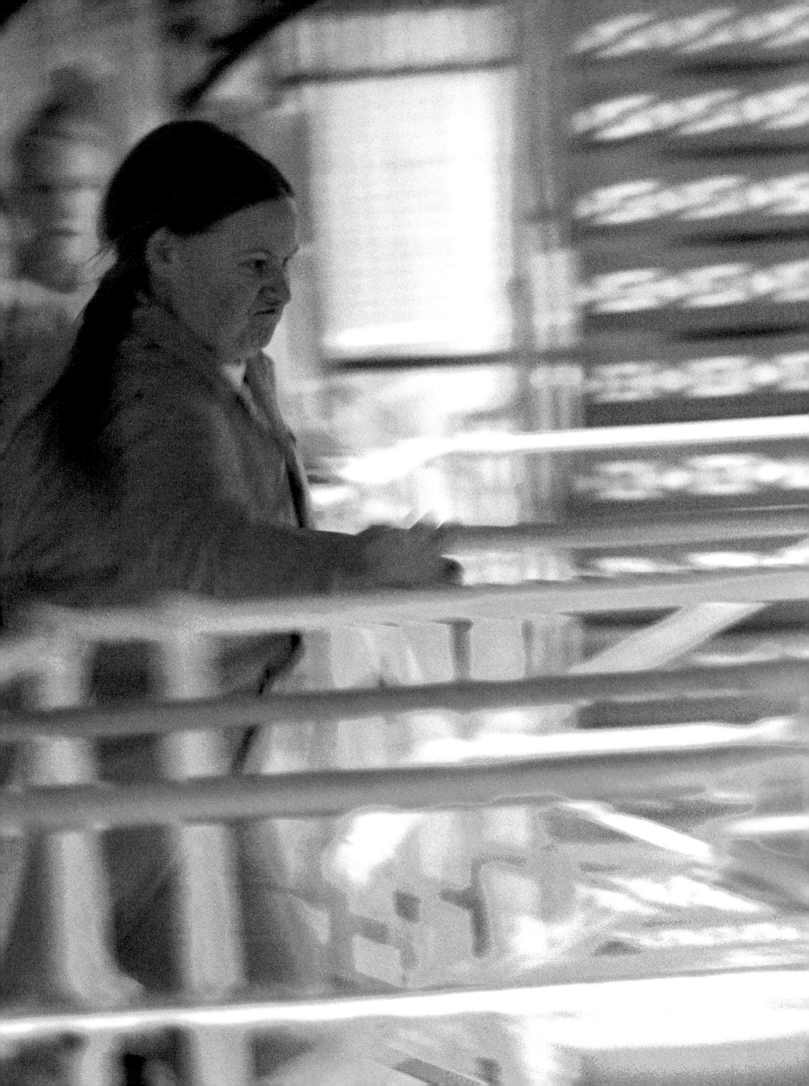

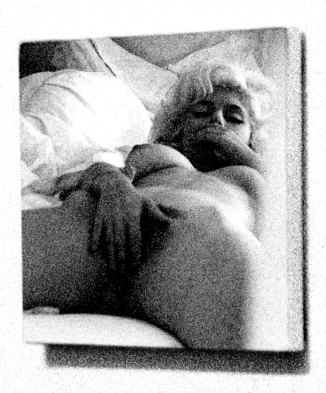

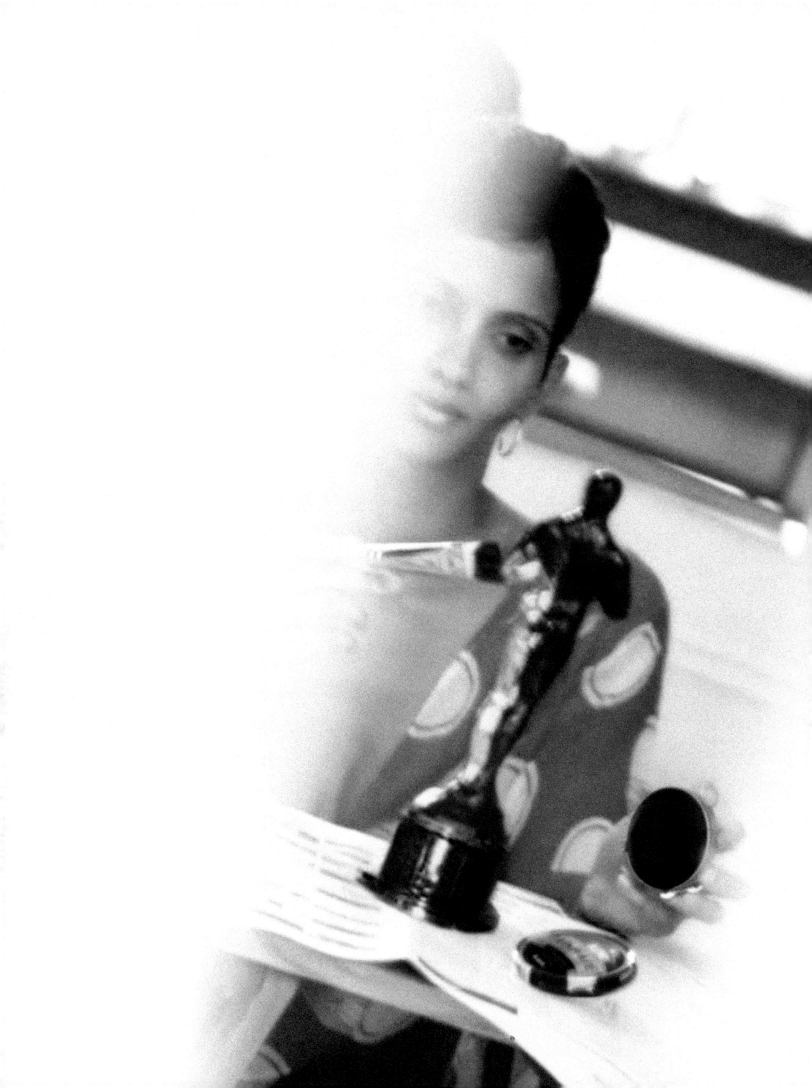

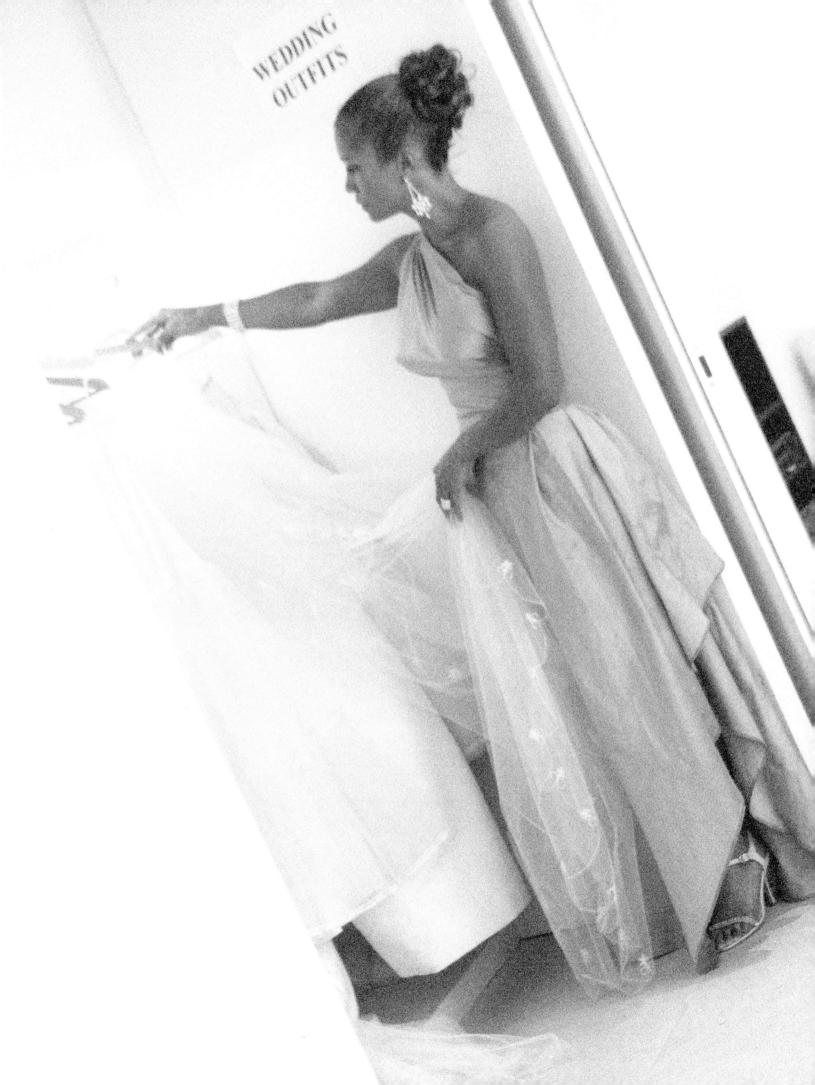

WEDDING
OUTFITS

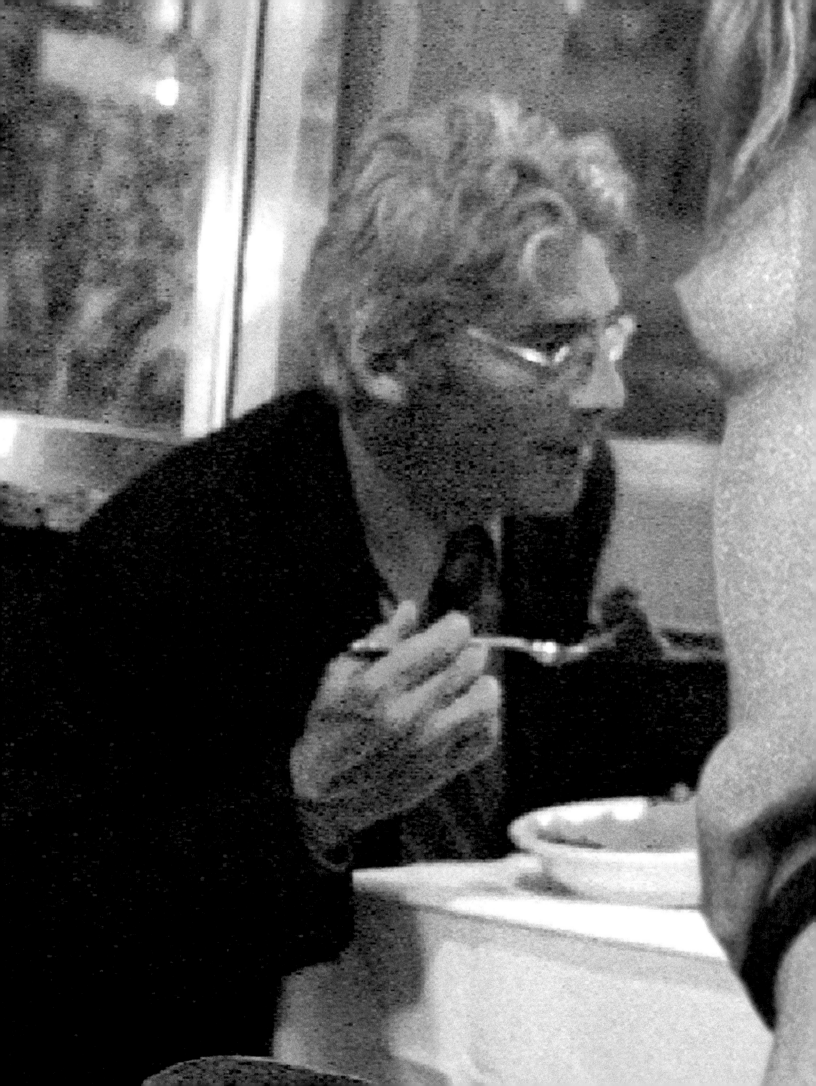

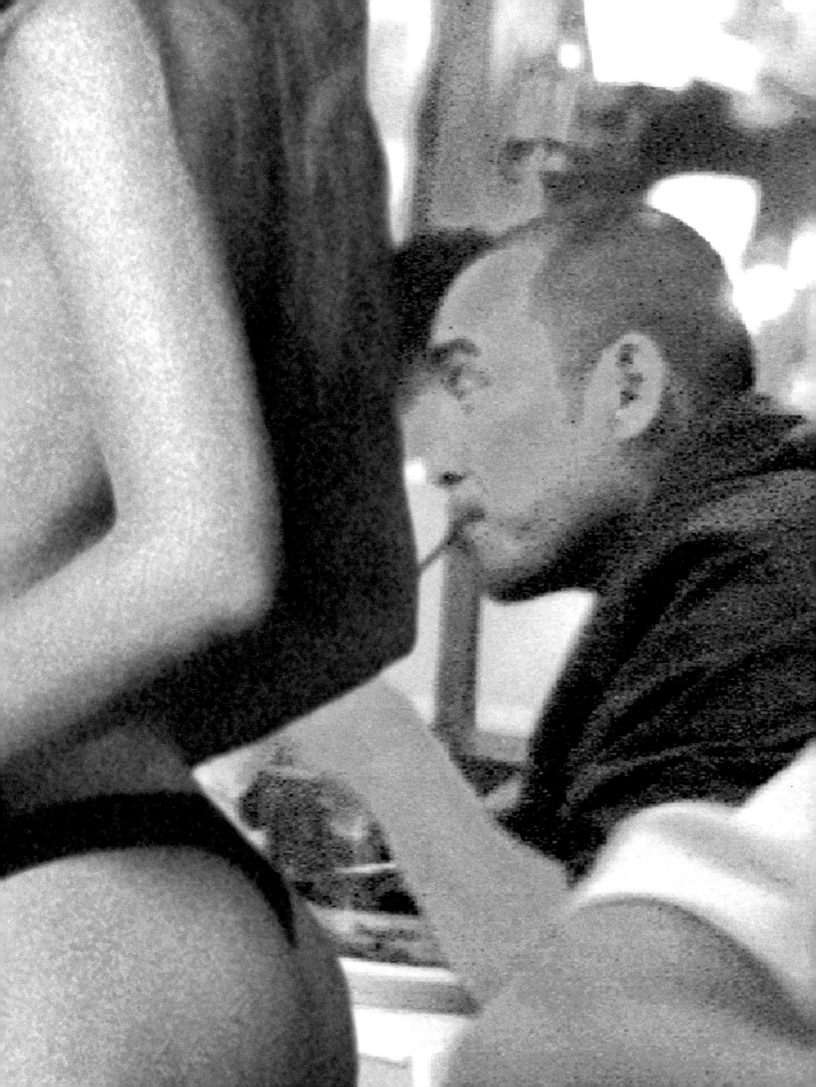

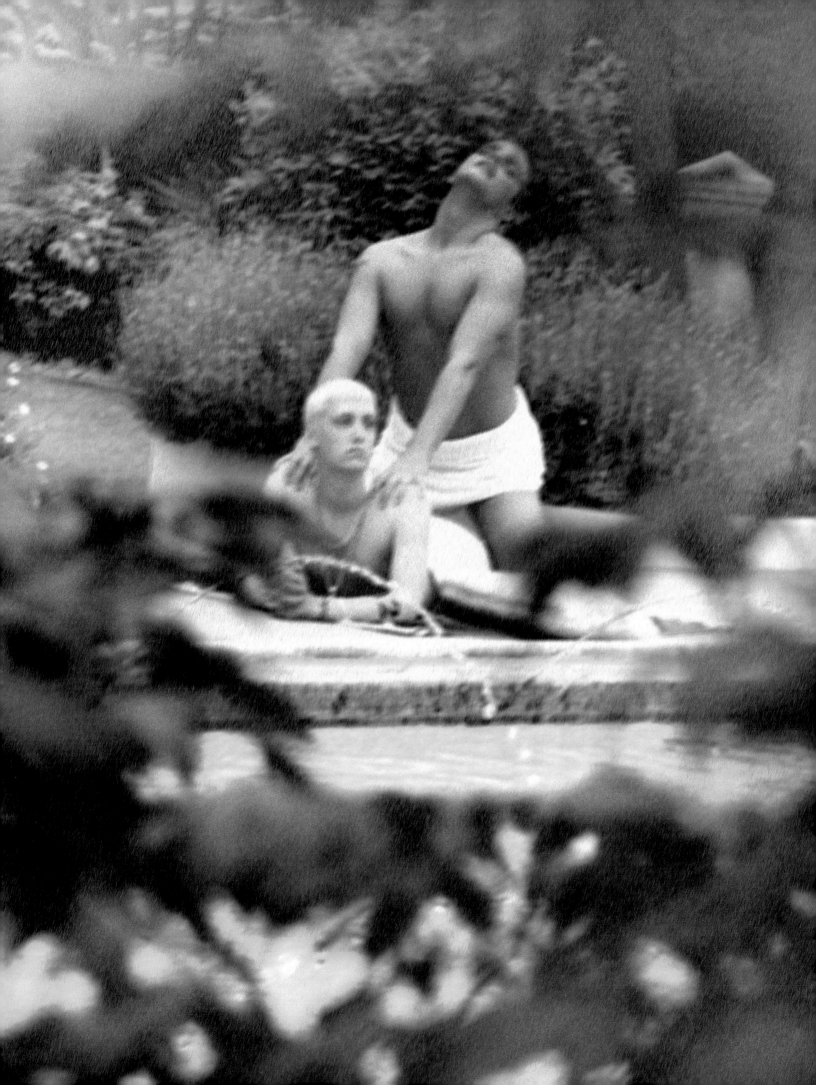

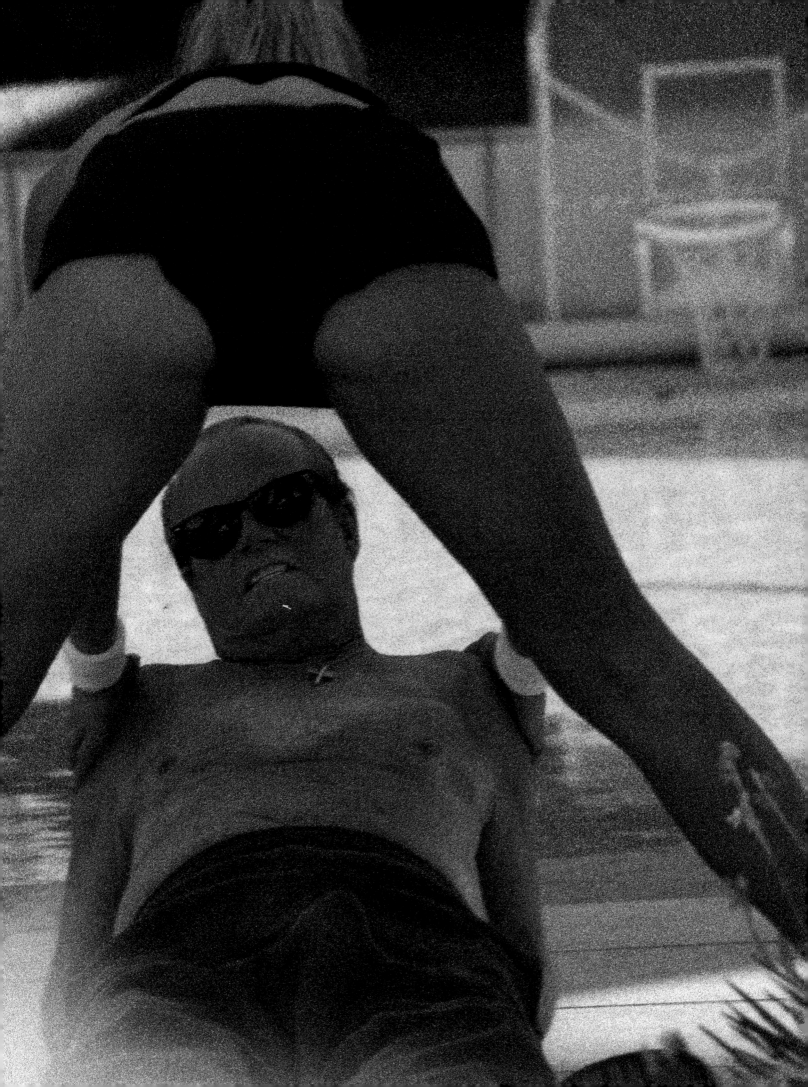

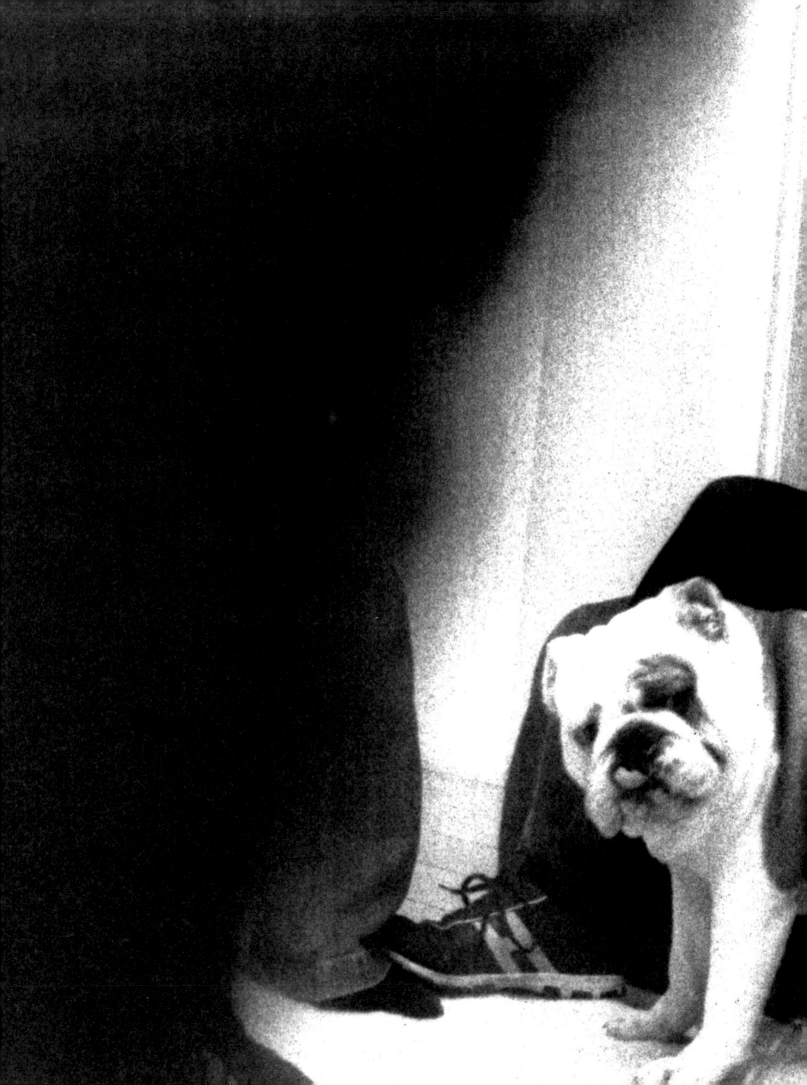

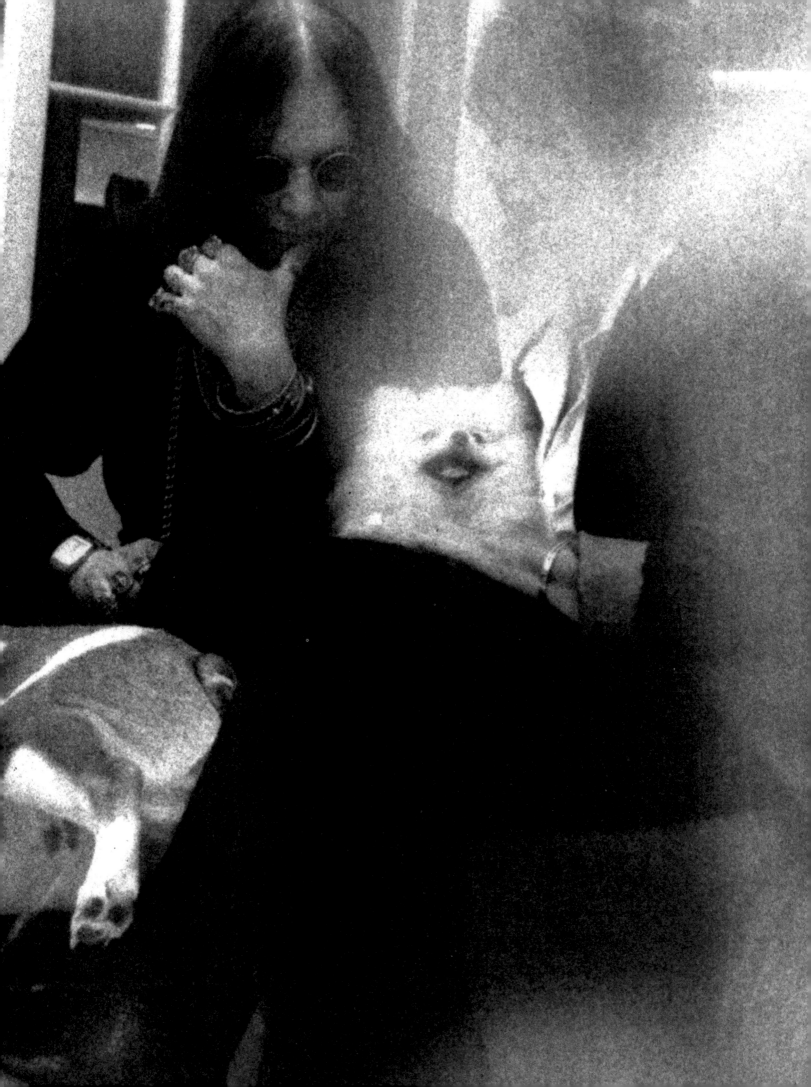

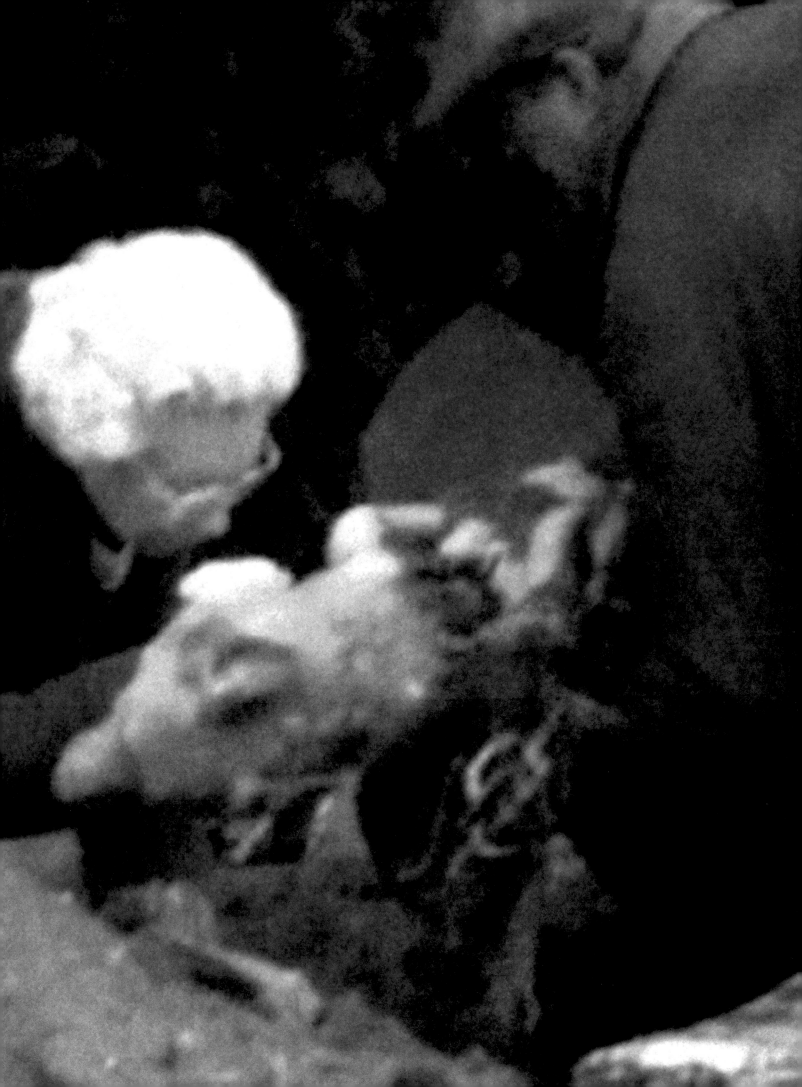

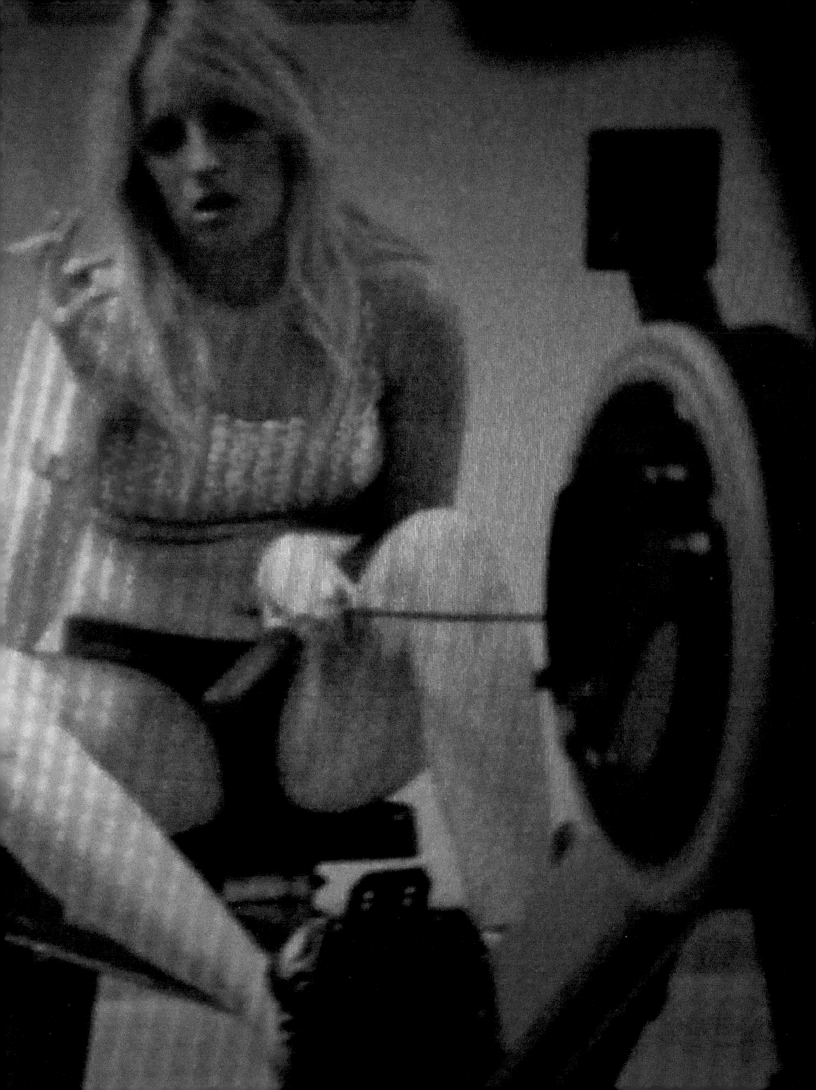

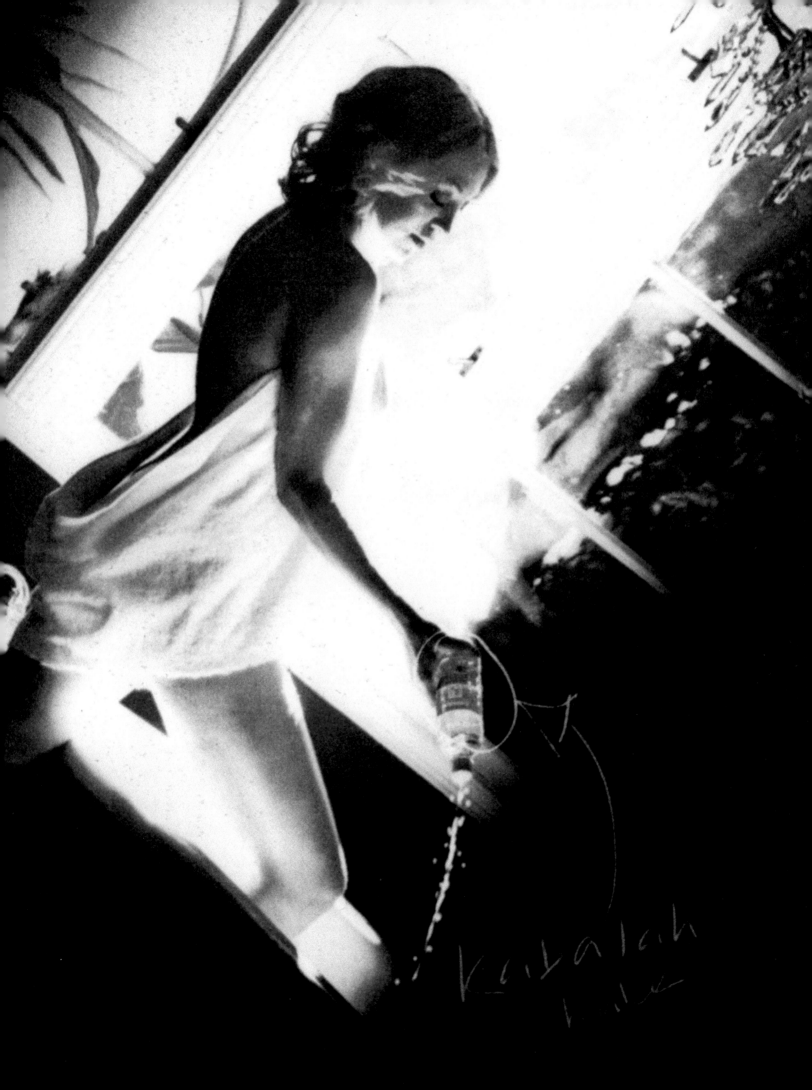

linedance_122

linedance_124

linedance_156

linedance_157

linedance_190

linedance_202

linedance_209

linedance_210

linedance_138

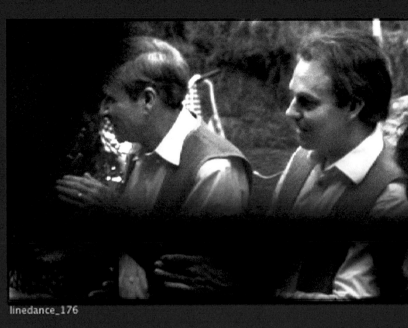
linedance_150

linedance_166

linedance_176

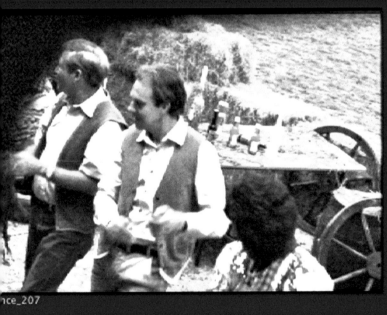
linedance_207

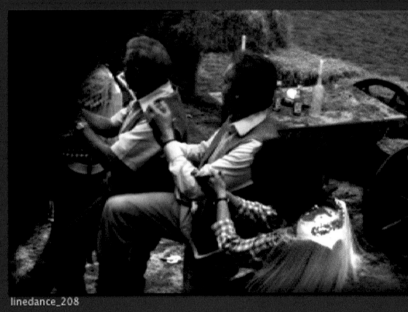
linedance_208

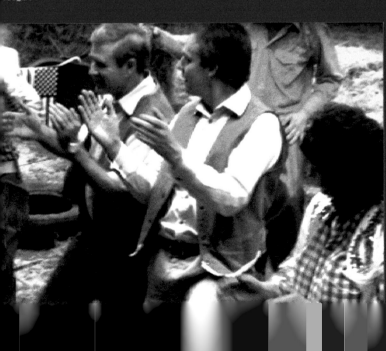

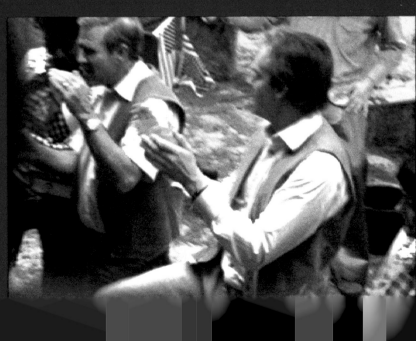

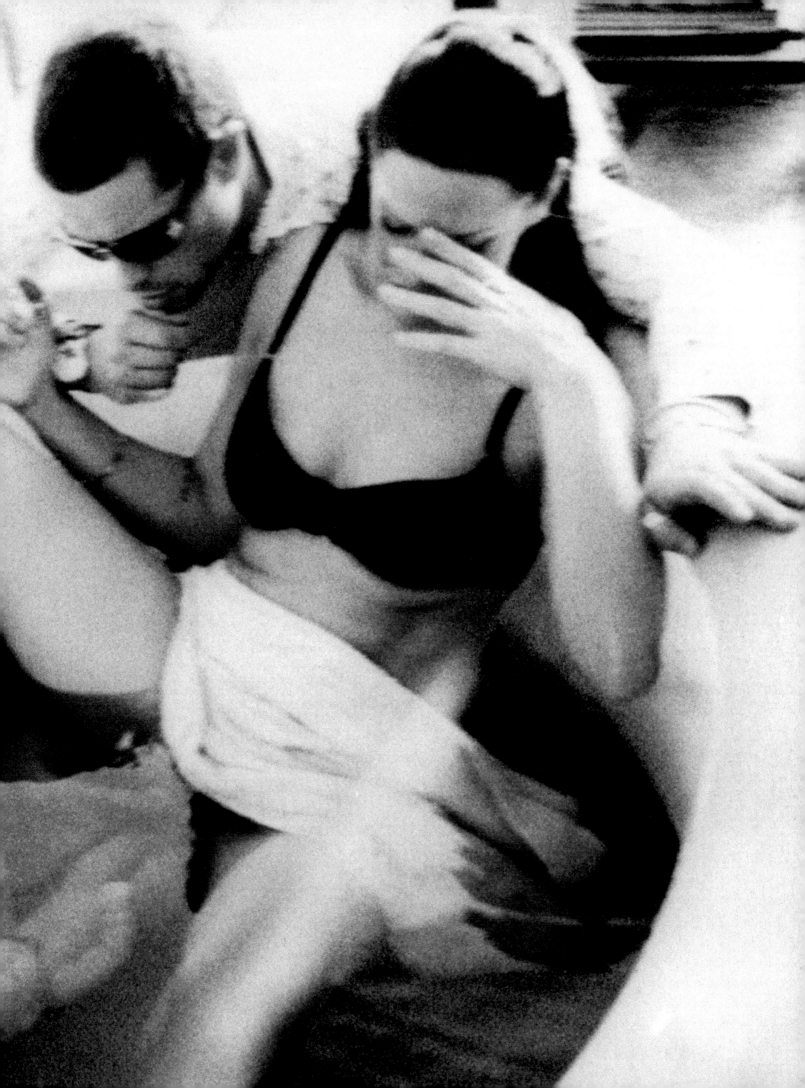

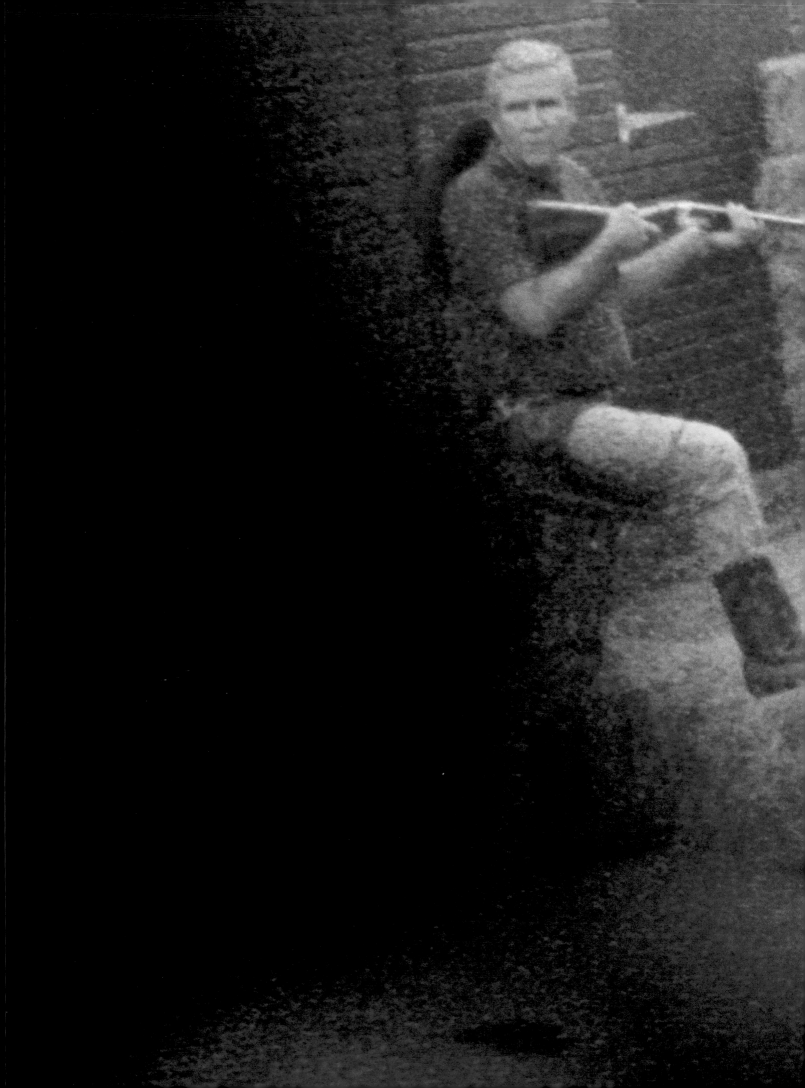

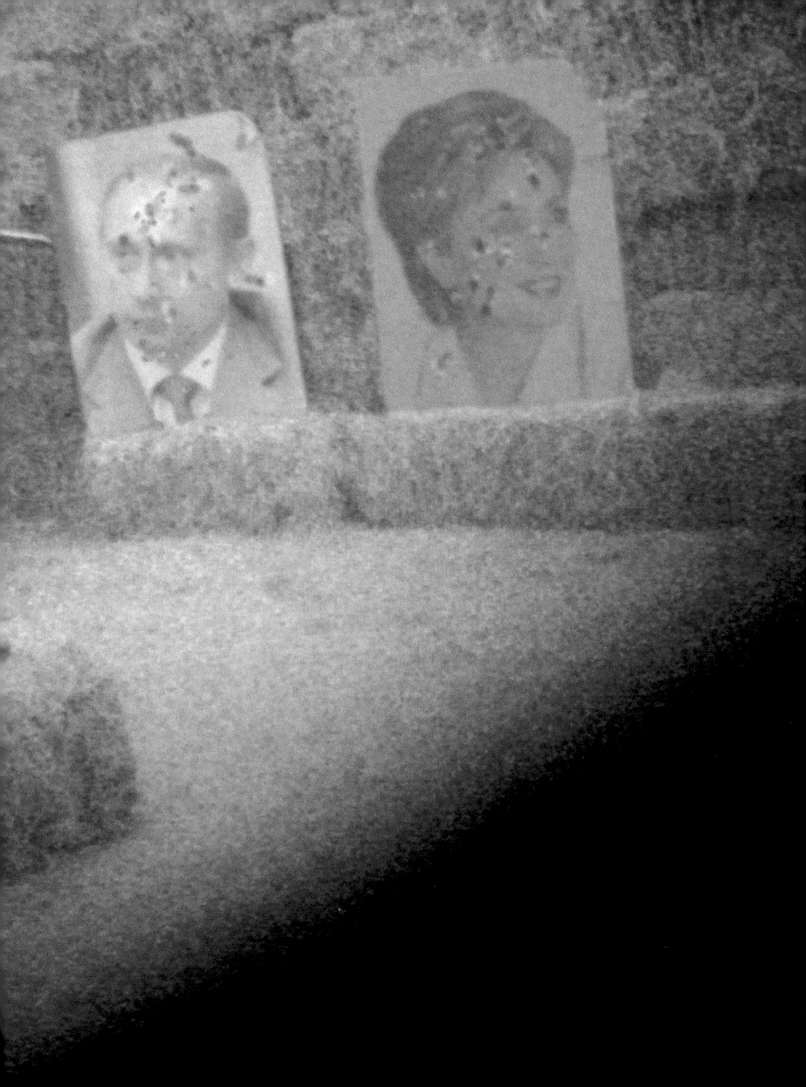

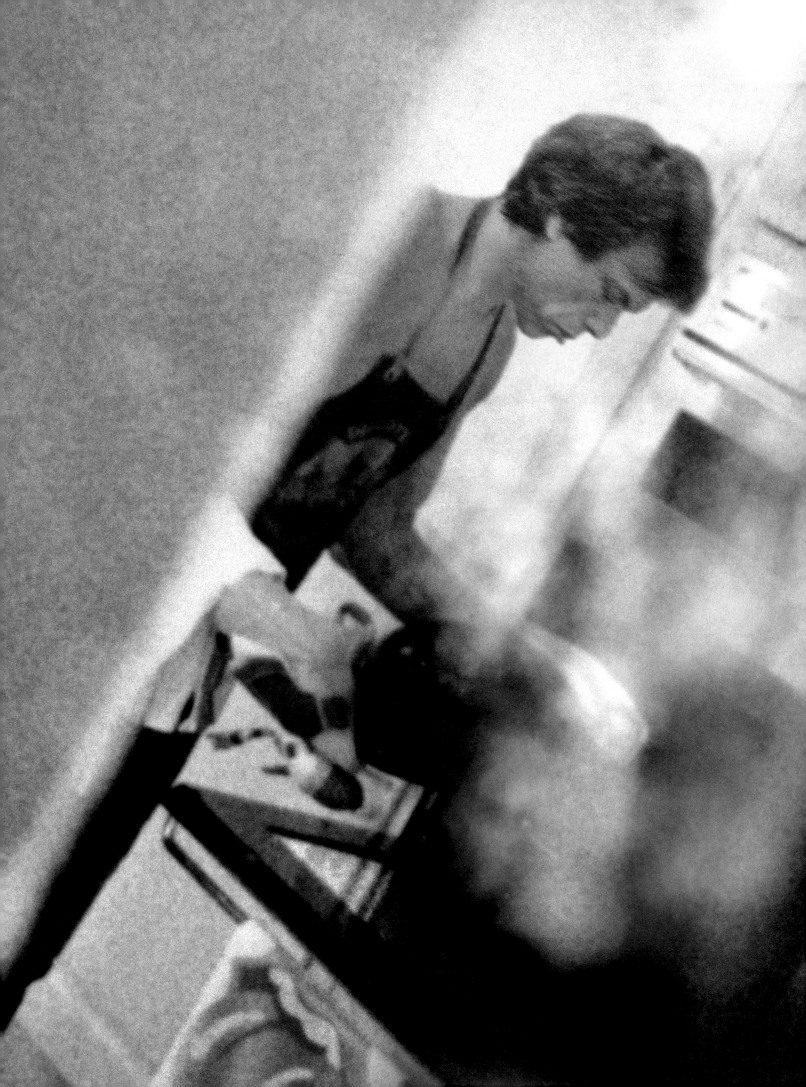

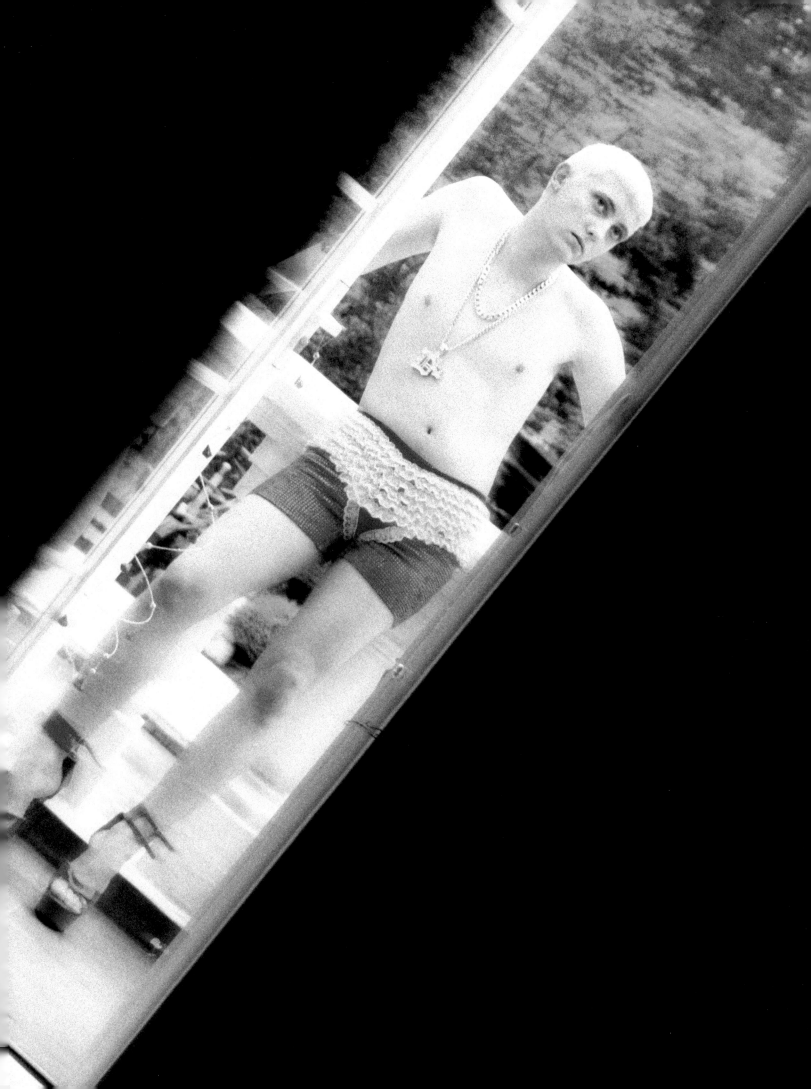

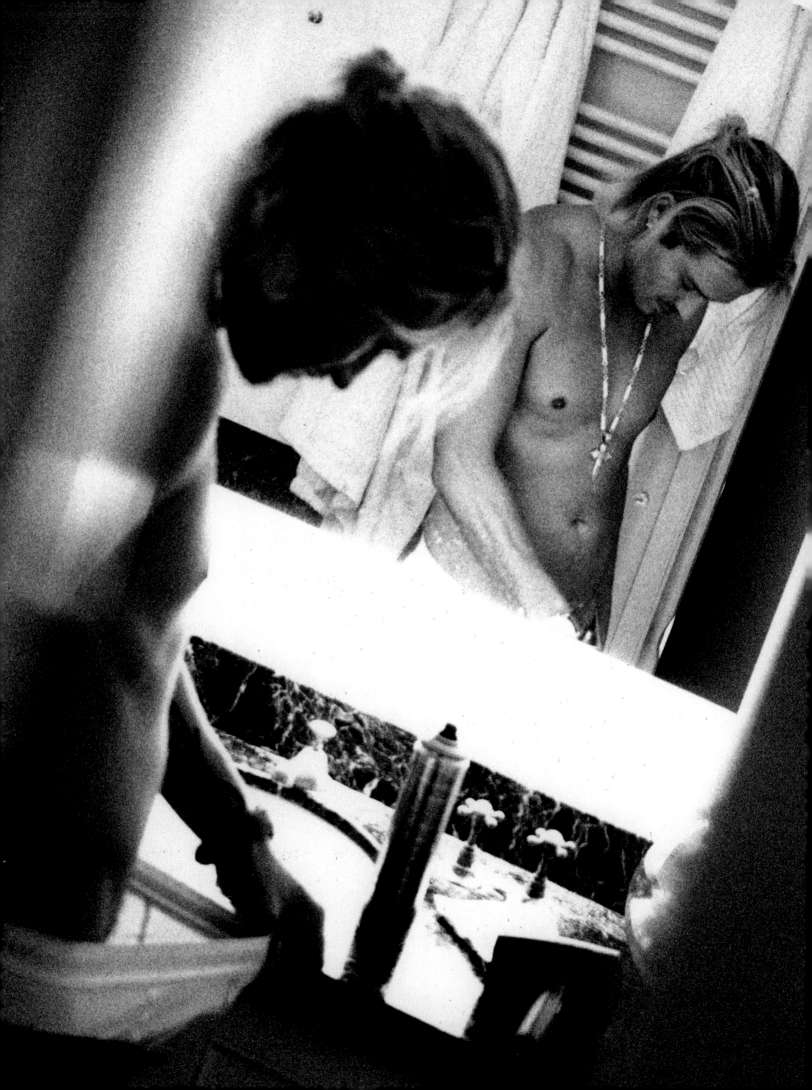

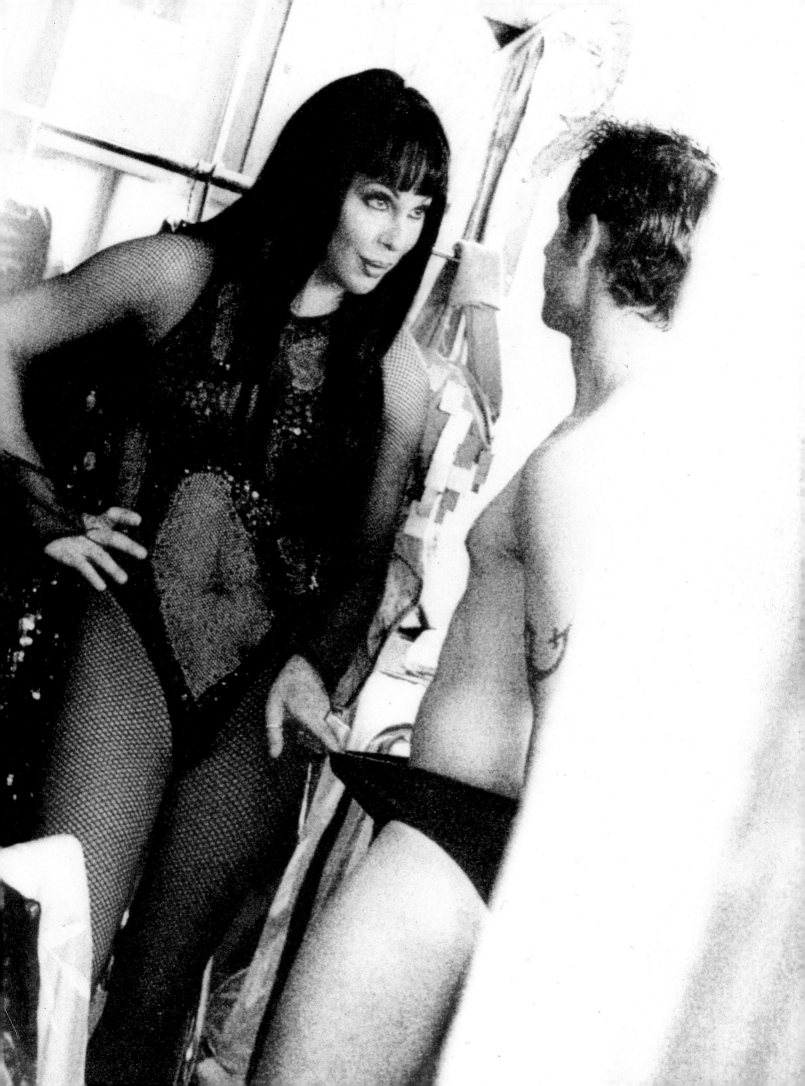

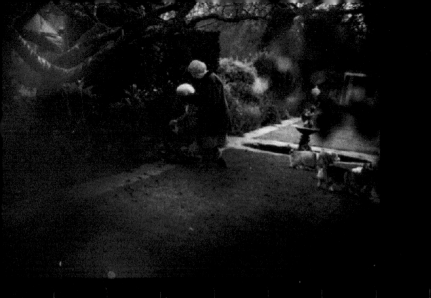

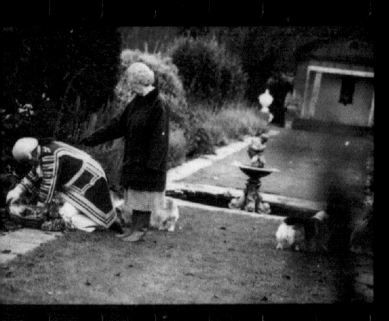

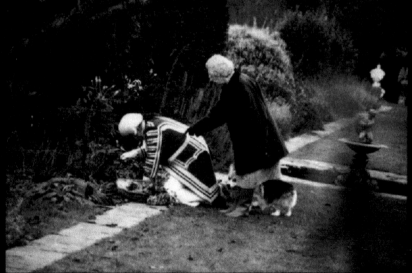

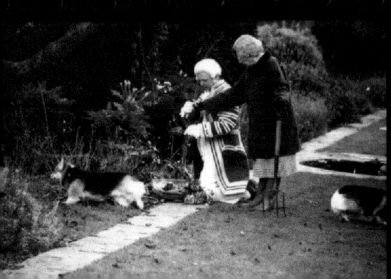

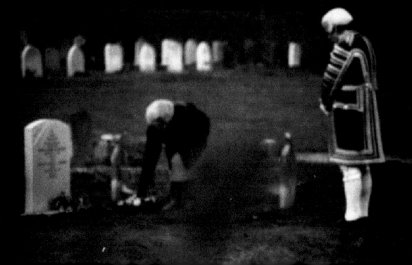

10 10A 11 11A

Z 34 KODAK P3200TMZ 35 KODAK P32

34 34A 35

27 KODAK P3200TMZ 28 KODAK P3200TMZ

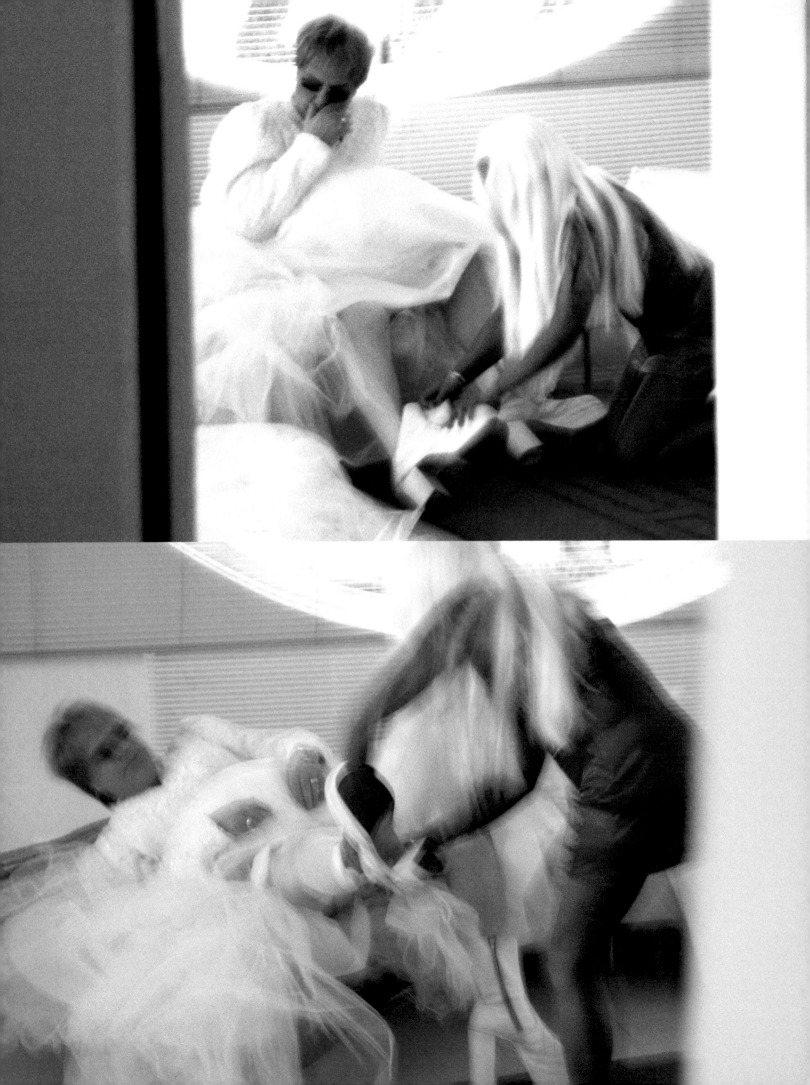

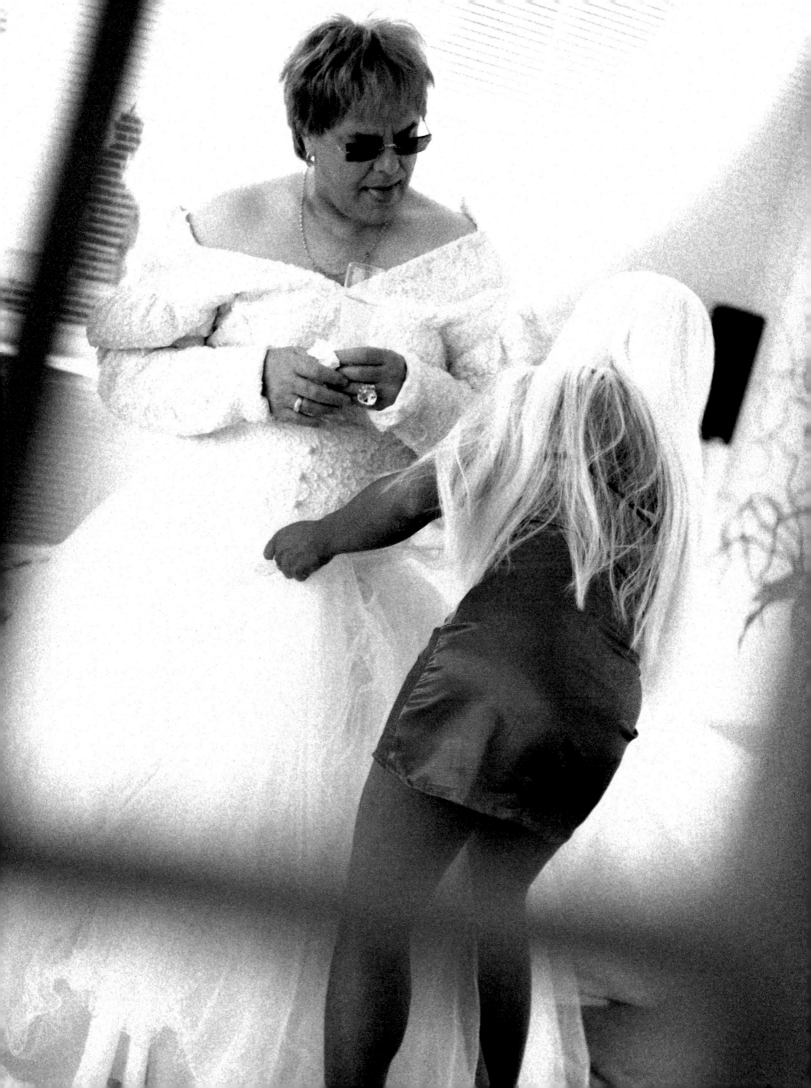

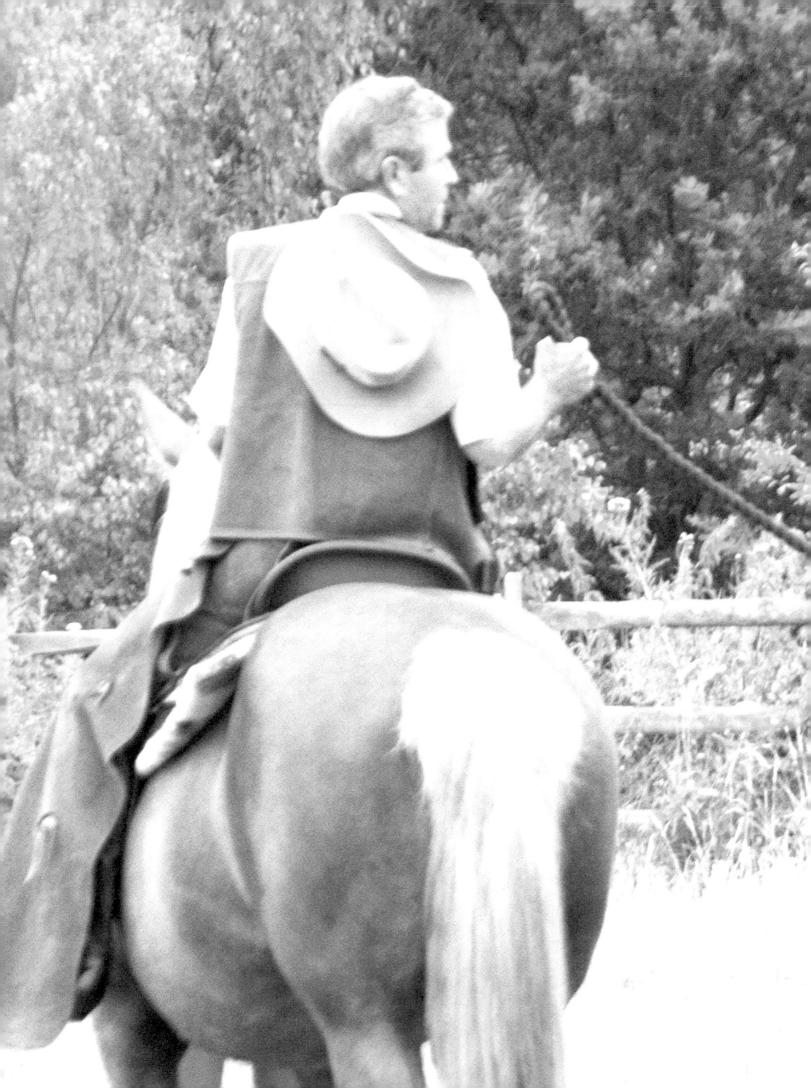

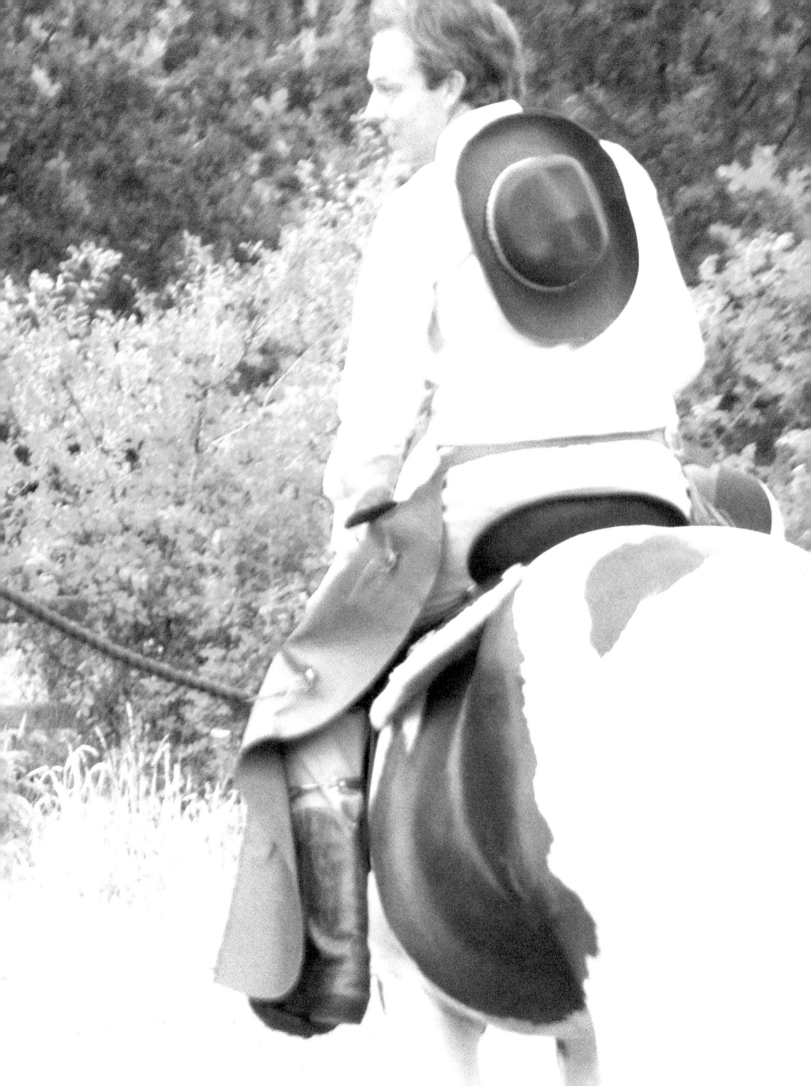

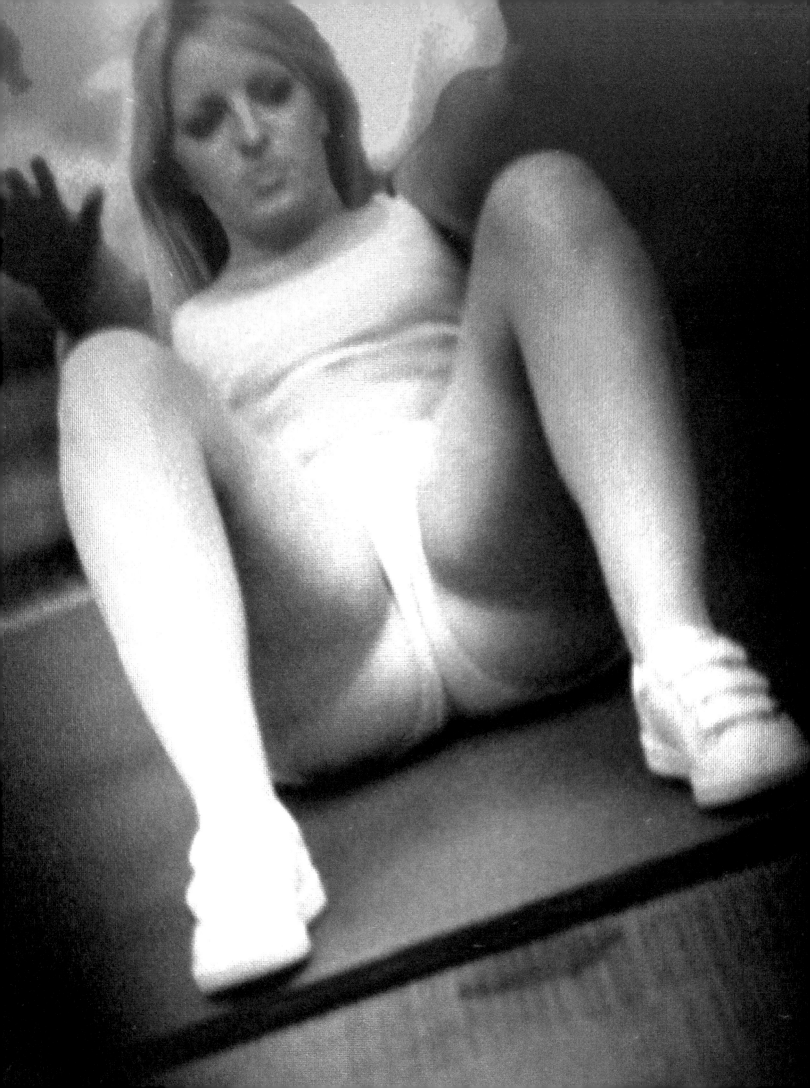

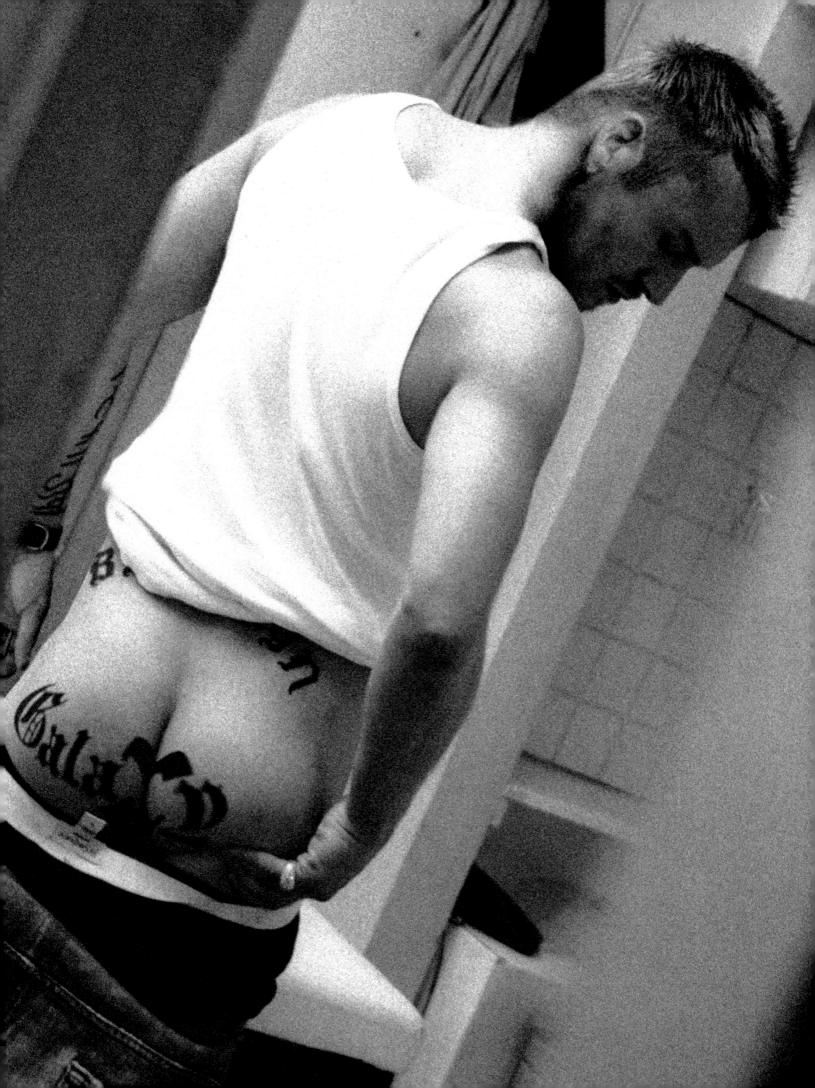

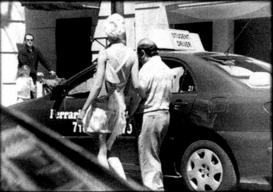

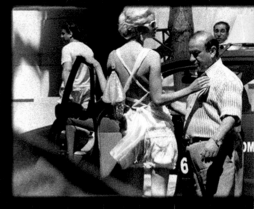

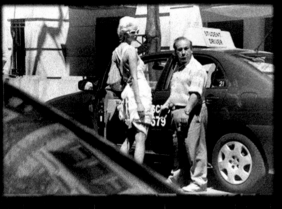

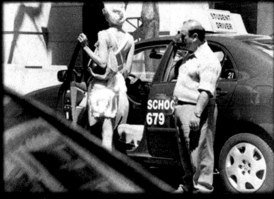

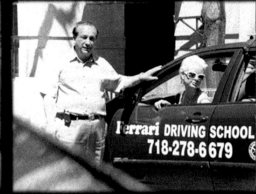

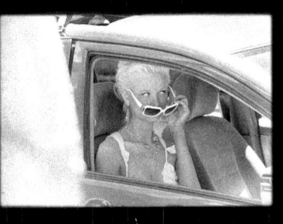

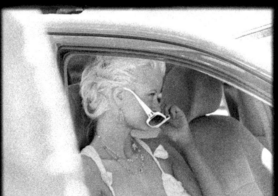

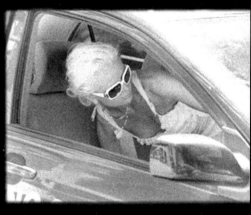

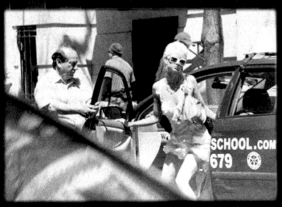

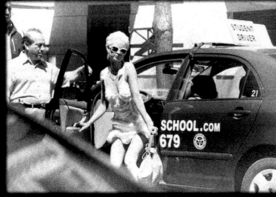

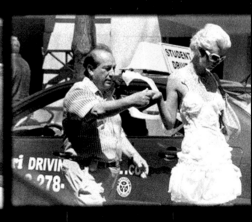

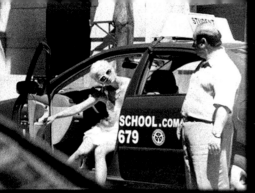
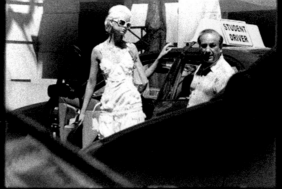
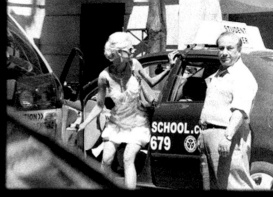
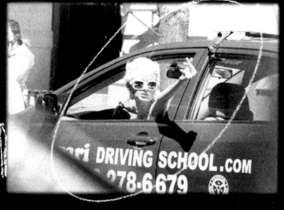
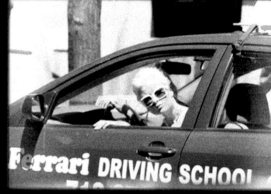
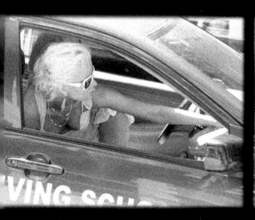
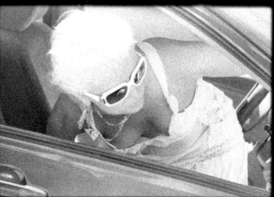
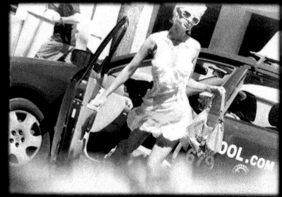
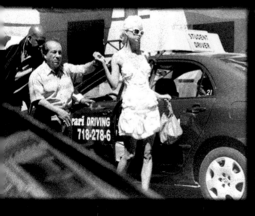
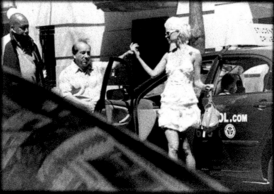

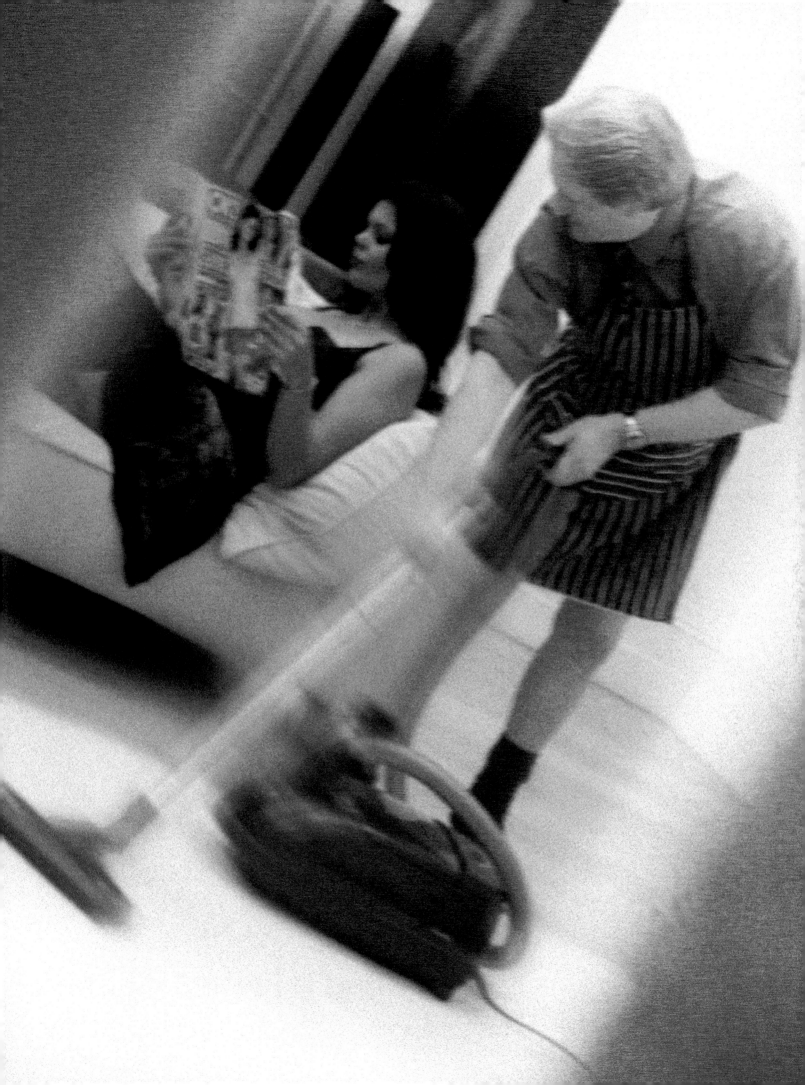

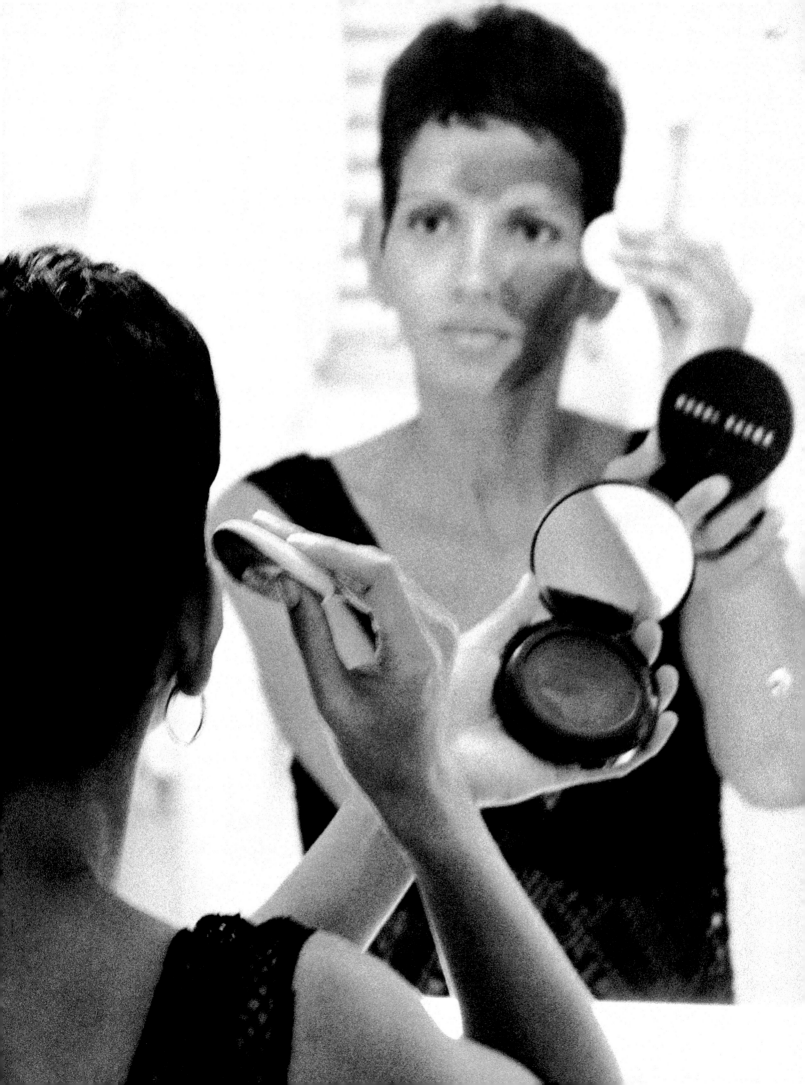

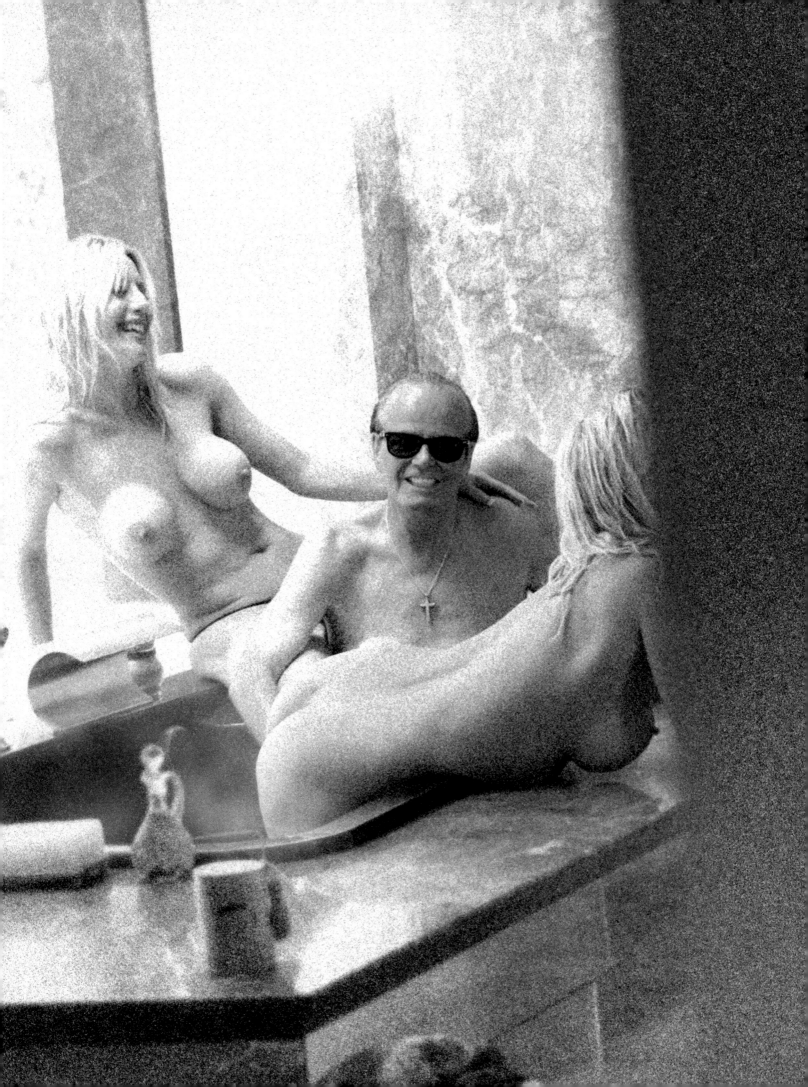

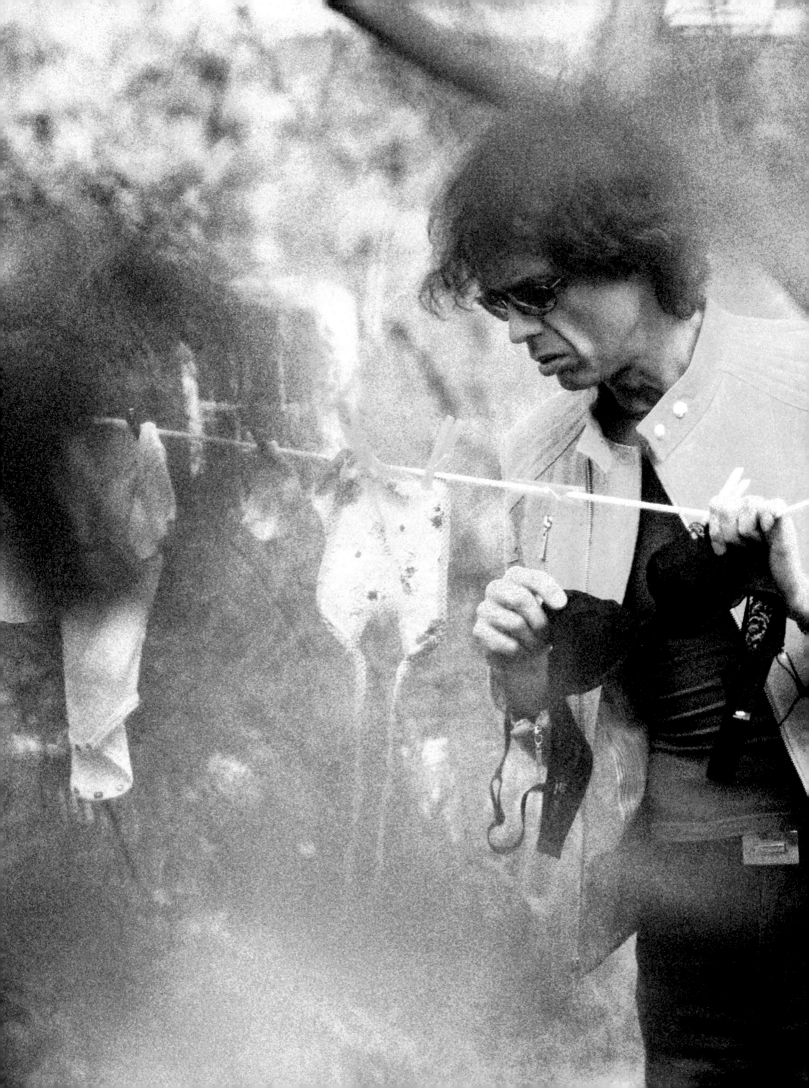

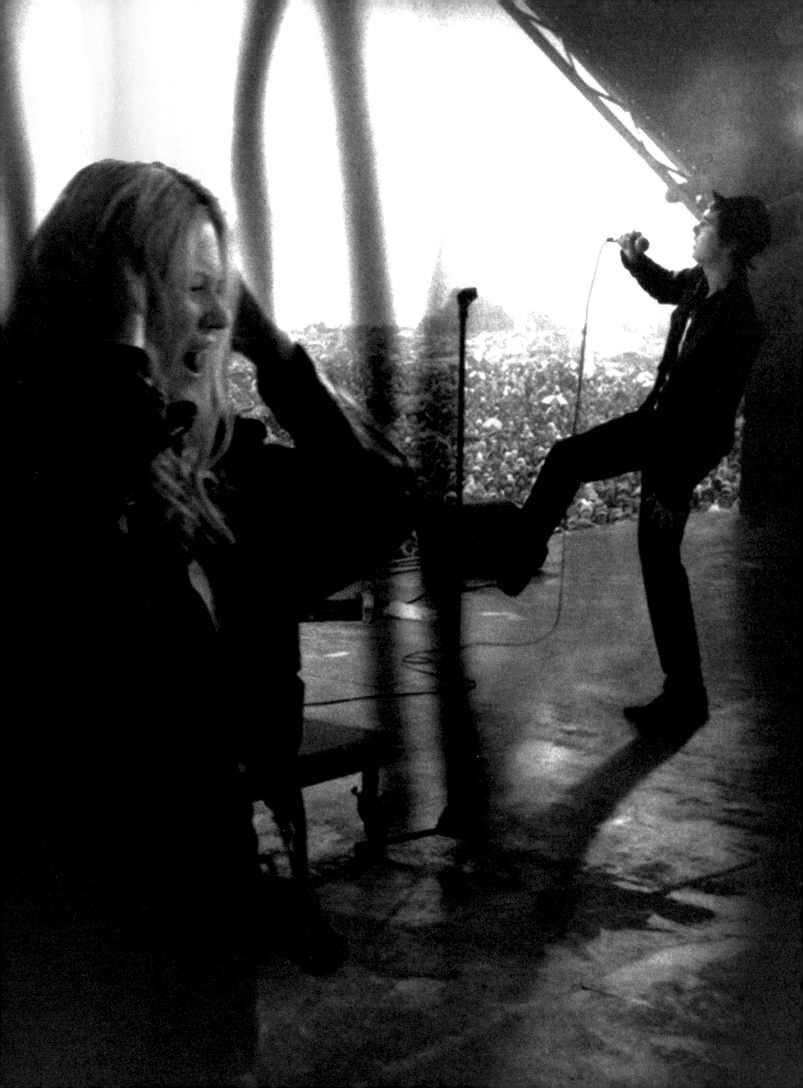

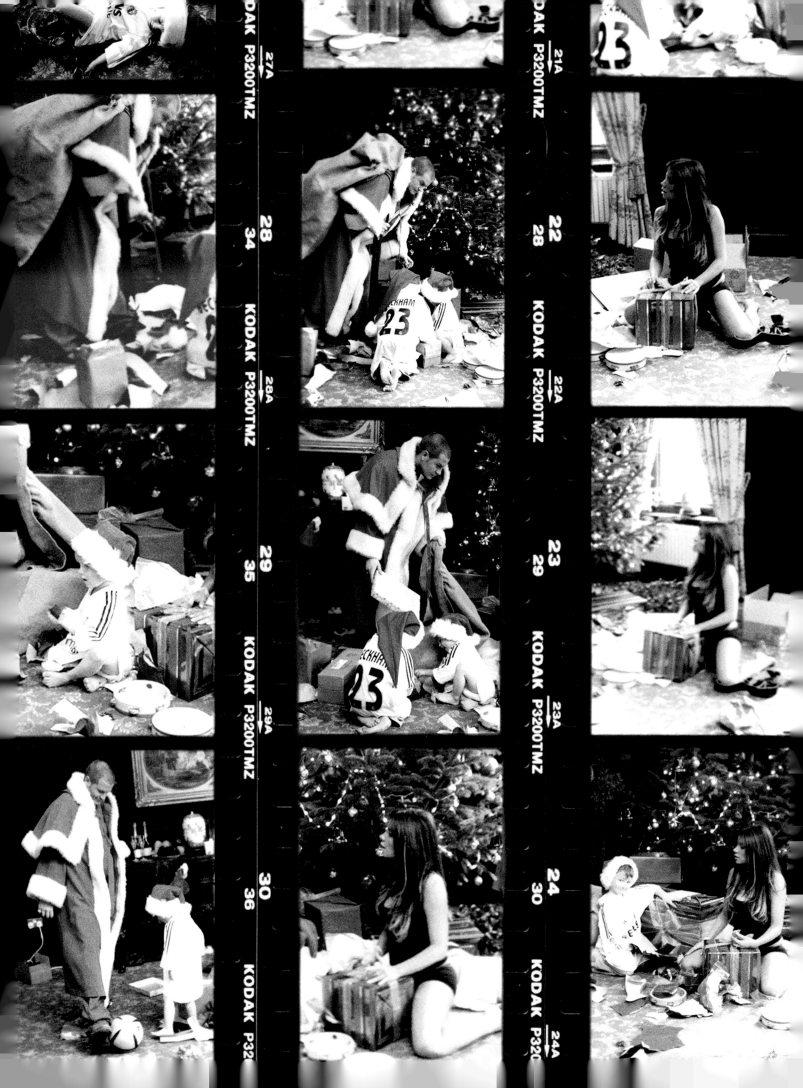

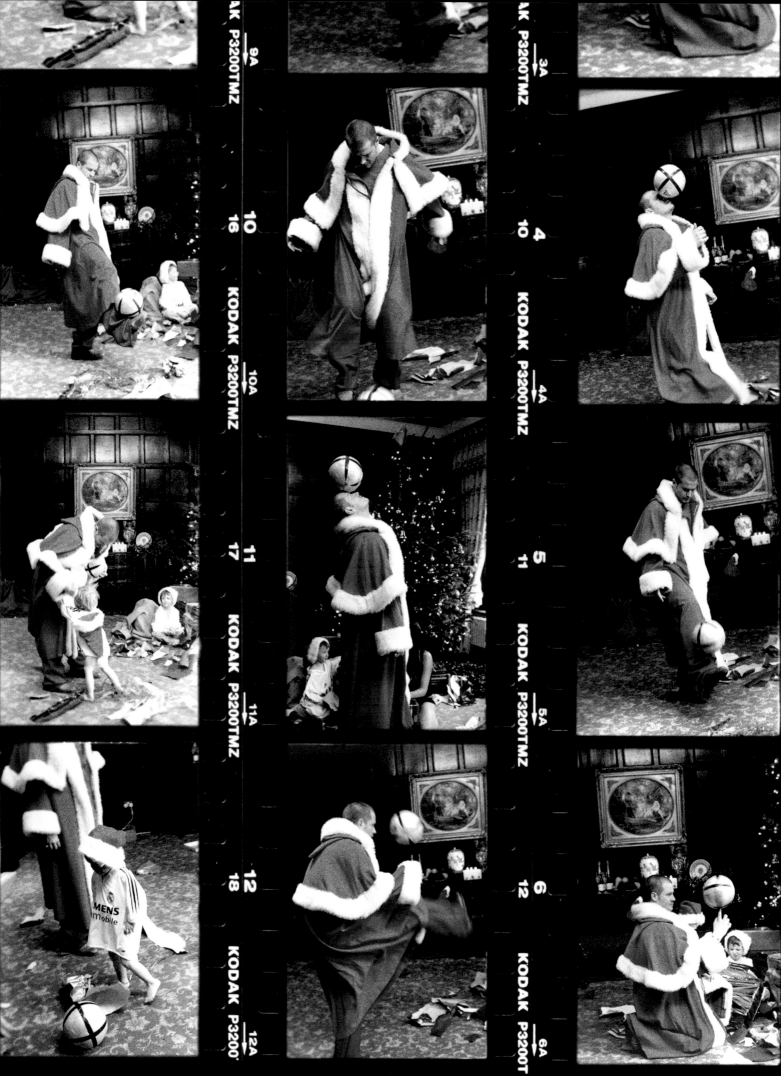

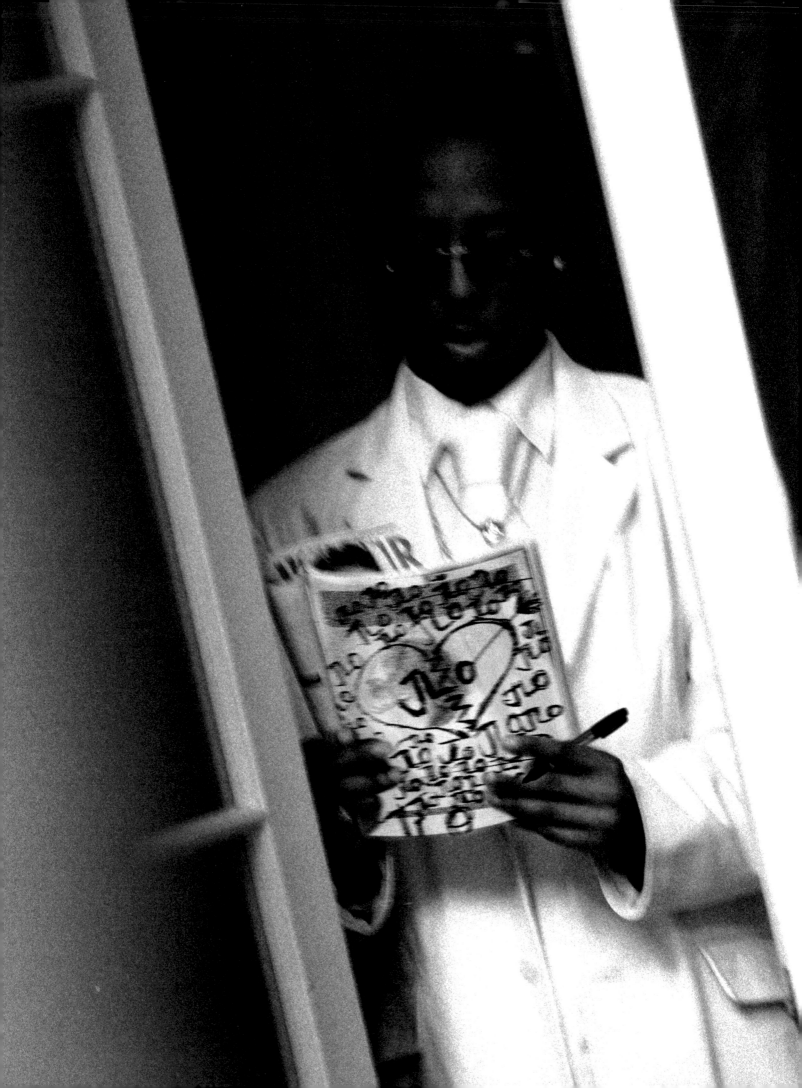

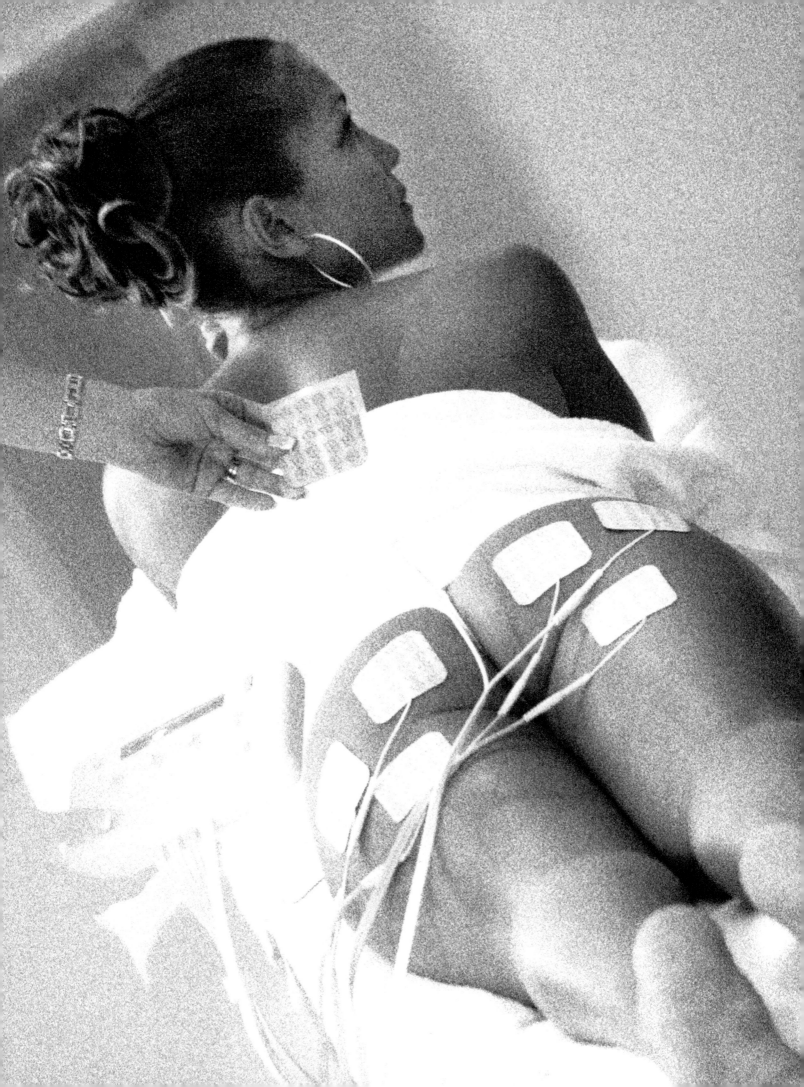

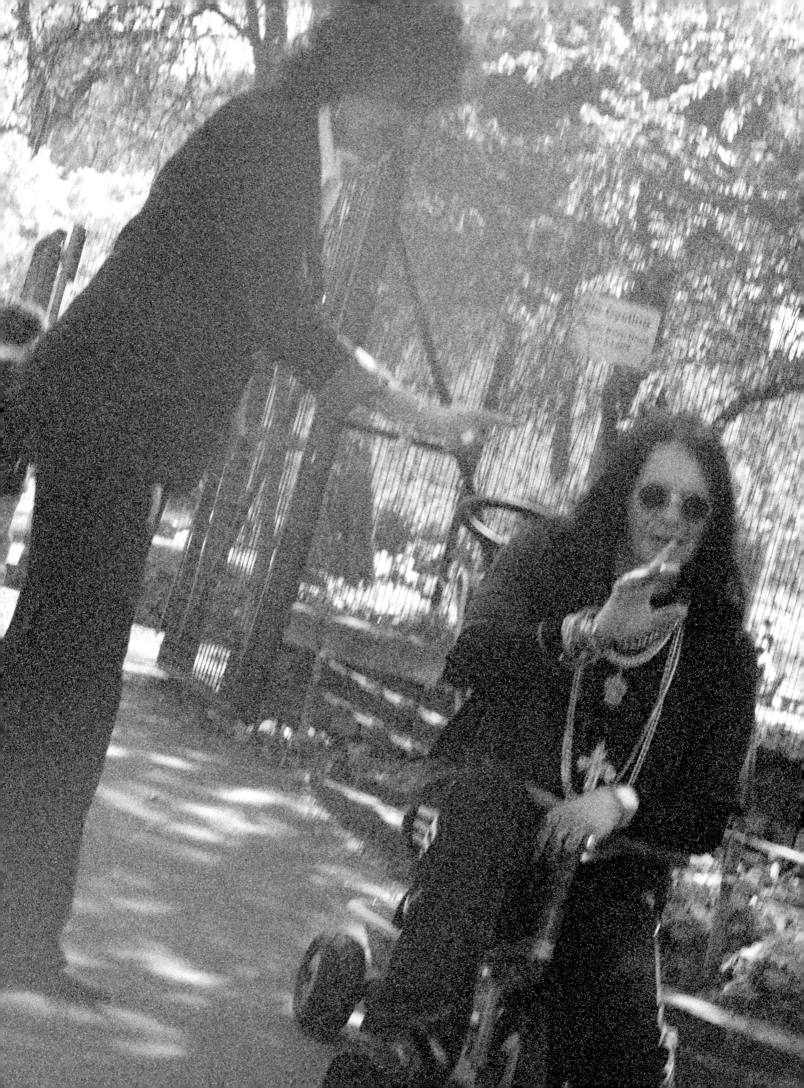

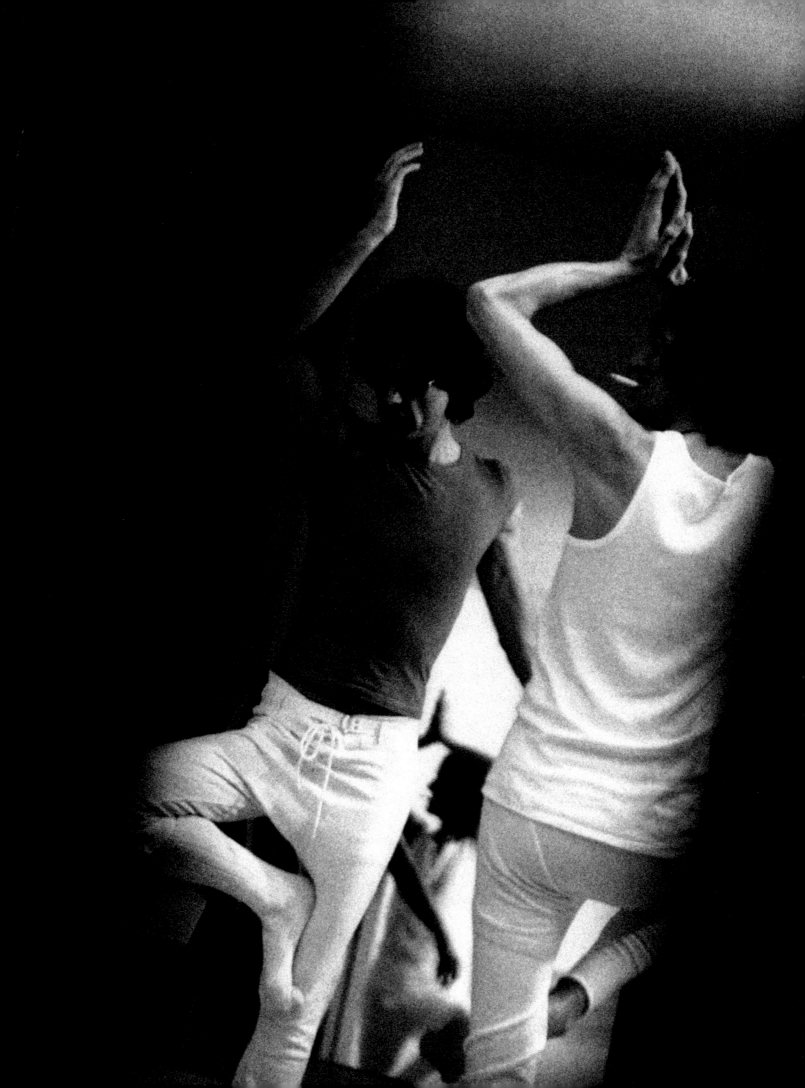

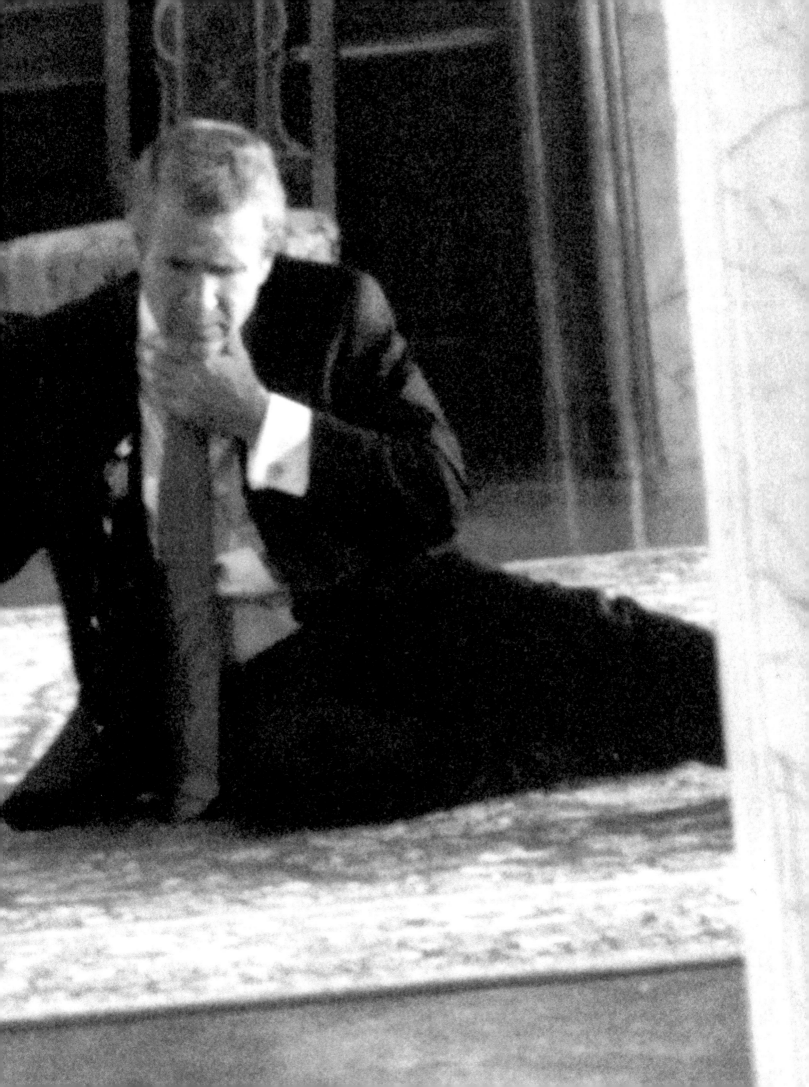

Liposuction
Dept

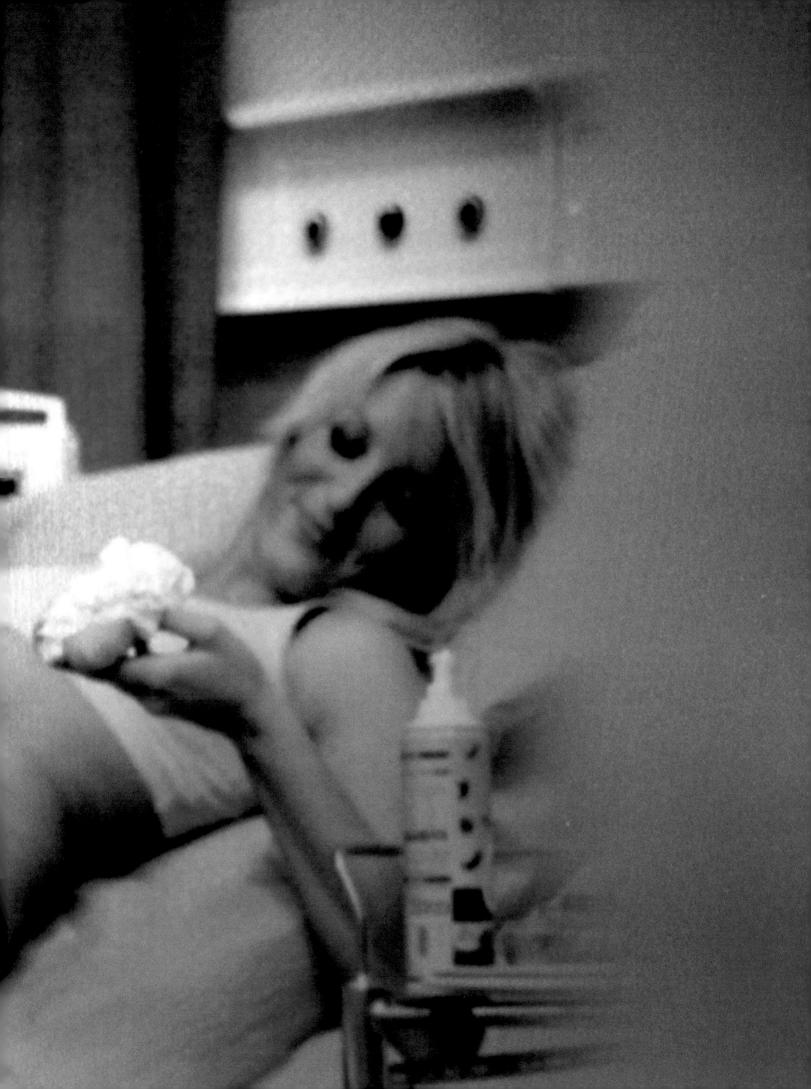

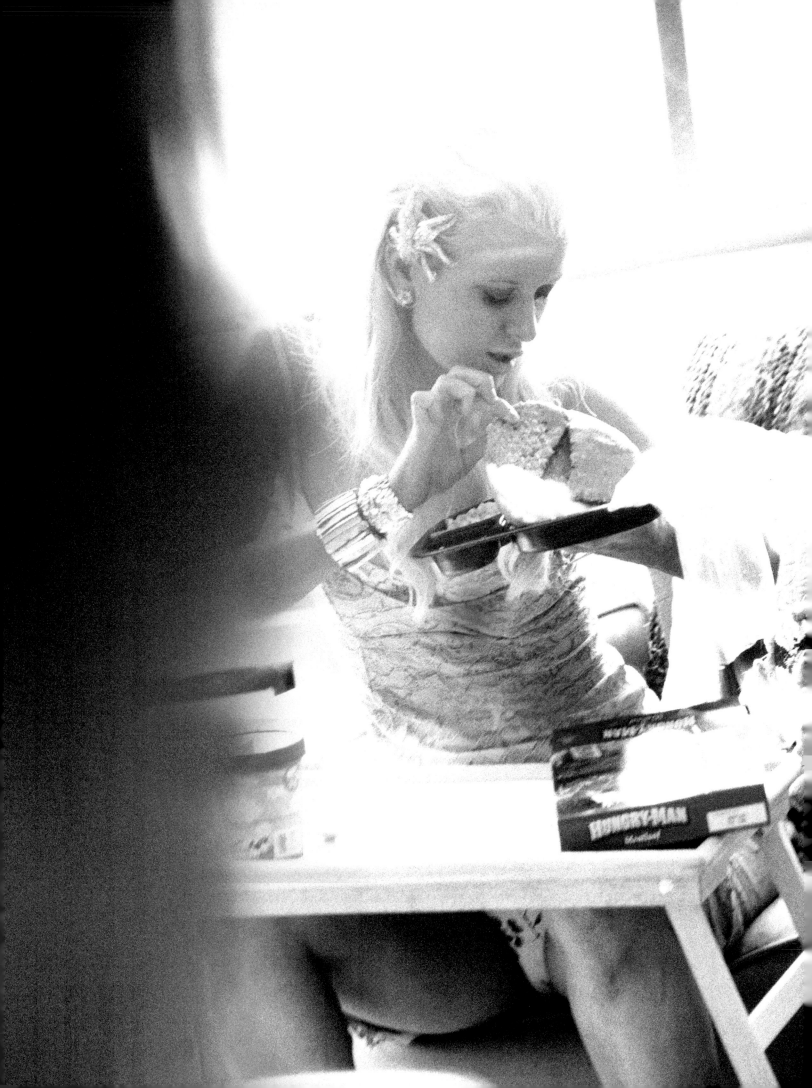

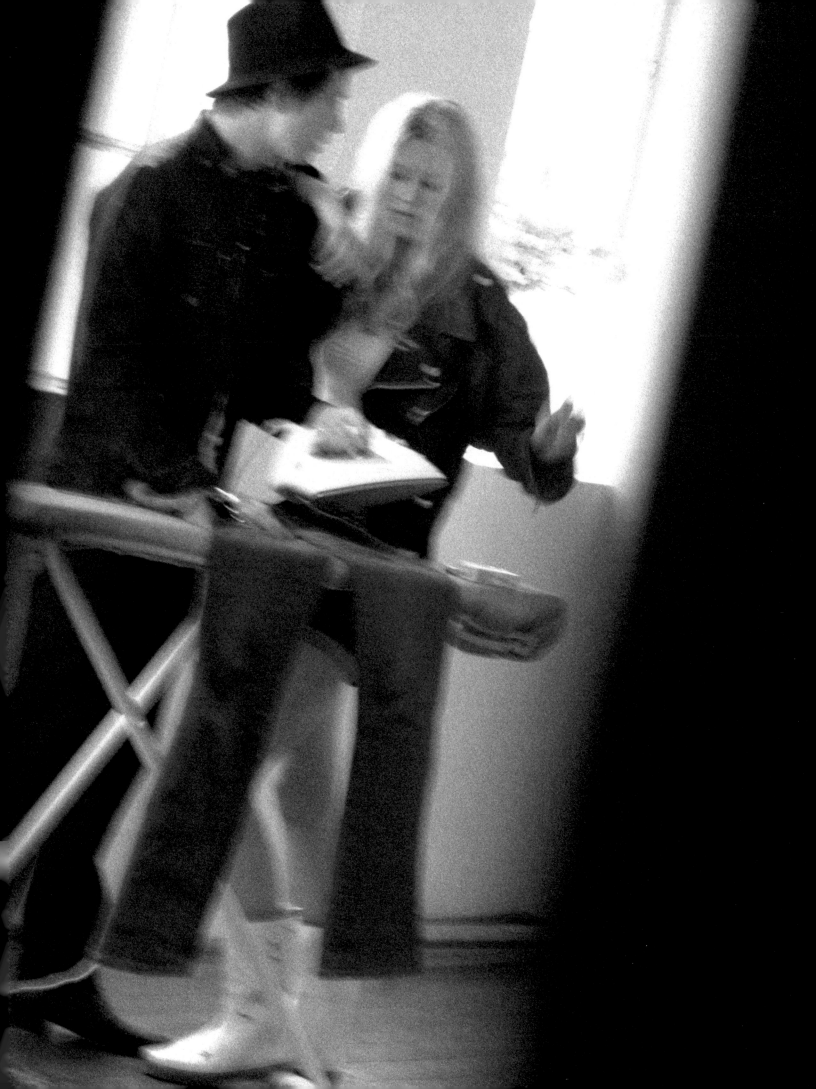

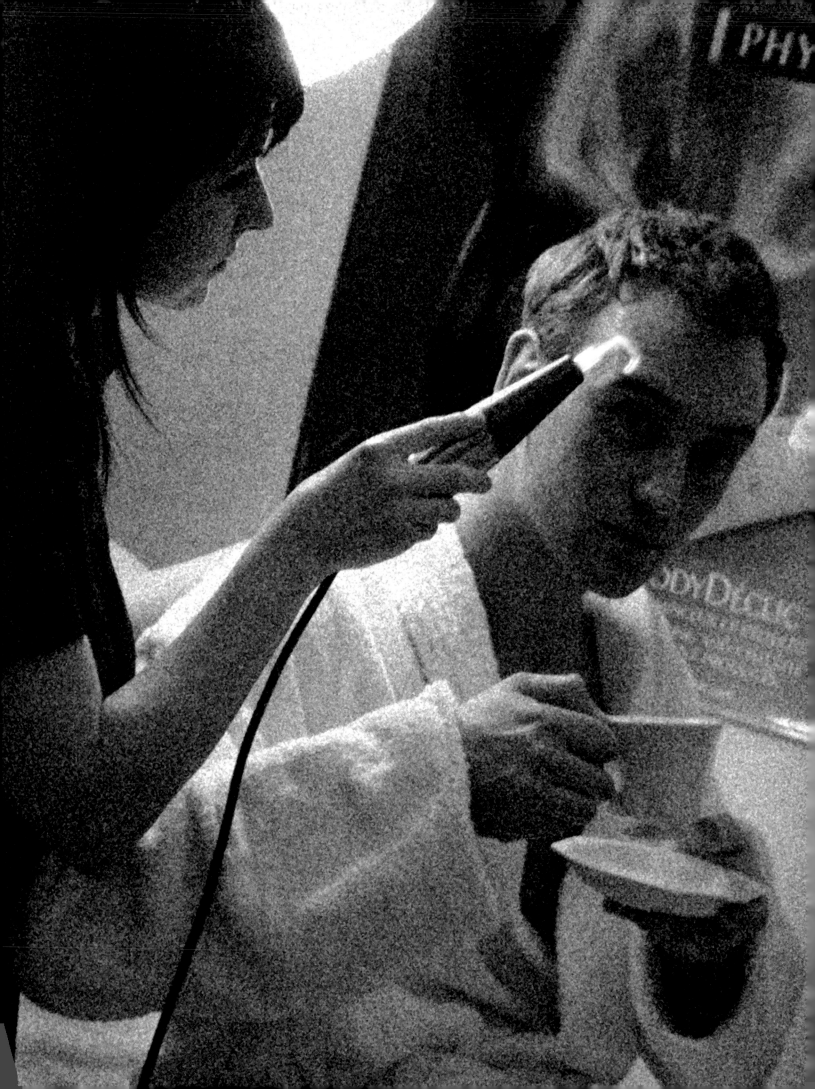

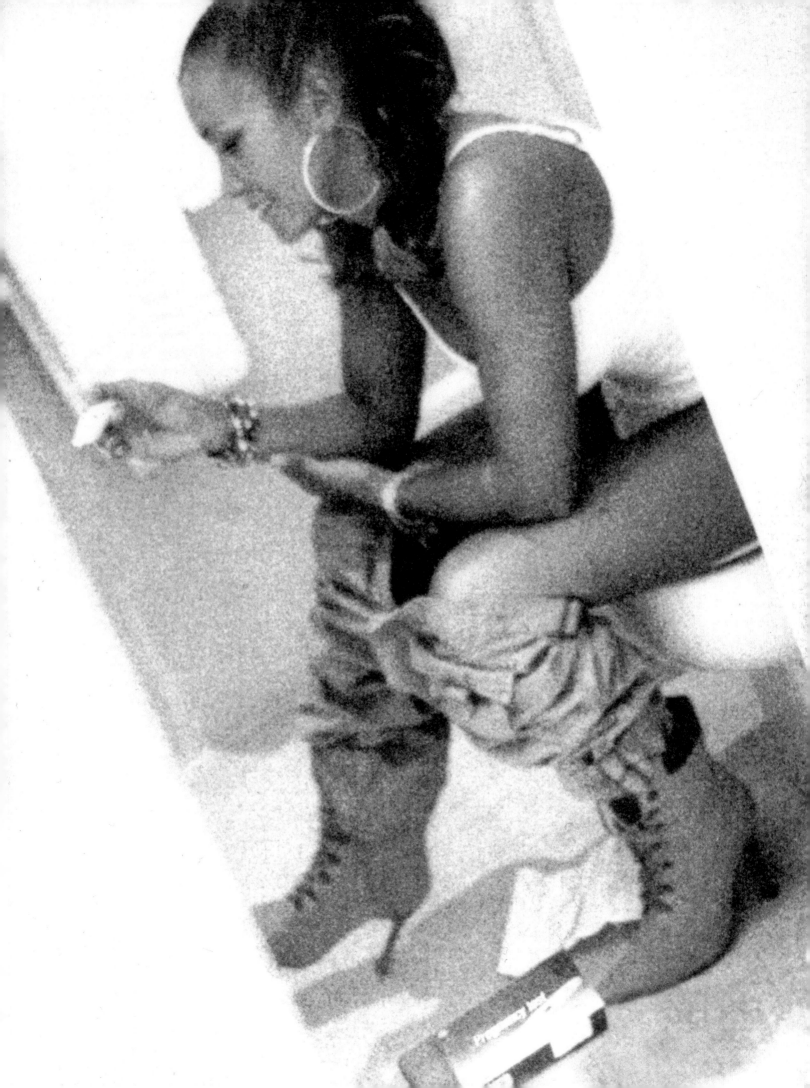

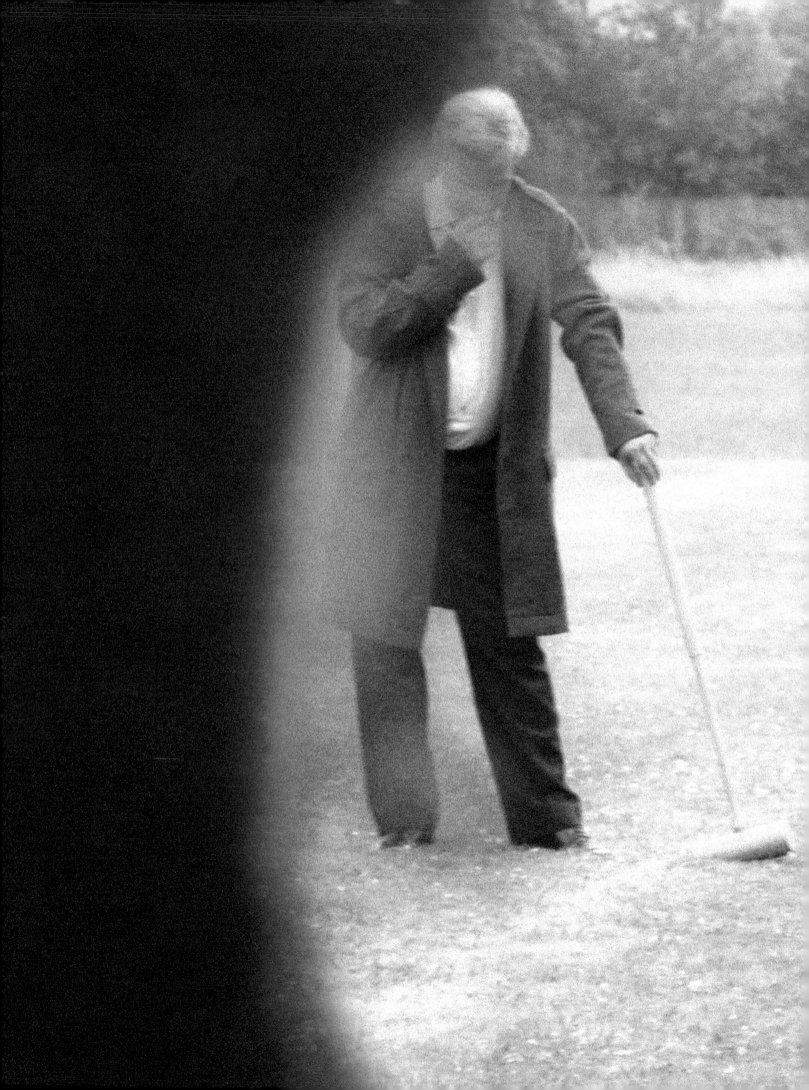

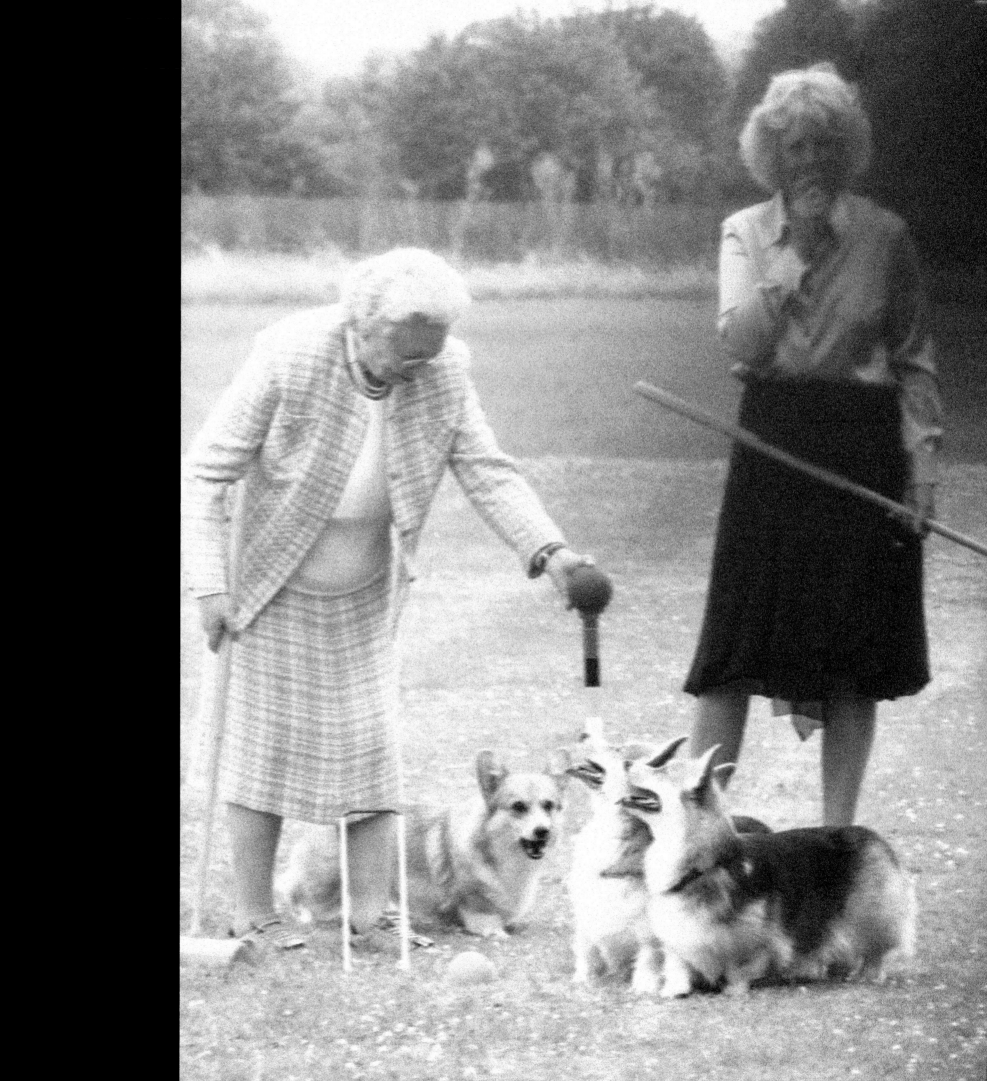

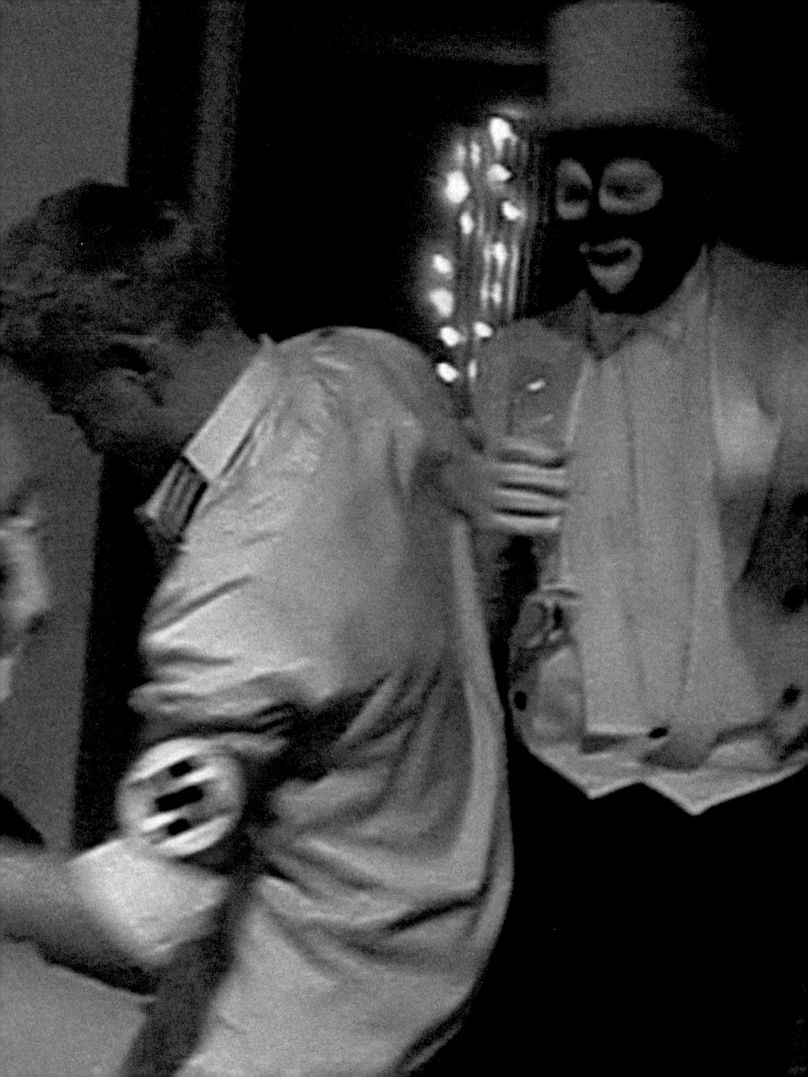

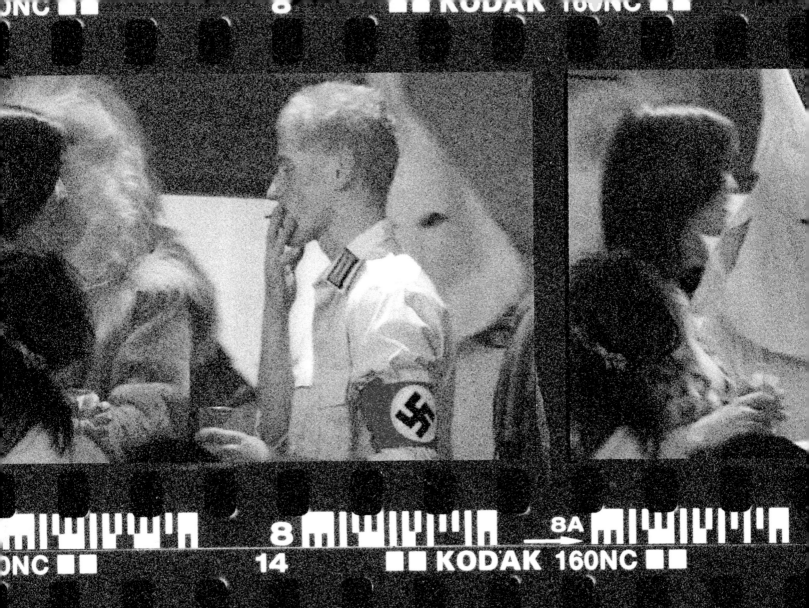

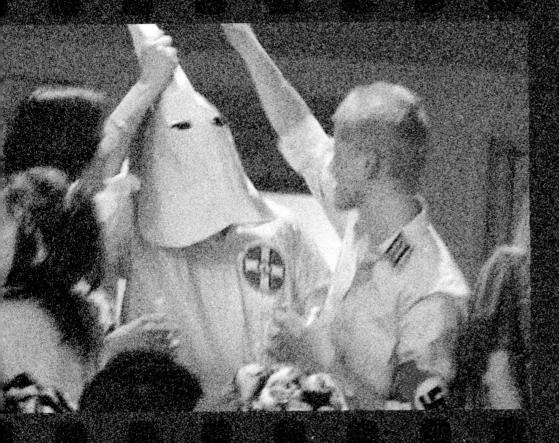

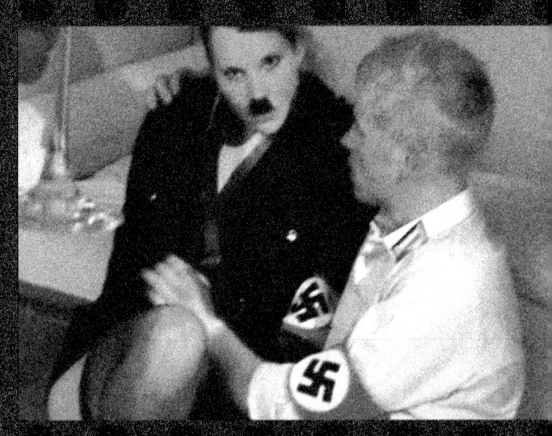

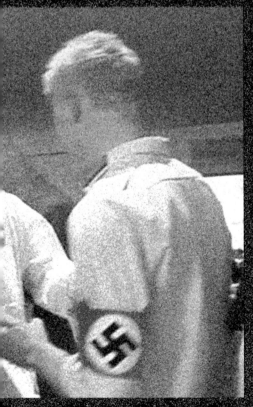

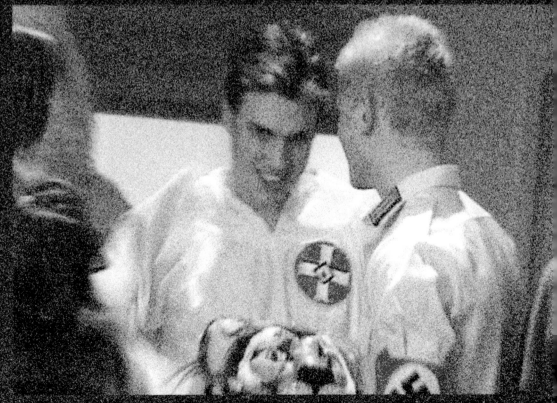

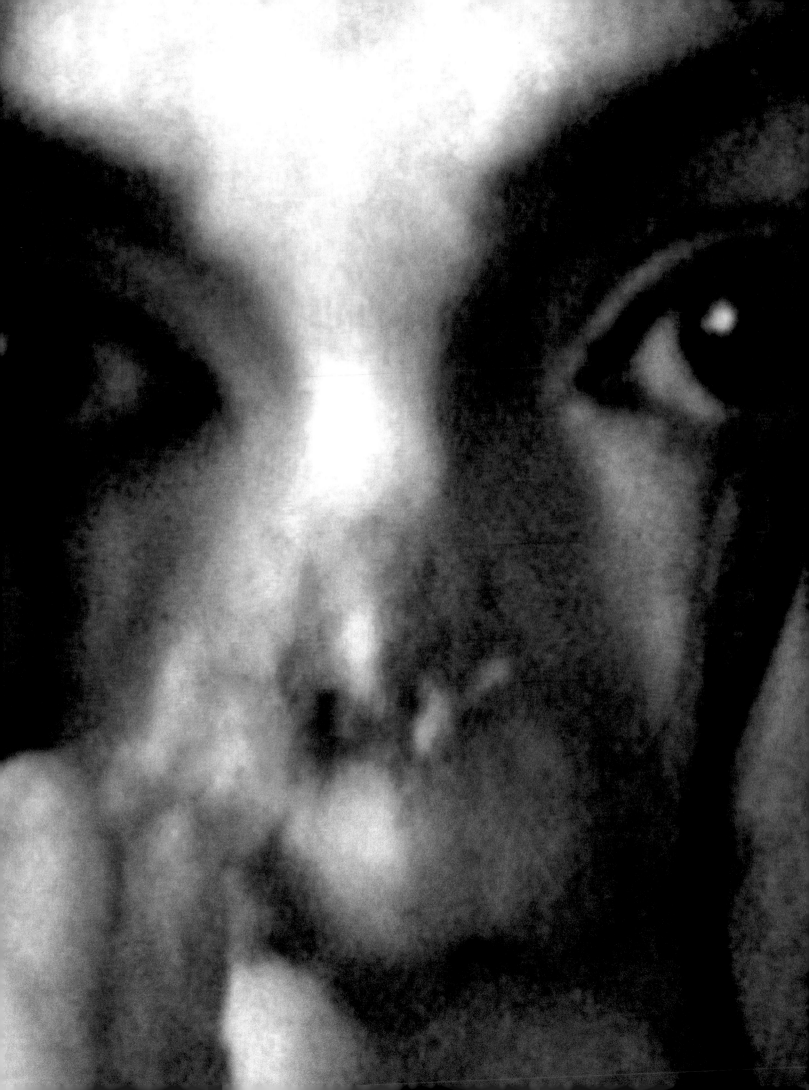

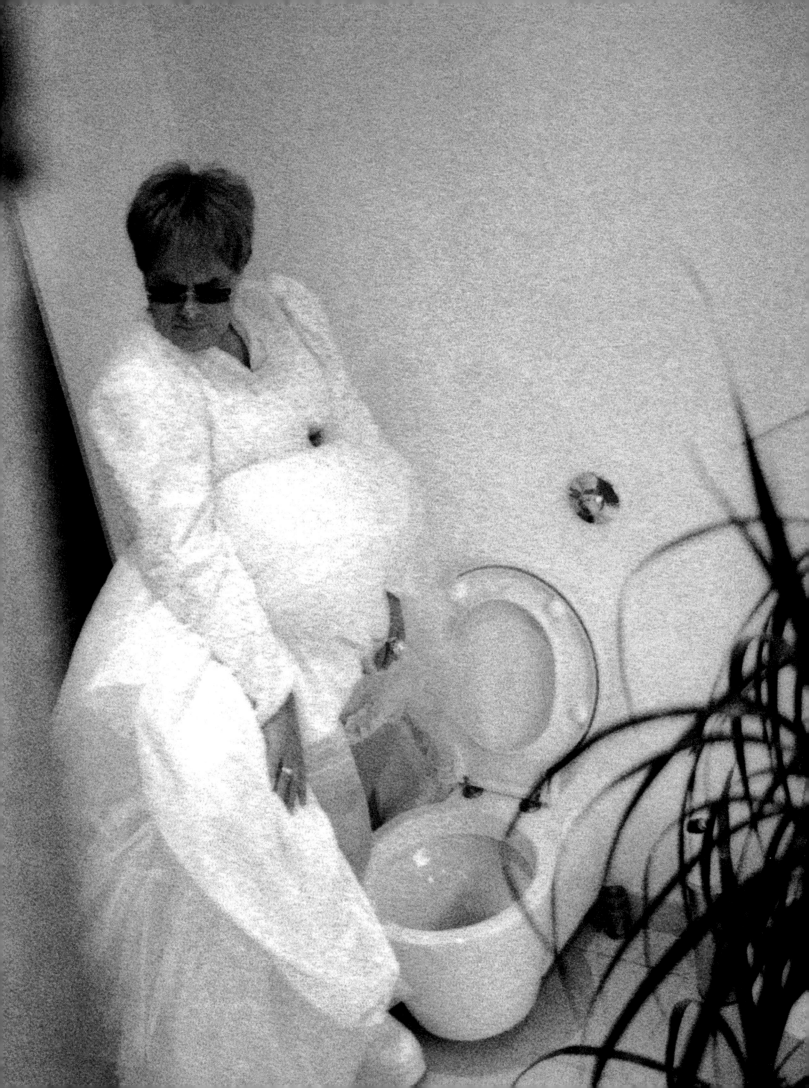

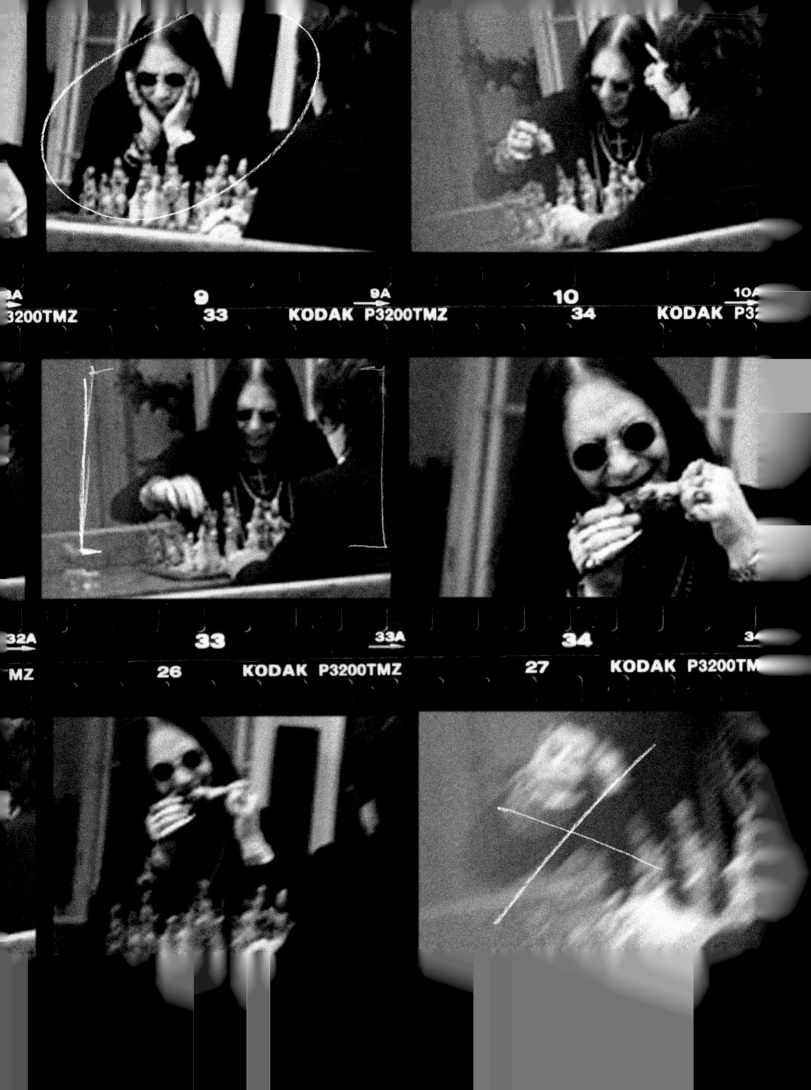

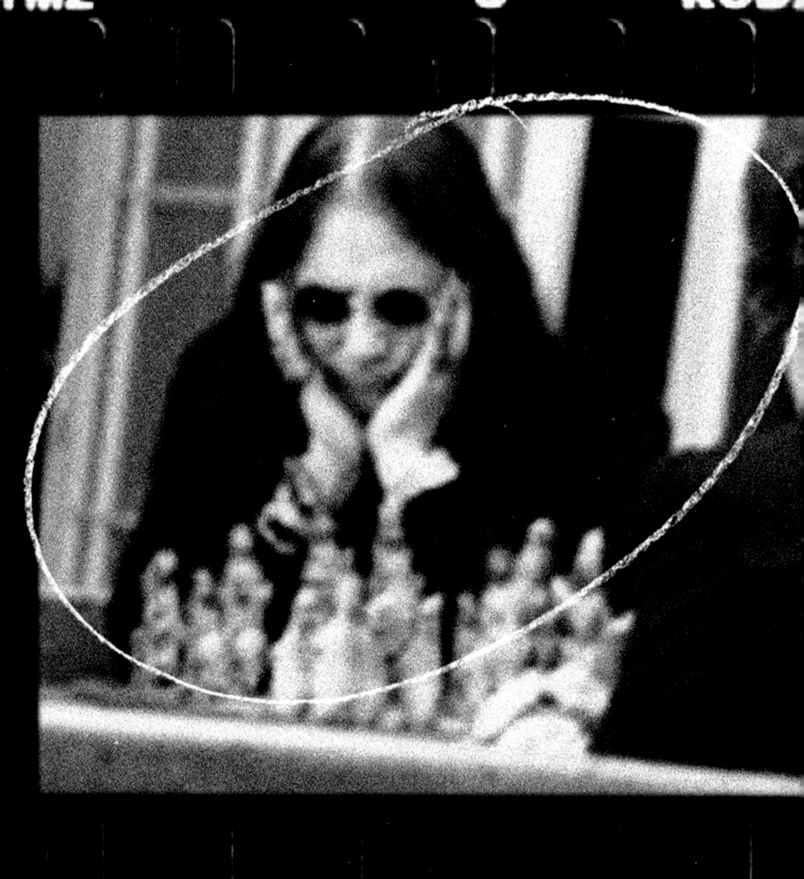

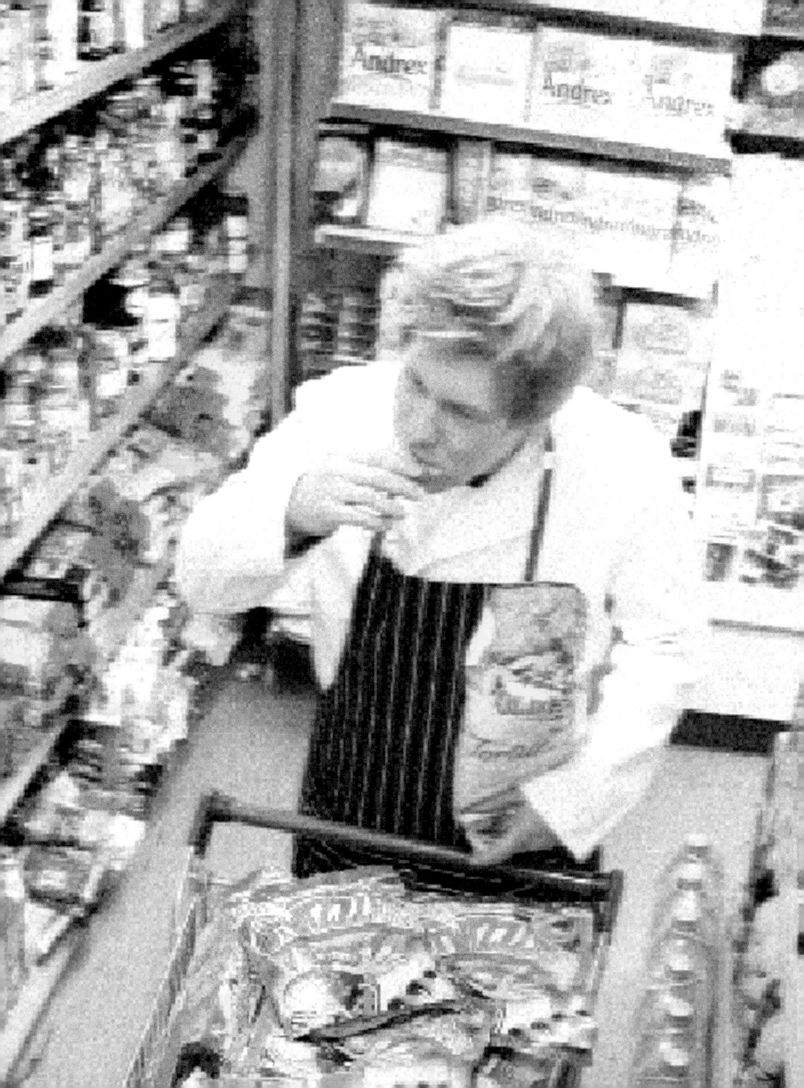

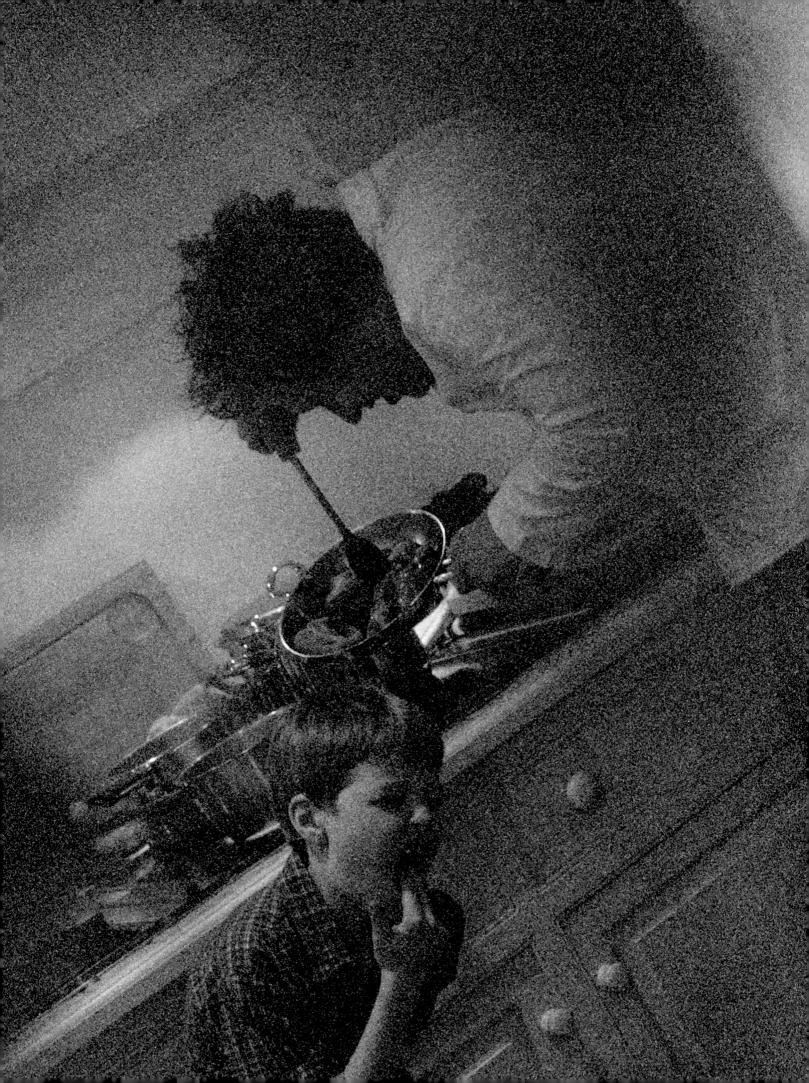

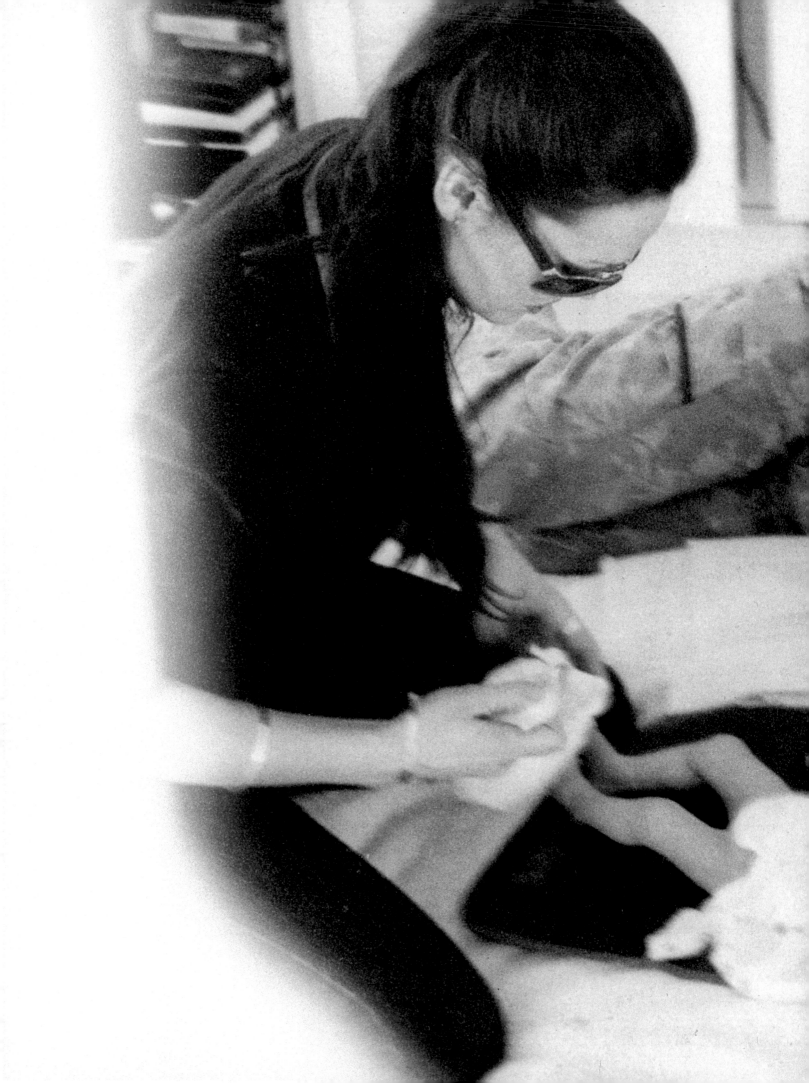

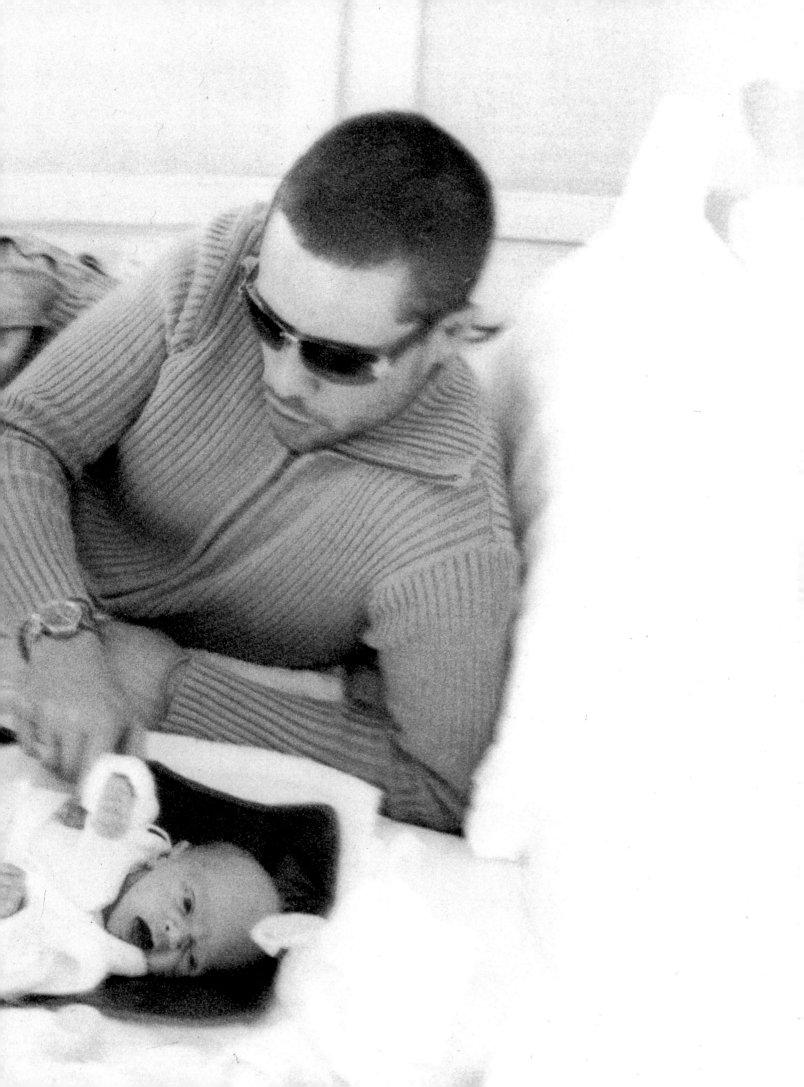

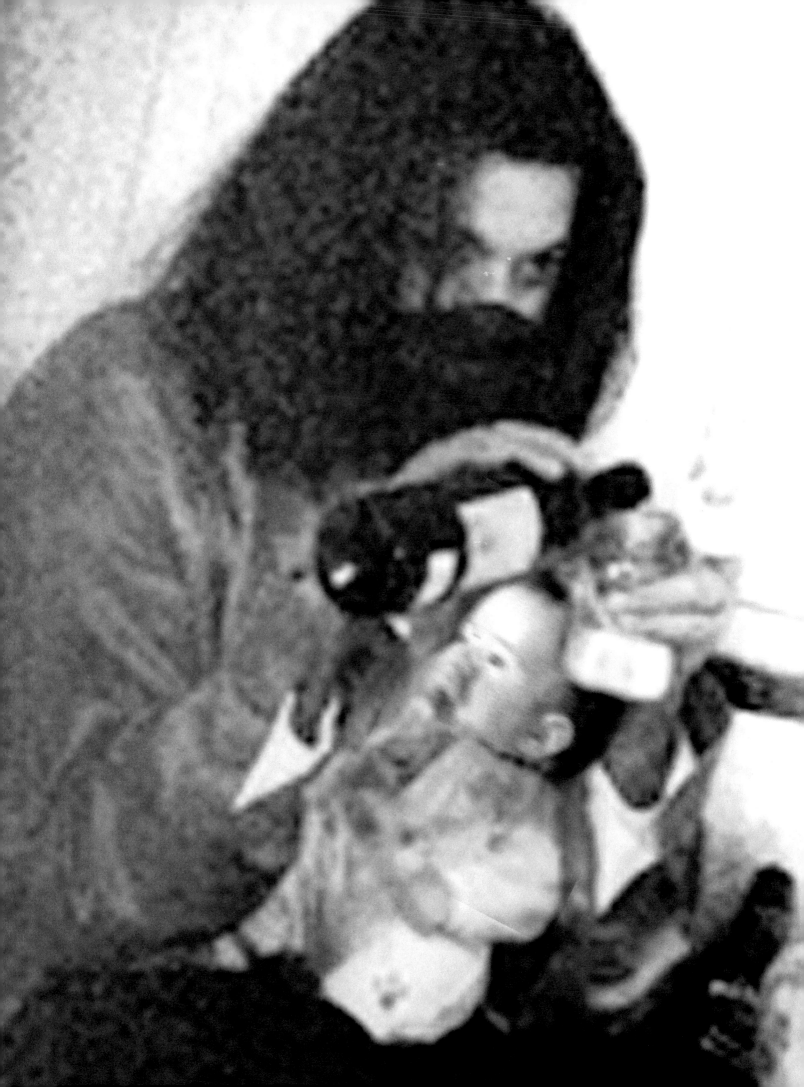

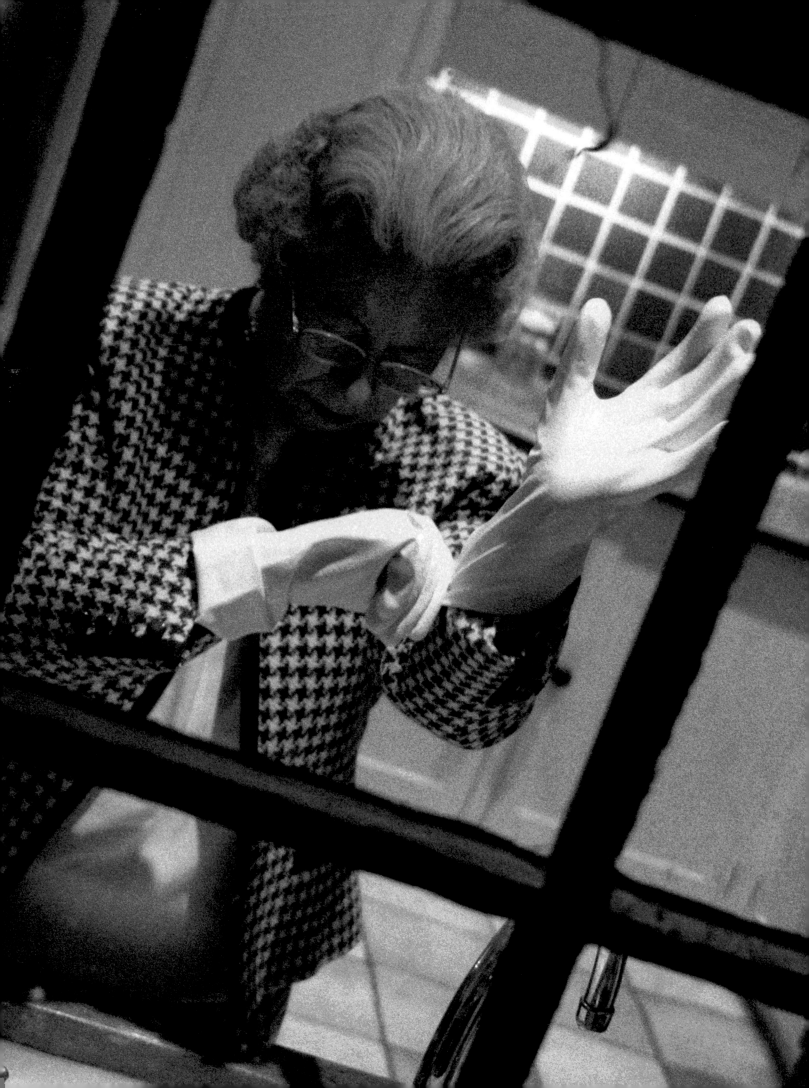

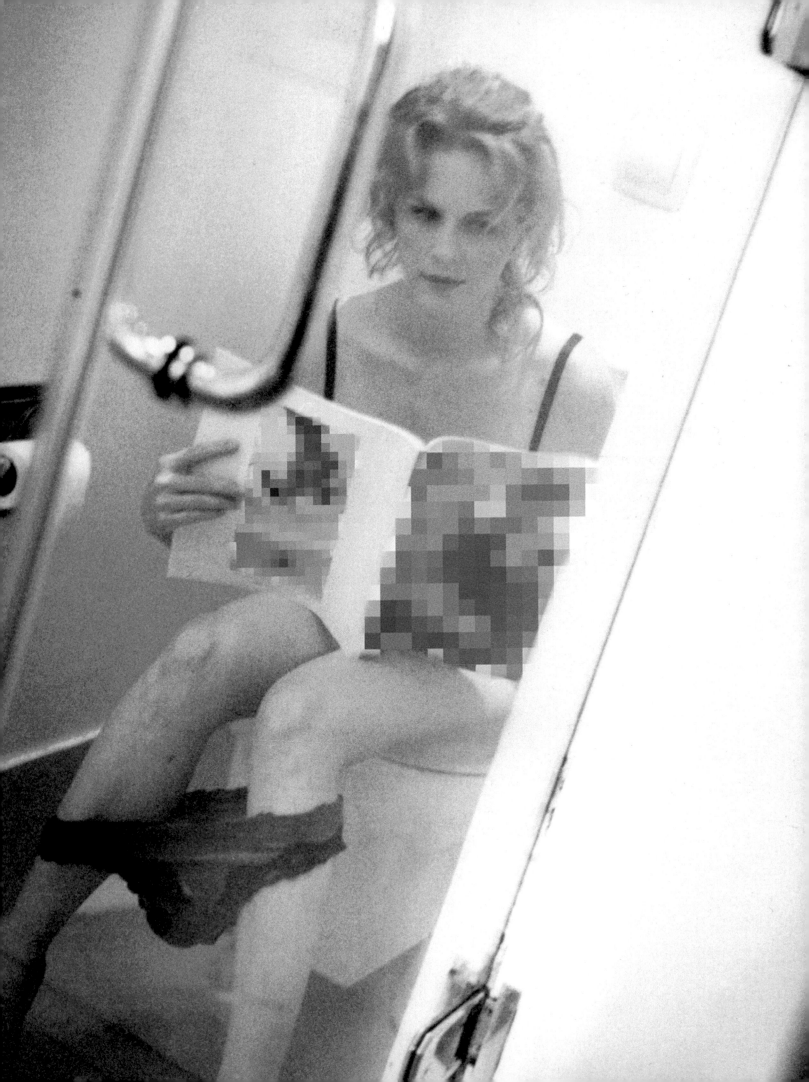

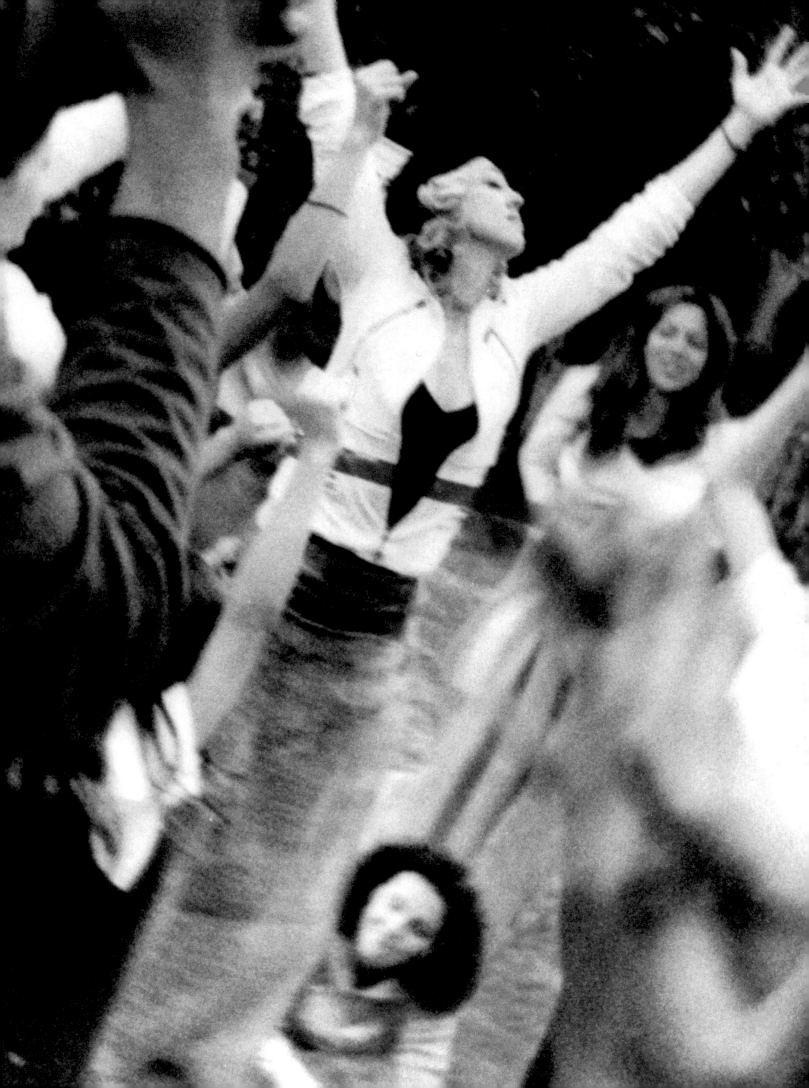

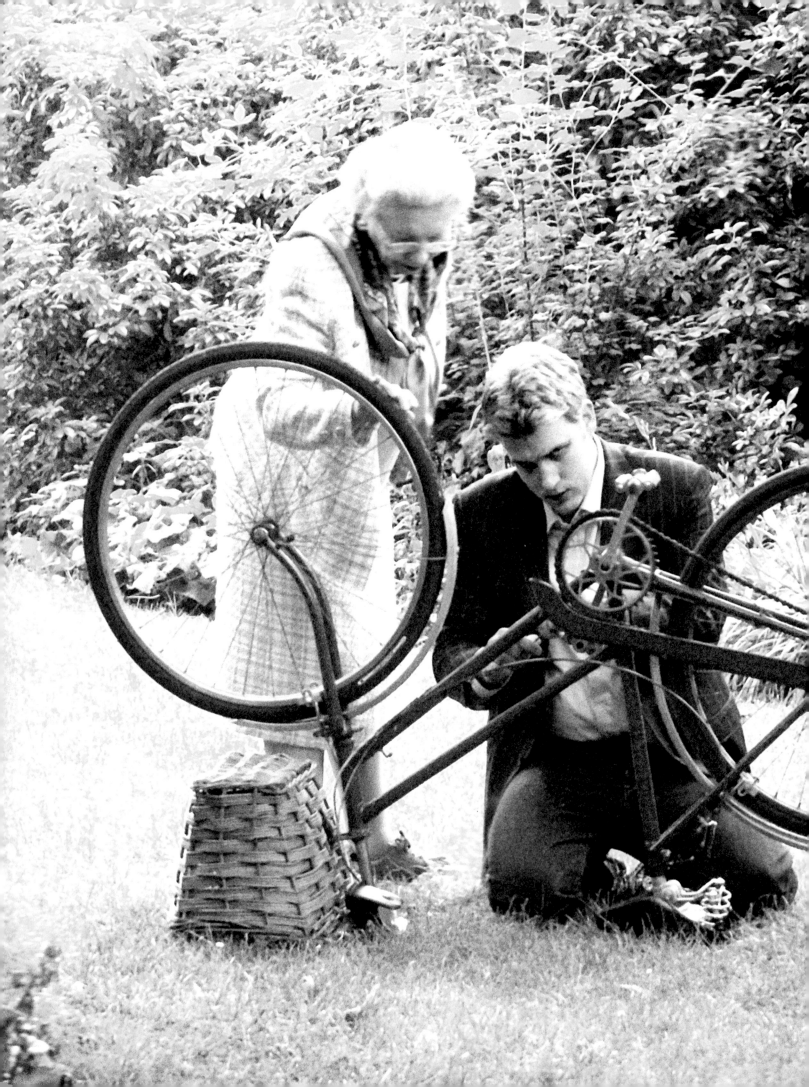

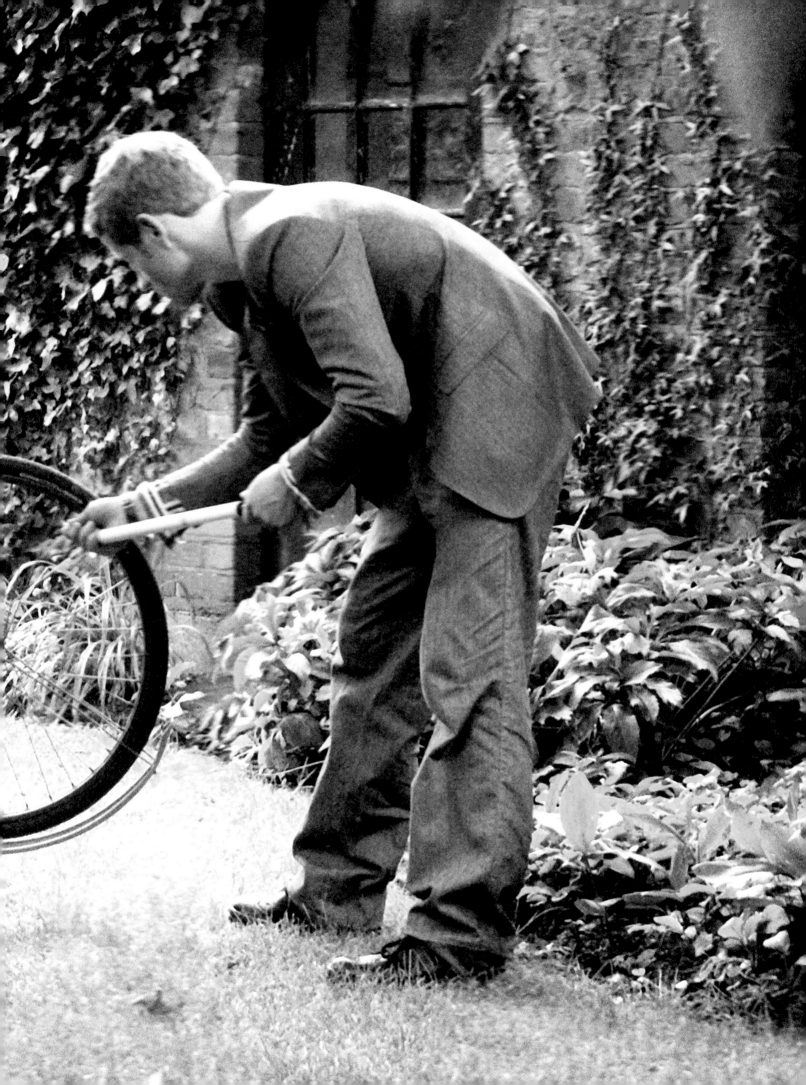

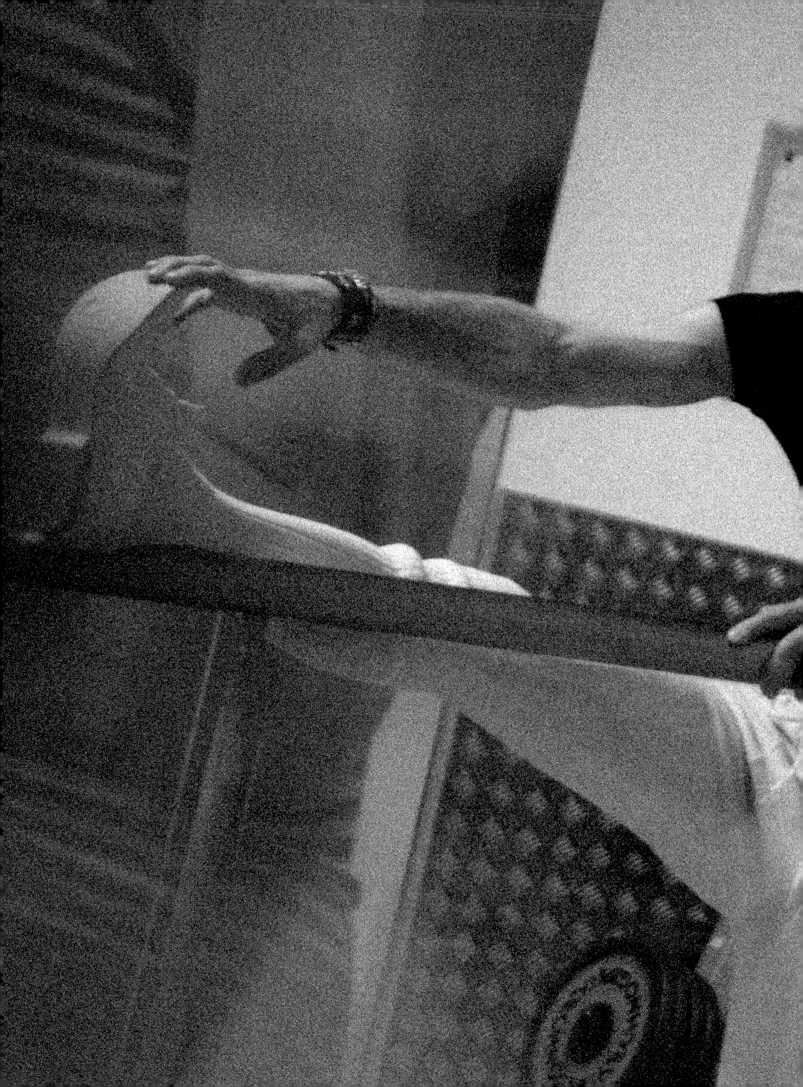

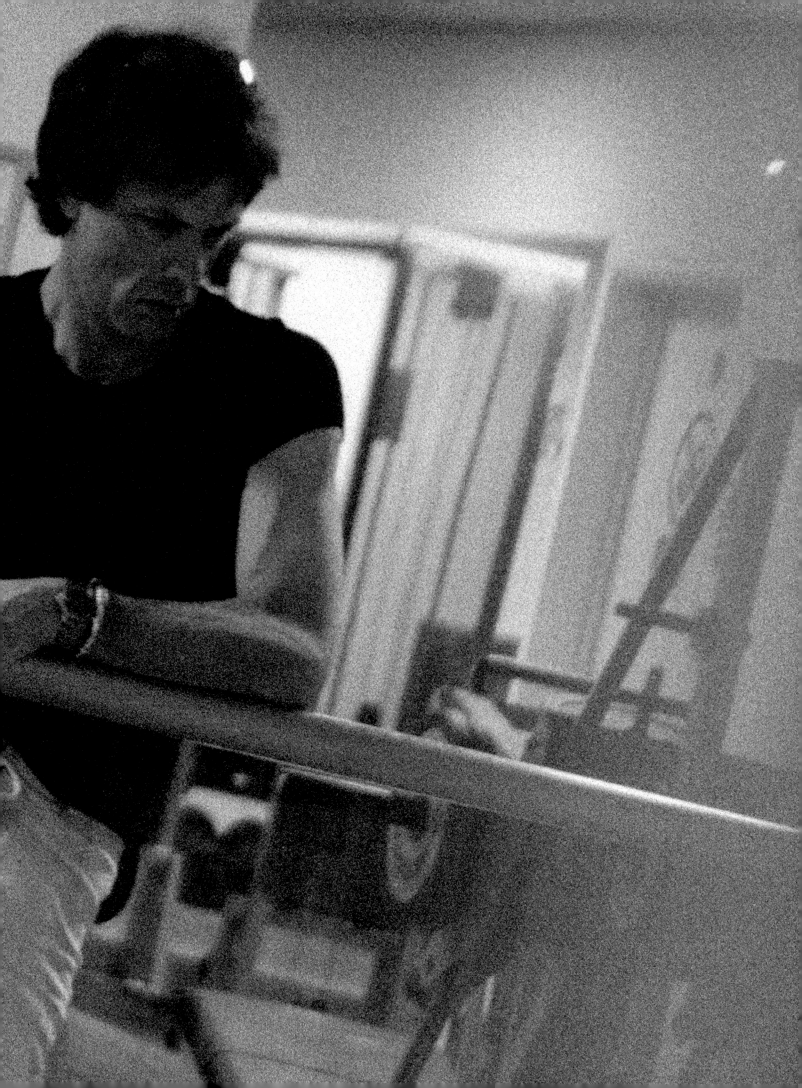

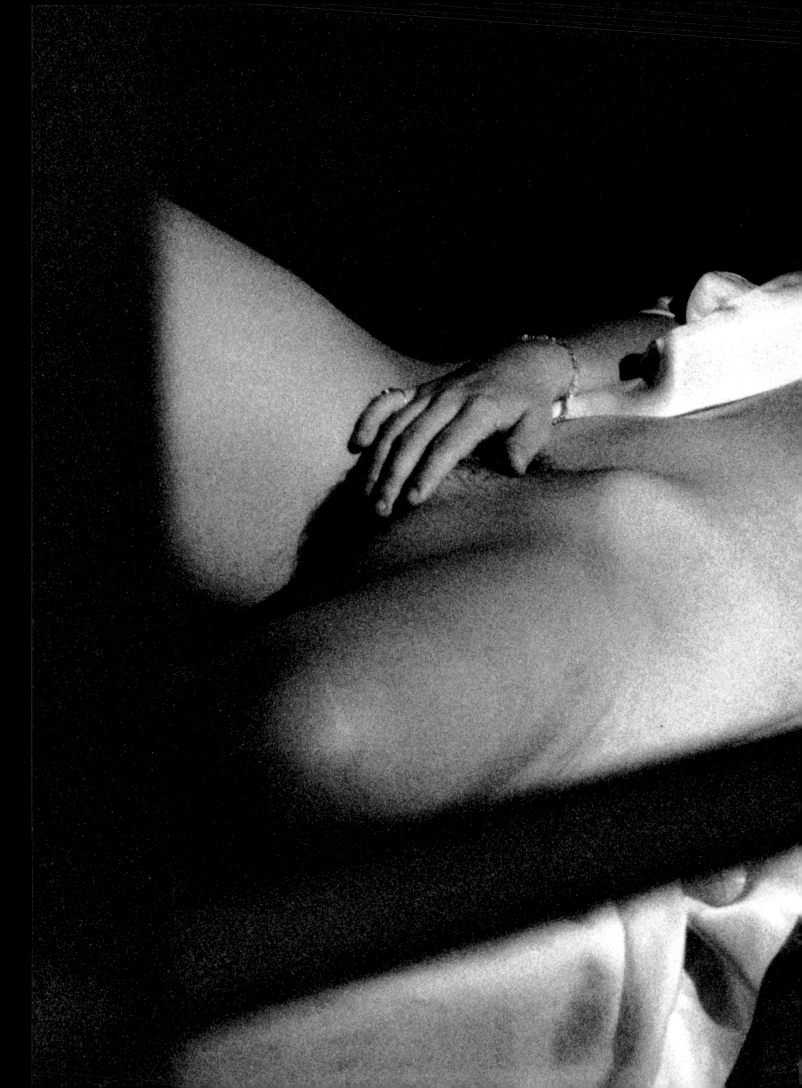

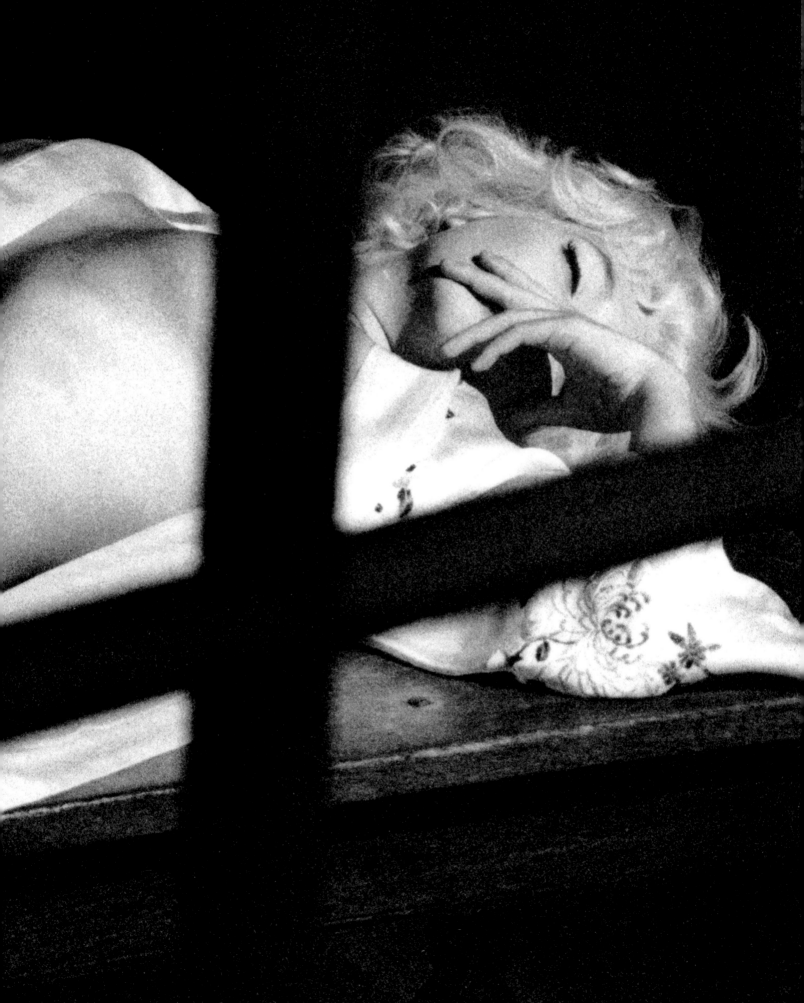

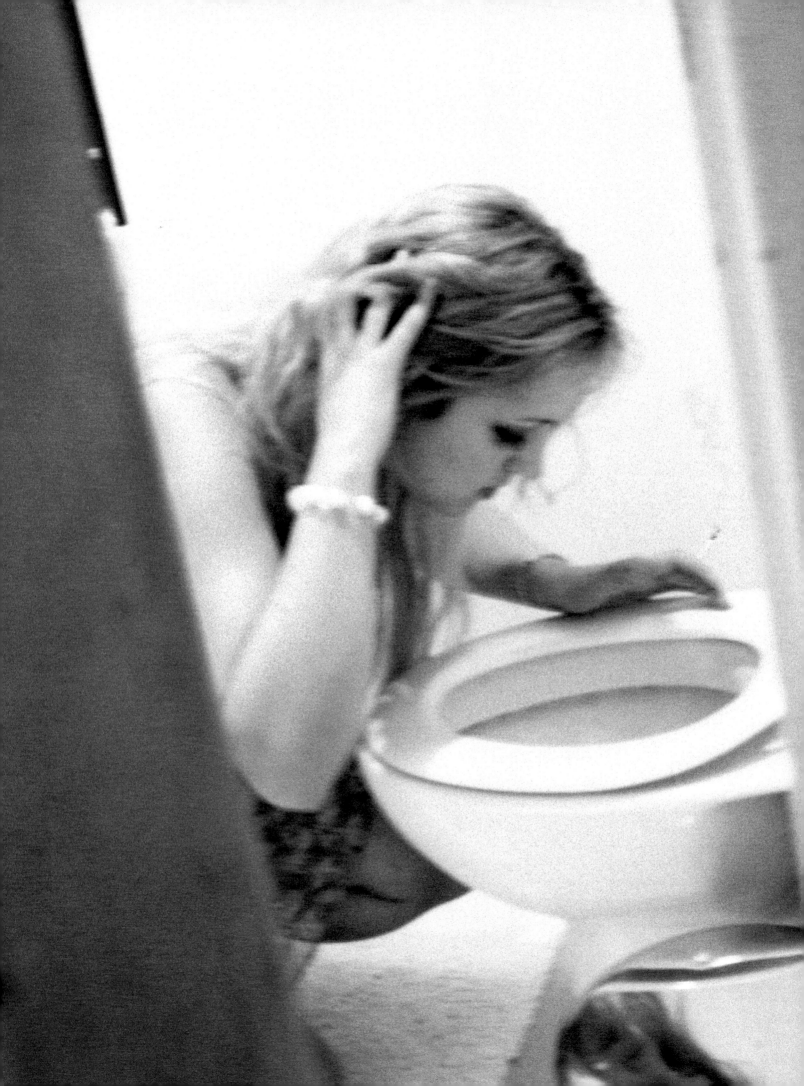

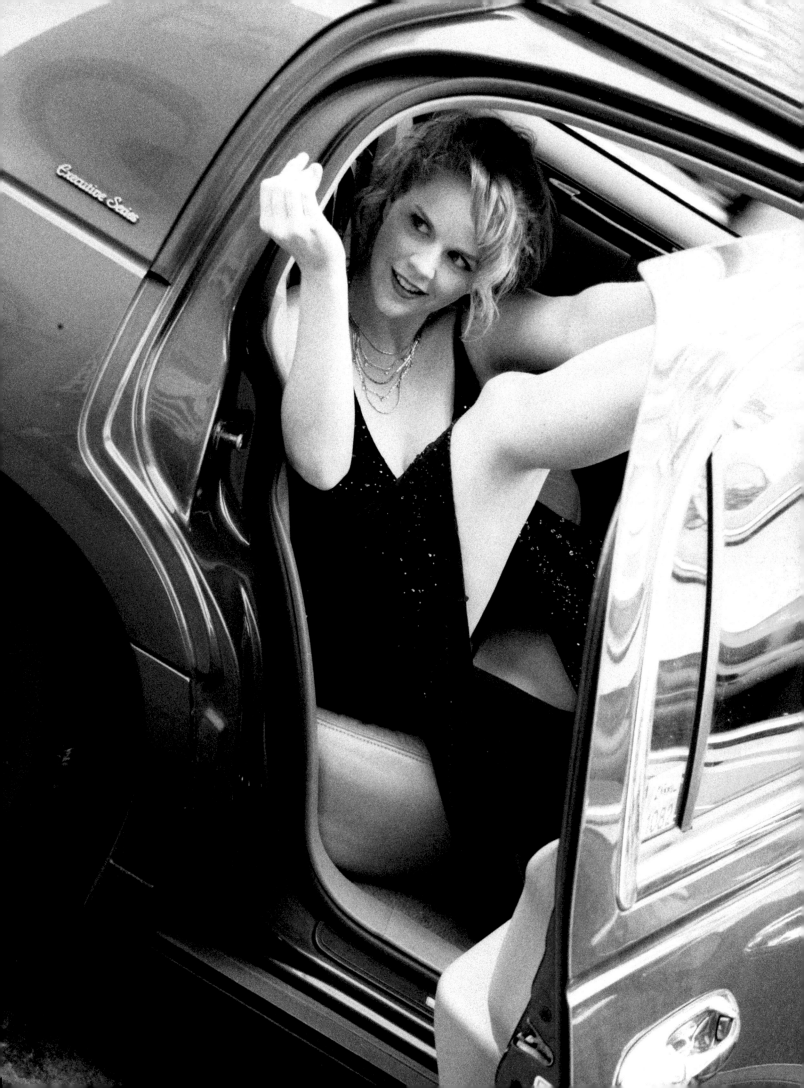

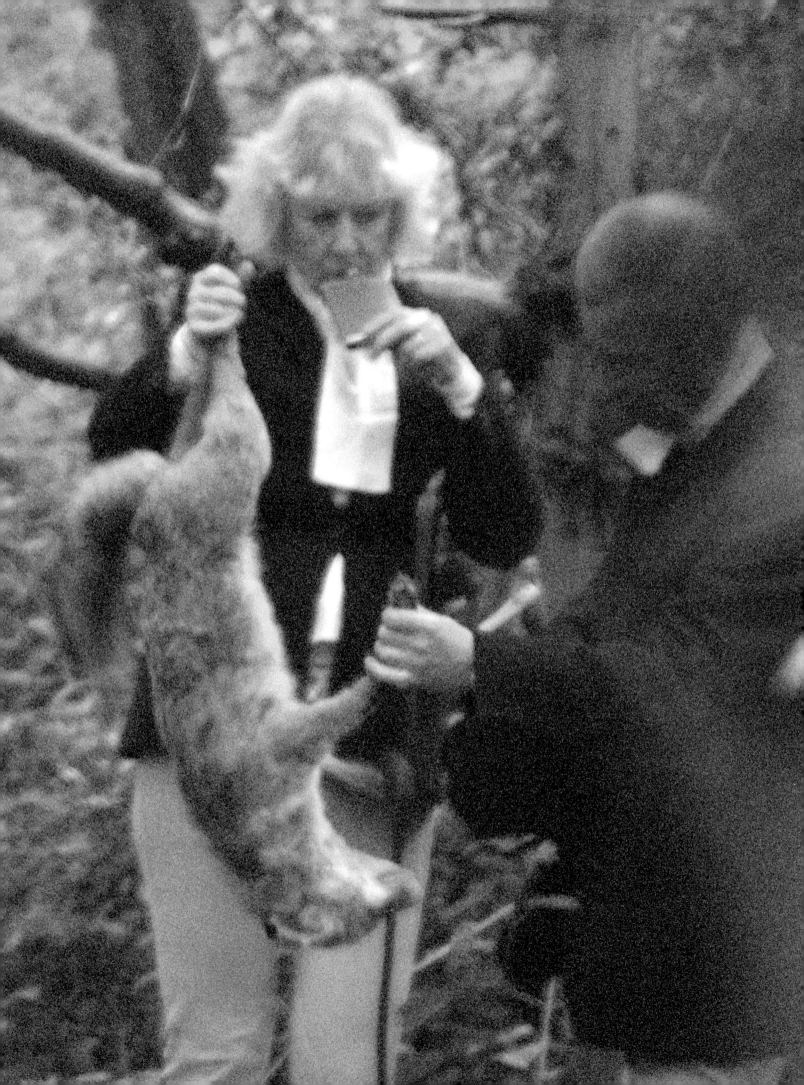

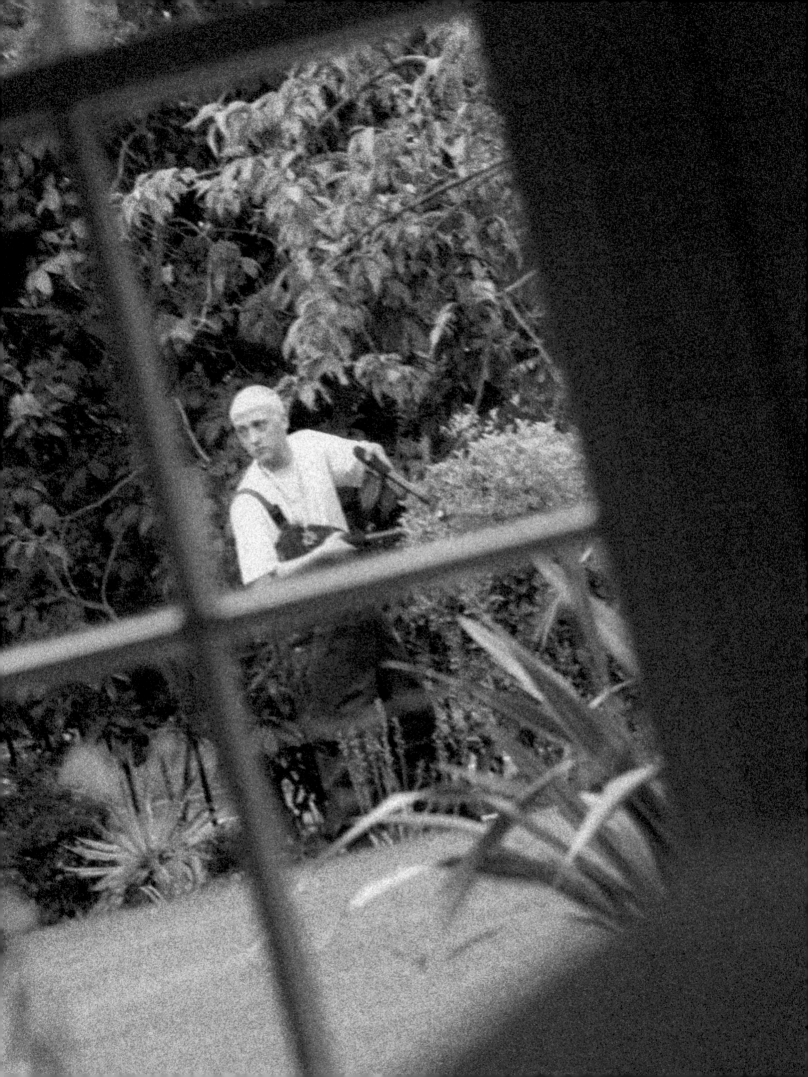

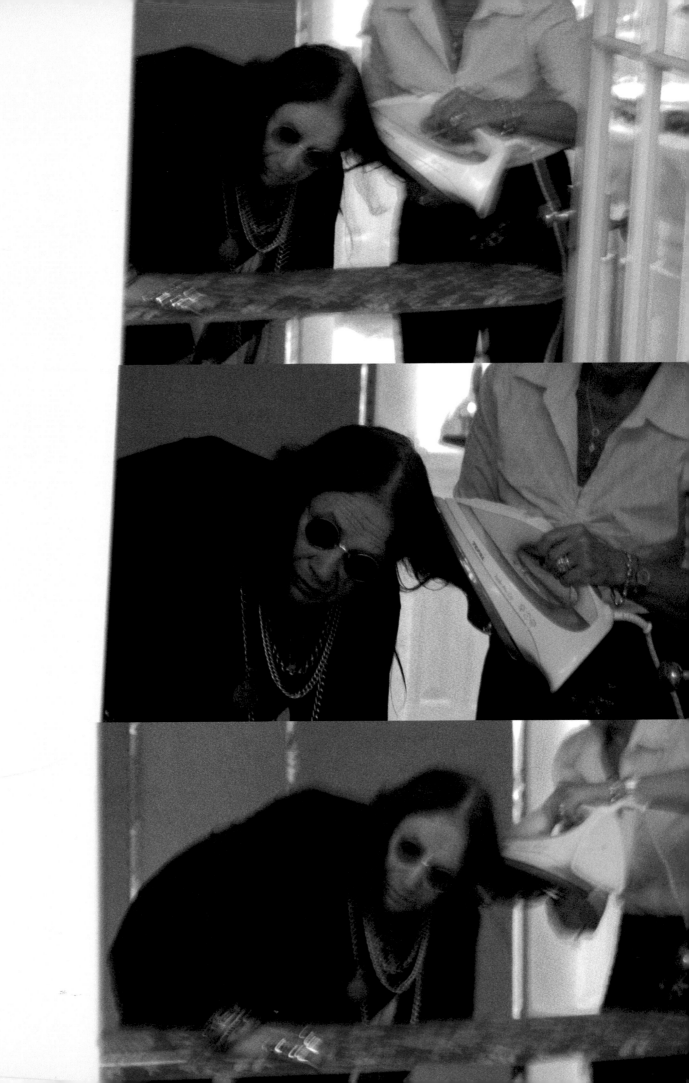

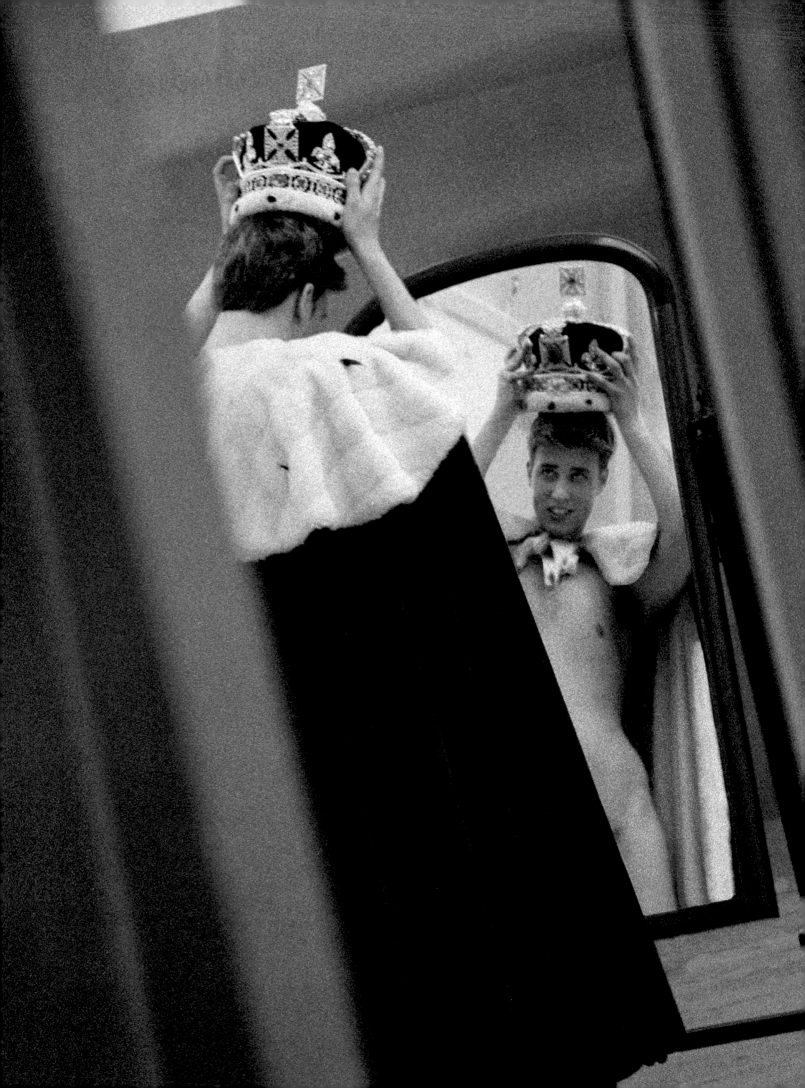

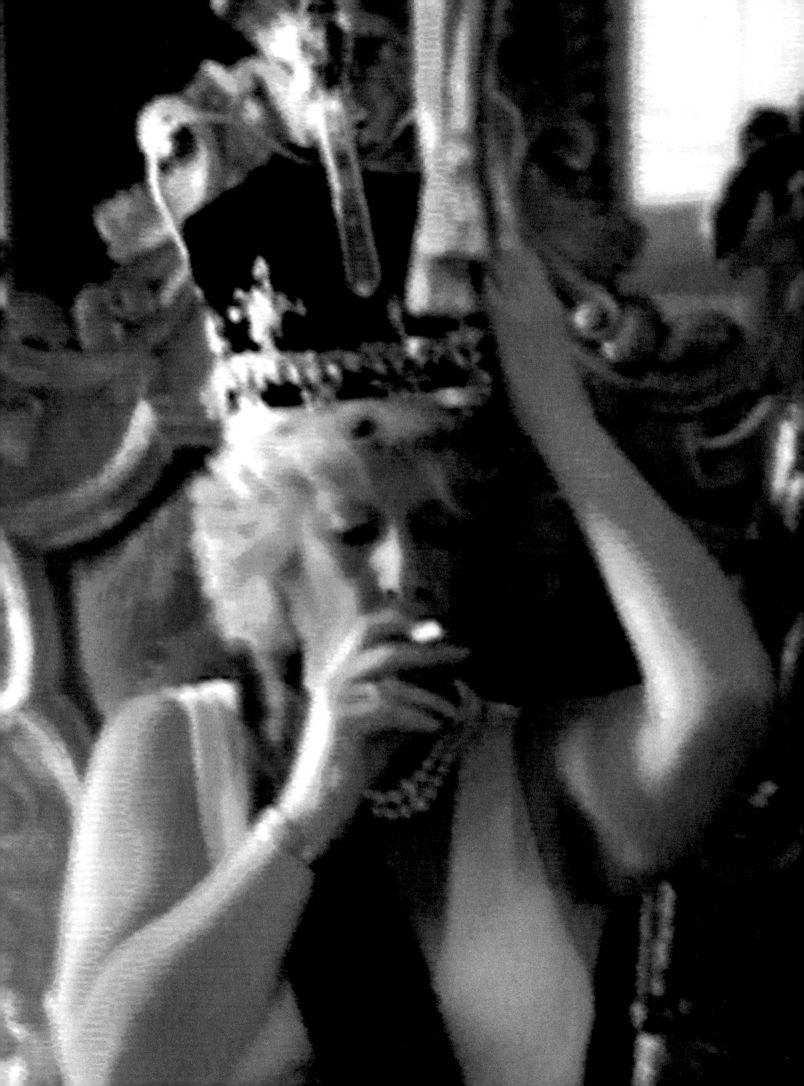

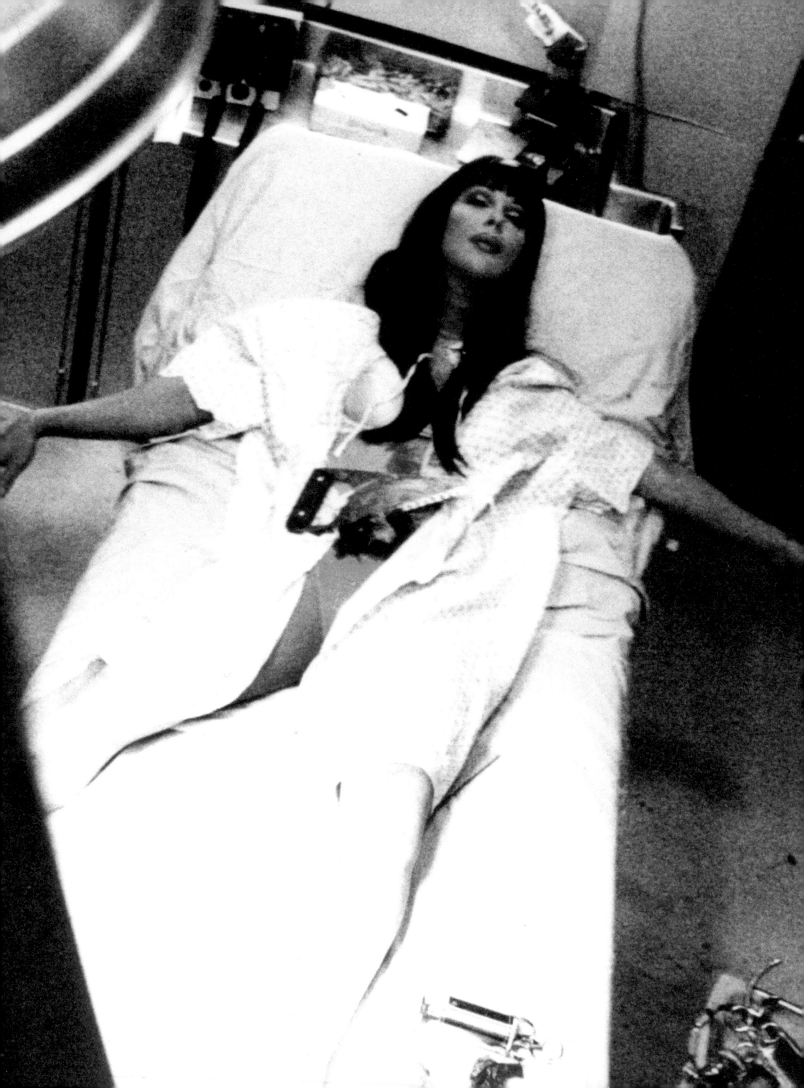

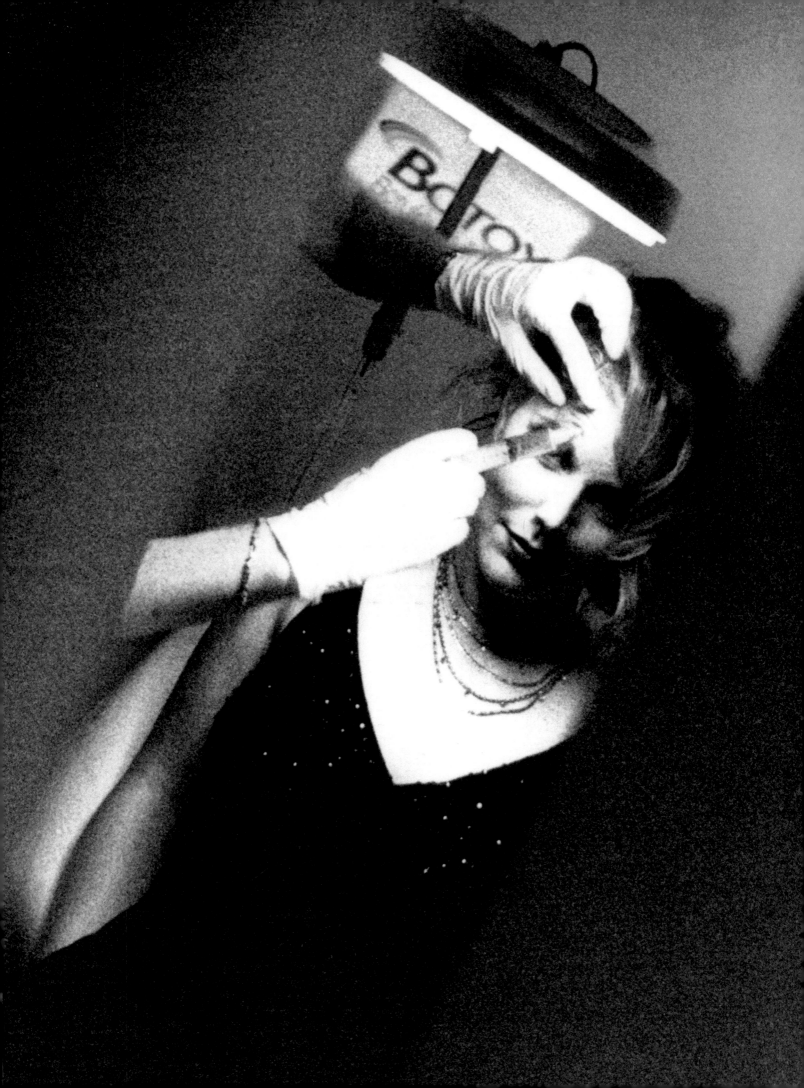

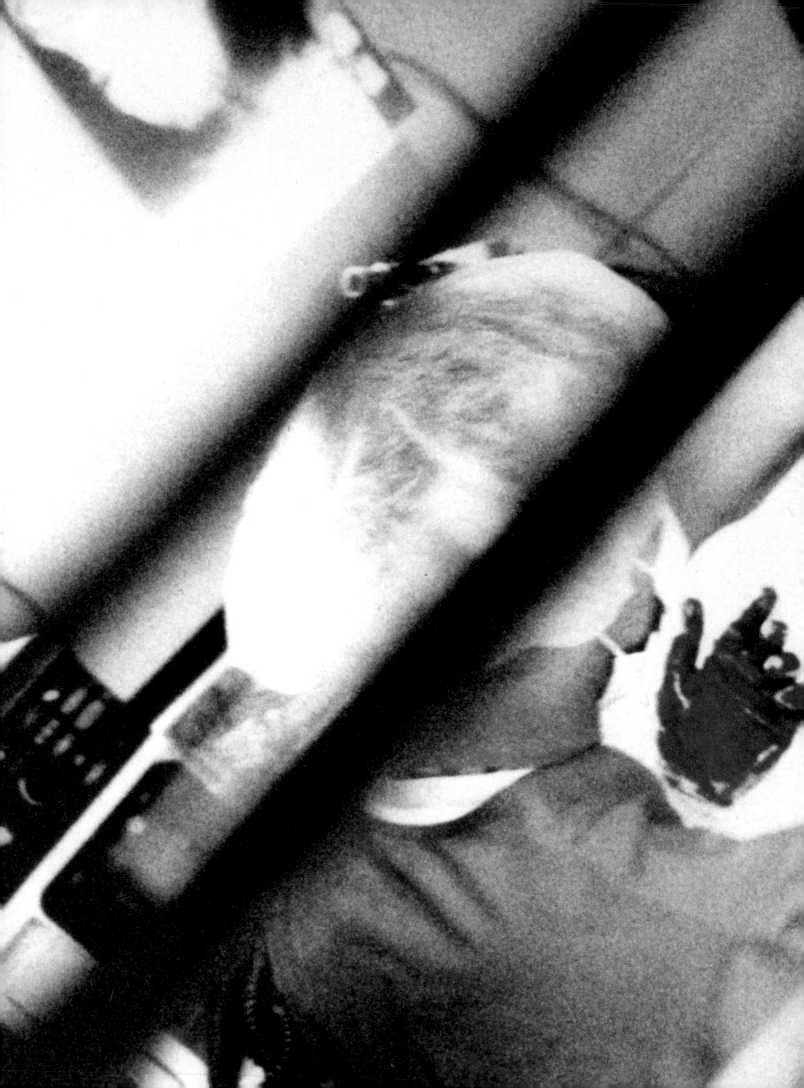

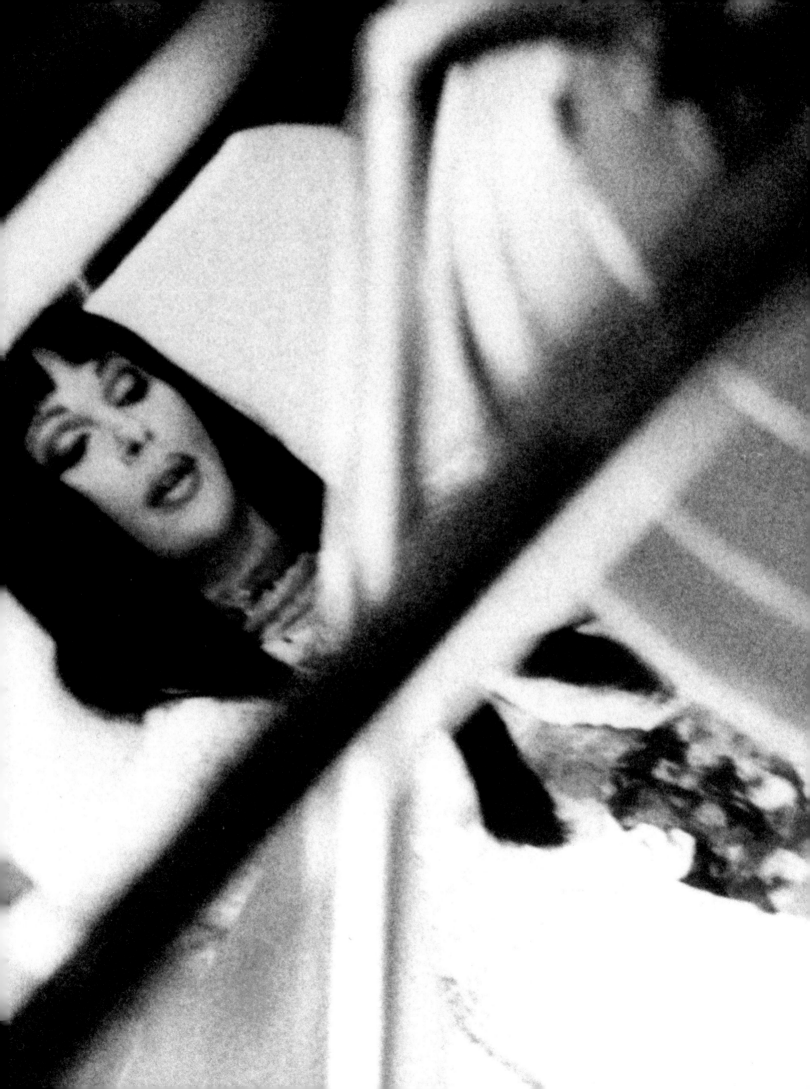

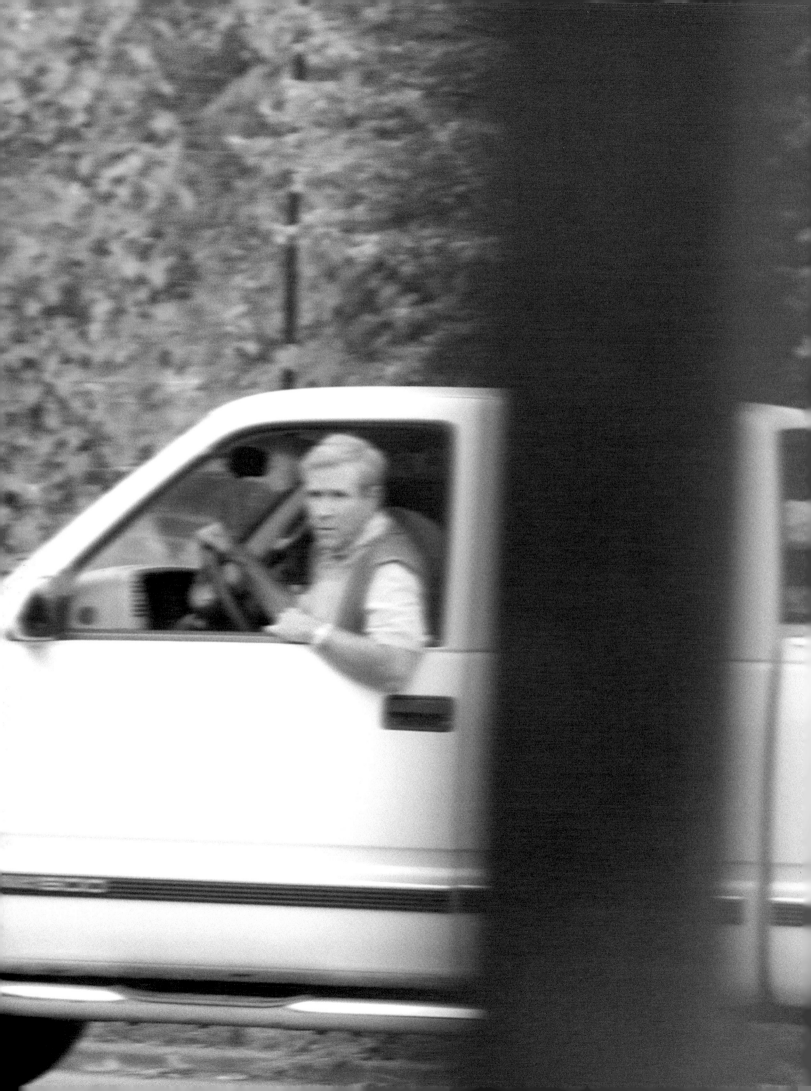

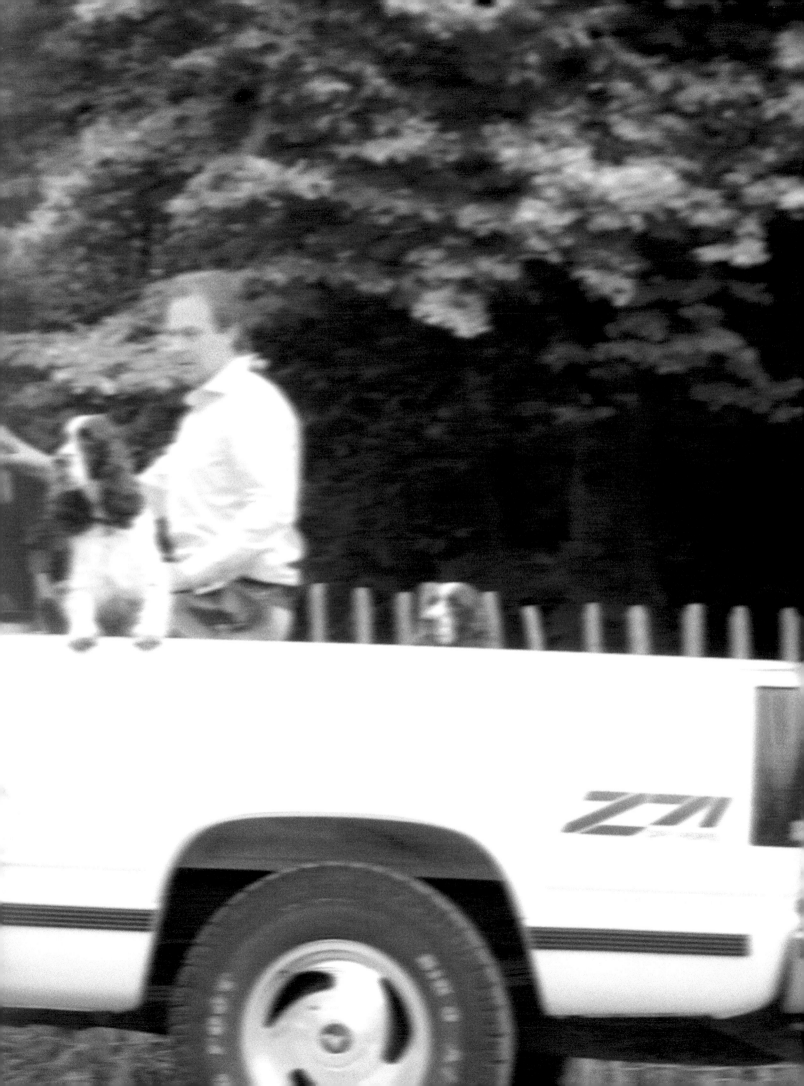

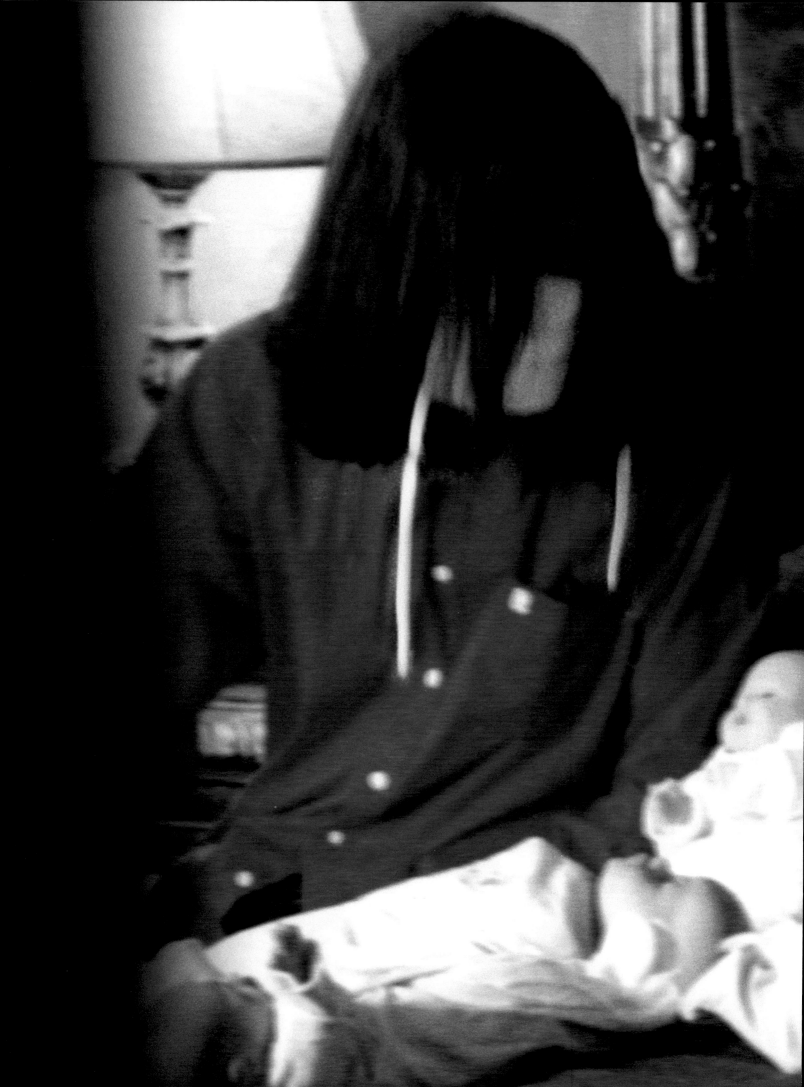

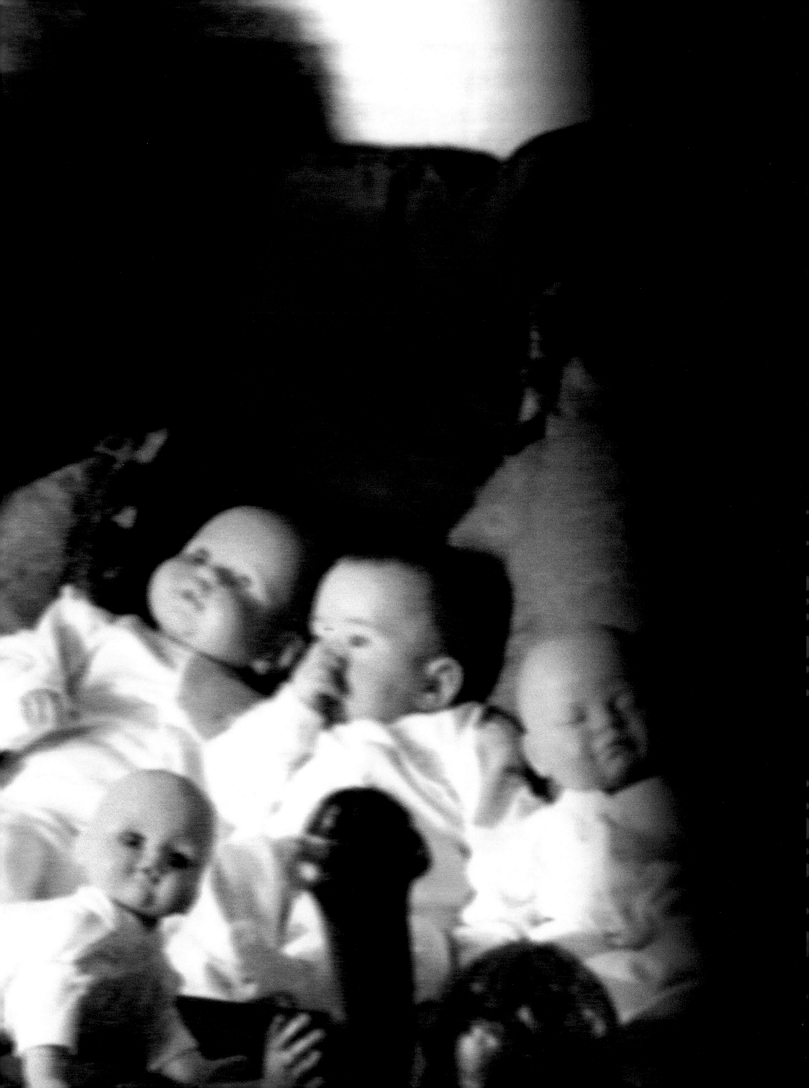

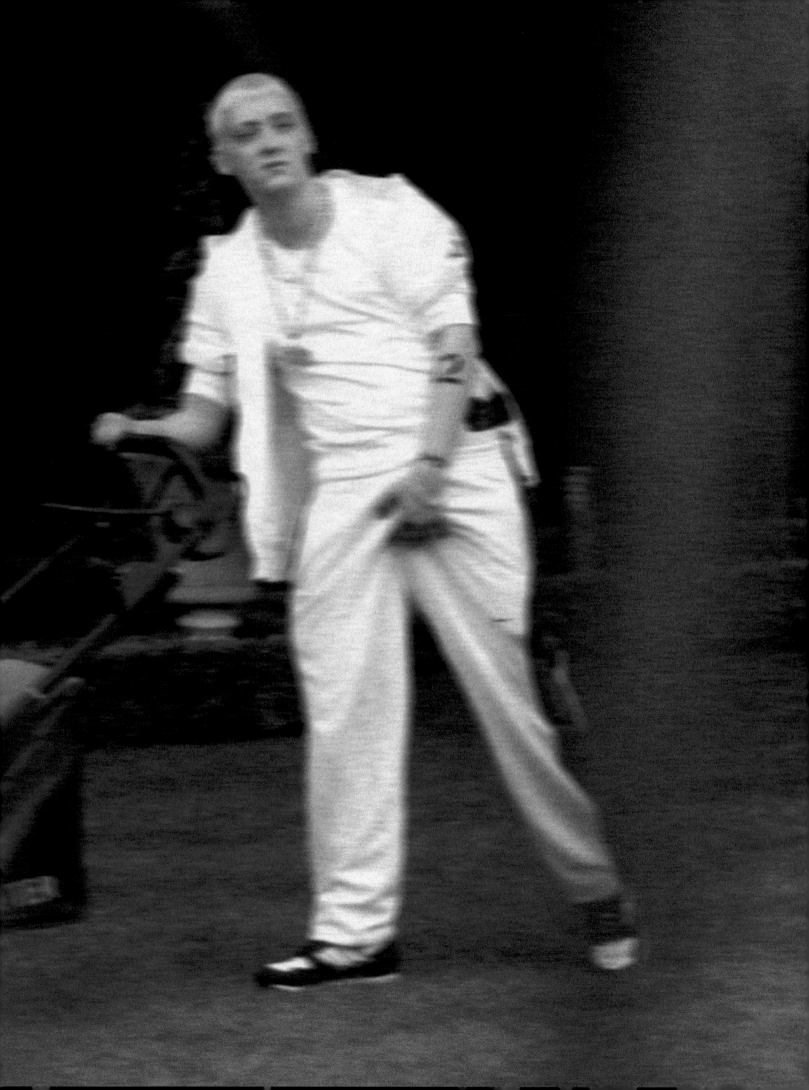

TMZ 25

31 31

KODAK 25A

P3200

31 31A

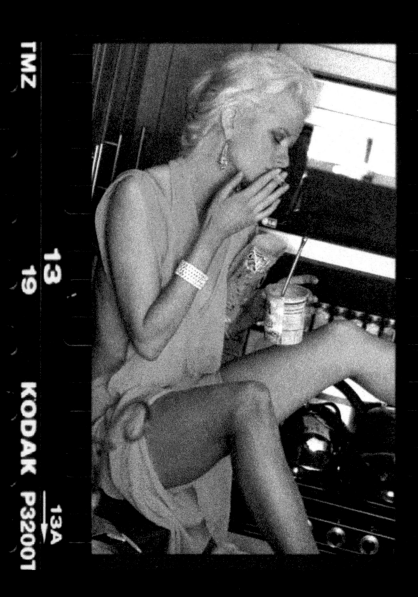

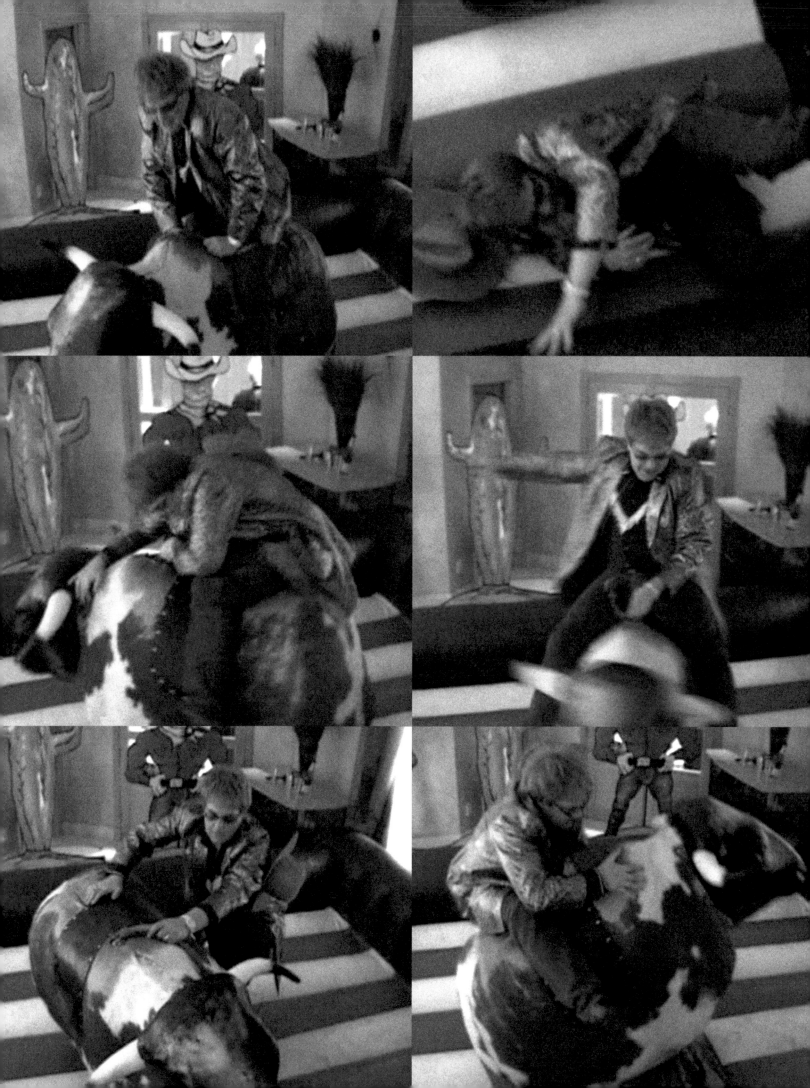

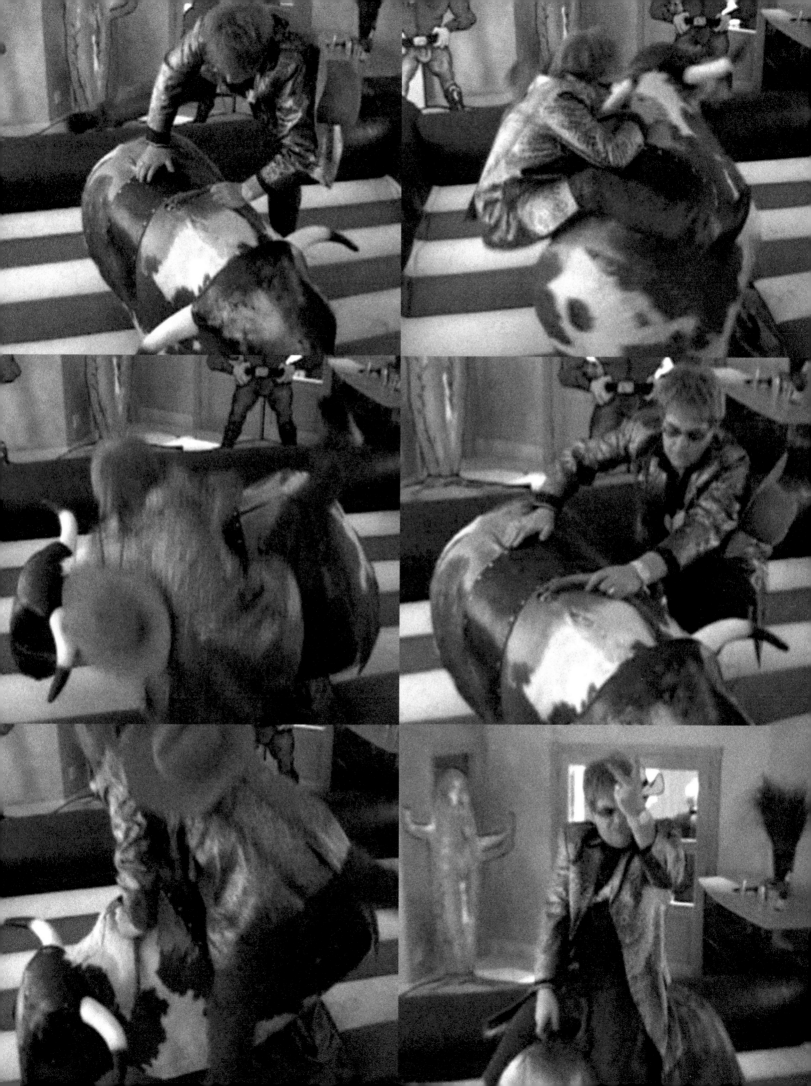

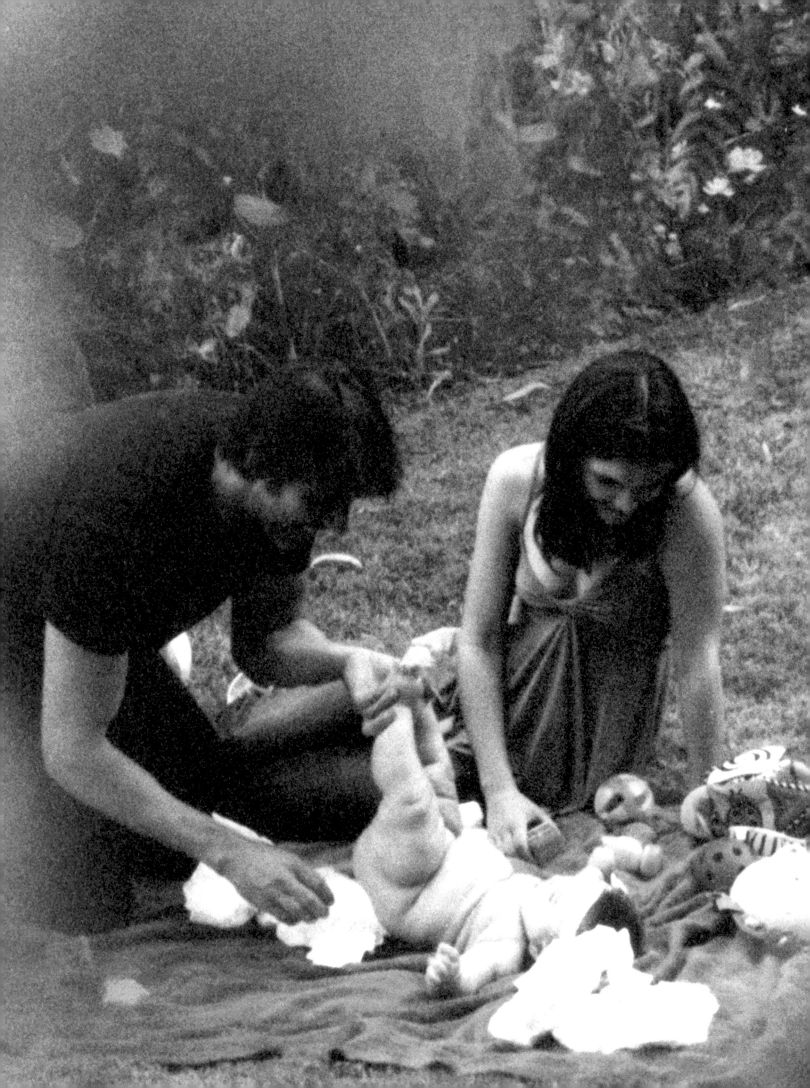

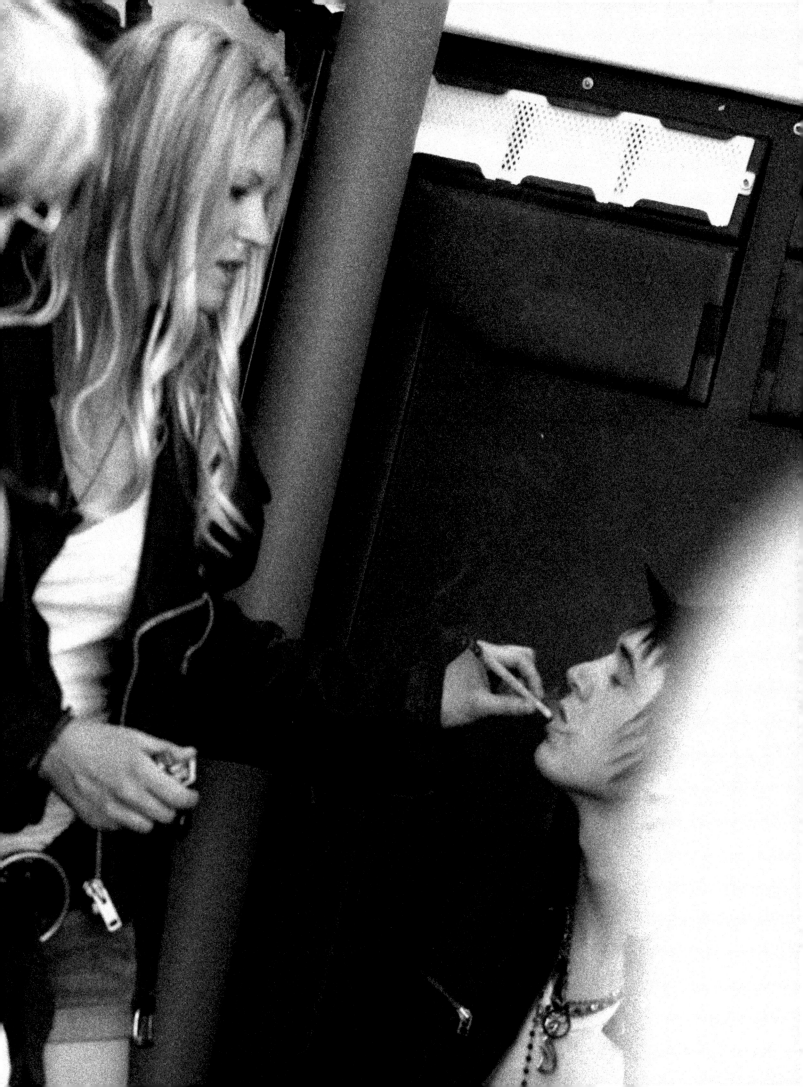

COLLAGEN
FILLERS

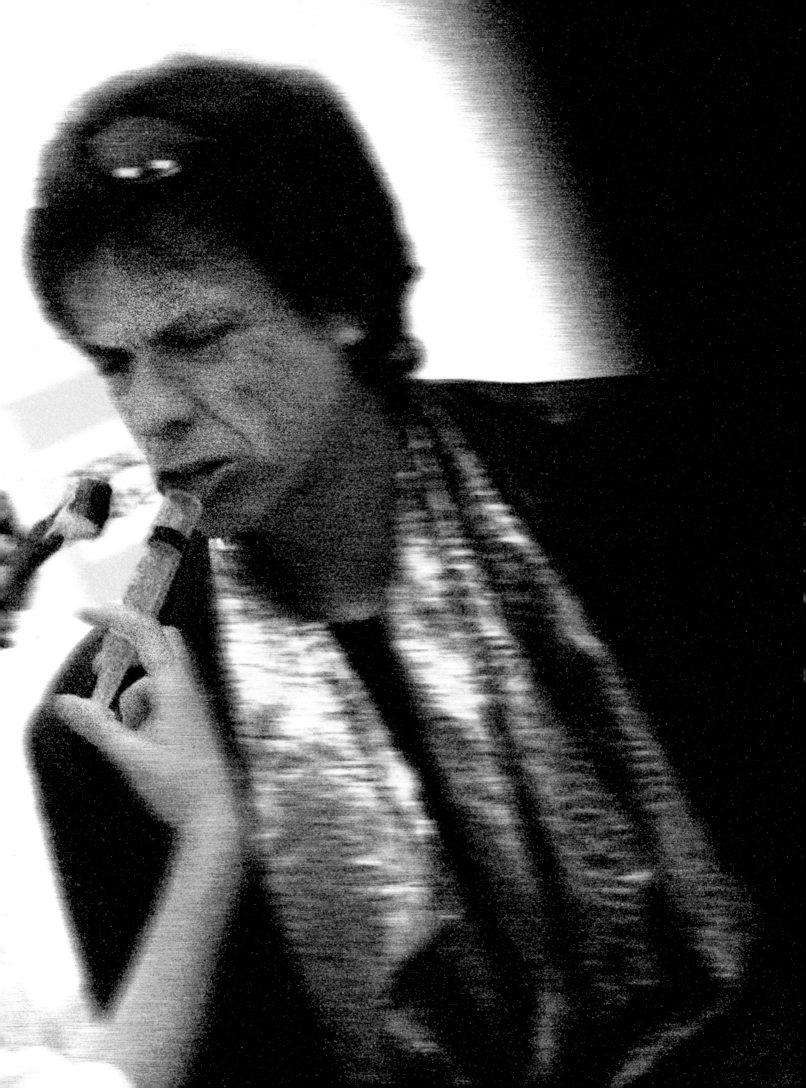

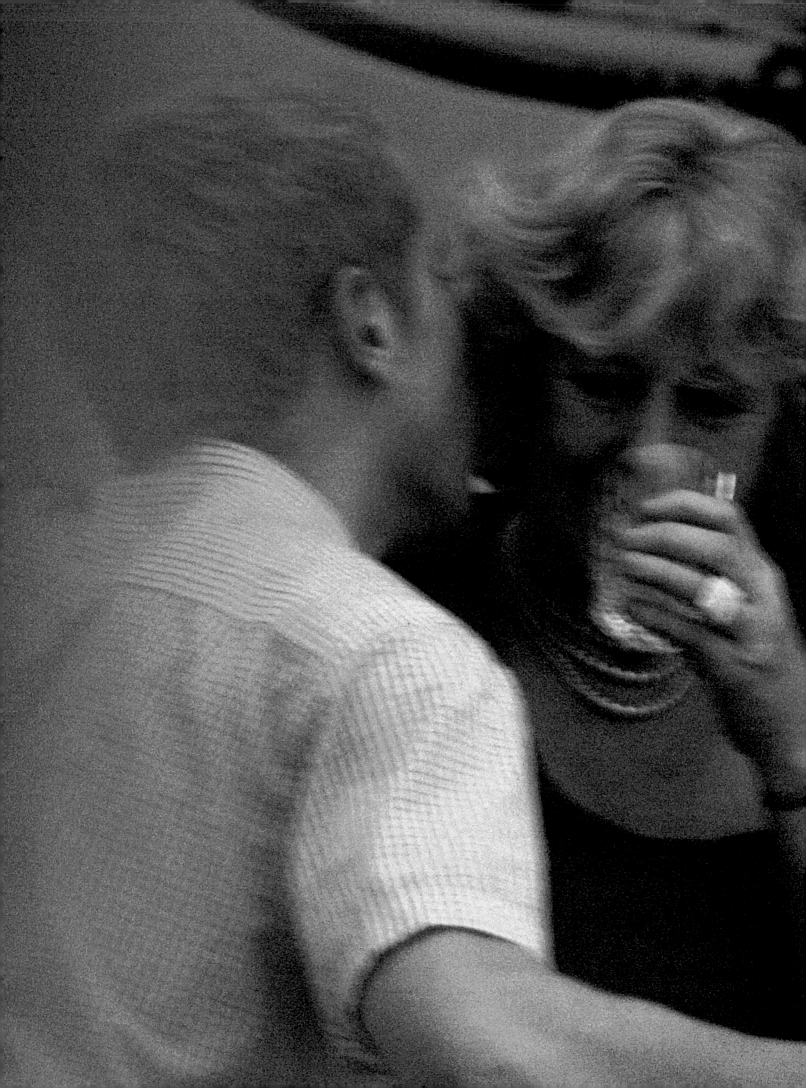

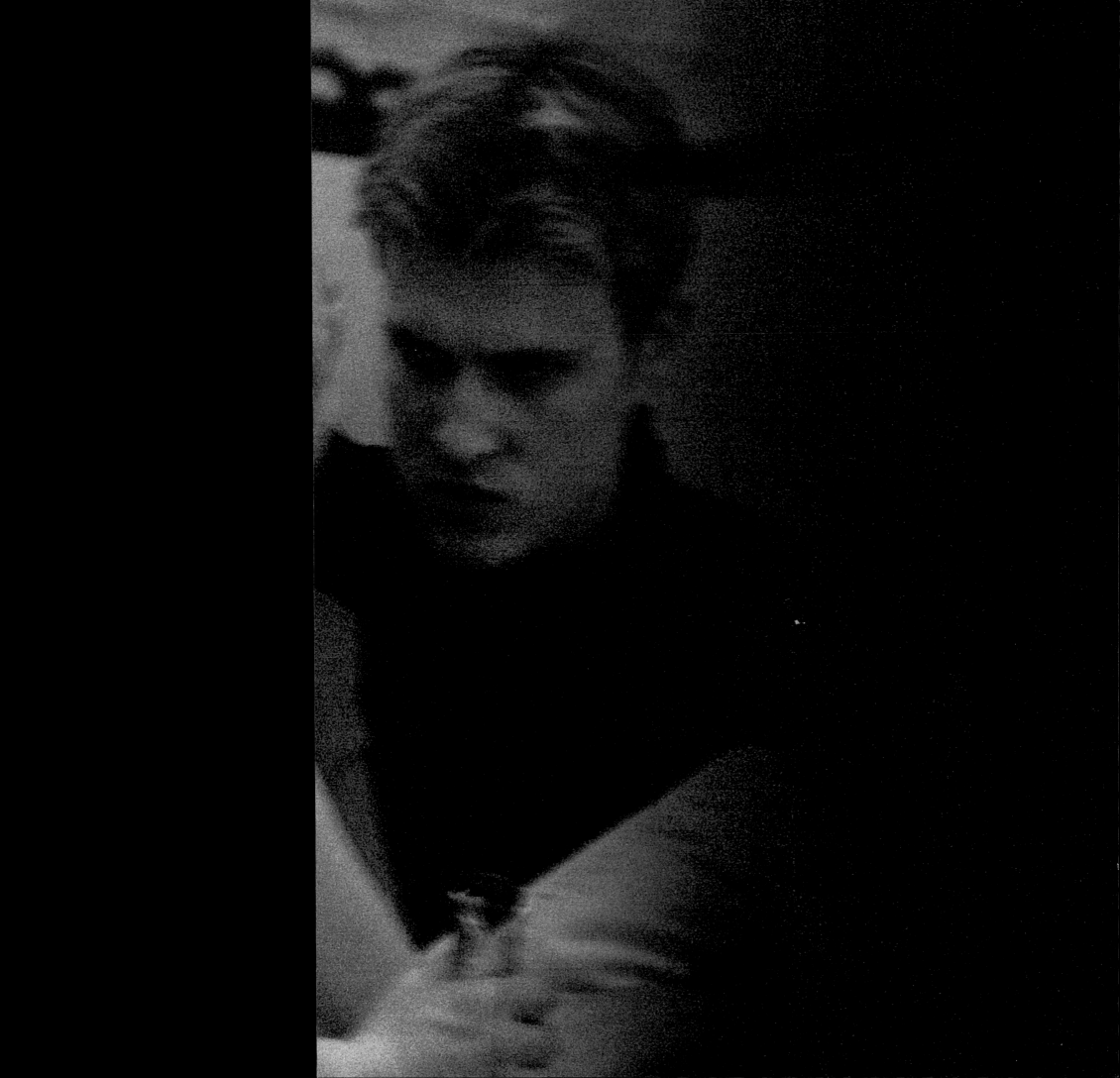

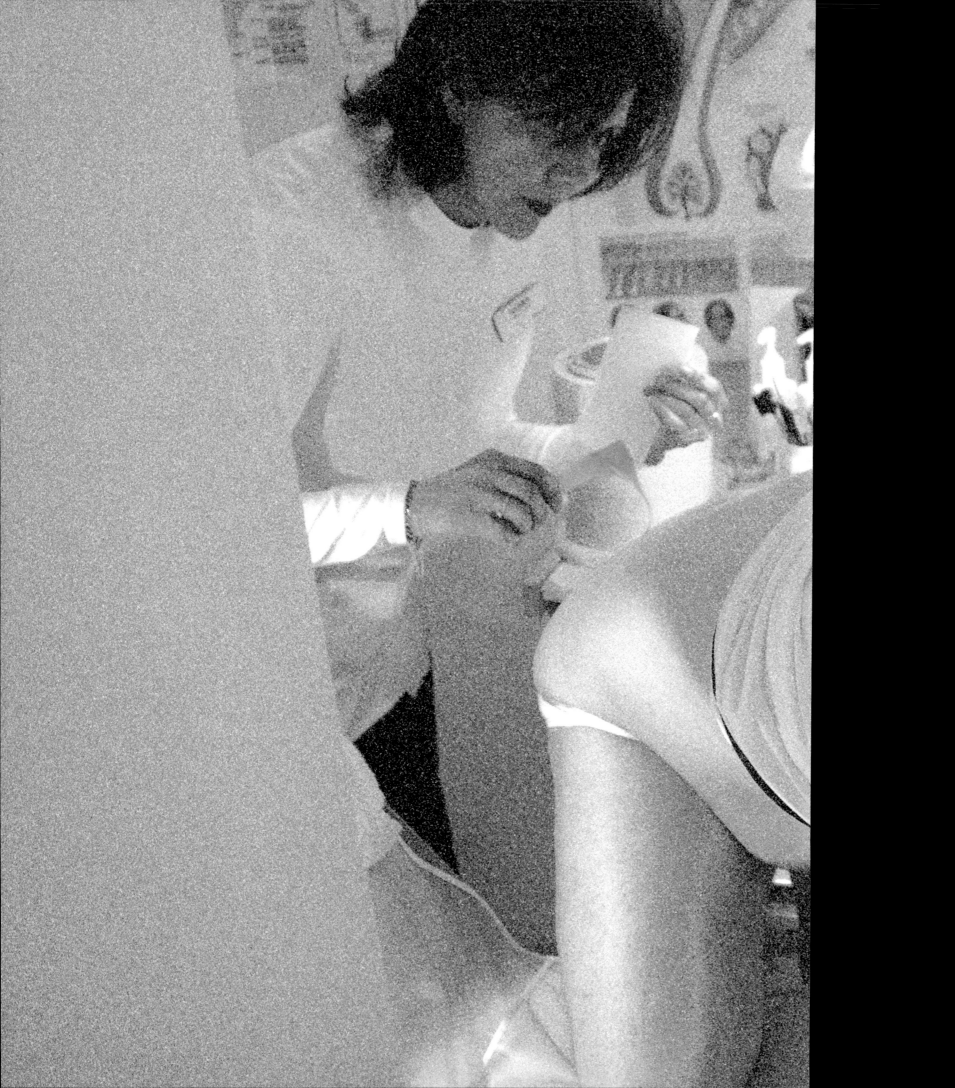

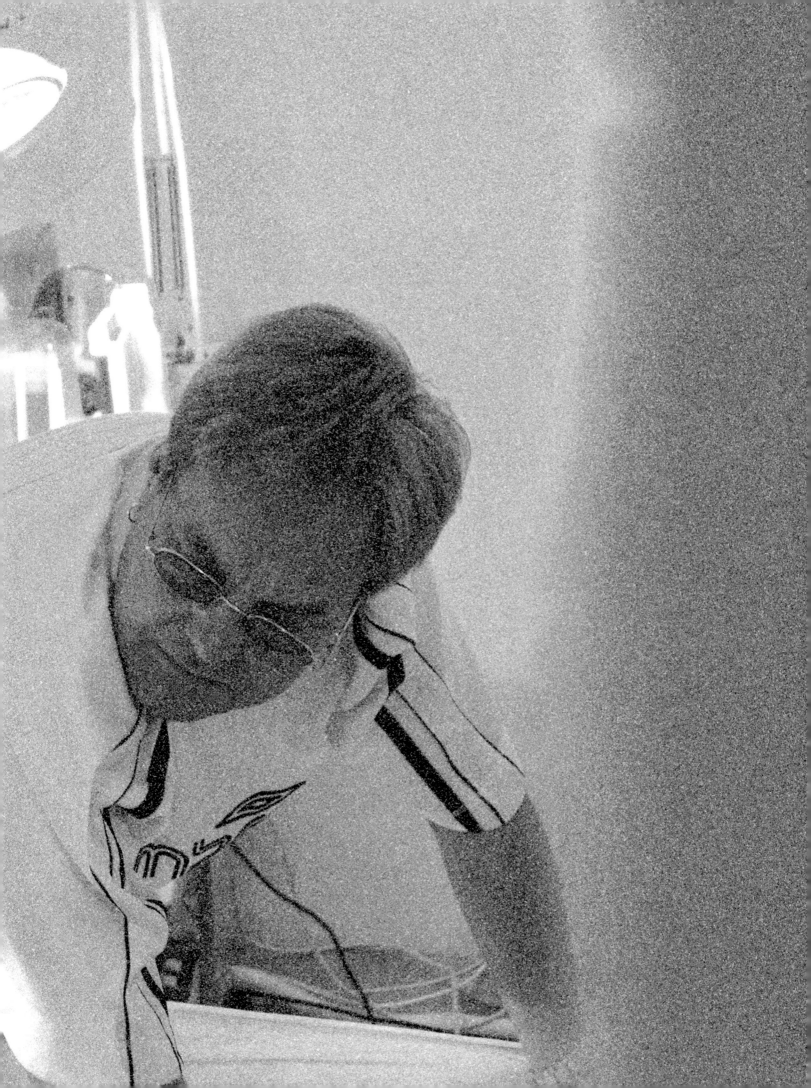

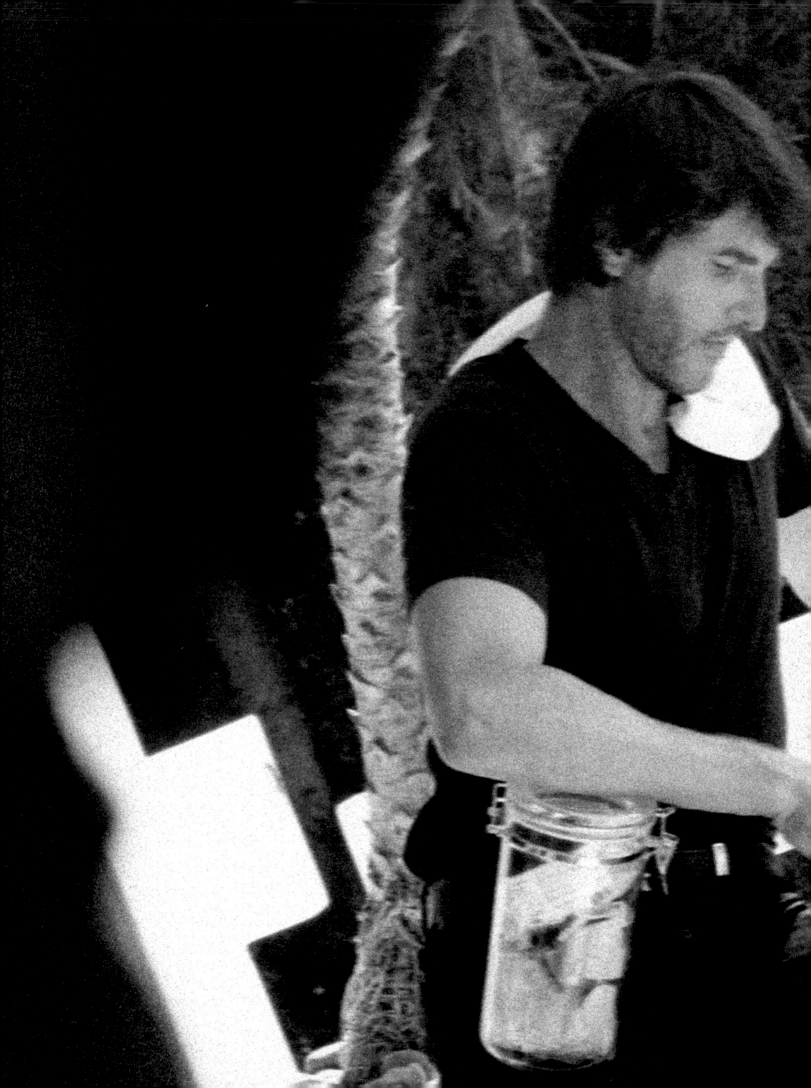

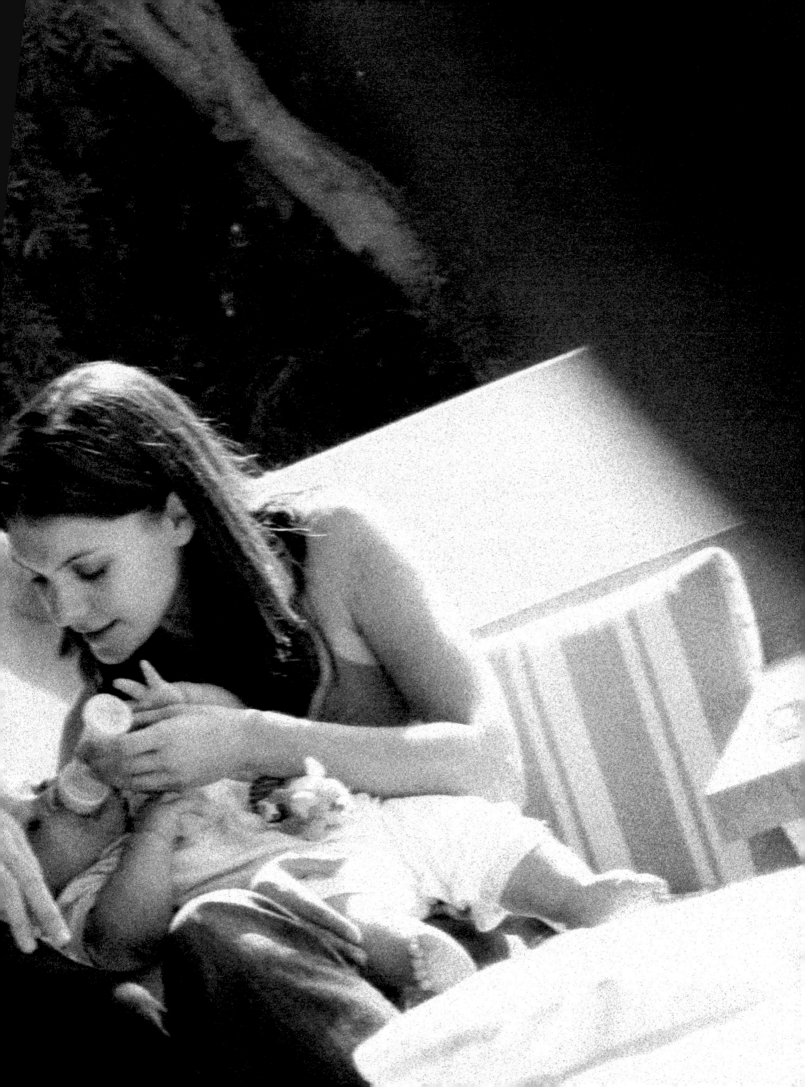

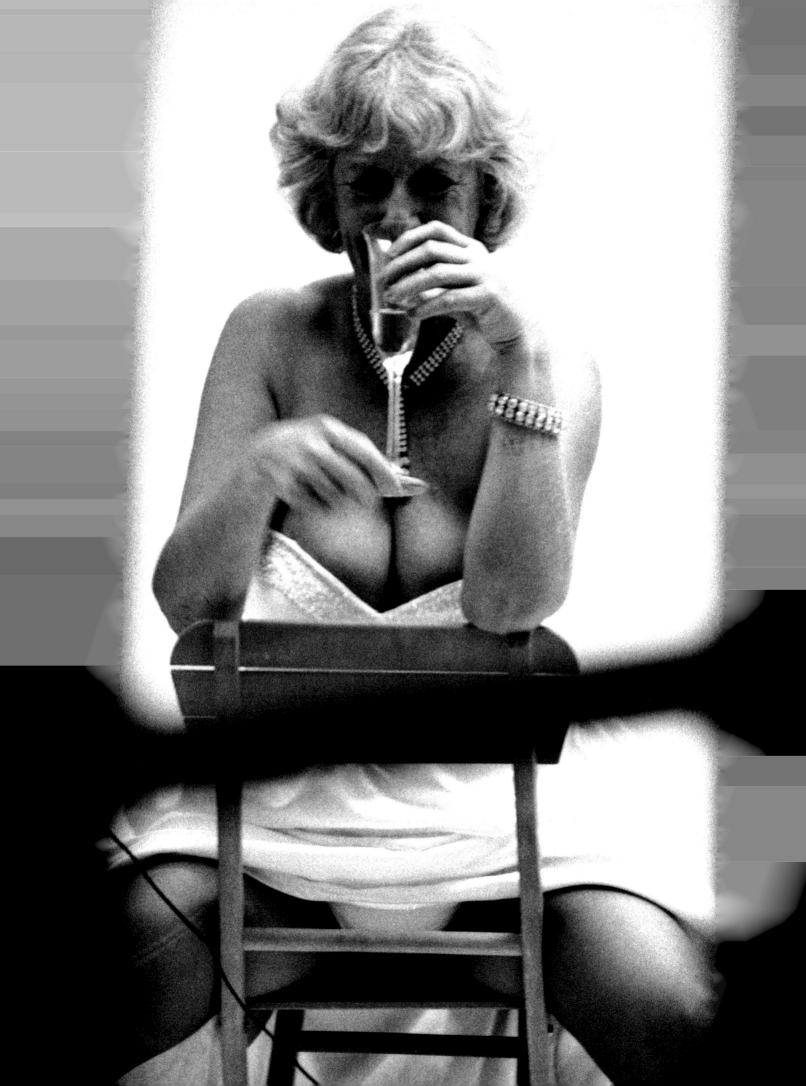

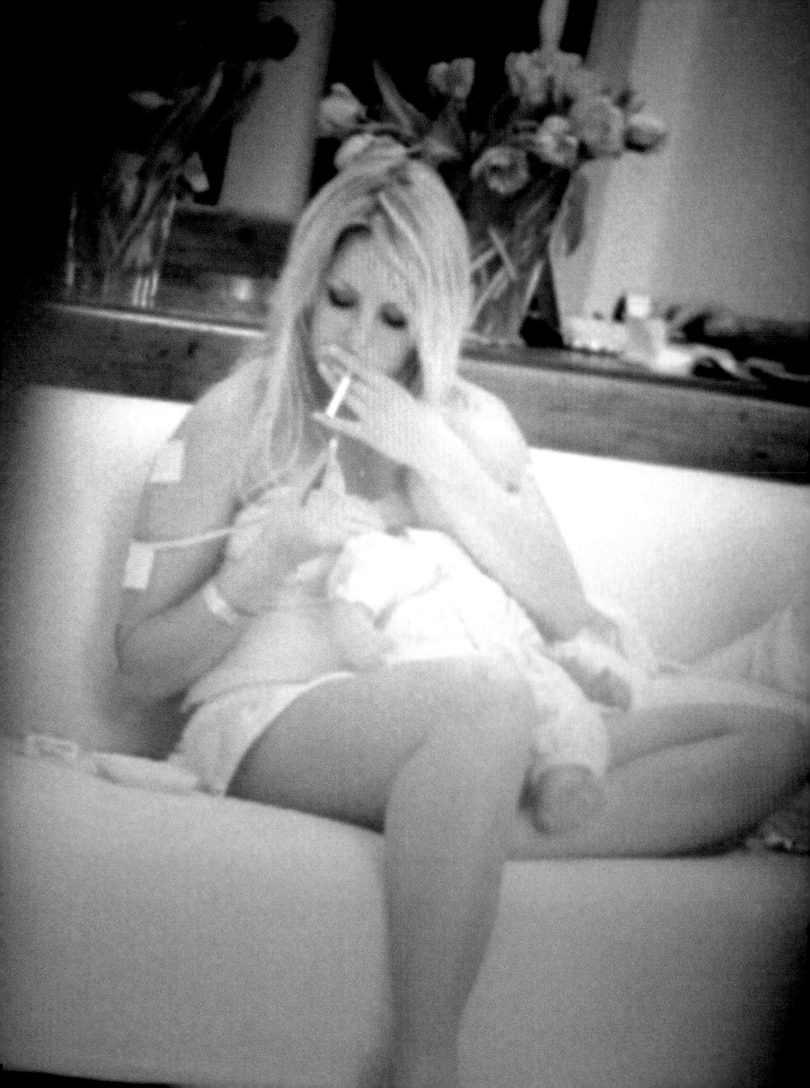

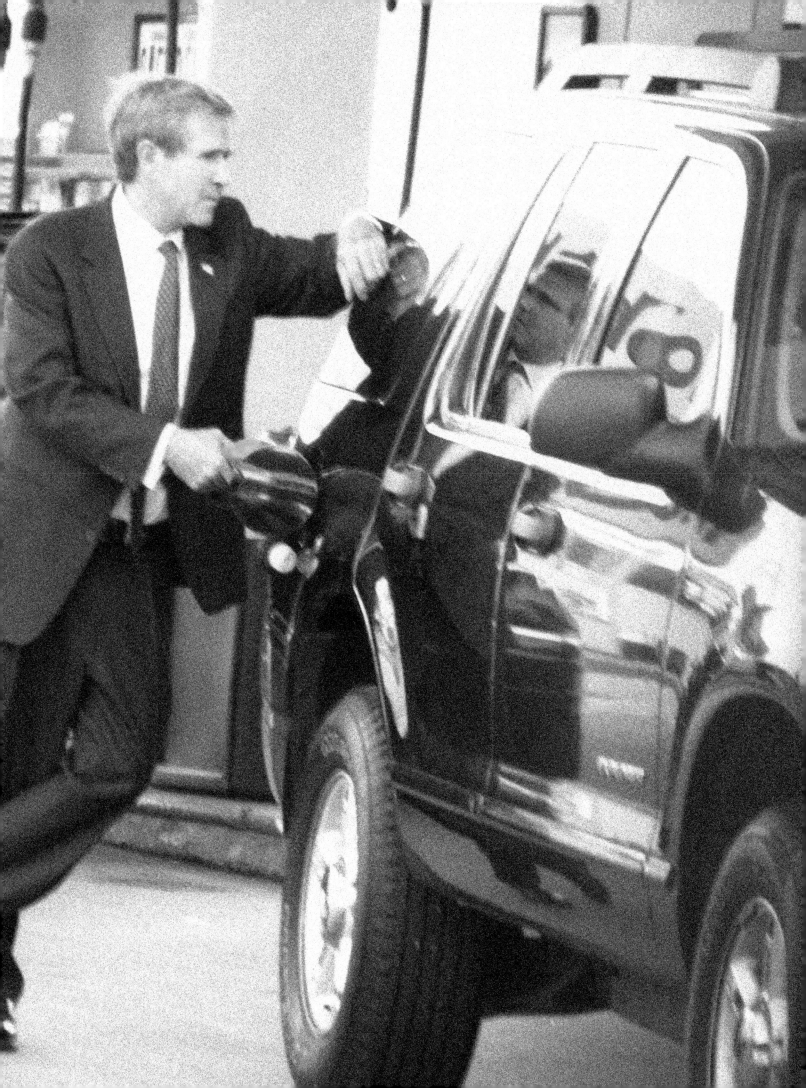

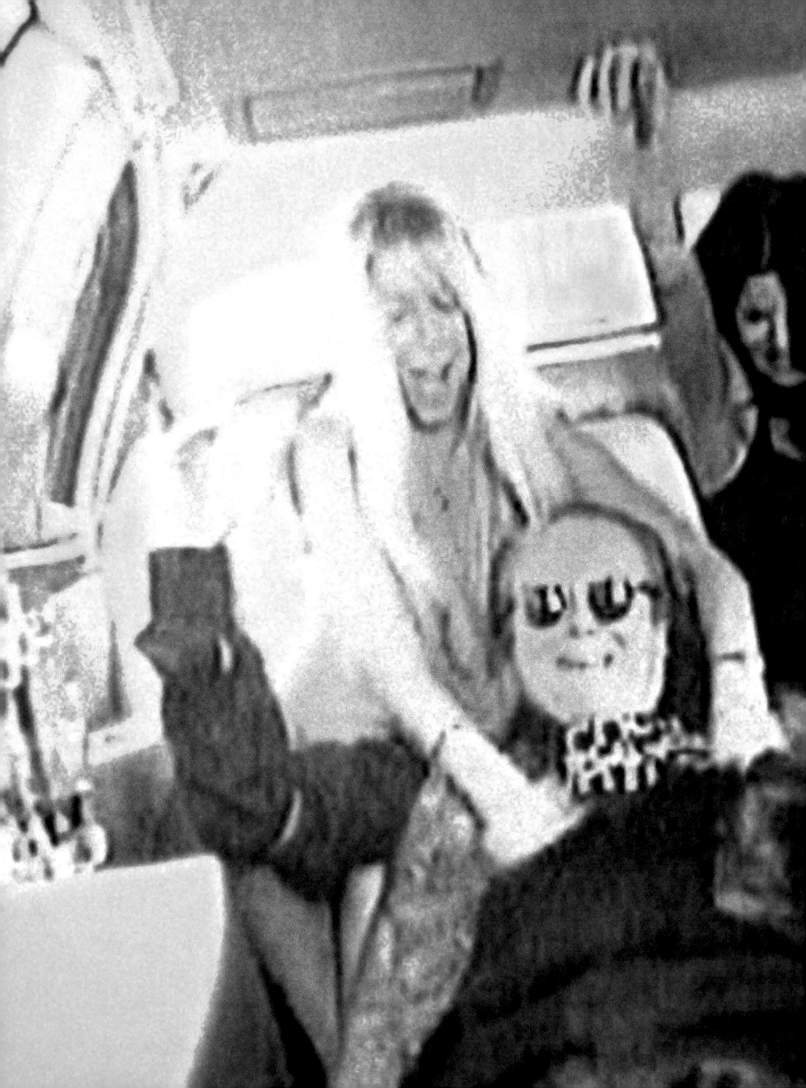

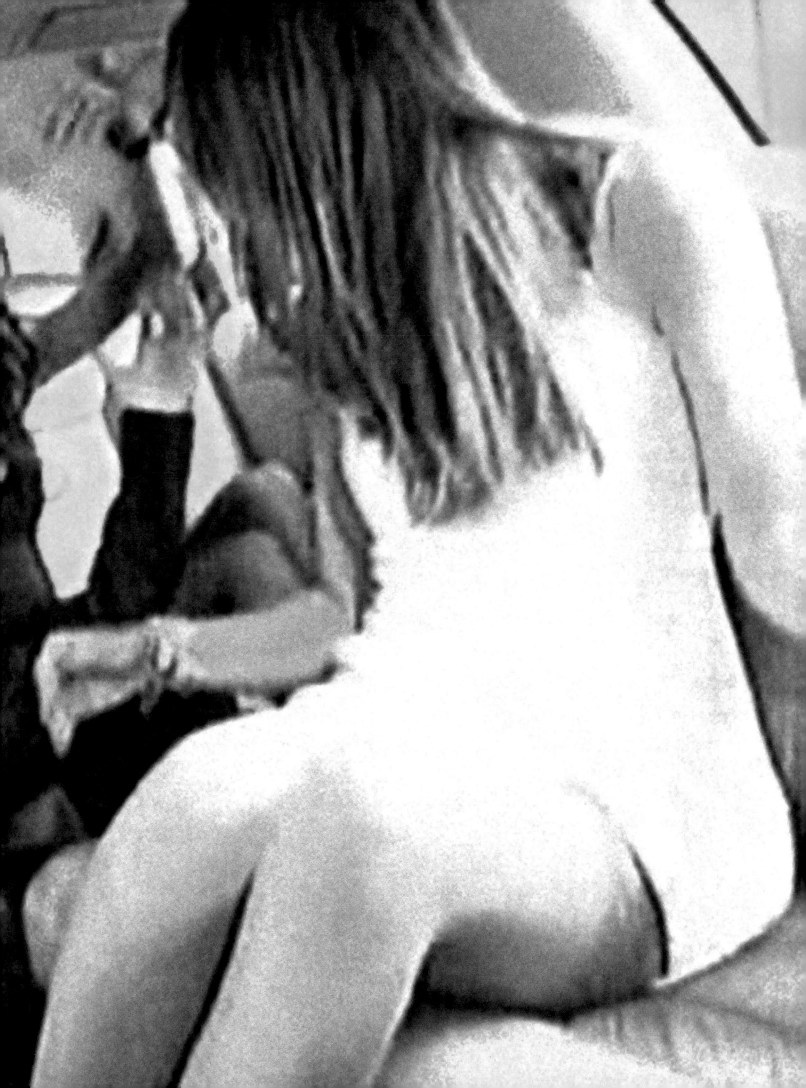

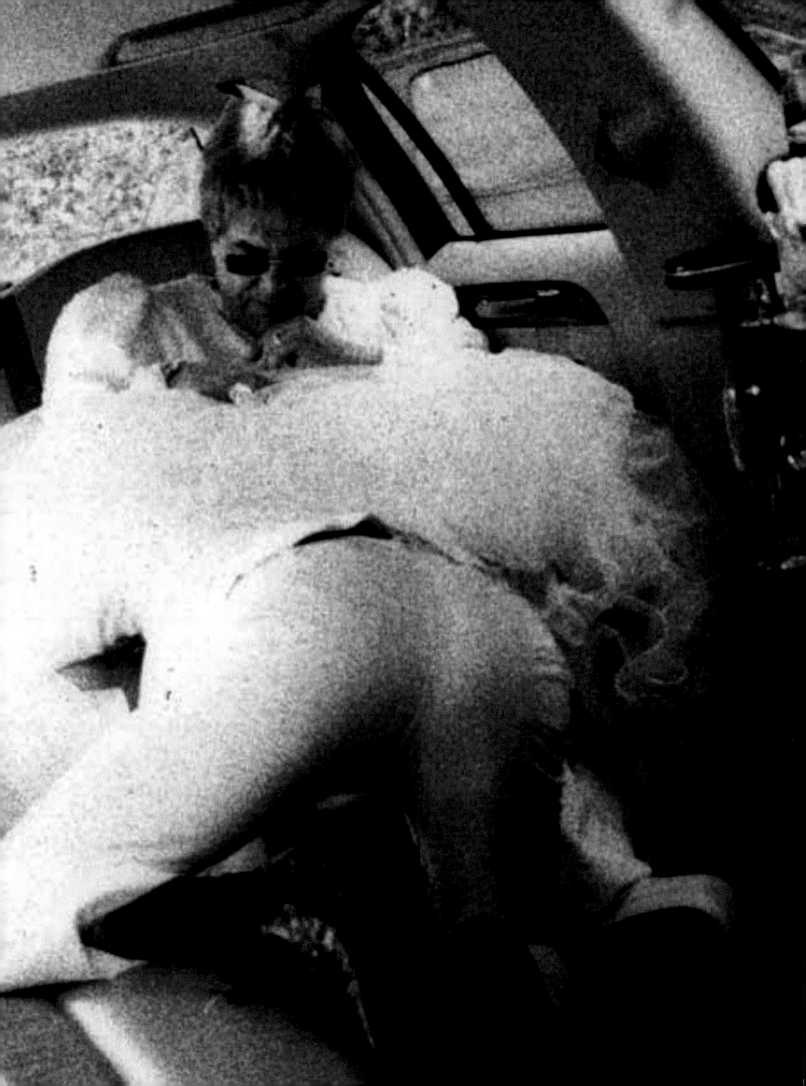

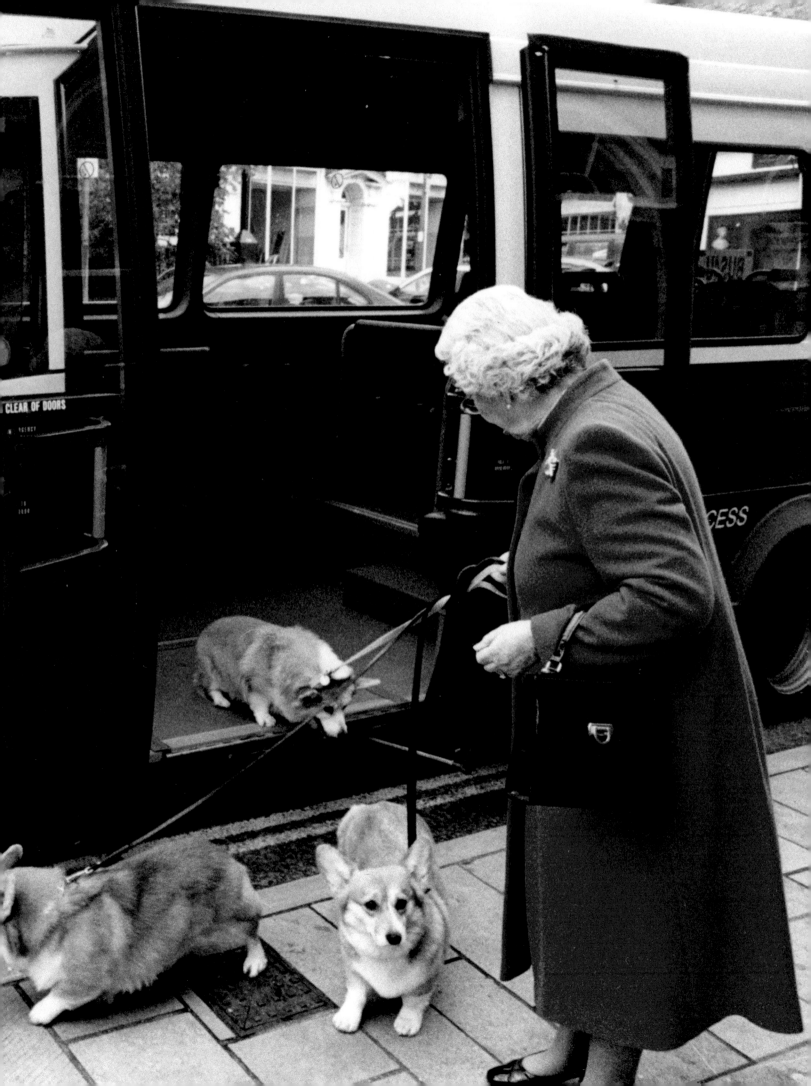

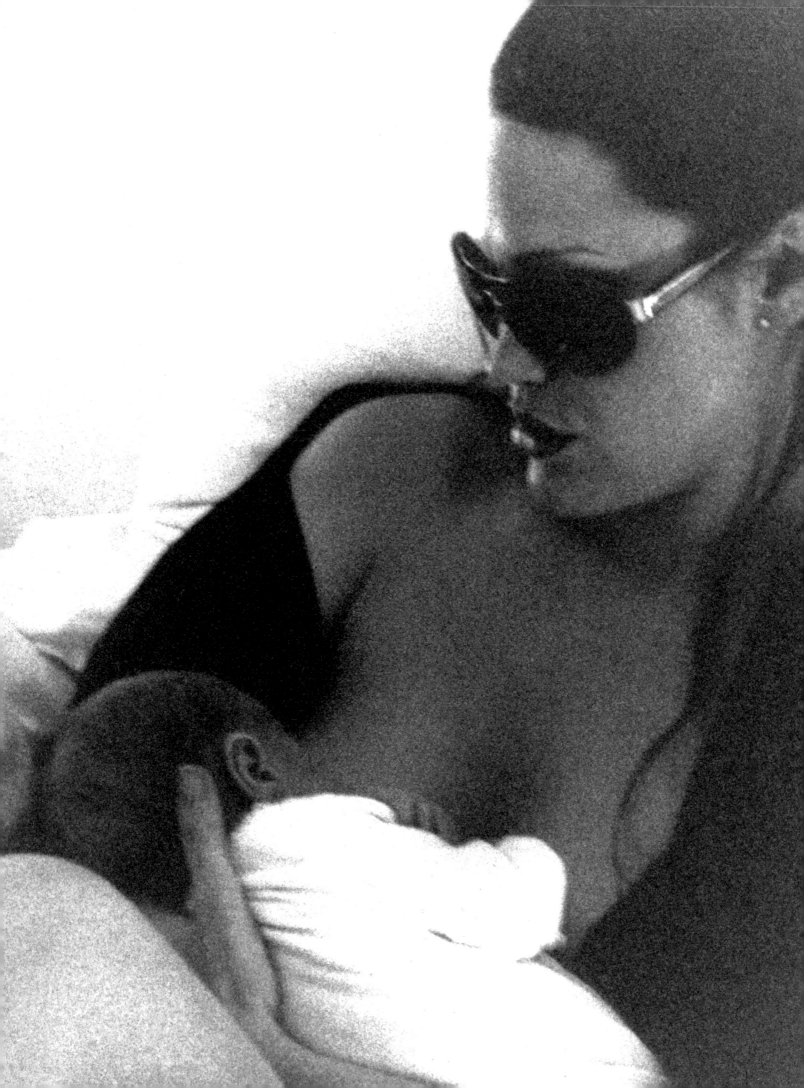

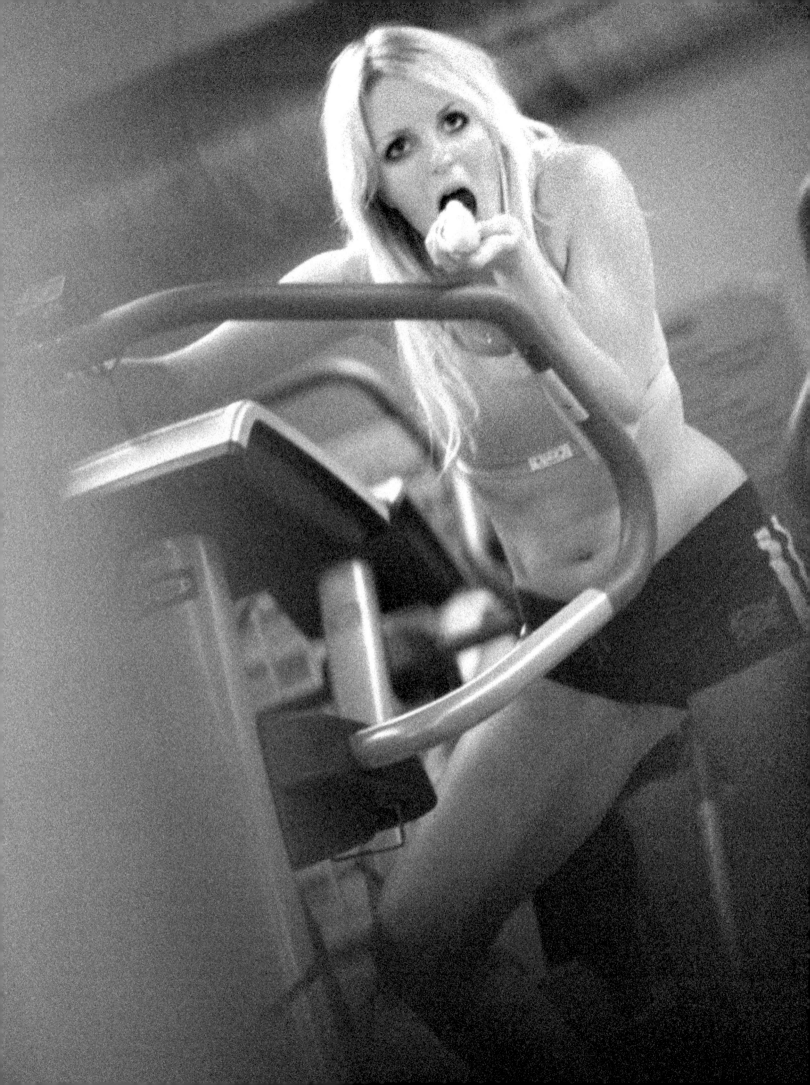

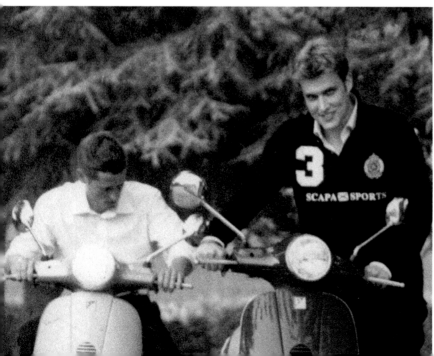

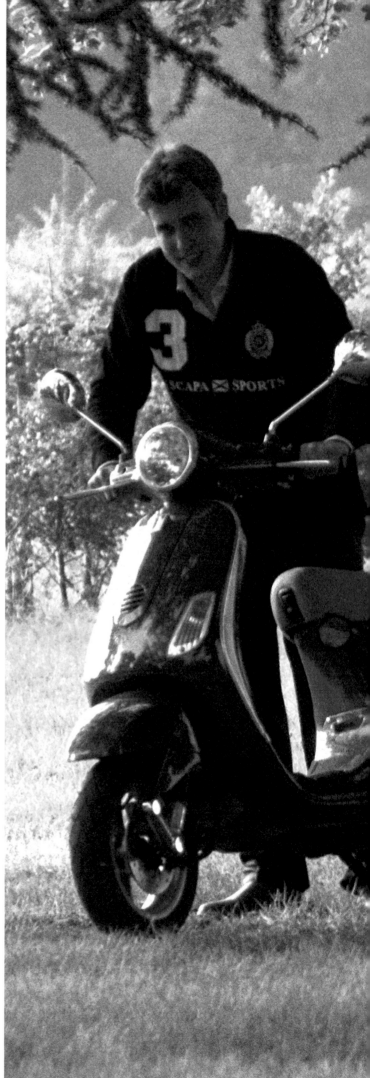

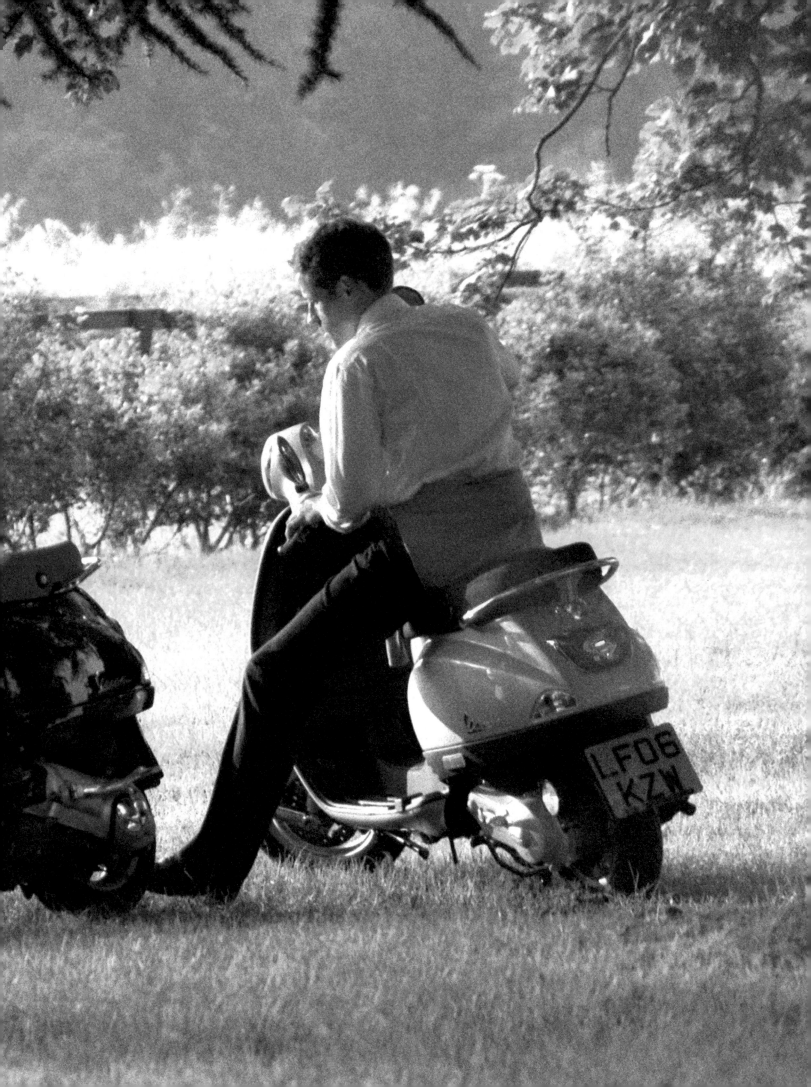

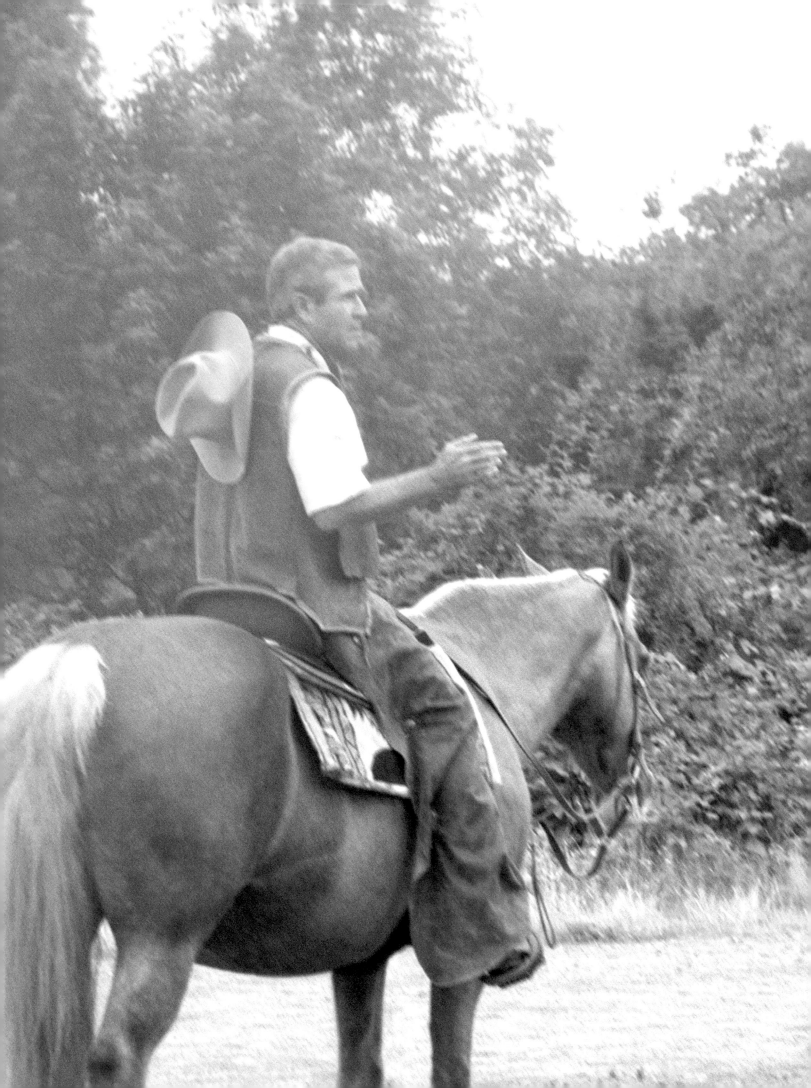

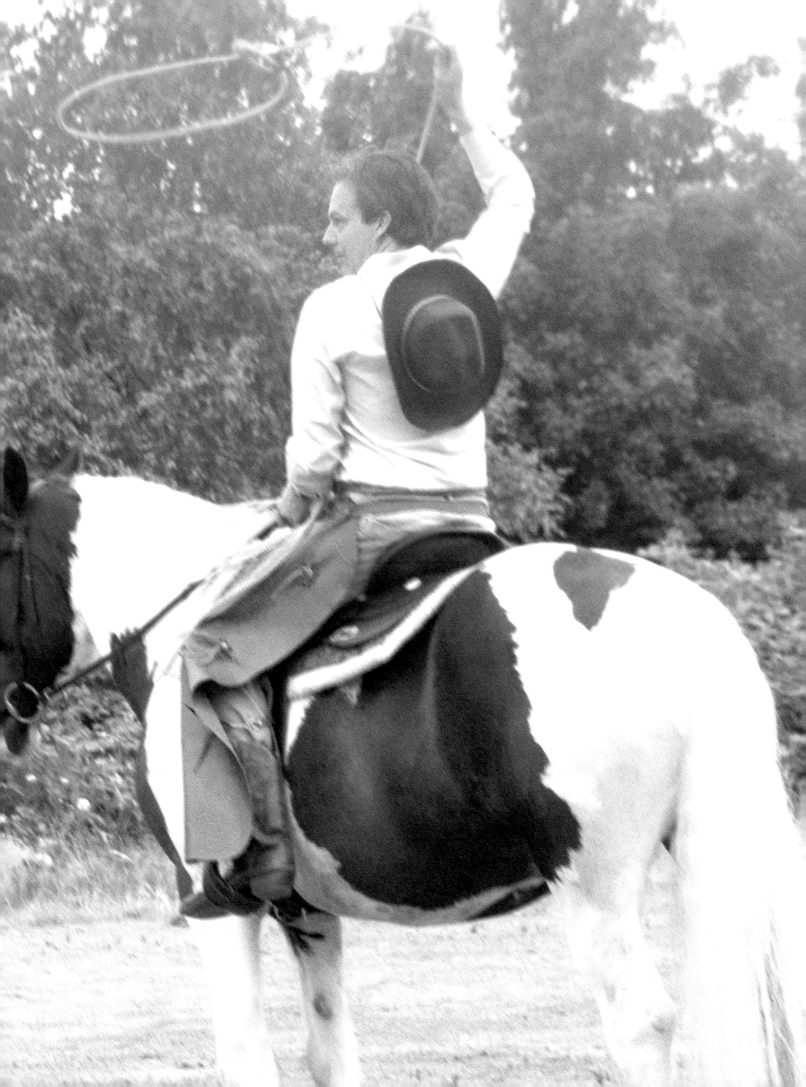

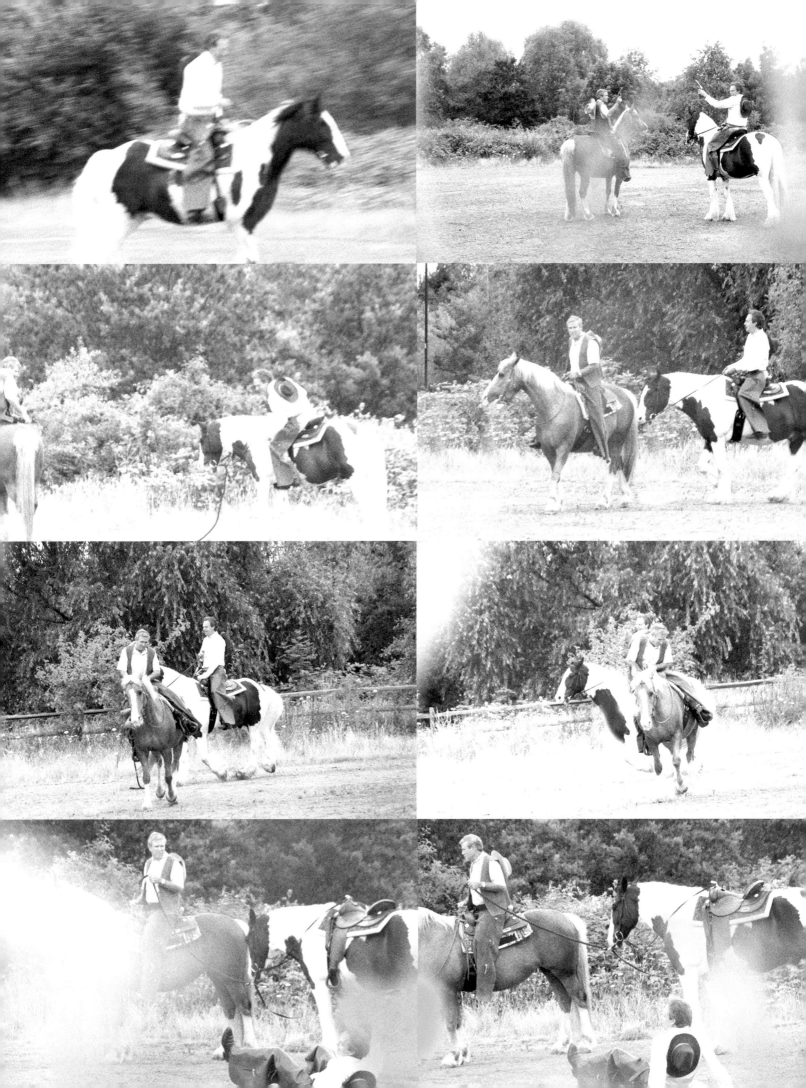

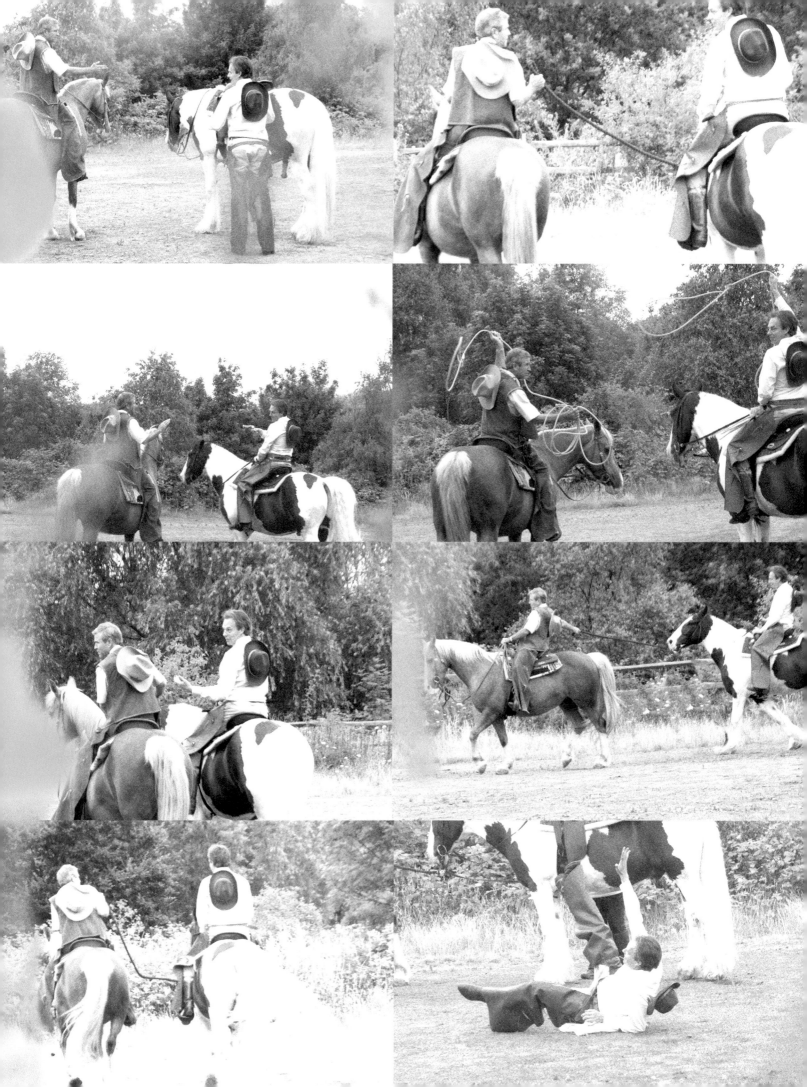

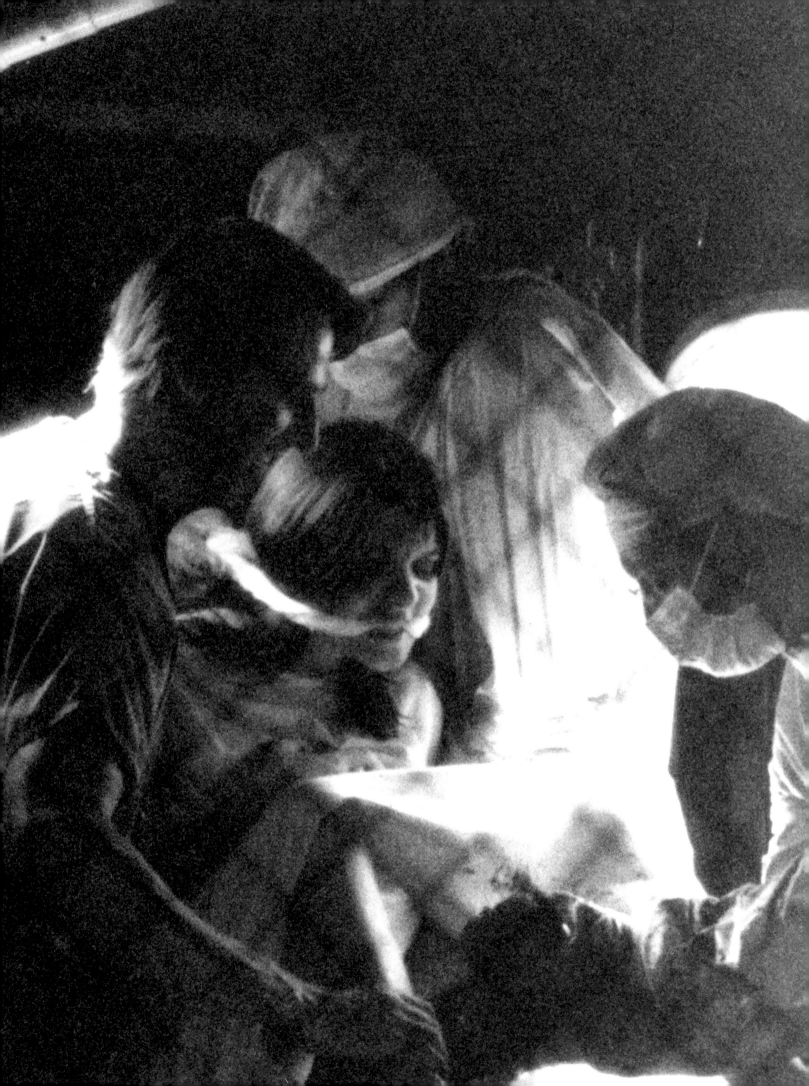

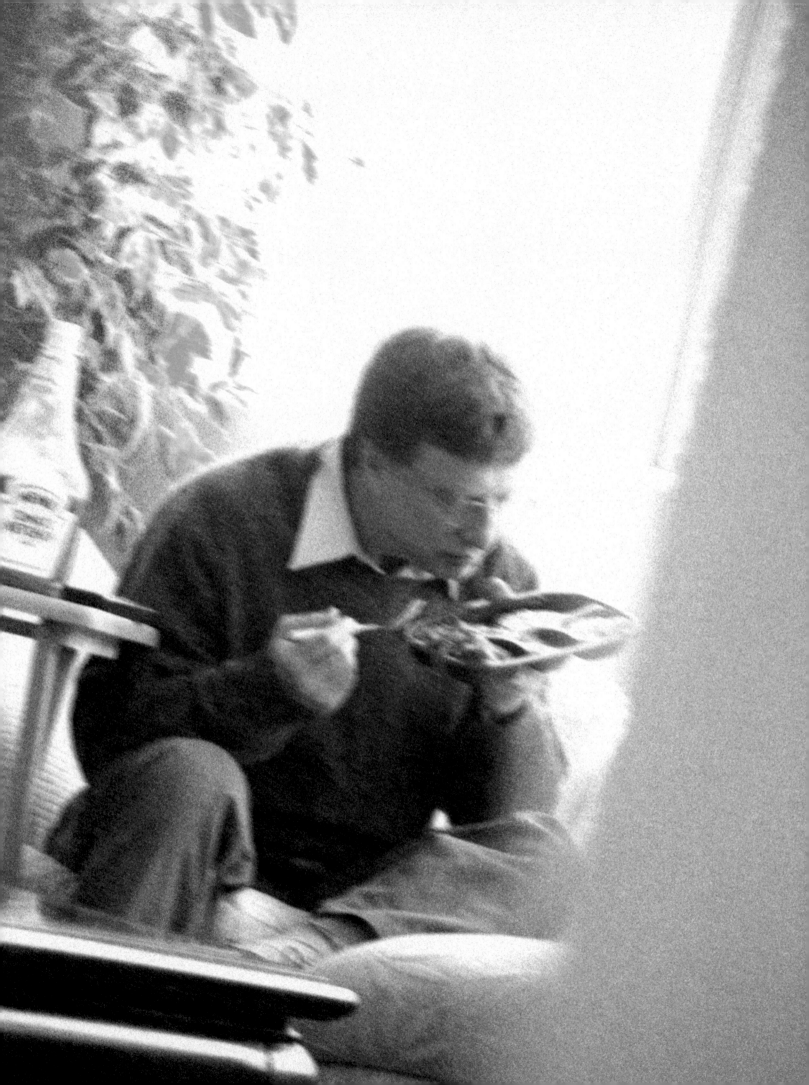

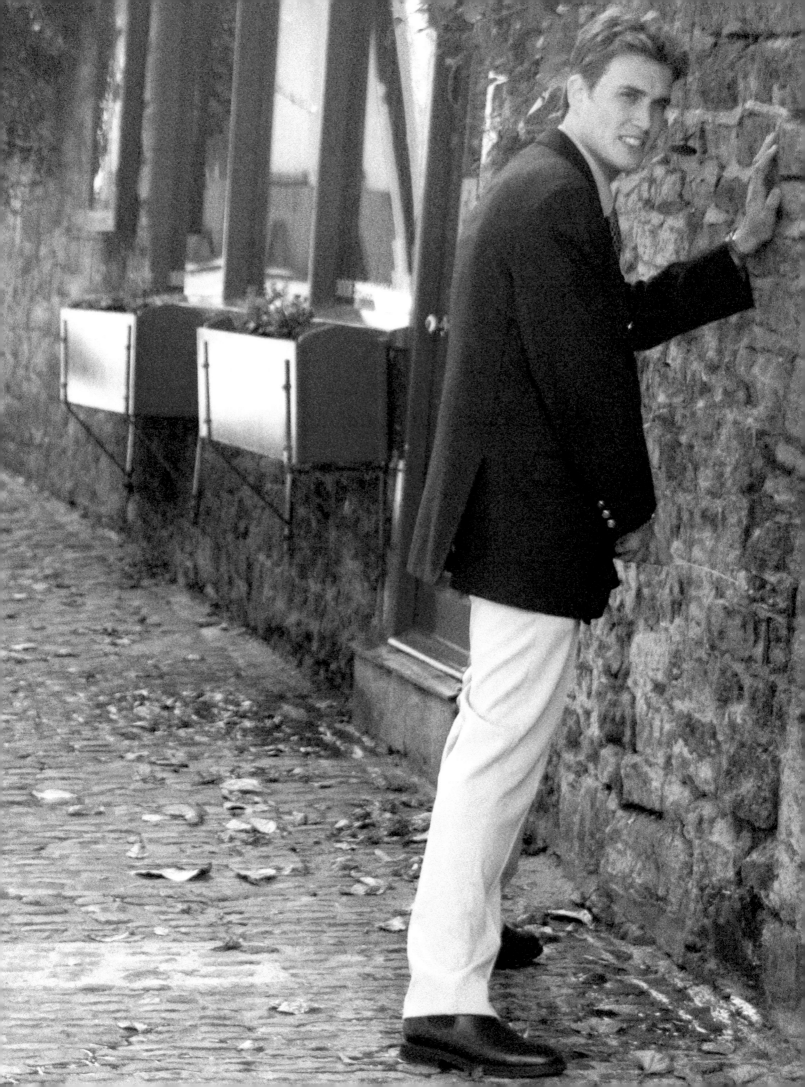

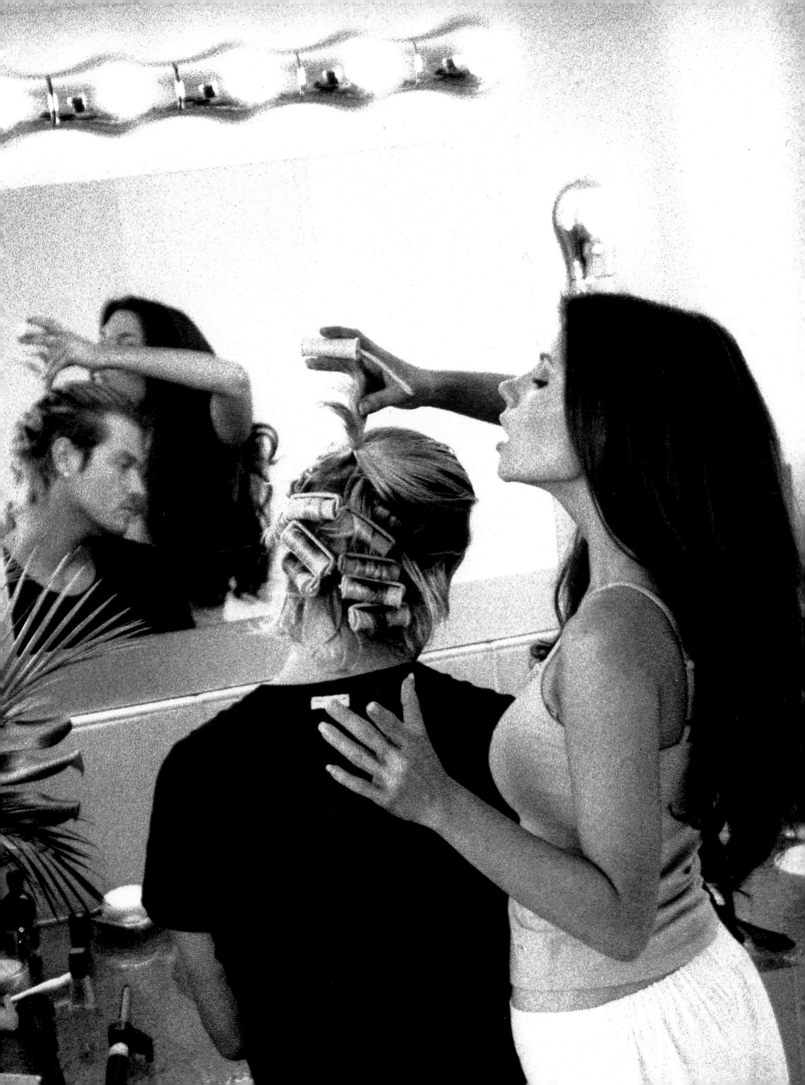

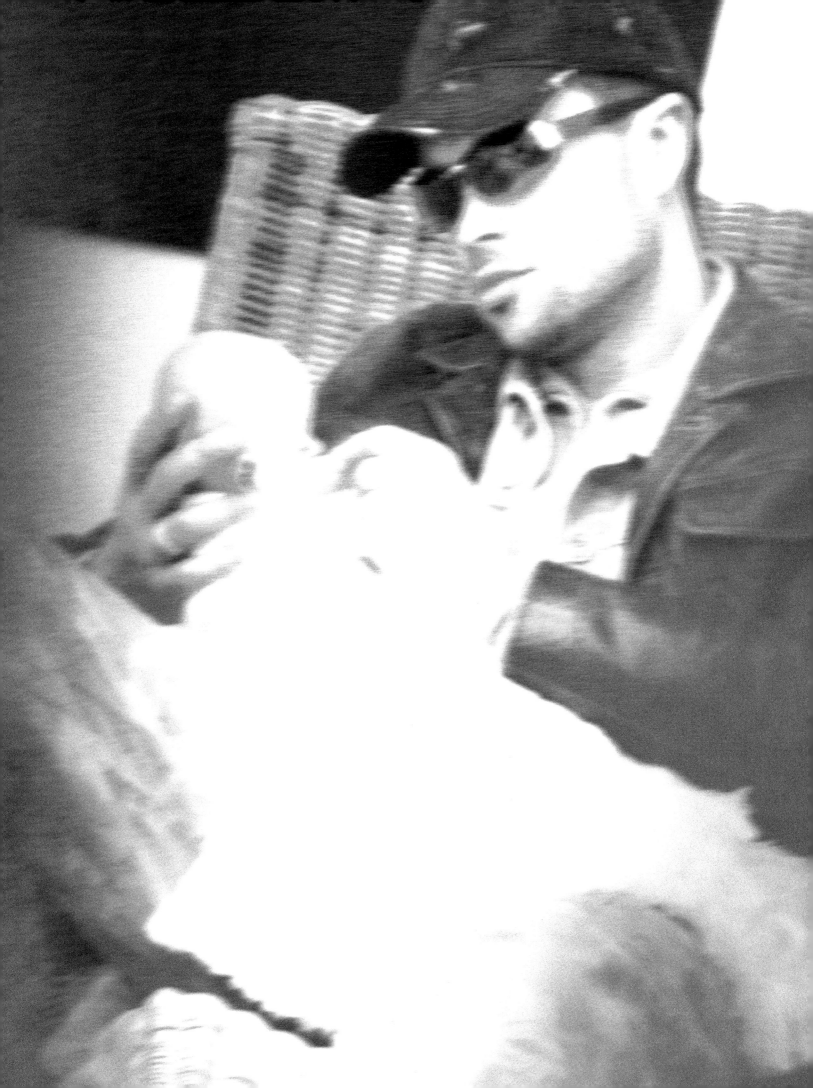

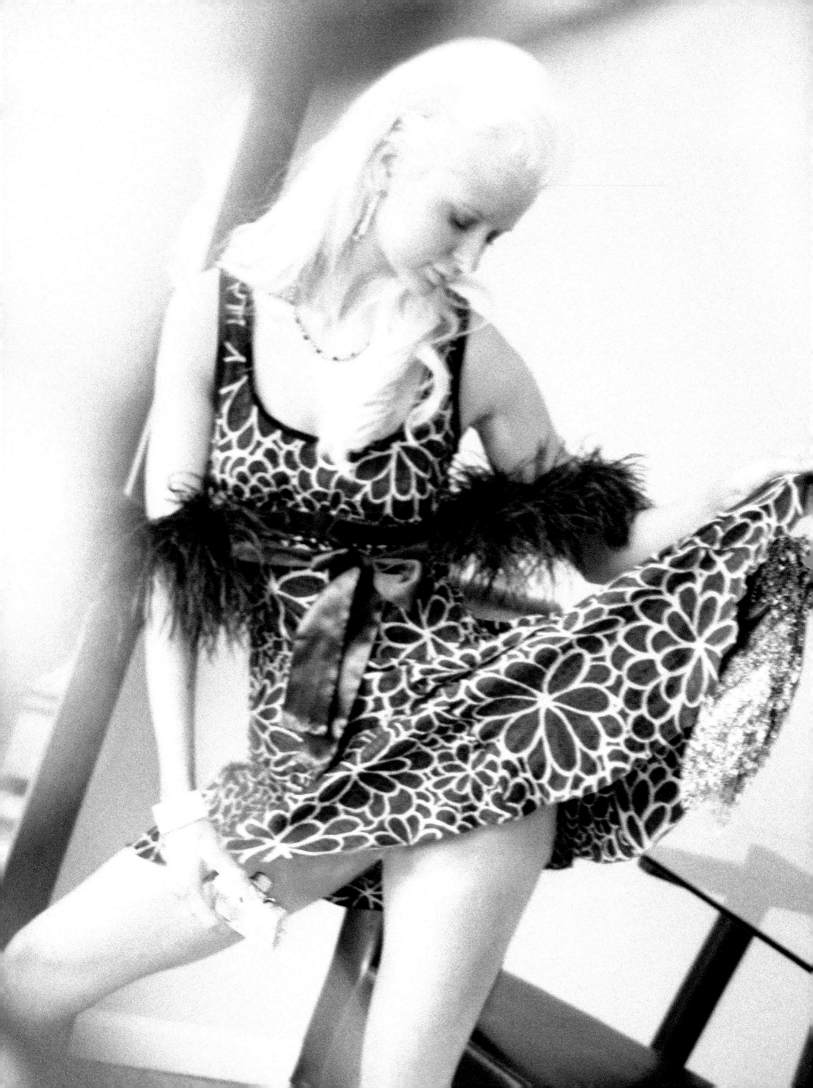

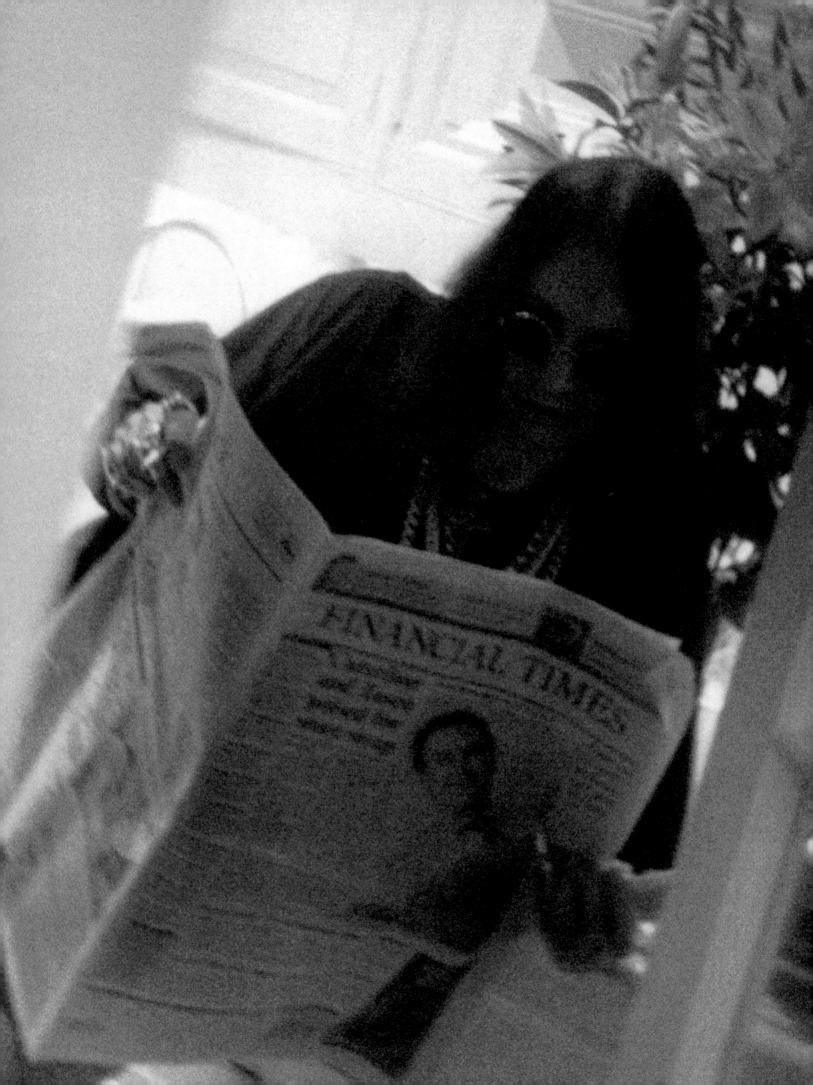

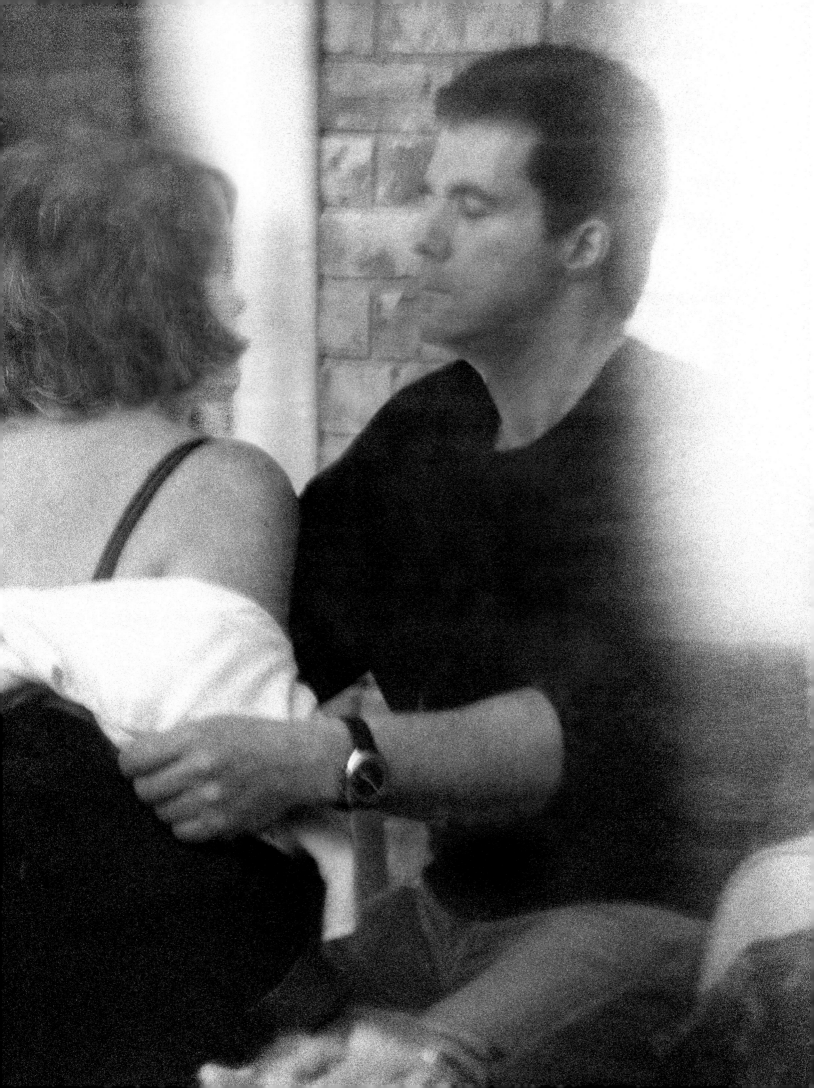

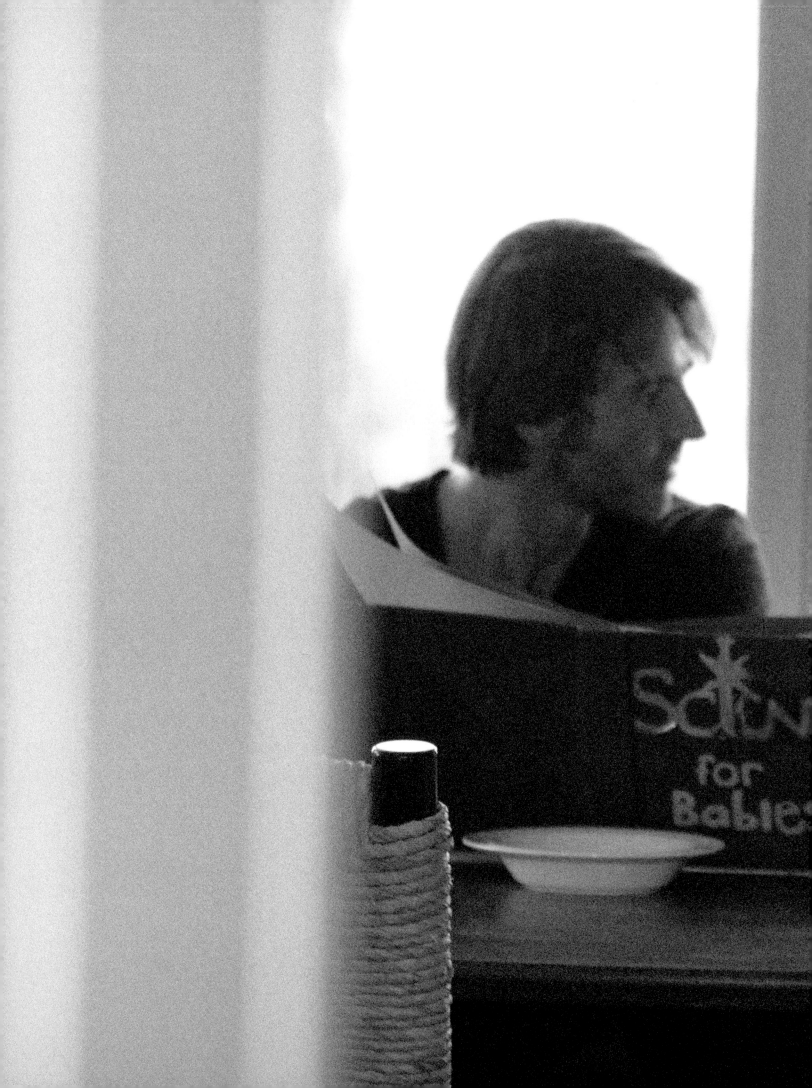

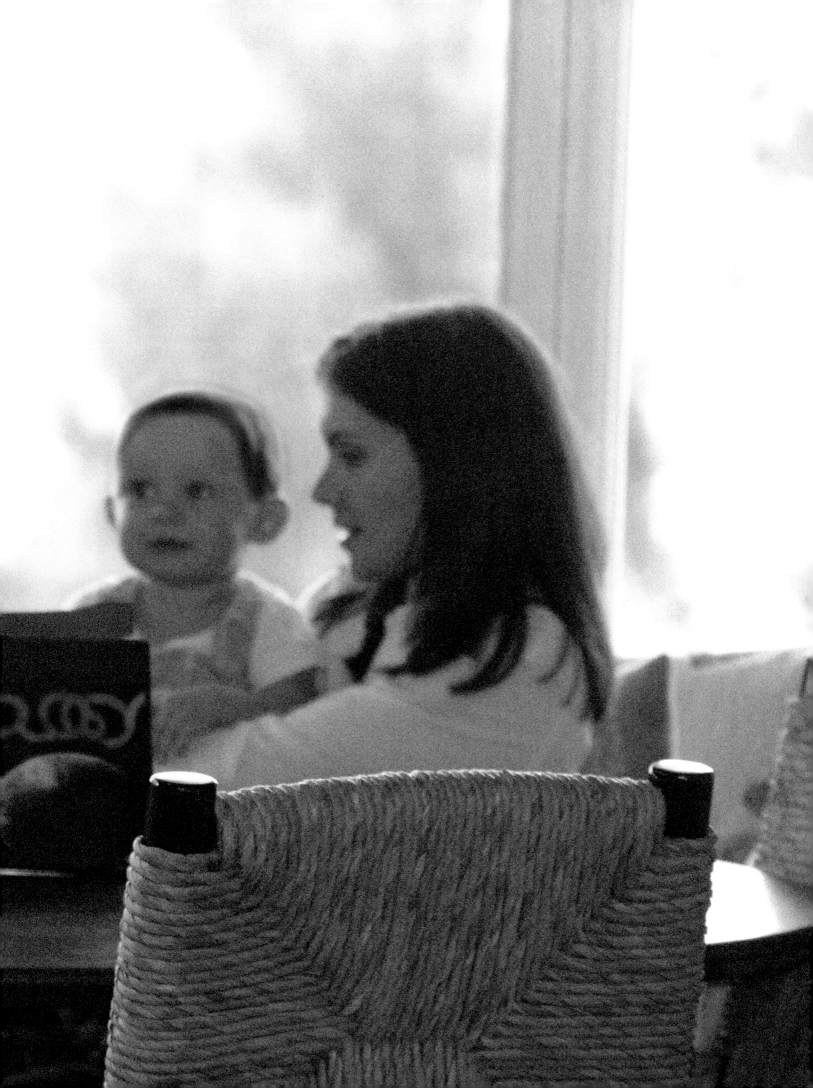

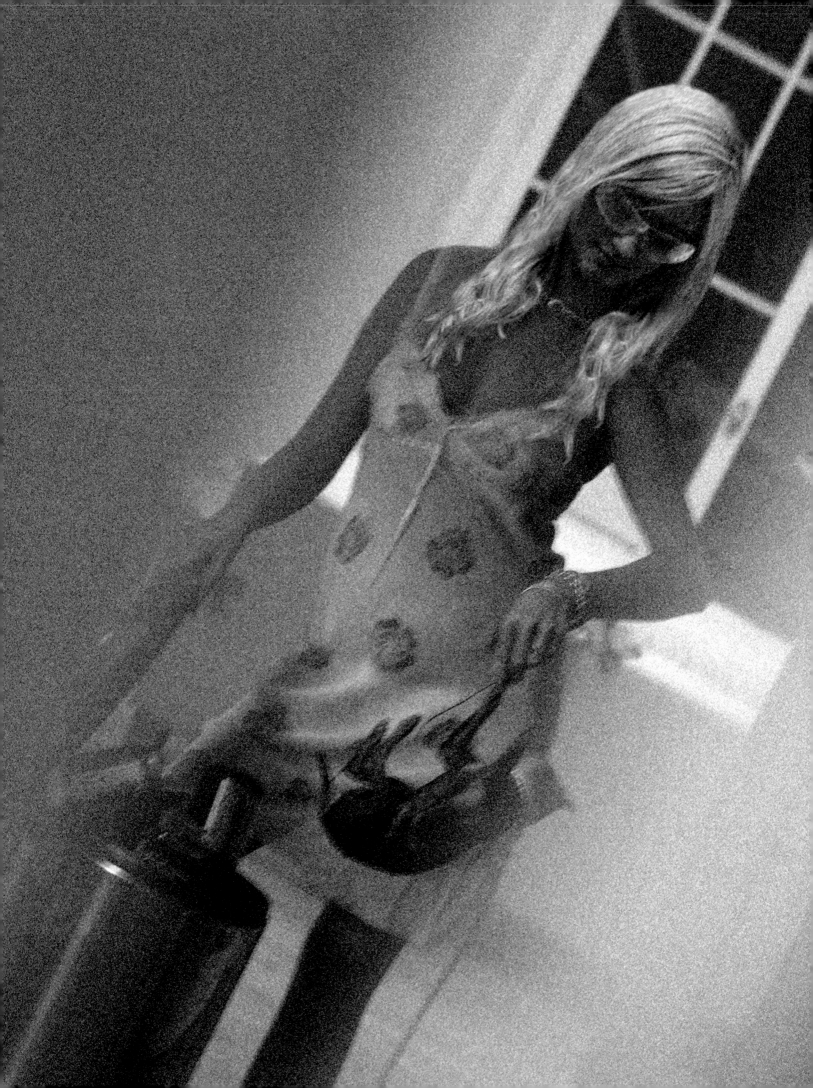

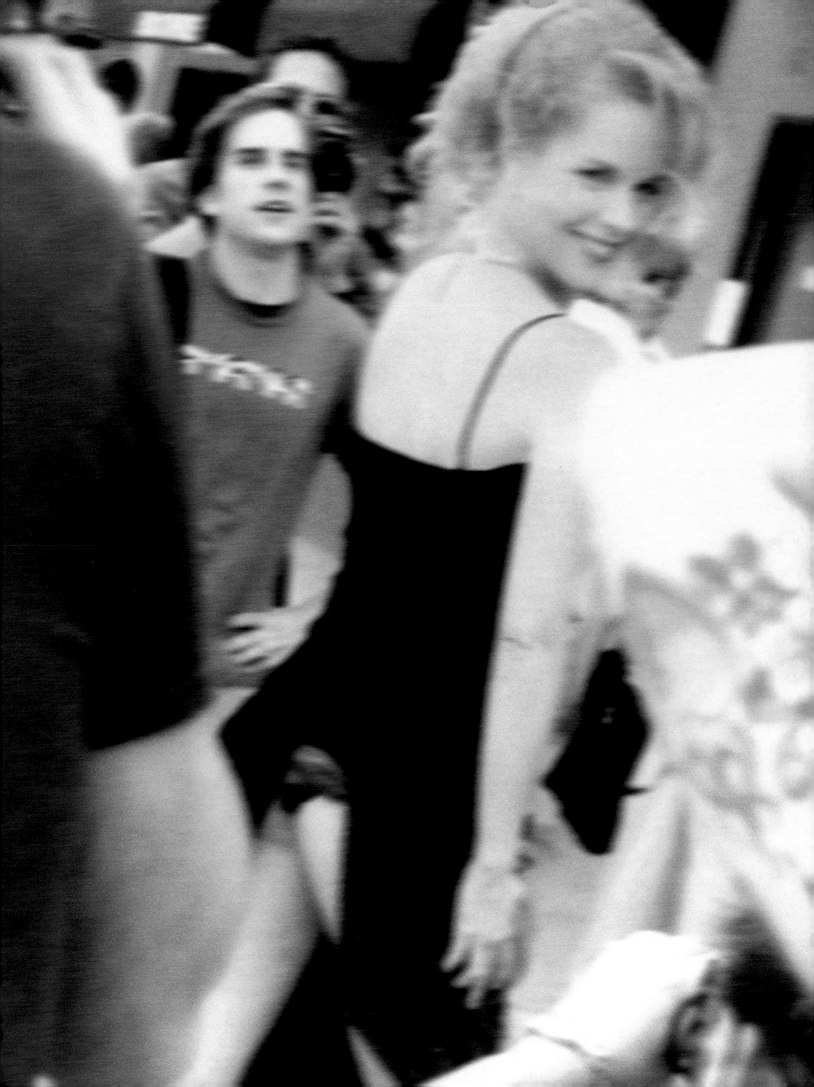

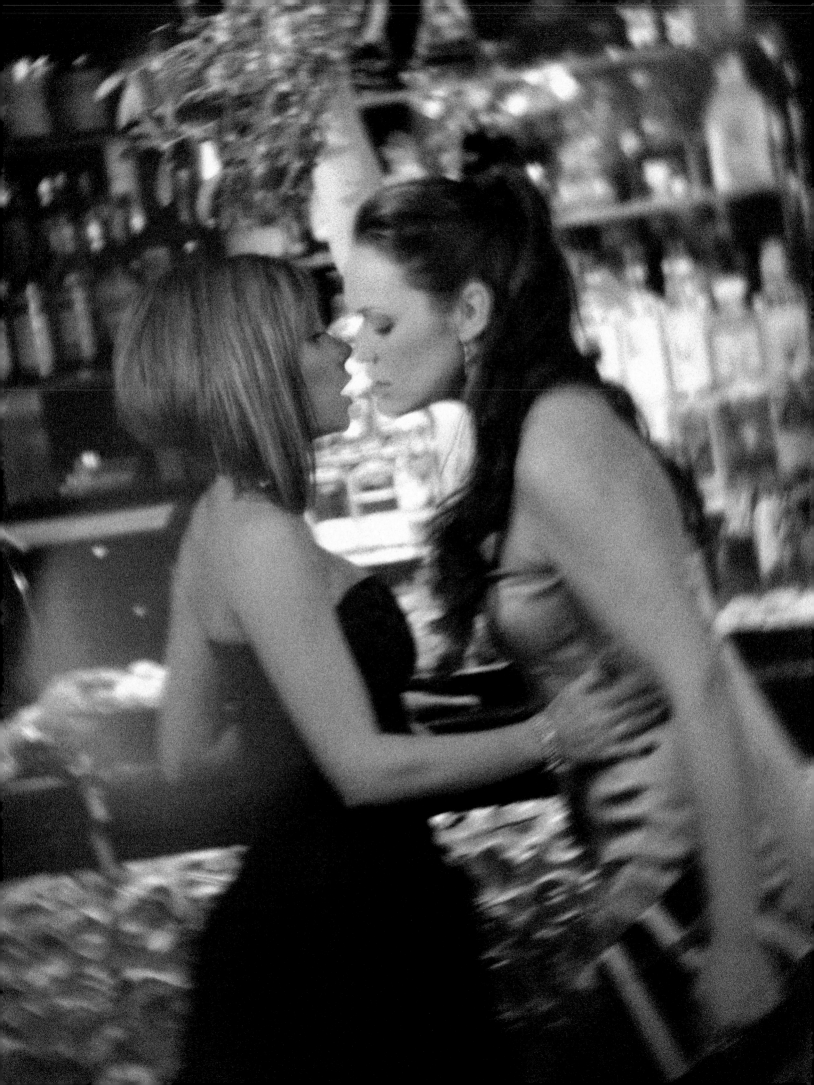

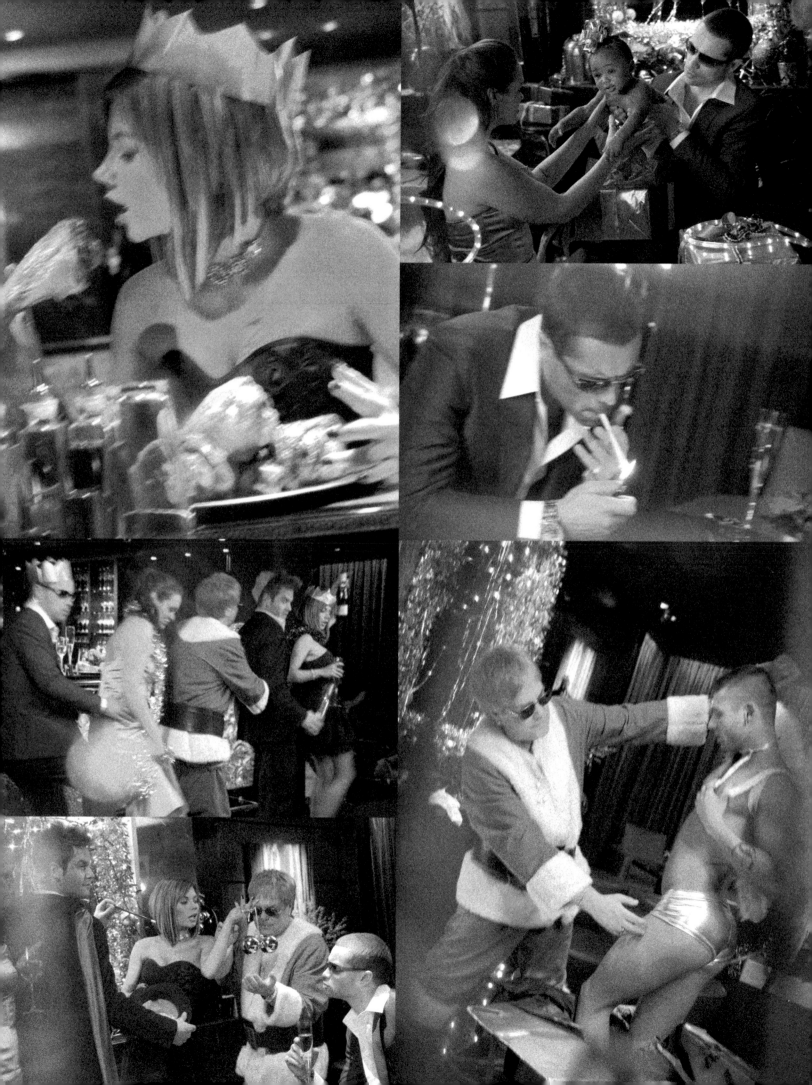

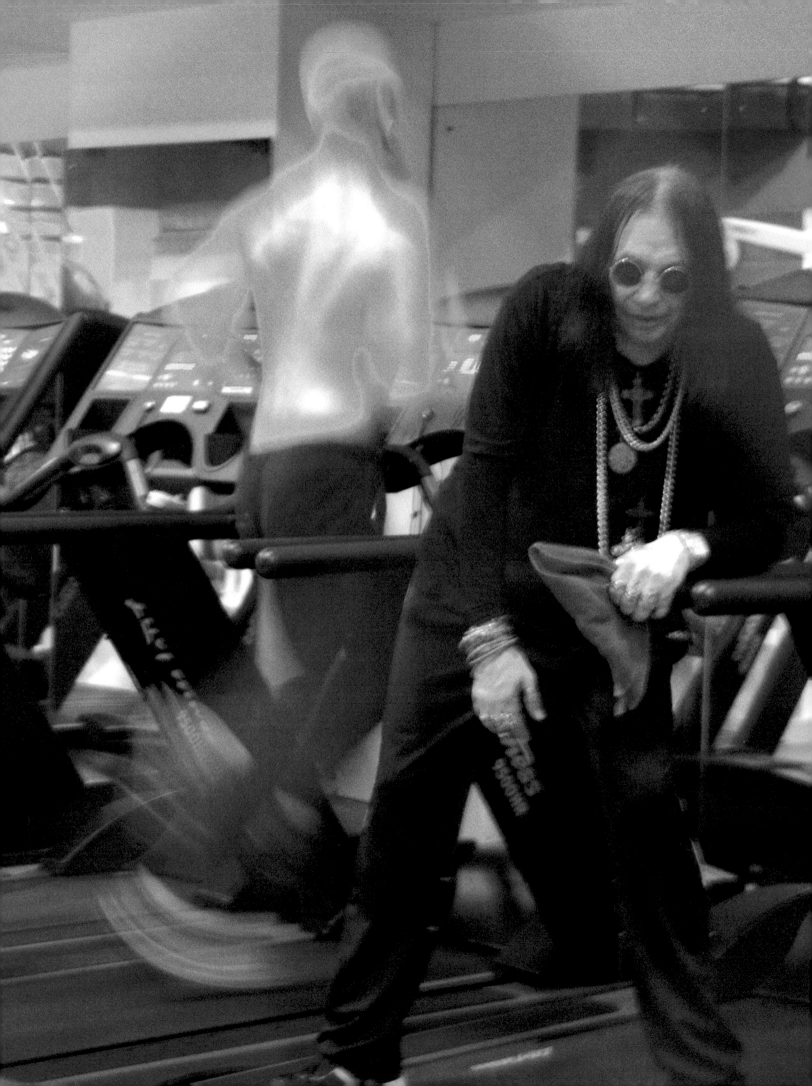

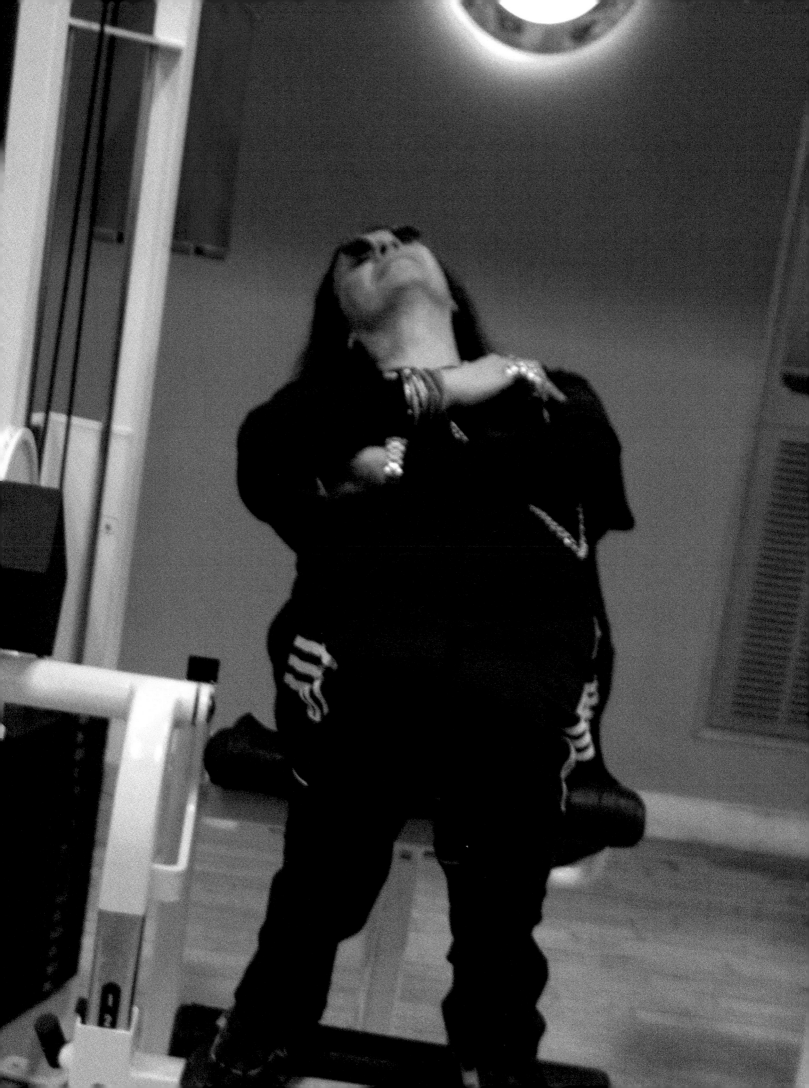

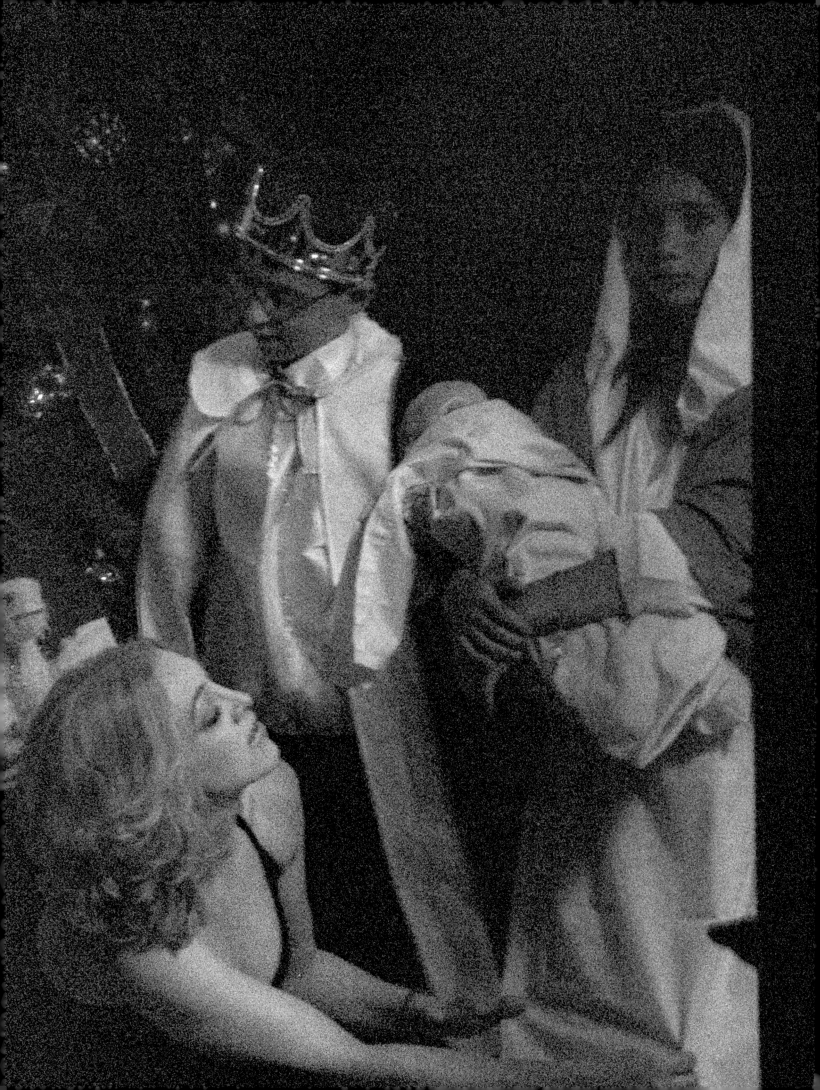

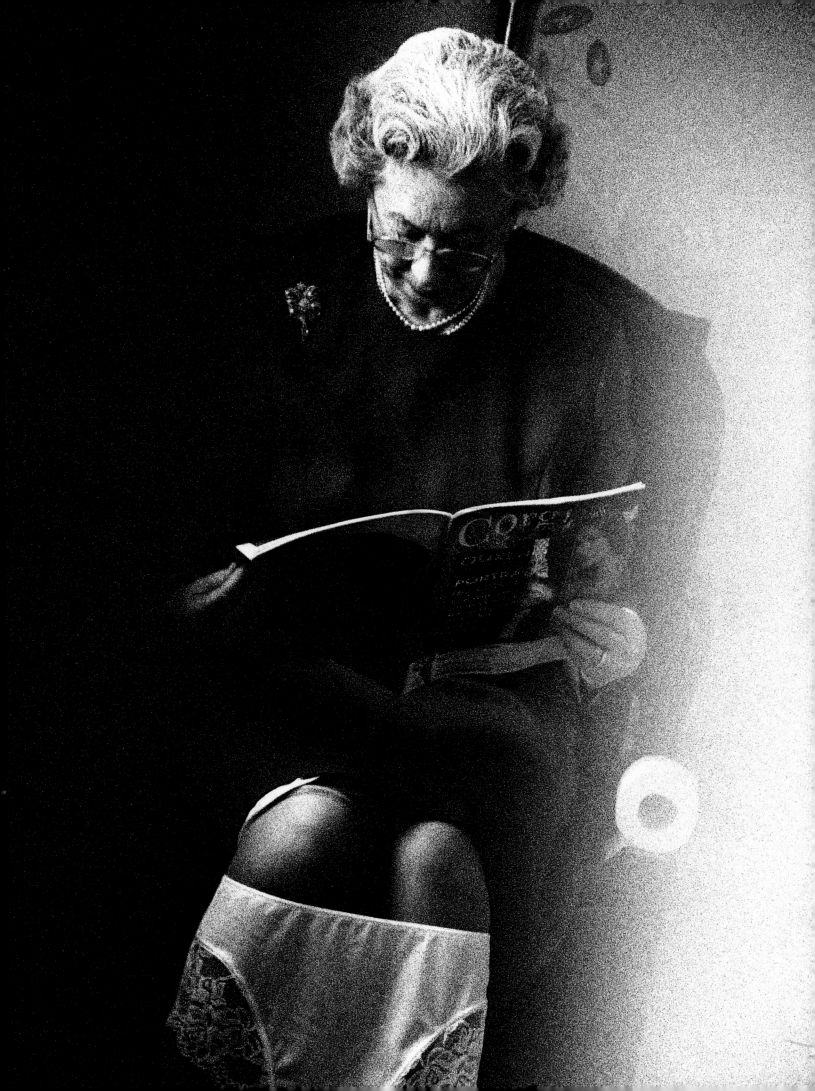

"Celebrity," John Updike famously remarked, *"is a mask that corrodes the face."*

But what of those who look upon that mask, and who dream of what lies behind it? When the famous walk the streets—if they do so at all—they are constantly being incorporated into the lives of others they do not know, but who believe they know them. If moderately recognizable, they are half-recalled faces, easily confused with the friends, acquaintances, and families of those who pass them by:

"Isn't that…?"

"Wasn't she…?"

"Aren't they…?"

The media realm from which the celebrities emerge, blinking into the prosaic light of day, is too lofty an Olympus for ordinary mortals to conceive of the Gods descending from—they wouldn't recognize Zeus as anything but a swan until…

It's this villagey regard, I would contend, that people are truly in search of when they desire modern fame. They understand, at a preconscious level, that to be famous in this over-lit age is to be recognized by the whole society in purely situational terms. I treasure an anecdote of the comedian Spike Milligan that sums this up perfectly. One day a new neighbor moved in next door to him. When Milligan came out of his house, the man said: "I've seen you on television." The following day, Milligan emerged, and seeing the man said: "I've seen you in your garden."

On good days the celebrity is a well-loved member of a tight, little community, rather than a mass society of savage alienation. Everyone has seen him or her in the garden. On bad days, the celebrity is the village idiot, its drunk, or its adulterer. On bad days, the community wants to put him in the stocks, and so he hires a publicist to sell his story to the parish magazine.

The enduring popularity of the royal family is not explicable in constitutional terms at all, nor is it a function of their seeming continuity. On the contrary, the Windsors and their consorts are truly contemporary celebrities: famous for nothing at all, save for their ability to copulate and cut ribbons. When Andy Warhol said that in the future everyone would be famous for fifteen minutes, he recognized that this yearning to escape anonymity was, in an age of burgeoning media, far more powerful than the traditional criteria of talent or greatness or beauty. He spoke—as must we all—for himself. The lack of any talent is a condition of this success; for only by epitomizing that yearn-

ing—as the voyeuristic Warhol did—can an individual be clasped to the global bosom.

When people look upon Alison Jackson's images as satiric, I feel they have profoundly missed the point. The Duke of Edinburgh might be made uncomfortable by seeing an image—apparently of himself—watching Marilyn Monroe masturbate; but that is incidental. Nor is the irony, undoubtedly implicit, in peeping at Mick Jagger, or Madonna ironing, anything more than a superficial attribute. And if we reverse the conceit, and ask ourselves: why do we find the notion of the regal at stool unsettling? The answer is because it forces us to dig further in our own shit. No, the capacity of these photographs to destabilize us, make us think, and, above all, make us question, lies on a deeper plane.

These are scenes of neurosis, domesticity, bodily functions, playfulness, birth, and death. Before mirrors, the wearers of the masks contemplate themselves; on padded benches they undergo painful cosmetic procedures. By being jolted into seeing the Gods as exactly the same sort of barnyard fowl as ourselves—a perception even the most hardheaded among us cannot resist—Jackson drives us to contemplate the very ordinary weal of common humanity: our neuroses, our domesticity, our bodily functions, our births and our deaths.

To me, these are the true vanitas paintings of the modern era. Like those arrangements of effulgent—but rotting—fruit and flowers; those extravagant boards, groaning with gold plate and glass; those coded symbols—the guttering candle, the hourglass, the stopped watch: the glimpsed lives of Jackson's subjects are profoundly still, and fraught with symbolism. These are things that we covet—indeed, they are not things at all, but people. This is the grainy, quotidian reality we turn away from to lose ourselves in gloss and matte betrayals.

Poor Pete and Kate, poor Tom and Katie,

poor Prince Wills and Bill Gates, poor hacked-about Michael Jackson, and poor, dumb Dubya. Poor Tony, whose legacy will be dust mixed with dried blood. Poor all of them—and poor us, for, just as the flowers and the fruit in vanitas paintings was depicted rotting, so we are all in a process of decay, our faces being corroded either by our fame or our obscurity.

Will Self is the author of five novels, four collections of short stories, three novellas, and five non-fiction books. He is also a contributor to many publications including The Independent, *and* Evening Standard *newspapers in London, where he lives. His latest novel is* The Book of Dave *(2006).*

„Prominenz", so eine berühmte Bemerkung von John Updike, „ist eine Maske, die das Gesicht zerfrisst." Doch was ist von jenen zu halten, die sich diese Masken anschauen und darauf brennen zu erfahren, was sich dahinter verbirgt? Wenn Berühmtheiten über die Straße spazieren – sofern sie das überhaupt tun –, werden sie ständig in das Leben anderer einbezogen, die sie gar nicht kennen, jedoch meinen, alles über sie zu wissen. Wenn sie nicht ganz so bekannt sind, werden sie im Vorbeigehen als vage erinnerte Gesichter wahrgenommen und leicht mit Freunden, Bekannten oder Familienmitgliedern verwechselt: „Ist das nicht …?", „War das nicht gerade …?", „Sind das nicht …?"

Die Medienwelt, aus der die Prominenten auftauchen, um im prosaischen Licht des Tages aufschimmert, ist ein Olymp in allzu schwindelnden Höhen, als dass sich gewöhnliche Sterbliche vorstellen könnten, die Götter würden herabsteigen – Zeus als Schwan würden sie erst erkennen, wenn …

WILL SELF

Es ist dieser nachbarschaftlich-dörfliche Umgang, würde ich behaupten, nach dem sich die Leute eigentlich sehnen, wenn sie in unseren Tagen Ruhm genießen wollen. Sie begreifen auf vorbewusste Weise, dass in diesem überbelichteten Zeitalter berühmt zu sein heißt, von aller Welt in jeder nur erdenklichen Situation erkannt zu werden. Mir fällt da eine Anekdote mit dem Schauspieler Spike Milligan ein, die genau das widerspiegelt: Eines Tages zog neben ihm ein neuer Nachbar ein. Als Milligan aus seinem Haus trat, sagte der Mann: „Ich habe Sie im Fernsehen gesehen." Am nächsten Tag kam Milligan wieder aus seiner Tür, sah den Mann und meinte: „Ich habe Sie in Ihrem Garten gesehen."

An guten Tagen ist der Prominente eher ein beliebtes Mitglied einer kleinen, begrenzten Gemeinschaft als Teil einer von brutaler Entfremdung geprägten Massengesellschaft. Jeder hat ihn oder sie schon mal im Garten gesehen. An schlechten Tagen ist der Prominente der Dorfidiot, die Saufnase oder der Ehebrecher des Kaffs. An schlechten Tagen will ihn die Gemeinschaft am liebsten an den Pranger stellen, dann engagiert er einen Schreiberling, um seine Geschichte an die Heimatzeitung zu verkaufen.

Die anhaltende Popularität der königlichen Familie ist im politisch-konstitutionellen Sinne gar nicht zu erklären und hat auch nichts mit der scheinbaren Kontinuität ihrer Geschichte zu tun. Ganz im Gegenteil, die Windsors und ihr Anhang sind eine wahrhaft zeitgenössische Prominenz: berühmt für rein gar nichts außer für ihre Fähigkeit, zu kopulieren und rote Bänder zu durchschneiden. Als Andy Warhol einmal äußerte, in Zukunft könne jeder fünfzehn Minuten lang berühmt sein, hatte er erkannt, dass sich dieses Verlangen, der Anonymität zu entfliehen, im Zeitalter einer florierenden Medienindustrie als sehr viel mächtiger erweisen würde als traditionelle Kriterien wie Talent, Bedeutsamkeit oder Schönheit. Er sprach – wie wir alle es tun müssen – für sich selbst. Das Fehlen jeglichen Talents ist eine Voraussetzung für diesen Erfolg. Allein schon die Verkörperung dieses Verlangens zu sein – was der voyeuristische Warhol war – genügt, damit ein Einzelner von der ganzen Welt an den Busen gehalten wird.

Wenn die Leute Alison Jacksons Bilder als satirisch ansehen, liegen sie, meiner Ansicht nach, ziemlich daneben. Mag sein, dass dem Herzog von Edinburgh nicht besonders wohl dabei ist, wenn er ein Foto sieht, das offensichtlich ihn zeigt, wie er gerade Marilyn Monroe beim Masturbieren zuschaut. Doch das ist zweitrangig. Auch ist die – zweifellos implizite – Ironie, die mitschwingt, wenn man Mick Jagger heimlich beobachtet oder Madonna beim Bügeln erwischt, kaum mehr als ein oberflächliches Merkmal. Was, wenn wir den Spieß umdrehen und uns fragen: Warum finden wir die Vorstellung einer Majestät beim Kacken verunsichernd? Die Antwort ist, weil sie uns dazu zwingt, tiefer in unserer eigenen Scheiße zu wühlen. Nein, der Umstand, dass uns diese Fotografien irritieren, zum Nachdenken und, vor allem, zum Hinterfragen anregen, hat tiefere Ursachen.

Die Szenerien bieten Neurosen, Häuslichkeit, Körperfunktionen, Spielerisches, Leben und Sterben dar. Vor dem Spiegel sinnieren die Träger der Masken über sich selbst. Auf gepolsterten Liegen unterwerfen sie sich quälenden kosmetischen Prozeduren. Indem sie uns aus heiterem Himmel damit konfrontiert, die Götter als das gleiche Hinterhofgeflügel zu sehen, wie wir selbst es sind – eine Wahrnehmung, der auch die Nüchternsten unter uns nicht widerstehen können –, weist sie uns mit sanftem Druck auf die Schwielen hin, die allen Menschen gemeinsam sind: auf unsere Neurosen, unsere Häuslichkeit, unsere Körperfunktionen, unser Leben und Sterben.

Für mich sind diese Bilder die wahren Vanitas-Gemälde der Moderne. Wie jene Arrangements strahlender – doch irgendwann faulender – Früchte und Blumen, jene üppig gedeckten Tafeln, die sich unter der Last goldener Teller und edler Gläser biegen, jene bedeutungsschweren Symbole – die verlöschende Kerze, das Stundenglas, die innehaltende Uhr. Die Motive, auf die uns Alison Jackson einen flüchtigen Blick erlaubt, strahlen eine tiefe Stille aus und sind aufgeladen mit Symbolik. Nach diesen Motiven verzehren wir uns, doch es sind keine Dinge, die dargestellt sind, sondern Menschen. Es ist der schnöde Alltag, von dem wir uns abwenden, um uns stattdessen in glänzenden oder matt schimmernden Scheinwelten zu verlieren.

Pete und Kate, ihr Armen, Tom und Katie, ihr Bedauernswerten, Prince William und Bill Gates, ihr Bemitleidenswerten, armer Michael Jackson, auf dem so viel herumgehackt wird, und armer, törichter Double-U-Bush. Armer Tony, dessen Erbe von Staub und getrocknetem Blut überdeckt sein wird. Ach, wie bedauernswert sind sie alle – genauso wie wir, denn wie die Blumen und Früchte auf den Vanitas-Gemälden erkennbar vergänglich sind, so sind wir alle dem Untergang geweiht, ob unsere Gesichter nun von Ruhm oder unserer Unbedeutendheit zerfressen werden.

Will Self ist Autor von fünf Romanen, vier Sammlungen mit Kurzgeschichten, drei Novellen und fünf Sachbüchern. Als Journalist schreibt er für zahlreiche Publikationen. Er ist unter anderem für den Independent *und den* Evening Standard *tätig und lebt in London. Sein jüngster Roman trägt den Titel* The Book of Dave *(2006).*

John Updike a observé un jour: «La célébrité est un masque qui vous ronge le visage.» Mais qu'en est-il de ceux qui regardent ce masque et rêvent de ce qu'il y a derrière? Quand une célébrité marche dans la rue (si cela lui arrive), elle est constamment incorporée dans les vies de gens qu'elle croise. Elle ne les connaît pas, mais eux croient la connaître. Si elle est moyennement reconnaissable, son visage à demi enfoui dans les mémoires est facilement confondu avec celui d'amis, de relations ou de parents. «Ce n'était pas…?»; «Tu as vu…?»;

«Mais c'est…» Le royaume médiatique d'où émergent les célébrités, aveuglées par la lumière prosaïque du jour, est un Olympe trop haut perché pour que les simples mortels conçoivent que les dieux en descendent. Ils ne reconnaîtraient pas Zeus autrement que sous la forme d'un cygne jusqu'à ce que…

À mon avis, c'est ce regard provincial que recherchent réellement ceux qui aspirent à la notoriété moderne. Ils comprennent, à un niveau préconscient, qu'être célèbre en cette époque à l'éclairage si brutal, c'est être reconnu par l'ensemble de la société en termes purement situationnels. Le comique Spike Milligan raconte une anecdote que j'adore et qui résume parfaitement la situation. Un jour, un nouveau voisin emménage à côté de chez lui. Voyant Milligan sortir de sa maison, il lui lance: «Vous, je vous ai vu à la télévision.» Le lendemain, Milligan l'aperçoit à nouveau et lui dit: «Vous, je vous ai vu dans votre jardin.»

Les bons jours, la célébrité est un membre bien-aimé d'une petite communauté soudée et non d'une société de masse gravement aliénée. Tout le monde l'a vue dans son jardin. Les mauvais jours, la célébrité est l'idiot du village, le soûlard de service, l'adultère. Les mauvais jours, la communauté veut la clouer au pilori et la célébrité recrute un agent publicitaire pour vendre son histoire au canard local.

La longue popularité de la famille royale britannique ne s'explique pas en termes constitutionnels; ce n'est pas non plus une fonction de sa continuité apparente. Au contraire, les Windsor et leurs consorts sont de vraies célébrités contemporaines: célèbres sans raison, sinon pour leur capacité à copuler et à couper des rubans. Quand Andy Warhol déclarait qu'à l'avenir tout le monde aurait droit à ses quinze minutes de célébrité, il reconnaissait que ce désir d'échapper à l'anonymat était, en cette ère de médias en pleine croissance, beaucoup plus puissante que les critères traditionnels de talents, de beauté ou de grandeur. Il parlait – comme nous le devons tous – pour lui-même. L'absence de tout talent est la condition de cette réussite; ce n'est qu'en personnifiant ce désir – comme l'a fait ce voyeur de Warhol – qu'un individu pourra être étreint sur le sein planétaire.

À mon sens, on a tort d'interpréter les images d'Alison Jackson comme satiriques. Le duc d'Edimbourg sera peut-être gêné de voir une image – apparemment de lui-même – observant Marilyn se masturber, mais c'est secondaire. De même, l'ironie, indubitablement implicite, de surprendre Mick Jagger ou Madonna en train de repasser n'est qu'un attribut superficiel. Nous pouvons retourner la question et nous demander: «Pourquoi trouvons-nous dérangeante l'idée de la reine sur les gogues?». La réponse: parce qu'elle nous oblige à fouiller un peu plus profondément dans notre propre merde. Non, la capacité qu'ont ces images à nous déstabiliser, à nous faire réfléchir et, surtout, à nous faire nous poser des questions, se situe à un niveau plus profond.

Ce sont des scènes de névrose, de domesticité, de fonctions physiologiques, de jeux, de naissance et de mort. Placés devant des miroirs, les porteurs de masque se contemplent; ils subissent des interventions cosmétiques douloureuses sur des bancs matelassés. En voyant brusquement les dieux exactement comme les volailles de basse-cour que nous sommes, une perception à laquelle même les plus réalistes d'entre nous ne peuvent résister, nous sommes amenés à contempler le bonheur très ordinaire de la simple humanité: nos névroses, notre domesticité, nos fonctions physiologiques, nos jeux, nos naissances et nos morts.

Pour moi, ce sont les vrais vanitas des temps modernes, ces représentations allégoriques de la vanité humaine. À l'instar de ces somptueux bouquets de fleurs et de fruits – mais pourrissants, de ces tables extravagantes croulant sous les assiettes et les coupes en or, de ces symboles codés (la flamme qui vacille, le sablier, la montre arrêtée), les vies entraperçues des sujets de Jackson sont profondément figées et chargées de symbolisme. Ce sont des objets que nous convoitons; de fait, ce ne sont pas des objets mais des personnes. C'est la réalité quotidienne, granuleuse, dont nous nous détournons pour nous perdre dans des trahisons glacées ou mates.

Pauvres Pete et Kate, pauvres Tom et Katie, pauvres prince William et Bill Gates, pauvre Michael Jackson qui a tant fait couler d'encre et pauvre idiot de Bush. Pauvre Tony, ne laissant derrière lui qu'un héritage de poussière mêlée à du sang séché. Pauvres tous tant qu'ils sont, et pauvres de nous car, tout comme les fleurs et les fruits des vanitas étaient montrés pourrissants, nous sommes tous en phase de décomposition, nos visages rongés soit par notre célébrité, soit par notre anonymat.

Will Self est l'auteur de sept romans (dont trois courts), de quatre recueils de nouvelles et de cinq essais. Également journaliste, il écrit dans de nombreuses publications comme The Independent *et* The Evening Standard. *Il vit à Londres. Son dernier roman (encore non traduit) s'intitule* The Book of Dave *(2006).*

CHARLES GLASS

No age has designed and purveyed more distractions from reality than ours. Reality is perhaps too ugly for those who impose it on us and reap its benefits for them to market it as well.

In its place, they give us images that mean nothing and somehow convince otherwise rational men and women that knowing what Paris Hilton is putting into her mouth is more important than what Rupert Murdoch stuffs into his pocket. It is no accident that Mr. Murdoch and others who share his wealth and control of means of reaching the public inflict on us images of the trivial, the pointless, and the benign rather than of the rapaciousness of a class that has arrogated to itself most of the world's wealth.

To control the image is to set the terms of debate or to obviate the need for debate. A starving child's picture on page one is fine, so long as it is tied to an appeal from Oxfam rather than a demand for justice that would stop all children from starving. No one published photographs of Robert Maxwell, another baron of the press, once esteemed in the pages of his and his rivals' papers, purloining his employees' pensions. The *Sunday Times* does not show Rupert Murdoch suborning politi-cians to rewrite their countries' media antitrust laws. Nor does the *News of the World* entrap Murdoch's children to publish exposés of decadent lives. Why did the press fail to expose Conrad Black's receipt of non-compete payments that his shareholders never received?

Why did it take other members of the plutocracy, Hollinger's institutional investors, to make the arrangement public? If you own the media, you are unlikely to reveal to the *sansculottes* what you are up to. Your reporters know better than to try. The wise policy, to which any Harvard MBA can attest, is to direct your readers' and viewers' gaze towards the meaningless antics of those you anoint with the dubious title "celebrity."

Advertisers love celebrity coverage. It does not threaten their products' image, and it leaves readers' intellects untainted. Celebrity is egalitarian. Anyone can become one, even a politician. Politicians' independence of the plutocracy has diminished in proportion to the growth of the plutocrats' wealth. Little more than administrators on behalf of the economy's owners, they are accorded the same treatment as rock musicians, game-show hosts, and soap stars. They ascend—or descend—to a constellation of being whereby what they eat, how they dress, and with whom they sleep removes their competence, integrity, and commitment to the common good from public scrutiny.

What can the public know of people whom they do not, in fact, know? How are citizens made to care whether a young prince drinks beer or an actor has a mistress? Alison Jackson

confronts us with the depths of a make-believe world and says, "There. The Queen is crawling on the floor with her corgis. Angelina Jolie is breastfeeding. Becks is sitting on the loo. Now what?" She is no mamarazza staking out a nightclub or knocking shop for the quick snapshot. She takes you right up Elton John's ass, after which you have to ask: "Do I ever want to see a photograph of this man again?" She delves deeper into this pretend world than the photographers who make their living doing it for real. She shows as much as it is possible to see of anyone, and she forces you to ask, "So fucking what?"

"Most of us live in artificial, man-made worlds that limit our experience," wrote Philip Jones Griffiths in the majestic retrospective book of his photography, *Dark Odyssey* (Aperture Foundation, 1996). Jones Griffiths is one of Britain's finest realist photographers, whose life's work has documented war, famine, deprivation, and common people who would never make their way into *Hello* or *OK!* He added, "No need to weave, sing, dance or even talk when the latest soap hits the dish." Nor any need to ask questions more profound than whether one oligarch's soccer club will outplay another oligarch's.

Alison Jackson is an artist rather than a

photojournalist. Her imaginative eye mimics the photographer's craft to turn the ubiquitous celebrity image around, to stretch it beyond logical possibilities, and to make palpable its inherent absurdity. At the same time, she satirizes, as did the best of the Georgian cartoonists, the politicians who have themselves set sail on the sea of celebrity, of lifestyle, of gossip, of product placement, and of mindless opportunities for more mindless celebrity photographs.

Alison Jackson is not mocking celebrities. She is ridiculing us. And we deserve it.

Charles Glass is the author of, among other books, The Tribes Triumphant (2006). *He was* ABC News *Chief Middle East Correspondent and has written for* Granta, The London Review of Books, The Spectator, *and* The Times Literary Supplement.

Kein Zeitalter hat bislang so viele Möglichkeiten geschaffen und geboten, Ablenkung von der Wirklichkeit zu finden, wie das unsrige. Vielleicht ist die Wirklichkeit zu hässlich für die Leute, die sie uns aufdrängen und Nutzen aus ihr ziehen, indem sie sie vermarkten.

Stattdessen bieten sie uns nichtssagende Bilder an, die gleichwohl eigentlich vernünftige Männer und Frauen davon überzeugen, es sei wichtiger zu wissen, was sich Paris Hilton in den Mund steckt, als zu erfahren, was sich Rupert Murdoch in die Taschen stopft. Es ist kein Zufall, dass uns Herr Murdoch und andere, die ähnlich wohlhabend sind wie er und jene Instrumente kontrollieren, mit denen man die Öffentlichkeit erreicht, uns Bilder des Trivialen und Überflüssigen zumuten und lieber die Güte als die Habgier einer Klasse illu-

strieren, die sich den größten Teil des Reichtums dieser Welt angeeignet hat.

Wer die Bilder kontrolliert, bestimmt die Themen oder kann eine notwendige Debatte vermeiden. Das Foto eines hungernden Kindes auf einer Titelseite macht sich gut, sofern es mit einem Aufruf von Oxfam verknüpft ist, nicht aber, wenn es mit der Forderung nach einer Gerechtigkeit verbunden ist, die dazu führen könnte, dass kein Kind mehr hungern muss. Niemand hat Fotos von Robert Maxwell, einem anderen Pressezaren, veröffentlicht, als in seinen eigenen Blättern und den Zeitungen seiner Rivalen auch noch bewundernde Worte zu lesen waren, dass er die Renten seiner Angestellten hat mitgehen lassen. Wenn Rupert Murdoch Politiker bedrängt, die Kartellgesetze für die Medienindustrie des jeweiligen Landes neu zu fassen, ist in der *Sunday Times* nichts davon zu sehen. Und die *News of the World* lauert auch nicht Murdochs Kindern auf, um der Öffentlichkeit eine dekadente Lebensführung zu enthüllen. Warum war die Presse nicht in der Lage darzulegen, wie Conrad Black Gelder seiner Anteilseigner in die eigenen Taschen fließen ließ? Warum mussten erst andere Mitglieder der Plutokratie, Hollingers institutionelle Anleger, die Sache publik machen? Wer die Medien sein Eigen nennt, wird den Sansculotten nicht gerade auf die Nase binden, was er vorhat. Und die Reporter wissen, wo sie sich besser zurückhalten. Die kluge Taktik, die jeder Harvard-Absolvent bestätigen kann, besteht darin, die Leser und den Blick der Zuschauer auf die belanglosen Eskapaden jener zu lenken, die man selbst zuvor mit dem zweifelhaften Titel „Prominenter" gekürt hat.

Anzeigenkunden lieben die Berichterstattung über Prominente. Für das Image ihrer Produkte ist sie in keiner Weise bedrohlich, und der Verstand der Leser bleibt unbefleckt. Prominenz hat etwas Gleichmacherisches.

Jeder kann berühmt werden, sogar ein Politiker. Die Unabhängigkeit der Politiker von der Plutokratie schwand im gleichen Maße, wie das Vermögen der Plutokratie wuchs. Als Figuren, die kaum noch mehr sind als Handlanger jener, die die wirtschaftliche Macht besitzen, wird ihnen die gleiche Behandlung zuteil wie Rockmusikern, Gameshow-Gästen und Seifenopernstars. Ihr Aufstieg oder Fall vollzieht sich unter den Augen der Öffentlichkeit nicht mehr entsprechend ihrer Kompetenz, Integrität oder Verpflichtung auf das Wohl der Allgemeinheit. Kriterien sind inzwischen, was sie essen, wie sie sich kleiden und mit wem sie schlafen.

Was kann das Publikum über Leute wissen, die sie doch in Wirklichkeit gar nicht kennen? Was sind das für Bürger, die sich darum scheren, ob ein junger Prinz Bier trinkt oder ein Schauspieler eine Geliebte hat? Alison Jackson konfrontiert uns mit den Abgründen einer Scheinwelt und sagt: „Schaut her. Die Queen kriecht mit ihren Corgis auf dem Boden herum. Angelina Jolie stillt ihr Baby. David Beckham hockt auf dem Klo. Na und?" Sie ist keine Mammarazza, die einen Nachtclub oder einen Puff belagert, um mal schnell einen Schnappschuss zu machen. Sie präsentiert Elton Johns Arsch, und man fragt sich danach: „Muss ich je wieder ein Foto dieses Mannes sehen?" Sie wühlt sich tiefer in diese falsche Welt als jene Fotografen, die ihren Lebensunterhalt damit verdienen, dass sie sich wirklich in ihr tummeln. Sie zeigt von jedem alles, was man überhaupt zeigen kann, und zwingt den Betrachter schließlich zu einem „Was kümmert mich das?".

„Die meisten von uns leben in künstlichen, von Menschenhand geschaffenen Welten, die unseren Erfahrungshorizont begrenzen", schrieb Philip Jones Griffith in *Dark Odyssey* (Aperture Foundation, 1996), einer stattlichen Retrospektive seines foto-

CHARLES GLASS

grafischen Werks. Jones Griffith, einer der vorzüglichsten realistischen Fotografen Großbritanniens, dokumentierte mit seinem Lebenswerk Krieg, Hunger, Entbehrung und jene gewöhnlichen Menschen, die nie eine Chance hätten, in *Hello* oder *OK!* vorzukommen. Und er bemerkte: „Wer soll denn noch weben, singen, tanzen oder auch nur reden, wenn die neueste Seifenoper beim Essen läuft?" Und tiefgründigere Fragen als die, ob der Fußballclub des einen Oligarchen wohl den des anderen Oligarchen schlagen wird, sind auch nicht mehr nötig. Alison Jackson ist eher eine Künstlerin als eine Fotojournalistin. Ihr fantasiebegabter Blick bedient sich der Technik des Fotografen, um das allgegenwärtige Bild eines Prominenten umzukrempeln, es jenseits erklärbarer Möglichkeiten anzusiedeln und die ihm innewohnende Absurdität spürbar zu machen. Gleichzeitig nimmt sie wie die besten Karikaturisten der Ära König Georgs jene Politiker aufs Korn, die im Namen der Prominenz, des Lifestyles, des Klatsches und der Selbstvermarktung jede sich bietende Möglichkeit nutzen, noch geistlosere Prominentenfotos von sich machen zu lassen.

Alison Jackson macht sich nicht über Prominente lustig. Sie verspottet uns. Wir haben es verdient.

Charles Glass ist unter anderem Autor des Buches The Tribes Triumphant *(2006). Er war Chefkorrespondent der* ABC-News *für den Nahen Osten und schreibt für* Granta, The London Review of Books, The Spectator *und das* Times Literary Supplement.

Jamais on a inventé et fourni autant de moyens de nous détourner de la réalité. Sans doute celle-ci est-elle trop laide pour ceux qui nous l'imposent, sans compter qu'il est plus rentable pour eux de la transformer en produit. À sa place, ils nous servent des images qui ne veulent rien dire et parviennent à convaincre des hommes et des femmes, pourtant rationnels, que savoir ce que Paris Hilton se fourre dans la bouche est plus important que ce que Rupert Murdoch se fourre dans les poches. Ce n'est pas un hasard si M. Murdoch ainsi que ceux qui partagent sa fortune et sa mainmise sur les moyens de communication nous infligent des images du trivial, de l'inutile et de l'inoffensif plutôt que celles de la rapacité d'une classe qui s'est accaparé la plus grande partie des richesses du monde.

Contrôler l'image signifie définir les termes du débat ou supprimer la nécessité d'un débat. L'image d'un enfant affamé en première page, c'est bien, tant qu'elle est associée à un appel de dons d'une organisation caritative et non à la revendication d'une justice qui empêcherait tous les enfants de mourir de faim. Personne n'a publié de photos de Robert Maxwell, autre baron de la presse autrefois très estimé dans ses journaux et ceux de ses concurrents, détournant les fonds de pension de ses employés. Le *Sunday Times* ne montre pas Rupert Murdoch arrosant des politiciens de par le monde pour qu'ils réécrivent leur législation antitrust visant à empêcher la concentration dans les médias. *News of the World* ne traque pas non plus les enfants de Murdoch pour publier des reportages sur leurs vies décadentes. Pourquoi la presse n'a-t-elle pas révélé les paiements de non-concurrence de Conrad Black dont ses actionnaires n'ont jamais vu un centime? Pourquoi a-t-il fallu que ce soit d'autres membres de la ploutocratie, les investisseurs institutionnels d'Hollinger, qui dévoilent la magouille? Quand vous possédez les médias, vous n'annoncez pas aux sans-culottes ce que vous trafiquez. Vos journalistes savent où ils ne doivent pas mettre les pieds. La meilleure politique, n'importe quel gestionnaire formé à Harvard vous le confirmera, est de diriger le regard de vos lecteurs vers les bouffonneries insignifiantes de ceux que vous avez anoblis du titre douteux de «célébrité».

Les annonceurs adorent la presse people. Elle ne menace pas l'image de leurs produits et ne corrompt pas l'intellect des lecteurs. La célébrité est égalitaire. N'importe qui peut en devenir une, même un politicien. L'indépendance des hommes politiques face à la ploutocratie a diminué proportionnellement à la croissance de la fortune des ploutocrates. Réduits au rôle d'administrateurs au service des propriétaires de l'économie, ils sont traités de la même manière que les rock stars, les animateurs de jeux télévisés et des vedettes de soaps. Ils s'élèvent vers (ou sombrent dans) une constellation où ce qu'ils mangent, portent et avec qui ils couchent a plus de poids que leur compétence, leur intégrité et leur engagement à servir la communauté au regard du peuple.

Qu'est-ce que le public peut savoir de gens dont, au fond, il ne sait rien? Comment fait-on pour que les citoyens se soucient de savoir si un jeune prince boit de la bière ou si un acteur a une maîtresse? Alison Jackson nous confronte avec les profondeurs d'un monde de faux semblants et nous dit: «Regardez, la reine rampe à quatre pattes avec ses corgis. Angelina Jolie allaite son bébé. Beckam est au petit coin. Et maintenant?» Ce n'est pas une mamarazza guettant à la sortie d'un night-club ou d'un bordel. Elle nous présente jusqu'au trou du cul d'Elton John; après quoi, on est en droit de s'interroger: «Ai-je vraiment envie de revoir une photo de ce type?» Dans ce monde factice elle va plus loin que les photographes qui en vivent pour de vrai. Elle montre autant qu'il est possible de montrer et vous force à demander: «Et alors?»

Dans le superbe album-rétrospective de son Œuvre, *Dark Odyssey* (Aperture

Foundation, 1996), Philip Jones Griffiths écrit: « La plupart d'entre nous vivons dans des mondes artificiels créés par l'homme, qui limitent notre expérience. » Jones Griffiths est l'un des meilleurs photographes réalistes britanniques. Il a consacré sa vie à documenter la guerre, la famine, la misère et la vie d' hommes ordinaires qui n'apparaîtront jamais dans les pages de *Hello* ou de *OK!*. Il ajoute : « Pas besoin de tisser, de chanter, de danser ni même de parler quand commence le dernier soap. » Pas besoin non plus de poser de questions plus profondes

que de savoir si le club de foot d'un oligarque battra celui d'un autre oligarque.

Alison Jackson est une artiste plutôt qu'une reporter-photographe. Son regard créatif imite le travail du photographe pour détourner l'image omniprésente de la célébrité, l'étirer au-delà de ses possibilités logiques et rendre palpable son absurdité inhérente. Parallèlement, elle satirise, dans la lignée des meilleurs caricaturistes anglais du 18e siècle, les politiciens qui se sont lancés eux-mêmes sur cet océan de célébrité, de mode de vie, de potins, de placement de

produits et d'occasions gratuites pour toujours plus de clichés bêtifiants de célébrités.

Alison Jackson ne se moque pas des célébrités. Elle nous ridiculise. Et nous l'avons bien cherché.

Charles Glass est l'auteur de nombreux ouvrages dont The Tribes Triumphant *(2006). Il a été le principal correspondant d'*ABC News *au Moyen Orient et a écrit pour* Granta, The London Review of Books, The Spectator *et le* Times Literary Supplement.

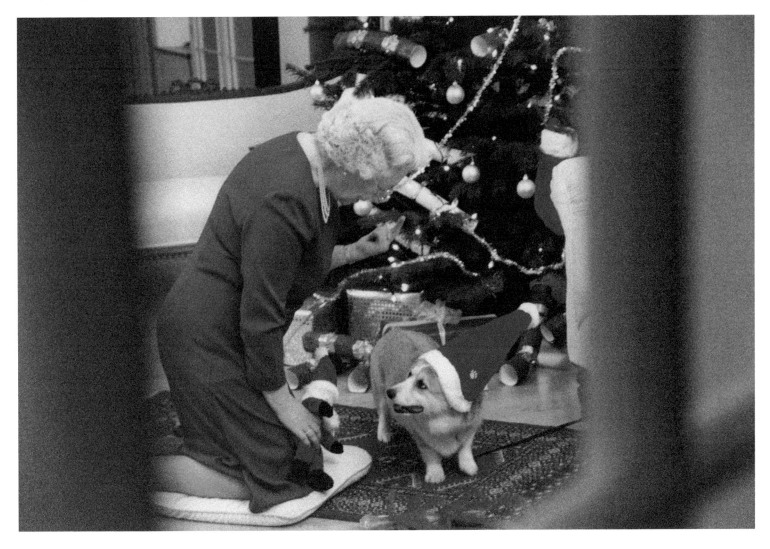

The phenomenon of celebrity, as we know it today, with its dazzling omni-present stars, is inconceivable without photography. We live in the image.

Thanks to photographs, still or moving, the faces of a Paris or a Britney, a Di or a Camilla, are seared into our minds; they are the brands, and we are the branded.

With whose face are you more familiar today: your grandfather's face, or Bill Clinton's? This is all grist for Alison Jackson's mill.

Jackson is acutely aware of photography's complex codes, and revels in counterintelligence operations. She knows that it is a conceit of our age to believe that we have invented celebrity photography. The photography of the famous (the high and the low) began more or less with the invention of photography, and the codes have mutated constantly. A quick look back at celebrity photography may help us better appreciate Jackson's mischief.

It is a misconception to think that celebrity photography has always been about glamorizing and idealizing beauty. It clearly has been this at times—one only has to think of the heavily retouched glamour portraiture of the 1920s and 1930s—but modern tastes find such pictures risible. We want to believe that what we are looking at is natural. Earlier periods of photography have also, in the main, wanted imagery rooted in reality. In 1858 we read of Herbert Watkin's portraits of celebrities, which "will no doubt prove interesting to the general public who will be anxious to behold the lineaments of those about whom they may have heard or read much." People first wanted contact, familiarity; they just wanted to see. It is difficult to believe, yet true, that when photographs became affordable for the average person and therefore readily accessible, it was not uncommon for people to buy portraits of absolute strangers. For a brief moment, everybody (or anybody) was worth celebrating.

The photography of celebrities as we know it began with tiny, stiff *cartes de visite*, which were much like playing cards, and it was a measure of their novelty that they were collected and traded eagerly, as children do with their manga cards today. Strangely, however, it was the banal aspect of photography that elevated the modern celebrity to cosmic heights. In the century before photography, famous statesmen, dancers, writers, actors, and actresses were worshipped in highly idealized

drawings and lithographs: leading ballerinas, for example, were depicted floating ethereally above the earth, with perfect pencil-point toes. Photography brought them down to earth with a thud. Those same dancers (up close and deprived of the artful *mise-en-scène* of the stage) appear in early daguerreotypes and *cartes de visite* as lumpy, earthbound creatures, hardly the stuff of dreams. Photographs wrecked illusions. Yet people couldn't get enough of them! They loved the fact that their idols were flawed, human. Photography brought a new warts-and-all intimacy, and disturbed the social order as well. We read that "gaping crowds" assembled in front of shop windows, where they were "delighted with such discordant elements of the social fabric as Nellie Farren and Lord Napier, the Bishop of Manchester and Miss Mabel Love"—that is, the high and the low, all brought to earth via photography.

The globalization, so to speak, of celebrity was evident as early as 1865. London's *Photographic News* reported that "an immense order from Japan has reached Paris for photographs of all the European royalties." The good news "spread like wildfire among photographers, and two hundred of them are on their way to that remote region." By 1870 the same magazine could conclude that "photography is becoming one of the most commonly recognized tests of popular interest in any person or thing, and the frequency with which a portrait is exhibited is regarded as the measure of the popularity or notoriety of the original."

By 1890 there was more sophistication on the part of the public, and a gossip columnist mocked the photographs of the Belgian royal family: "The Princess leans on the Prince in what is doubtless intended to represent an affectionate attitude, but the impression produced is that she is taking his measure for a coat." Where was this "democratic regard" of

photography taking us? Surely, sniffed the writer, towards a "supreme negligence of order of any kind."

There was much anxiety about celebrity photography. It was noted that a new kind of female celebrity was emerging, one based neither on social class nor on classic beauty or attainment, but merely on being photogenic. A new term was invented—"the professional beauty." Celebrity photography was also seen as an invasion of privacy by many. In 1890 a certain Captain Illarinoff, a Russian, embarked on a European tour with a phonograph and a camera, hoping to make photographs of celebrities and record their words at the same time. A magazine article surmised that the Captain would probably end up with a photograph "of an irate celebrity ejecting him forcibly from his premises, accompanied by a phonographic record of what the celebrity said while doing so." (To 21st-century ears, this catastrophic scenario sounds all too familiar. Sadly, the good Captain seems to have disappeared from history, strangled or buried alive, perhaps, by his desperate cornered prey.)

Meanwhile, in England, a photograph of Prince William that was being exhibited in London shop windows had become the subject of much curiosity: "Prince William has a deformed arm, nearly dead, and finished off with a ball of flesh, kept in a pouch. In the photograph the left hand is concealed by the boy's cap, and there is nothing to show the deformity. … The anxiety of the spectators to make out the shape of the hand is quite typical of the interest which anything concerning royalty, no matter how insignificant, creates." This observation, too, seems familiar!

But royalty came to tire of photography's incessant demands. Empress Eugenie, having learned the hard way that photographs didn't always flatter, had decided never again to "honour photographs with sittings." Alarmed,

WILLIAM EWING

The *Photographic News* hoped that "no member of our Royal Family will follow suit." But the same writer observed more presciently that, actually, "as long as the Queen allows herself to be photographed, it doesn't matter very much whether she appears in public or not." This lesson would be learned anew on the death of Princess Diana, when editors around the world realized that they had a vast enough repository of pictures to keep Diana "alive" for years.

The Prince and Princess of Wales were responsible for a modest scandal involving photography—in 1870. It appears that a royal baby had not acted regal enough during a portrait sitting, and an impatient Prince had suggested using any other baby, on the Alison Jackson-like principle that, to quote the Prince, "all babies of that age are alike!" Reporting the incident, the journalist suggested another alternative to the real thing: "a laughing, crying model made from india-rubber or other plastic and flexible material."

Jackson may be specifically addressing the cult of celebrity of the here-and-now, but clearly the issues she addresses are deeply rooted in photographic history. Princess Di is alive and well, photographically speaking. She has married Dodi, and the baby is beautiful. Don't we have a sublime studio portrait à la Lord Snowdon to prove it? And doesn't the adoring gaze Di gives her baby prove that she is a natural mother?

As Jackson well knows, photography does not just register. It amplifies and empowers. When people see a star in the flesh, they are almost always disappointed. "He is so small!" they often say. In one of the 19th-century accounts quoted earlier, the celebrity was called "the original," and the photograph a "pale copy." It would seem that the 21st century has reversed the equation: now the photograph appears to be the original, and the celebrity the

pale copy. The best way for a celebrity to remain in the limelight today is to stay out of sight.

Alison Jackson could have resorted to electronic manipulation for her fictions, but that would have deprived the images of frisson: our delight is knowing that they are look-alikes, tempered with a nagging doubt: are we always sure? In an age of digital manipulation we'd be forgiven for assuming her cast of characters were pixelated avatars instead of look-alikes. In fact, Jackson delights in traditional photography, and especially its application in the domain of celebrity. She enjoys mocking the photograph's conventions and confusing its codes. Ironically, her photographs can claim objective, documentary status: there is no retouching, no darkroom trickery. She shows reality. It is we who bring to the work the fiction, willing these characters to be the gods and goddesses we crave.

William Ewing, *director of the Musée de l'Eysée, Lausanne, is a noted author and photography curator. His exhibitions have been shown at the Museum of Modern Art, the International Center of Photography, and many other museums and galleries worldwide. His most recent book is* Face: The New Photographic Portrait *(2006), and he is celebrated as author of* The Body *(1994).*

Ohne die Fotografie ist das Phänomen Berühmtheit, so, wie wir es heute erleben, mit all jenen strahlenden, omnipräsenten Stars, unvorstellbar. Wir leben in einer Bilderwelt. Ob durch Einzelaufnahmen oder bewegte Bilder, die Gesichter von Paris oder Britney, Diana oder Camilla prägen sich uns ein. Sie sind die Markenzeichen, wir die Gebrandmarkten. Wessen Gesicht, verehrter

Leser, ist Ihnen heute vertrauter – das Ihres Großvaters oder das von Bill Clinton? Genau das ist Wasser auf die Mühlen von Alison Jackson.

Sie ist sich der komplexen Codes der Fotografie sehr bewusst und hat an Manövern der Spionageabwehr ihre wahre Freude. Sie weiß, dass wir uns einbilden, die Starfotografie sei eine Erfindung unseres Zeitalters. Doch das Ablichten berühmter Persönlichkeiten (höheren oder niederen Ranges) setzte mehr oder weniger bereits mit der Erfindung der Fotografie ein, und die Codes haben sich unablässig verändert. Ein kurzer Blick zurück auf die Geschichte der Fotografie berühmter Menschen mag uns helfen, Alison Jacksons Streiche auch wirklich zu würdigen.

Es ist irrig zu meinen, bei der Fotografie von Berühmtheiten habe stets die Verherrlichung und Idealisierung von Schönheit im Mittelpunkt gestanden. Zu gewissen Zeiten war dies tatsächlich der Fall – man denke nur an die Glamourporträts der 1920er und 1930er Jahre –, doch vom heutigen Gesichtspunkt aus betrachtet wirken solche Bilder lächerlich. Wir wiegen uns gerne in dem Glauben, dass alles, was wir betrachten, ganz natürlich ist. Auch in den frühen Jahren der Fotografie war man schon im Wesentlichen bestrebt, die Bildsprache in der Realität zu verankern. 1858 war zu Herbert Watkins Porträts von Berühmtheiten zu lesen, sie seien „zweifellos von Interesse für das allgemeine Publikum, das darauf bedacht ist, sich die Gesichtszüge der Menschen einzuprägen, von denen es so viel gehört oder gelesen hat." In erster Linie ging es den Leuten um einen Kontakt, um Vertrautheit, sie wollten einfach etwas fürs Auge. Man mag es kaum glauben, doch es stimmt: Als Fotografien für jedermann erschwinglich und damit leichter zugänglich wurde, war es nichts Ungewöhnliches, dass

man sich Porträts völlig fremder Personen kaufte. Für einen kurzen Moment erschien jeder x-Beliebige der Huldigung wert.

Am Anfang der Prominentenfotografie, wie wir sie kennen, standen winzige, steife Visitenkarten, die eher wie Spielkarten aussahen, und der Umstand, dass sie gesammelt und eifrig gehandelt wurden – so, wie es Kinder heutzutage mit Manga-Kärtchen tun –, mag uns eine Vorstellung davon vermitteln, wie attraktiv dieses Novum damals war. Wie dem auch sei, seltsamerweise war es der banale Aspekt der Fotografie, der moderne Berühmtheiten in kosmische Höhen katapultierte. In dem Jahrhundert vor der Erfindung der Fotografie drückte sich die Verehrung für bekannte Staatsmänner, Tänzerinnen, Schriftsteller, Schauspieler und Schauspielerinnen in stark idealisierten Zeichnungen und Lithografien aus: Primaballerinen zum Beispiel wurden geradezu ätherisch auf hauchdünnen Zehenspitzen über dem Erdboden schwebend dargestellt. Die Fotografie brachte sie buchstäblich mit einem Rums auf den Boden der Tatsachen zurück. Just jene Tänzerinnen wirken (von Nahem besehen und bar jeglicher kunstvoller *Mise-en-scène* einer Bühne) auf frühen Daguerreotypien und Visitenkarten wie plumpe und sehr irdische Kreaturen, die nicht unbedingt zum Träumen reizen. Fotografien zerstörten Illusionen. Doch die Leute konnten nicht genug davon bekommen! Ihnen gefiel die Tatsache, dass ihre Idole mit Makeln behaftete menschliche Wesen waren. Die Fotografie enthüllte Fehler und Schwächen und brachte auch Unruhe ins soziale Ordnungsgefüge. Es wird berichtet von „gaffenden Menschenmengen", die sich vor Schaufenstern versammelten und darüber „amüsierten, dass so gegensätzliche Elemente der Gesellschaft wie Nellie Farren und Lord Napier, der Bischof von Manchester und Miss Maple Love" zusammengebracht wurden – ob

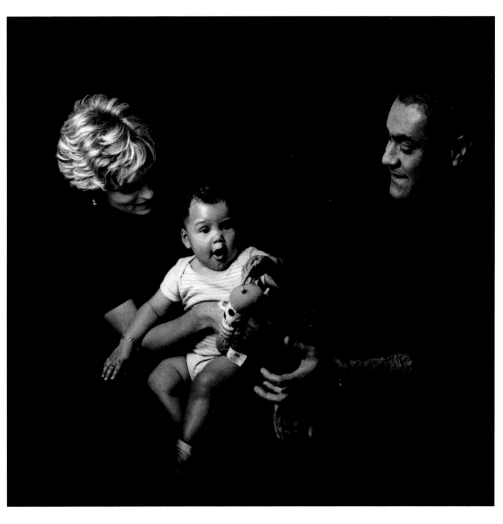

höhere Kreise oder niedere Stände, die Fotografie beförderte sie alle in die gleiche Realität.

Die Globalisierung von Prominenz deutete sich bereits 1865 an. Die Londoner *Photographic News* berichtete, dass „in Paris aus Japan ungeheure Mengen von Fotografien aller europäischen königlichen Hoheiten bestellt wurden." Diese aufregende Nachricht „verbreitete sich unter Fotografen wie ein Buschfeuer, und nun machen sich zweihundert Vertreter dieser Zunft auf in jene ferne Weltgegend." 1870 konnte die gleiche Zeitschrift feststellen, dass „die Fotografie auf

dem besten Wege ist, sich zum allgemein anerkannten Prüfstein für das öffentliche Interesse an jeglicher Person oder Sache zu entwickeln und die Häufigkeit, mit der ein Porträt ausgestellt und betrachtet wird, kann als Maßstab für die Beliebtheit oder Bekanntheit des Abgebildeten gelten." 1890 sah das Publikum dann schon genauer hin, und ein Klatschkolumnist spottete über die Fotos der belgischen Königsfamilie: „Die Prinzessin lehnt sich an den Prinzen, zweifellos eine Geste, die Zuneigung verdeutlichen soll, doch man hat eher den Eindruck, als wolle sie bei ihm Maß für einen Mantel nehmen." Wohin

brachte uns dieser „demokratische Blick", den die Fotografie uns lehrte? Sicherlich, so der Autor naserümpfend, zu jener „uneingeschränkten Missachtung jeglicher Ordnung."

Die Prominentenfotografie gab einigen Anlass zu Besorgnis. Man stellte fest, dass sich eine neue Art weiblicher Prominenz herausbildete, die weder auf der Zugehörigkeit zu einer bestimmten sozialen Klasse noch auf klassischer Schönheit oder irgendwelchen Leistungen gründete, es genügte, fotogen zu sein. Ein neuer Begriff – „professionelle Schönheit" – kam auf. Prominentenfotografie wurde auch als Eindringen in die Privatsphäre wahrgenommen. 1890 begab sich ein gewisser Hauptmann Illarinoff, ein Russe, bewaffnet mit einem Phonographen und einer Kamera, auf Europatour. Er hoffte, Berühmtheiten fotografieren und gleichzeitig ihre Stimmen aufnehmen zu können. In einem Zeitschriftenartikel wurde gemutmaßt, der Hauptmann werde wohl mit einer Fotografie enden, die „eine erzürnte Berühmtheit zeigt, die ihn gerade gewaltsam von ihrem Anwesen verweist, zusammen mit einer phonographischen Aufzeichnung dessen, was die Berühmtheit dabei von sich gegeben hat." (Ein solches Katastrophenszenario kommt uns Zeitgenossen des 21. Jahrhunderts nur allzu bekannt vor. Betrüblicherweise blieb der gute Hauptmann wie vom Erdboden verschluckt, von seinem erbosten, in die Enge getriebenen Opfer vielleicht aufgeknüpft oder lebendig begraben.)

Inzwischen erweckte ein Foto von Prinz William, das in Londoner Schaufenstern ausgestellt wurde, große Neugierde: „Prinz William hat einen fast völlig unbrauchbaren verkrüppelten Arm, der in einem von einer Ledermanschette umhüllten Fleischklumpen endet. Auf der Fotografie wird er von der Mütze des Jungen verdeckt, nichts weist auf die Missbildung hin … Das Verlangen der Gaffer, die Umrisse der Hand ausmachen zu

wollen, ist typisch für das Interesse an allem, was die Königsfamilie betrifft, gleichgültig, wie unwichtig es ist." Auch diese Beobachtung kommt uns sehr bekannt vor!

Die Königlichen wurden der unablässigen Ansprüche, die die Fotografie an sie stellte, müde. Kaiserin Eugénie, die unangenehmerweise die Erfahrung machen musste, dass Fotografien die dargestellte Person nicht immer vorteilhaft aussehen lassen, hatte beschlossen, „Fotografen" nie wieder „mit Posieren zu beehren." Darob ganz beunruhigt, äußerte die *Photographic News* die Hoffnung, dass „kein Mitglied unserer königlichen Familie diesem Beispiel folgen möge." Der gleiche Autor stellte allerdings auch vorausschauend fest, dass es „kaum darauf ankommt, ob sich die Königin in der Öffentlichkeit zeigt oder nicht, sofern sie sich weiterhin fotografieren lässt." Diese Erkenntnis sollte sich nach dem Tod von Prinzessin Diana erneut durchsetzen, als Verleger auf der ganzen Welt feststellten, dass sie noch über so reichliches Bildmaterial verfügten, dass sie Diana noch über Jahre hinaus „am Leben" erhalten konnten.

Der Prinz und die Prinzessin von Wales sorgten – im Jahr 1870 – für einen bescheidenen Skandal in Sachen Fotografie. Offensichtlich hatte sich ein königliches Baby während Porträtaufnahmen nicht majestätisch genug verhalten, und so schlug der ungehaltene Prinz vor, man möge doch ein anderes Baby nehmen, und erklärte, ganz den Prinzipien Alison Jacksons entsprechend, „alle Babys dieses Alters sehen doch ohnehin gleich aus"! Der Journalist, der über den Vorfall berichtete, schlug daraufhin vor, man könne doch, statt eines echten Säuglings, auch „eine lachende, plärrende Puppe aus Kautschuk oder einem anderen künstlichen und formbaren Material" nehmen.

Alison Jackson mag ausdrücklich an den Prominentenkult des hier und jetzt anknüpfen,

doch die Themen, die sie anspricht, sind tief in der Geschichte der Fotografie verwurzelt. Prinzessin Diana lebt und ist wohlauf, fotografisch gesehen. Sie hat Dodi geheiratet, und das Baby ist ganz entzückend. Gibt es da nicht als Beweis dieses erhabene Studioporträt in der Manier Lord Snowdons? Und zeigt der hingebungsvolle Blick, den Diana ihrem Baby schenkt, nicht klar und deutlich, dass sie eine geborene Mutter ist?

Alison Jackson weiß sehr genau, dass die Fotografie nicht nur aufzeichnet. Sie verstärkt und hebt hervor. Sehen die Leute einen Star aus Fleisch und Blut, sind sie fast immer enttäuscht. „Er ist ja so klein!", heißt es dann oft. In einem der schon zitierten Berichte aus dem 19. Jahrhundert wird die Berühmtheit als „das Original" bezeichnet und die Fotografie als „müder Abklatsch". Man könnte meinen, diese Gleichung habe sich im 21. Jahrhundert umgekehrt: Heutzutage scheint die Fotografie das Original zu sein und der Prominente der müde Abklatsch. Die beste Möglichkeit für einen Prominenten heute, im Scheinwerferlicht zu bleiben, scheint darin zu bestehen, sich nicht blicken zu lassen.

Alison Jackson hätte sich für ihre fiktiven Bilder elektronischer Manipulation bedienen können, doch das hätte den Aufnahmen den schönen Schauer genommen: Unser Vergnügen besteht darin zu wissen, dass wir es hier mit Doppelgängern zu tun haben, dass dabei jedoch stets der quälende Zweifel mitschwingt: Sind wir uns dessen auch immer ganz sicher? Im Zeitalter digitaler Manipulation würde es uns niemand verdenken, wenn wir ihre Figuren für gepixelte Avatare statt für Doppelgänger halten. Aber sie hat an traditioneller Fotografie, vor allem an ihrem Einsatz im Hinblick auf Prominente, ihre wahre Freude. Vergnügt setzt sie sich über Bildkonventionen hinweg und wirbelt die Codes durcheinander. Ironischerweise können

ihre Fotos Objektivität, einen dokumentarischen Charakter beanspruchen: Da ist nichts retuschiert oder in der Dunkelkammer getrickst. Sie zeigt die Realität. Wir sind es, in deren Köpfen die dazugehörigen Storys ihren Ausgang nehmen, weil uns die Vorstellung gefällt, diese Figuren seien die Götter und Göttinnen, nach denen wir gieren.

William Ewing, Direktor des Musée de l'Élysée Lausanne, ist als Autor und als Kurator für Fotografie bekannt. Von ihm verantwortete Ausstellungen waren im Museum of Modern Art, im International Center of Photography sowie in zahlreichen anderen Museen und Galerien der Welt zu sehen. Sein neuestes Buch heißt Face: The New Photographic Portrait *(2006), er ist auch der Autor des bekannten Buches* The Body *(1994).*

Le phénomène de la célébrité telle que nous la connaissons aujourd'hui, avec ses stars éblouissantes et omniprésentes, est inconcevable sans la photographie. Nous vivons dans l'image. Grâce à elle, figée ou animée, les traits de Paris ou de Britney, de Lady Di ou de Camilla sont gravés dans nos esprits. Ce sont des fers dont la marque a été grillée dans nos chairs. Quel visage vous est-il le plus familier aujourd'hui, celui de Bill Clinton ou celui de votre grand-père? Tout ceci apporte de l'eau au moulin d'Alison Jackson.

Profondément consciente des codes complexes de la photographie, Jackson s'amuse à monter des opérations de contre-espionnage. Elle sait que c'est une vanité de notre temps de croire que nous avons inventé la photo de célébrité. Les photos de gens célèbres (pour le meilleur et pour le pire) sont nées plus ou moins en même temps que la photographie elle-même, et les codes n'ont cessé de muer depuis. Un bref regard sur son histoire nous aidera peut-être à mieux apprécier l'espièglerie de Jackson.

On croit à tort que la photographie de célébrité a toujours cherché à idéaliser la beauté. Ce fut parfois le cas (il suffit de penser aux portraits glamour fortement retouchés des années vingt et trente), mais le goût moderne trouve ces images risibles. Nous voulons croire que ce que nous voyons est naturel. Les premiers photographes ont, en général, également recherché une iconographie enracinée dans la réalité. En 1858, on lit à propos des portraits de célébrités d'Herbert Watkin qu'ils «intéresseront sans nul doute le grand public très curieux de voir enfin les traits de ceux dont il a tant entendu parler ou sur lesquels il a tant lu». Les gens demandaient avant tout un contact, la familiarité; ils voulaient simplement voir. Incroyable mais vrai: lorsque les photos devinrent facilement accessibles, à la portée de toutes les bourses, il n'était pas rare que des gens achètent des portraits de parfaits inconnus. L'espace d'un bref instant, tout le monde (ou n'importe qui) méritait d'être célébré.

Les photos de célébrités sont d'abord apparues sous la forme de petites «cartes de visite», très semblables à des cartes à jouer. Leur succès était tel qu'elles étaient collectionnées et échangées avec passion, comme le font aujourd'hui les enfants avec leurs cartes manga. Paradoxalement, ce fut la banalité même de l'image photographique qui éleva la célébrité moderne à des hauteurs cosmiques. Avant l'avènement de la photographie, les hommes d'État, les danseurs, les écrivains, les acteurs et les actrices étaient vénérés au travers de dessins et de lithographies très idéalisés. Les grandes ballerines, par exemple, étaient représentées telles des nymphes éthérées flottant au-dessus du sol, leurs orteils délicats pointés à la perfection. La photographie les ramena lourdement à terre. Ces mêmes ballerines, vues de près et sans mise en scène soignée, apparaissent sur les premiers daguerréotypes et cartes de visites comme des créatures rondelettes et très terrestres. Pas vraiment de quoi faire rêver. Les photographies brisaient les illusions et pourtant les gens en redemandaient! Ils aimaient découvrir que leurs idoles étaient imparfaites, humaines. En montrant tous les défauts, la photographie créait une intimité et perturbait l'ordre social. Des «attroupements de badauds fascinés» se formaient devant les vitrines, «se délectant de voir des éléments discordants du tissu social tels que Nellie Farren et lord Napier, l'évêque de Manchester et Miss Mabel Love», à savoir le haut et le bas du panier, tous ramenés sur terre par la photographie.

La «mondialisation» de la célébrité se faisait déjà sentir dès 1865. Le *Photographic News* de Londres rapporte que «Paris a reçu du Japon une commande énorme de photographies de toutes les têtes couronnées d'Europe». La bonne nouvelle «s'est répandue comme une traînée de poudre parmi les photographes et deux cents d'entre eux sont déjà en route vers ce pays lointain». En 1870, la même revue concluait: «La photographie est en passe de devenir le meilleur indicateur de l'intérêt populaire pour une personnalité ou un objet, et la fréquence avec laquelle un portrait est exposé permet de mesurer la popularité ou la notoriété de l'original.»

En 1890, le public était devenu plus sophistiqué et un chroniqueur mondain se moquait ainsi des photos de la famille royale belge: «La princesse est penchée vers le prince dans ce qui se veut sans doute un geste de tendresse mais elle donne plutôt l'impression d'être en train de prendre ses mesures pour un manteau.» Où nous conduisait donc cette «considération démocratique» de la photogra-

phie? D'après le chroniqueur, vers «une suprême négligence de l'ordre sous toutes ses formes».

La photographie de célébrités déclenchait beaucoup de passions. On remarqua l'émergence d'un nouveau type de femme célèbre. Sa notoriété ne se basait ni sur son rang social ni sur sa beauté classique ni sur ses accomplissements, mais sur le simple fait d'être photogénique. On inventa un nouveau terme : «la beauté professionnelle». La photographie de célébrité était également vécue par beaucoup comme une viol de l'intimité. En 1890, un certain capitaine russe, Illarinoff, entama un tour d'Europe, armé d'un phonographe et d'un appareil photo, afin de photographier des célébrités et d'enregistrer leurs propos simultanément. Un article dans un magazine déclara que le capitaine finirait probablement avec une photo d'une «célébrité courroucée l'expulsant manu militari de chez elle, accompagné d'un enregistrement phonographique d'un flot d'injures». (Pour le lecteur du 21e siècle, ce scénario catastrophe paraît bien familier. Hélas, le brave capitaine semble avoir disparu sans laisser de traces, peut-être étranglé ou enterré vivant par une de ses proies acculée au désespoir).

Entre-temps, en Angleterre, une photo du prince William exposée dans une vitrine de Londres suscita une vive curiosité : «Le prince William a un bras difforme, pratiquement mort, qui finit par une boule de chair enfouie dans un petit étui. Sur la photo, sa main gauche est cachée par sa casquette et rien ne laisse trahir son handicap... Les efforts des spectateurs pour tenter de distinguer la forme de la main est typique de l'intérêt pour tout ce qui touche à la royauté, aussi insignifiant cela soit-il.» Là encore, cette observation nous paraît familière!

Mais la royauté finit par se lasser des exigences incessantes de la photographie. L'impératrice Eugénie, ayant appris à ses dépens que les photographies n'étaient pas toujours flatteuses, décida de ne «plus jamais poser devant un appareil photo». Alarmé, le *Photographic News* espéra «qu'aucun membre de notre famille royale ne suivrait son exemple». Toutefois, le même auteur observa également avec plus de prescience : «Tant que la reine elle-même se laisse photographier, il n'est pas très important qu'elle apparaisse ou non en public». Une leçon apprise à nouveau à la mort de la princesse Diana, lorsque les rédacteurs en chef du monde entier se rendirent compte qu'ils disposaient de suffisamment de photos d'archives pour la garder «vivante» pendant des années.

En 1870, le prince et la princesse de Galles furent responsables d'un mini-scandale lié à la photographie. Le bébé royal ne s'étant pas comporté de manière très régalienne lors d'une séance de pose, le prince, s'impatientant, proposa d'utiliser un autre nourrisson, conformément au principe d'Alison Jackson que "tous les bébés de cet âge se ressemblent". Rapportant l'incident, le journaliste suggéra une autre solution : «Remplacer le vrai bébé par un modèle riant et pleurant ; en caoutchouc ou dans une autre matière plastique et flexible.»

Jackson traite peut-être spécifiquement du culte de la célébrité «ici et maintenant», mais les questions qu'elle pose sont profondément enracinées dans l'histoire de la photographie. La princesse Diana est vivante et en bonne santé, photographiquement parlant. Elle a épousé Dodi et ils ont eu un magnifique bébé. N'avons-nous pas un sublime portrait à la lord Snowdown pour le prouver? Et le regard adorateur que Lady Di porte à son enfant ne démontre-t-il pas qu'elle est une mère naturelle?

Comme le sait fort bien Jackson, la photographie ne fait pas qu'enregistrer. Elle amplifie et rend plus fort. Quand les gens voient une star en chair et en os, ils sont presque toujours déçus. «Il est si petit!», disent-ils souvent. Dans un des articles du 19e siècle cité plus haut, la célébrité était appelée «l'original» et sa photo «une pâle copie». Au 21e siècle, la situation semble s'être inversée : aujourd'hui, la photo semble être l'original et la célébrité une pâle copie. Le meilleur moyen pour une célébrité de rester sous les projecteurs, c'est encore de ne pas se montrer.

Alison Jackson aurait pu recourir à la manipulation électronique pour raconter ses histoires, mais cela aurait rendu ses images moins troublantes : nous savons qu'il s'agit de sosies, mais il reste un doute lancinant : en sommes-nous toujours sûrs? À une époque de manipulation numérique, nous serions en droit de présumer que ses personnages sont des avatars pixelisés plutôt que des sosies. En fait, Jackson aime la photographie traditionnelle, et particulièrement son application dans le domaine de la célébrité. Elle aime se moquer des conventions de la photographie et perturber ses codes. Ironiquement, ses images peuvent revendiquer un statut objectif, documentaire : il n'y a pas de retouches, pas de tours de passe-passe dans la chambre noire. Elle montre la réalité. C'est nous qui projetons de la fiction dans son travail, voulant que ces personnages soient les dieux et les déesses que nous recherchons tant.

***William Ewing**, actuellement directeur du Musée de l'Elysée à Lausanne, est un auteur et conservateur de photographies réputé. Il a organisé des expositions au Museum of Modern Art et à l'International Center of Photography de New York ainsi que dans de nombreux autres musées et galeries partout dans le monde. Son ouvrage le plus récent s'intitule* Faire face: le nouveau portrait photographique *(2006), et il est l'auteur célébré du livre* Le Corps *(1994).*

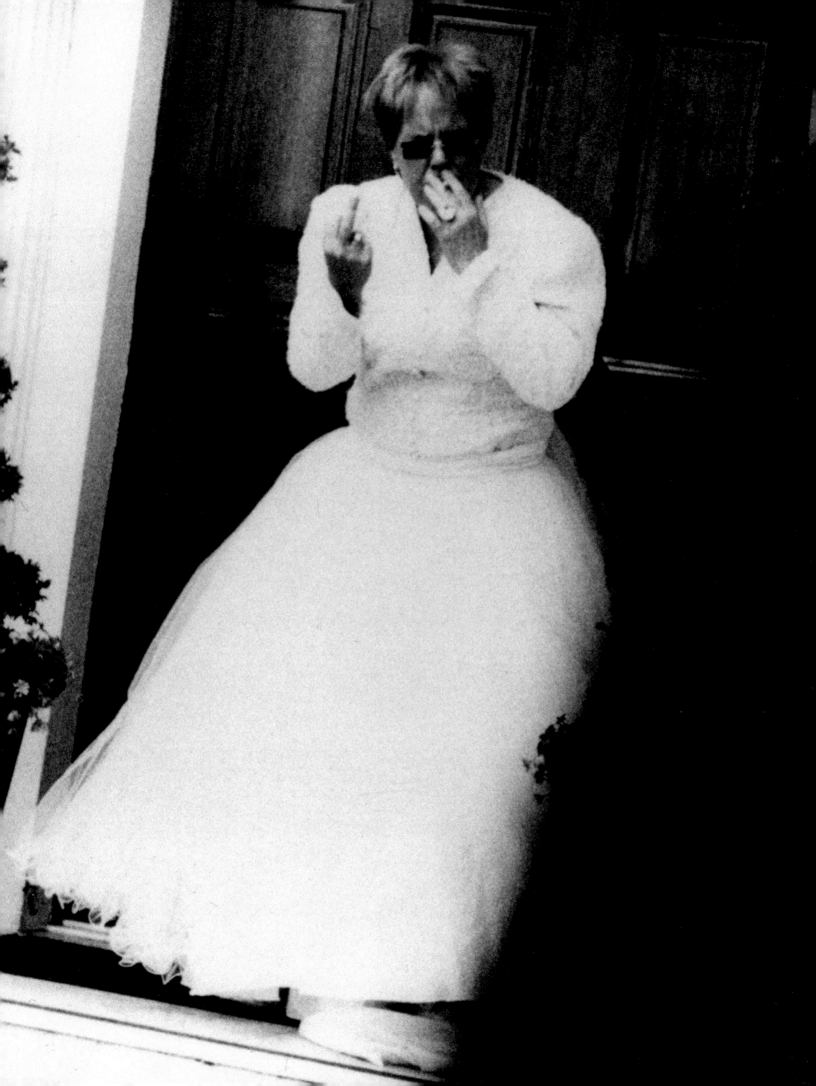

ACKNOWLEDGEMENTS

I am very grateful to many people for their assistance and support in the making of this book. I particularly wish to thank:

The creative team: *Sean Thompson, George Bright, Tom Rawstorne, Molly Watson, Joanne Morris, Olivia Glazebrook, Camilla Long, Bettina Von Hase, Joana Schliemann,* and *Kira Jolliffe.*

Thank you to *Zenon Texeira* and *Howard Forrester* from Kraken Creative.

My highly skilful and much appreciated casting director *Dave Cooper*, and my hair and make-up team *Linda McKnight, Sue Daniels,* and *Heather Squire.*

Grateful thanks to *Seb Winter* and photographic consultants *Dave Bentley, Frank Thurston,* and *Dan Prince.* My production and post-production team: Michael Dyer Associates, *Lyn Dyer, Dave Bentley, Mark Hubbard, Chad Koch, Chris Norton, Brian Voce, Alan Skipp, Ross Casswell, Heather Clarke, Von Thomas, Virginie Drouot, Betsy Dennis, Lynne Martin, Andrew Tapper, Dot Findlater, Susan Scott,* and *Rob Thomas* at The Window Seat.

Essayists *William Ewing, Charles Glass,* and *Will Self. Benedikt Taschen, Florian Kobler,* and everyone at TASCHEN.

Neal Brown for editorial assistance.

With special thanks to *Lorne Michaels* of SNL.

Paul Arden, Caryn Mandabach, Tina Pelini, Kasim Kutay, Peter Banks—a constant support, *Nick Sutherland-Dodd, Paul Stephens* at ICM, *Paul Sommers* at Tiger Aspect for his patient support and for giving permission to use some of the photographs from Double Take and similarly to the BBC, Channel 4, and *Robert Norton.*

Thank you to *Patty Mayer* at Mitchell Silverberg Krupp, Los Angeles for keeping me on the straight and narrow, legally speaking.

Thank you to *Johnny Pigozzi* for the fabulous photographs of me with "Becks".

The many galleries and curators with whom I am working, or have worked with, over the years, particularly the Richard Salmon Gallery.

My excellent look-alikes.

Finally, I would like to thank the many politicians and celebrities who, in the truest sense, have made this book possible.

BIOGRAPHY

Working in the mass communication media of films, advertising, television, and books—as well as art galleries—*Alison Jackson* has won numerous awards. Creator of the best selling book *Private*, and director of the infamous TV series *Double Take*, as well as films and programmes on Tony Blair, the Royal Family and the private lives of soccer players, Jackson is a force to be reckoned with.

Jackson studied sculpture and photography at London's Royal College of Art, since when she has exhibited in leading contemporary art galleries and museums throughout Europe and North America.

Mit Film und Fernsehen, Werbung und Büchern – aber auch in Kunstgalerien – ist *Alison Jackson* in vielen Bereichen der Massenkommunikation aktiv und wurde bereits mit zahlreichen Preisen ausgezeichnet. Ihr Buch *Private* wurde zum Bestseller, sie ist Regisseurin der berüchtigten Fernsehserie *Double Take* sowie zahlreicher Filme und Beiträge über Tony Blair, die königliche Familie und das Privatleben von Fußballern: Mit Alison Jackson muss man rechnen!

Sie studierte Bildhauerei und Fotografie am Londoner Royal College of Art und hat seither in führenden Galerien für zeitgenössische Kunst und Museen in ganz Europa und Nordamerika ausgestellt.

Travaillant avec les moyens de communication de masse – films, publicité, télévision et livres – tout en exposant dans les galeries d'art, *Alison Jackson* a remporté de nombreux prix. Auteur du bestseller *Private*, réalisatrice de la fameuse (et scandaleuse) série télévisée *Double Take*, ainsi que de films et d'émissions sur Tony Blair, la famille royale et la vie privée de footballeurs, c'est une artiste avec laquelle il faudra désormais compter.

Alison Jackson a étudié la sculpture et la photographie au Royal College of Art de Londres. Depuis, elle a exposé dans les plus grandes galeries d'art contemporain et les musées d'Europe et d'Amérique du Nord.

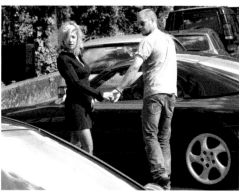

Portrait of the artist 2007 by Johnny Pigozzi

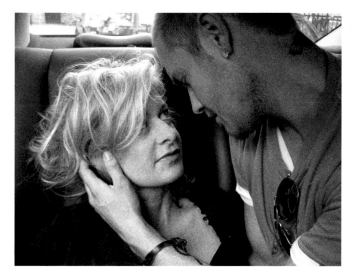

IMPRINT

To stay informed about upcoming TASCHEN titles, please request
our magazine at www.taschen.com/magazine or write to TASCHEN,
Hohenzollernring 53, D-50672 Cologne, Germany,
contact@taschen.com, Fax: +49-221-254919. We will be happy to
send you a free copy of our magazine which is filled with information
about all of our books.

© 2007 TASCHEN GmbH
Hohenzollernring 53, D–50672 Köln
www.taschen.com

EDITOR: Florian Kobler, Cologne
EDITORIAL CONSULTANT: Neal Brown, London
DESIGN: Sense/Net, Andy Disl and Birgit Reber, Cologne
PRODUCTION: Ute Wachendorf, Cologne
GERMAN TRANSLATION: Egbert Baqué, Berlin
FRENCH TRANSLATION: Philippe Safavi, Paris

Printed in Germany
ISBN 978–3–8228–4638–4